JEREMY SCOTT

JEREMY SCOTT

FOREWORD BY JEFFREY DEITCH

RIZZOLI NEW YORK

New York · Paris · London · Milan

THE PEOPLE'S DESIGNER

"Taking trash and making treasure—it is so much part of me." JEREMY SCOTT points to an intriguing assemblage in the garden below his house in the Hollywood Hills. A tractor seat is mounted on an upright spring, welded onto a massive tractor wheel. It resembles the junk sculpture made by New York School artists in the late 1950s. "This chair down there was made by my grandfather," Jeremy explains, "and it's from the farm I grew up on. It's one of the things I played on when I was a kid. That chair represents me so much because I grew up in this world of taking one thing and creating something else out of it— recontextualizing it."

The chair was one of numerous assemblage works made by Jeremy's grandfather, not as "art" but as a way to make something useful from discarded material. Jeremy's grandmother shared this industrious attitude, reassembling thrown-away fabric into beautiful quilts. His grandparents' ingenious craft projects became an inspiration for Jeremy's own approach to his work.

We are sitting on the terrace of Jeremy's small but exquisite house, a perfect example of the 1930s Hollywood moderne style. It is perched above a steep canyon, a private aerie with spectacular views. The tables and chairs are piled with fabrics and samples. A living-room wall has been transformed into an inspiration board, with lists of ideas for future designs and compilations of images from art and popular culture. What was once the dining-room table is now Jeremy's desk, where he has carved out a space for his laptop computer amid stacks of sneaker samples, wrinkled garments, and oversize toys. The house has become Jeremy's personal design studio. He is more inspired working alone in his house than in his professional studio in West Hollywood. "I think of myself as an artist," Jeremy states without pretense. "I'm an artist who uses fashion as a medium."

Beyond the lines of a perfectly cut dress or the expert's detail in his tailoring, JEREMY SCOTT is interested in creating iconic imagery that people wear. He is intent on communicating with people through his work, becoming part of the culture and part of people's lives. He likes to work in the mainstream, while still being a rebel. For Jeremy, the contemporary avant-garde is no longer about making work for an elite group of like-minded people. His goal is "to get the work out there."

Jeremy uses his collaborations with cultural icons like RIHANNA, KATY PERRY, and MILEY CYRUS as a megaphone, as a way to infiltrate pop culture even further. He is using fashion and celebrity to create a new kind of performance art. He creates pop iconography that can penetrate the culture like the commercial icons that he recycles and reassembles. He extends his reach through his collaboration with ADIDAS: LIL WAYNE was the first person to wear Jeremy's teddy-bear sneakers, flaunting them during his first concert after having been released from jail.

Jeremy's work is characterized by humor, an embrace of popular culture, and a fascination with iconography. He has a brilliant facility with words and slogans, often incorporating them into his designs. "LOST FOR WORDS" is the title of one of the sections of this book, a playful allusion to his outrageous use of words and the role of language as an essential

element of his fashion design. His designs pay homage to artists like ANDY WARHOL, ED RUSCHA, KEITH HARING, and KENNY SCHARF, who, like Jeremy, repurpose pop iconography to make it even more iconic.

I presented Jeremy's work at Deitch Projects in 2003 as art, not as fashion. Jeremy's SEXYBITION was an art performance inspired by a carnival sideshow. About a dozen booths were constructed around the perimeter of the gallery with different themes, including a barnyard with live sheep, a stable with horses, a schoolroom, a church, a kitchen, a jungle, and a dungeon, where Jeremy's muse, the actress LISA MARIE, struggled against her chains. In each tableau, models were minimally dressed in a look from Jeremy's Spring 2004 collection. SEXYBITION was a sensation, inspiring immense press coverage that was both enthusiastic and satirical. Only later did I realize that SEXYBITION also resulted in Jeremy being banned from coverage on Style.com and in other mainstream fashion magazines for years.

Jeremy grew up on a small cattle farm in Lowry City, Missouri (population 624), where "the Ozarks meet the Great Plains." His path to success as a fashion designer is an archetypal American story, but more characteristic of the nineteenth or early-twentieth century than the twenty-first: Missouri farm boy becomes an international fashion star by way of Paris. An Internet search on Lowry City tells you that 22% of its residents live below the poverty line and brings up snapshots of a house and barn for sale for $12,000. There was limited contact in Lowry City with the worlds of art and fashion, but the necessity of creatively reassembling discarded material, where there was no money to buy something new, taught Jeremy essential aesthetic lessons.

Around the fifth grade, Jeremy's parents—an engineer and a schoolteacher—moved the family to a semirural section on the edge of Kansas City. For the first time he had access to shopping malls and fashion magazines. I asked Jeremy if he was aware of high fashion as a teenager; his answer was that he was "obsessed." He followed VOGUE and INTERVIEW and would read copies of COLLEZIONE for free at the bookstore. His bible was ANNIE FLANDERS' DETAILS. He would also follow ELSA KLENSCH on CNN. JEAN PAUL GAULTIER became his great inspiration. He would call up salespeople at Bergdorf Goodman and Saks Fifth Avenue in New York and Chicago and ask them to describe their GAULTIER merchandise on the phone. He would save up to buy choice examples when they went on sale and have them sent to him. Every night he would fall asleep talking with his small circle of fellow enthusiasts on the phone about what they would wear to school the next day.

At school his extreme appearance created tension, resulting in almost weekly incidents and altercations. His mother was called to the school frequently, where he was repeatedly admonished and asked why he couldn't just dress like everybody else. He excelled in his art classes, however, and one teacher cleared out a closet so that Jeremy would have his own room for his ceramics. When he was able to realize his high-school fantasy of a trip to Paris, where he thought that he could finally find "his people," he and his sister rushed off the plane to the Gaultier shop. Prepared for the greatest thrill of his life, Jeremy was heartbroken to have the door shut in his face by the staff, telling him it was closing time.

Preparing for his graduation from high school, he applied to the Fashion Institute of Technology, but the application was returned several weeks later, folded and damaged, with a letter telling him his portfolio lacked creativity. His mother insisted that he leave the house rather than hang around without a job or a course of study, so Jeremy enrolled in a summer course at New York University. In New York he instantly felt acceptance, immediately found like-minded people, and after an exciting interview he was invited to apply to Pratt, where he would earn his degree in art.

After graduation, Jeremy was determined to return to Paris. Ironically, the internship that he found to earn the money required for the trip was with the New York office of MOSCHINO, working for the very same person who would call him twenty years later to offer him the position of creative director. When he had saved enough money, he left for Paris, assuming that he could find the same type of paid internship that he had in New York. He was not prepared, though, for the bureaucratic red tape that made a paid job in Paris impossible to attain.

Instead Jeremy hung out at the clubs, making enough friends to be asked to organize parties. Knowing of his engagement with fashion, one of the clubs asked him to organize a fashion show. Using scraps of fabric and unsold pieces thrown away at the close of flea markets, Jeremy constructed his first collection. A fellow club kid who was a performance artist offered to lend her stage lights. His friend PABLO OLEA dragged a black car door back to their apartment, thinking that it might make a good prop for the runway. Jeremy thought that it might be better used as an extravagant invitation to the show, with the information about the event painted on it. They thought about whom to send it to, and decided to deliver it to the home of MARIE-CHRISTIANE MAREK, who hosted a popular fashion program on television. The ruse worked, and Marie-Christiane sent a crew to cover Jeremy's show. She did not attend herself, but she edited in her commentary with the footage, creating the impression that she was actually there. The television coverage brought Jeremy to the attention of Paris fashion insiders, resulting in his winning the Venus de la Mode award for best young designer—the first non-French person to receive the honor. With the prize money he was able to mount his second show, winning the Venus de la Mode award for a second time.

Jeremy's third show in Paris was attended by ISABELLA BLOW and American fashion editors. Having arrived with no money, no connections, and no job, Jeremy had managed to launch his career in Paris. Aside from a short internship with MARC JACOBS in New York while he was a student at Pratt, Jeremy has never worked under another designer, and until his current position as creative director of MOSCHINO had never held a traditional job working in the fashion industry. He has built his career on his own. His approach has been do-it-yourself, just like on the farm.

Jeremy remembers when the residents of Lowry City were thrilled to get their first McDonald's, feeling that their town was finally on the map. Now, in 2014, the Golden Arches are the inspiration for Jeremy's celebrated debut collection for MOSCHINO. The Missouri farm boy has recycled one of the most all-American icons to create a sensation for one of the most iconic European fashion brands—and become an icon all his own along the way.

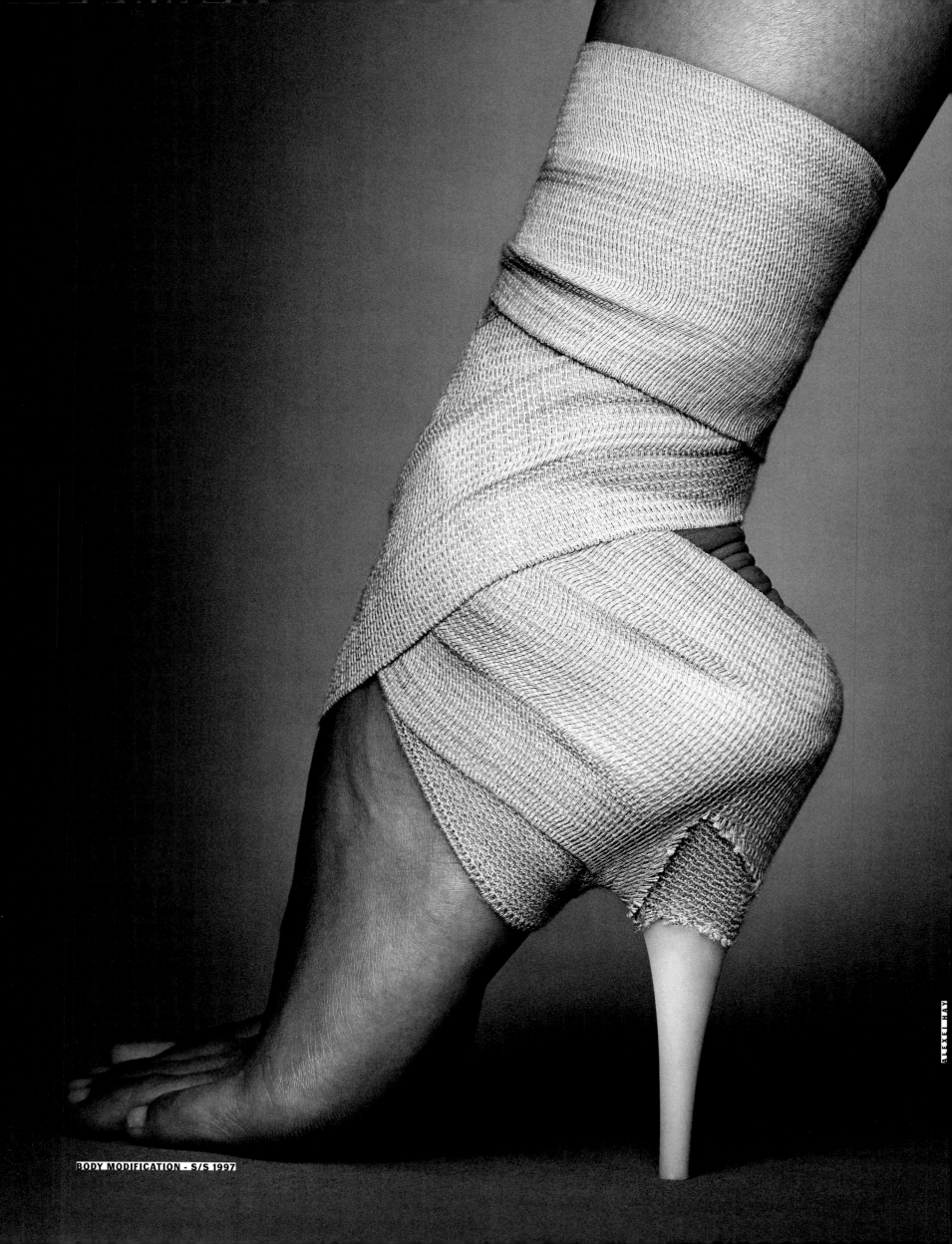

BODY MODIFICATION - S/S 1997

ALEXEI HAY

SOMETIMES A DREAM COMES ALONG THAT
IS SO LARGE IT'S BIG ENOUGH FOR TWO.
THANK YOU FOR SHARING MY DREAM, PABLO.
J.S.

AMERICAN
DREAM

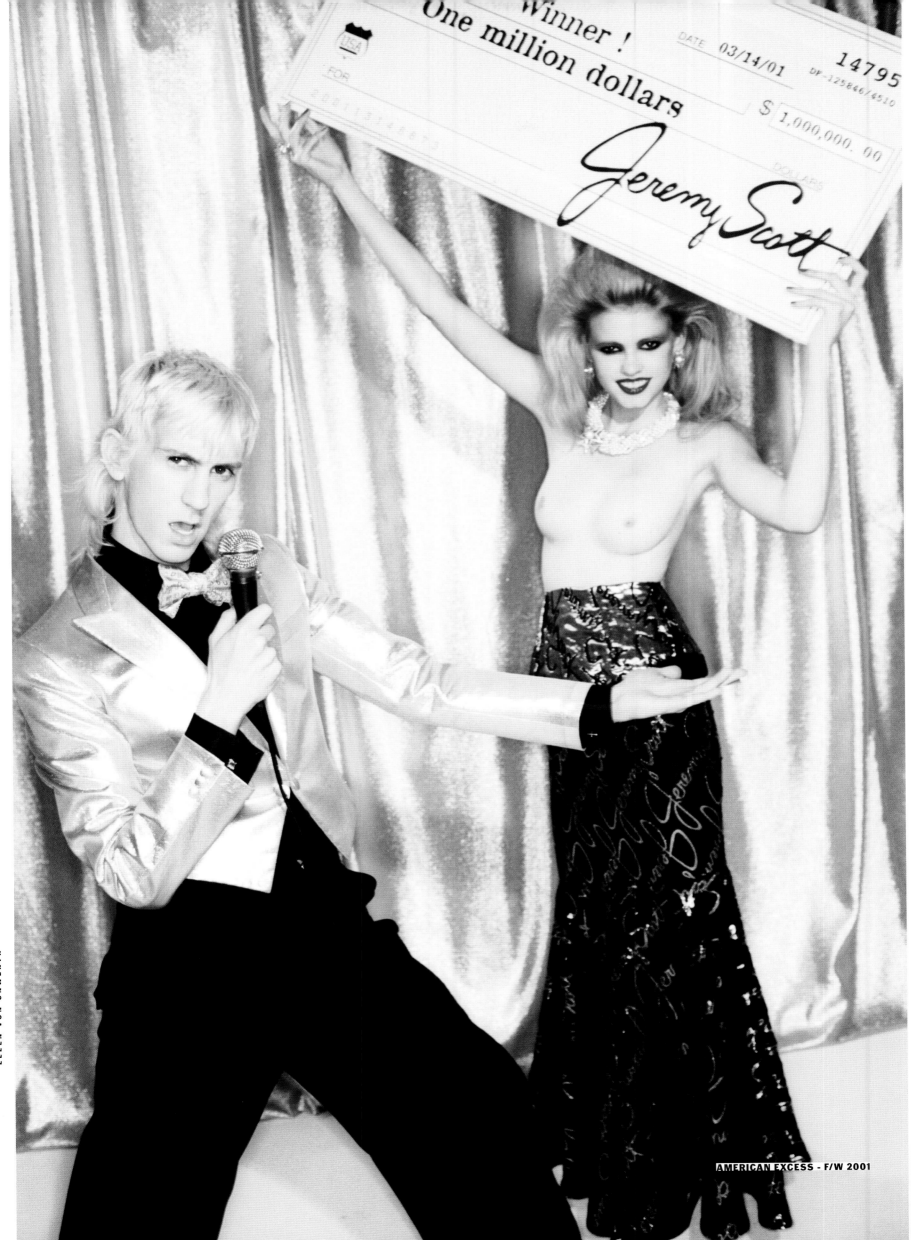

Winner !
One million dollars

DATE 03/14/01

14795

USA

DP-125846/4510

FOR

S $ 1,000,000. 00

DOLLARS

Jeremy Scott

ELLEN VON UNWERTH

AMERICAN EXCESS - F/W 2001

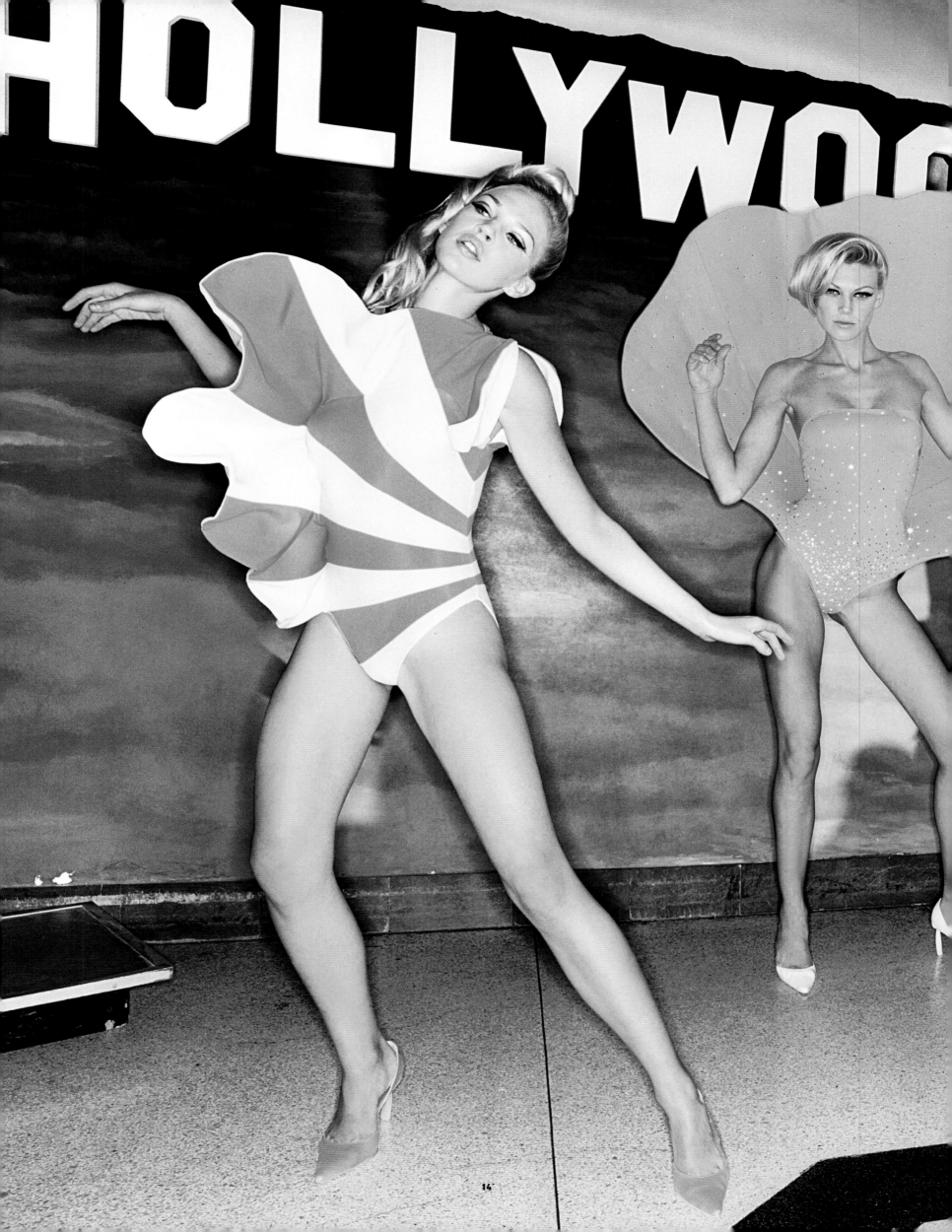

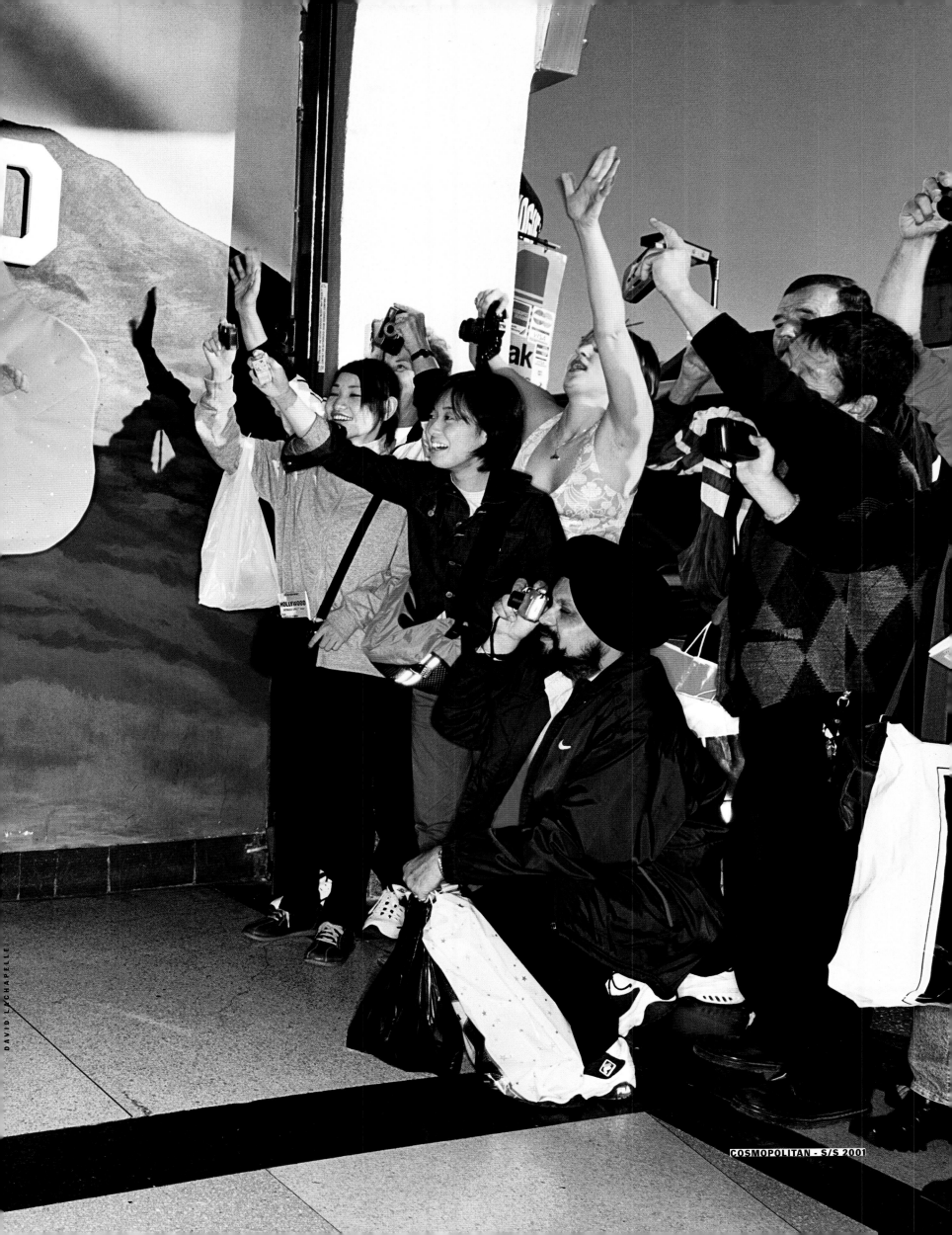

COSMOPOLITAN - S/S 2001

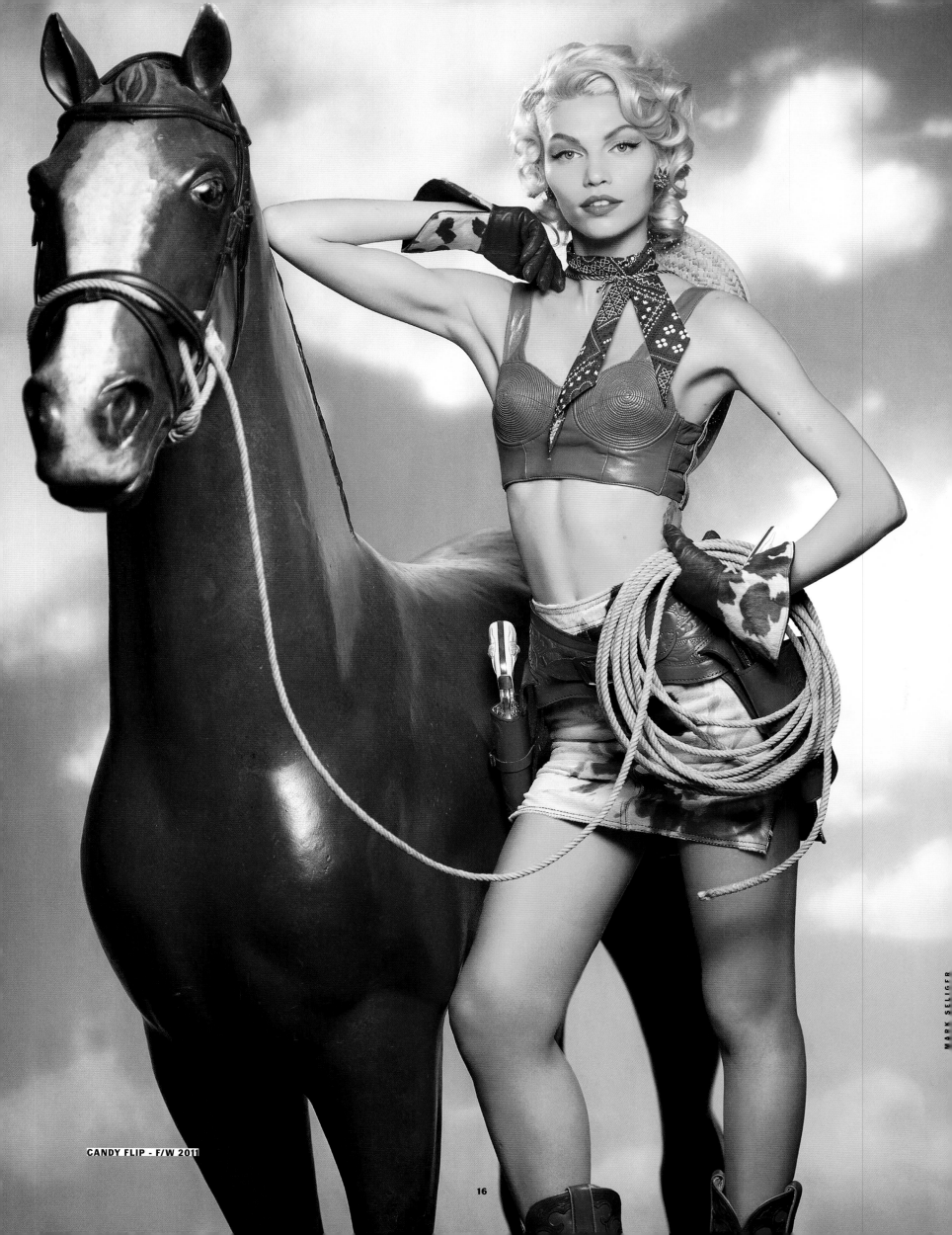

CANDY FLIP - F/W 2011

MARK SELIGER

16

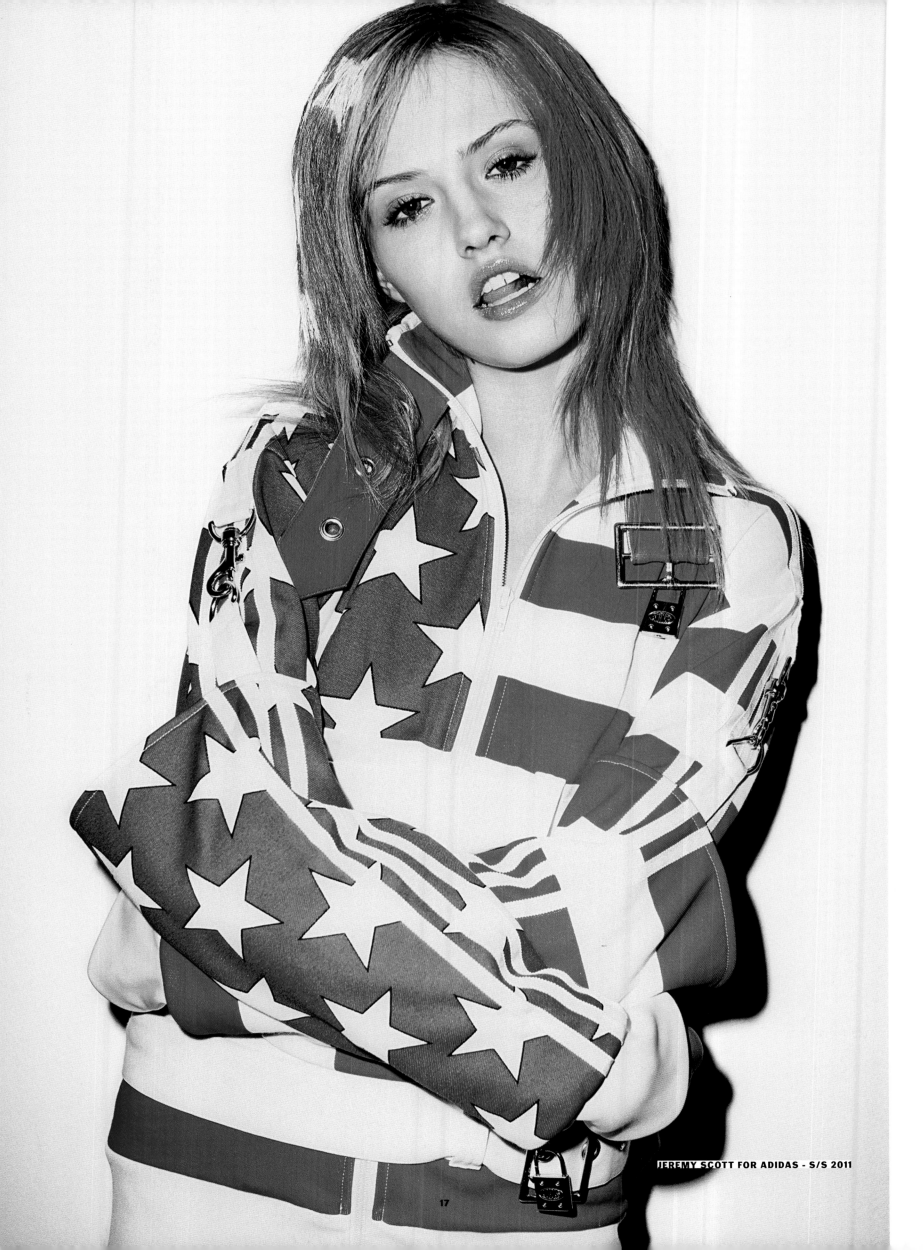

JEREMY SCOTT FOR ADIDAS - S/S 2011

17

Jeremy
Thanks for the
great clothes!
♡ Vanna

19

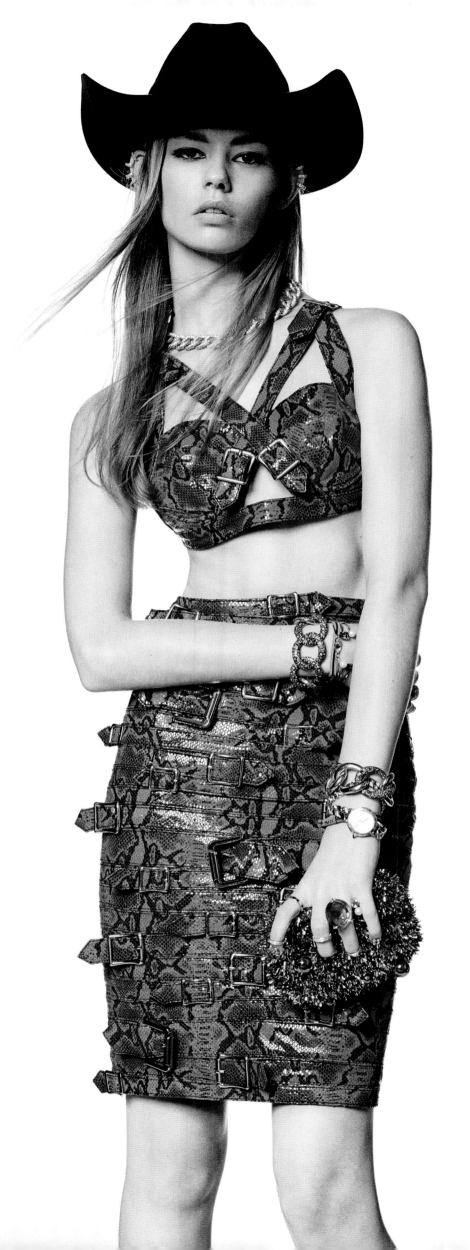

TEENAGERS FROM MARS - S/S 2014

LOST
FOR
WORDS

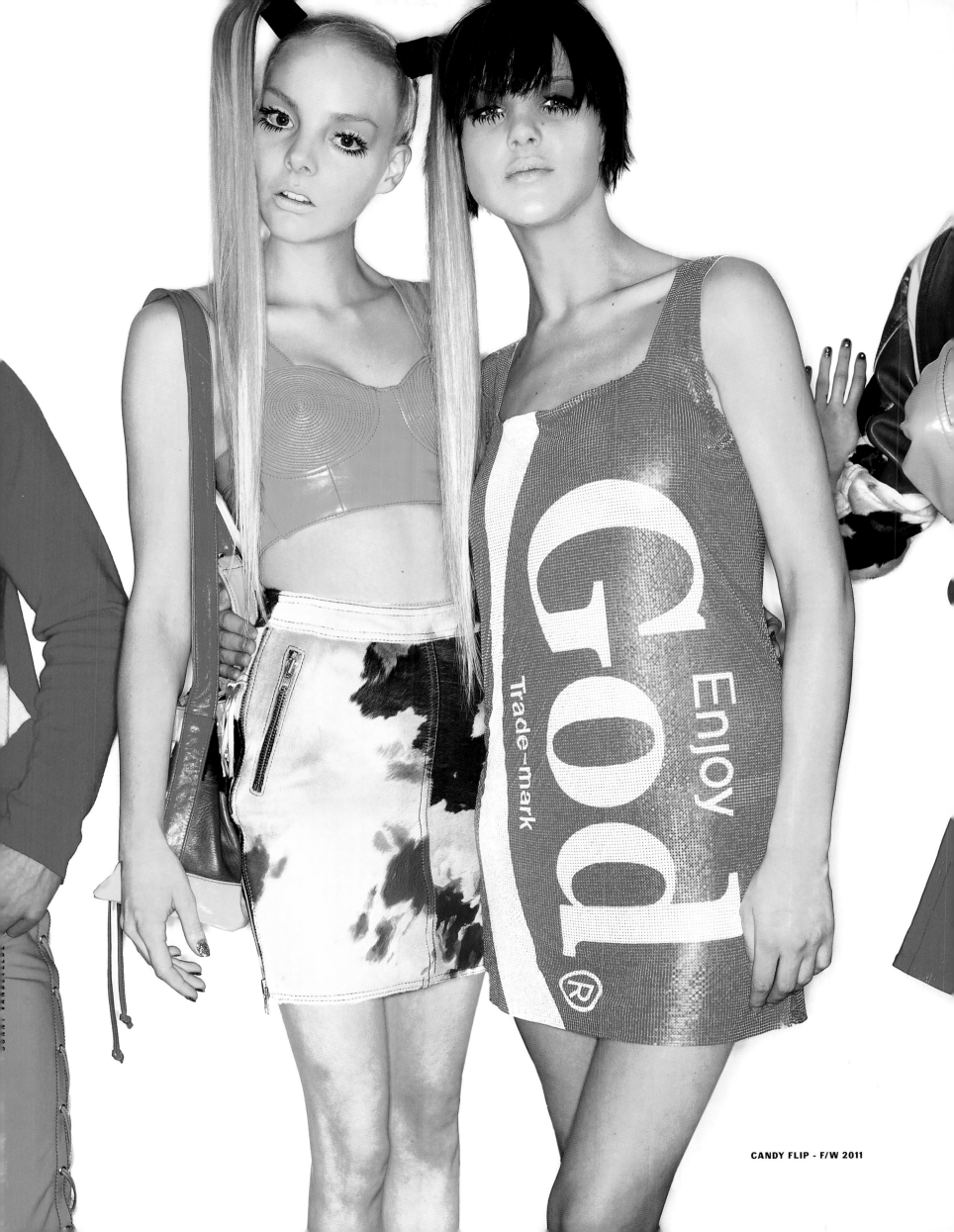

CANDY FLIP - F/W 2011

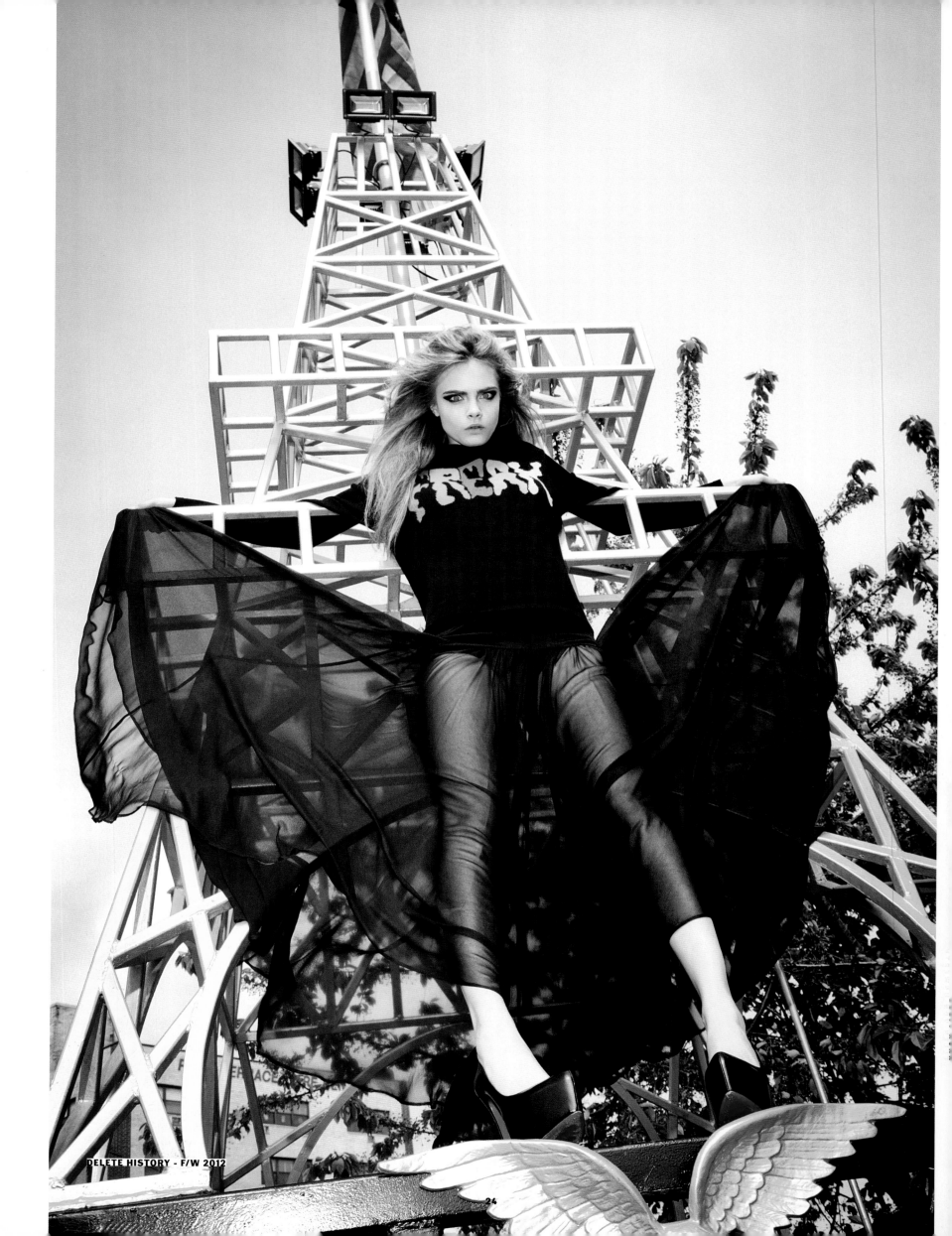

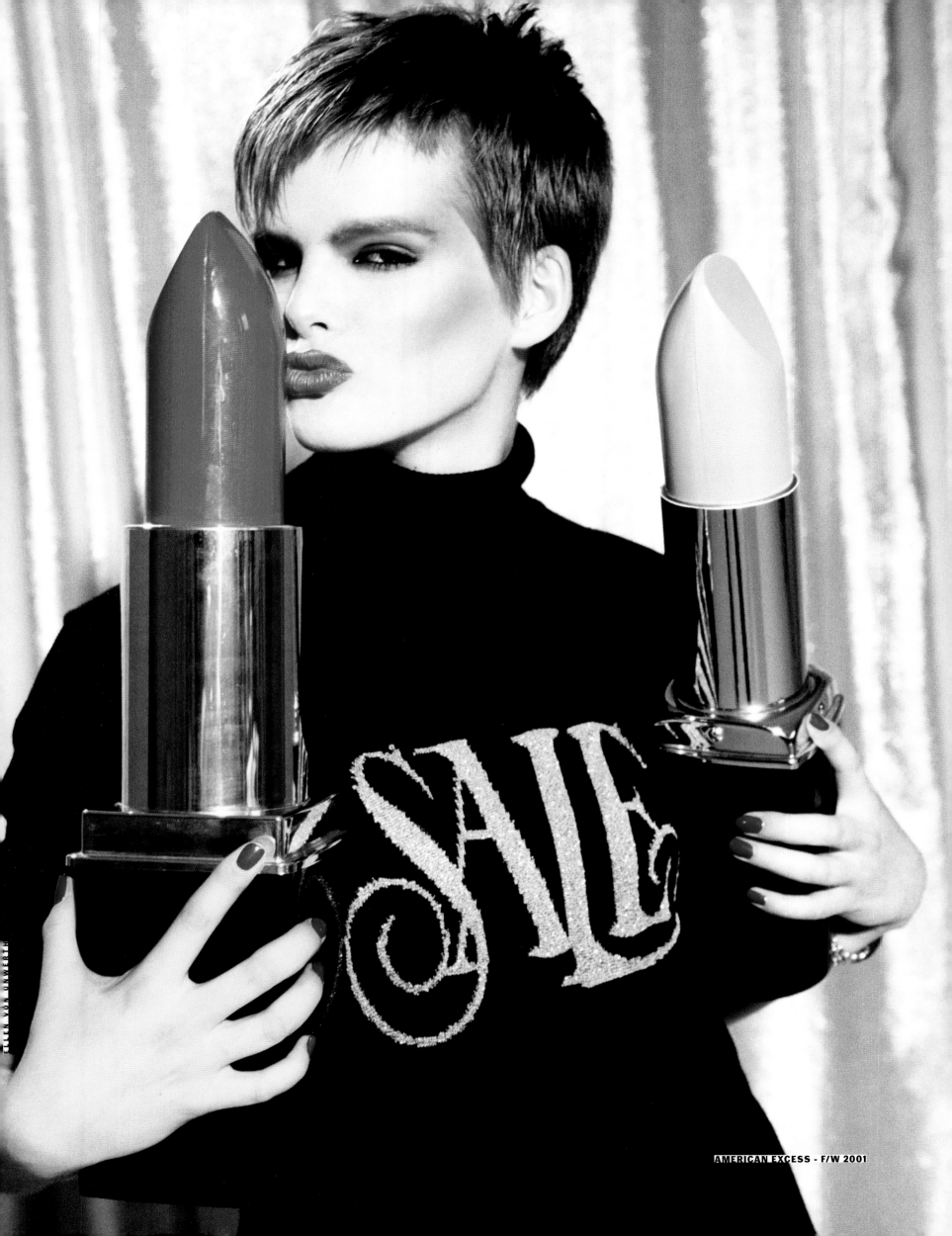

AMERICAN EXCESS - F/W 2001

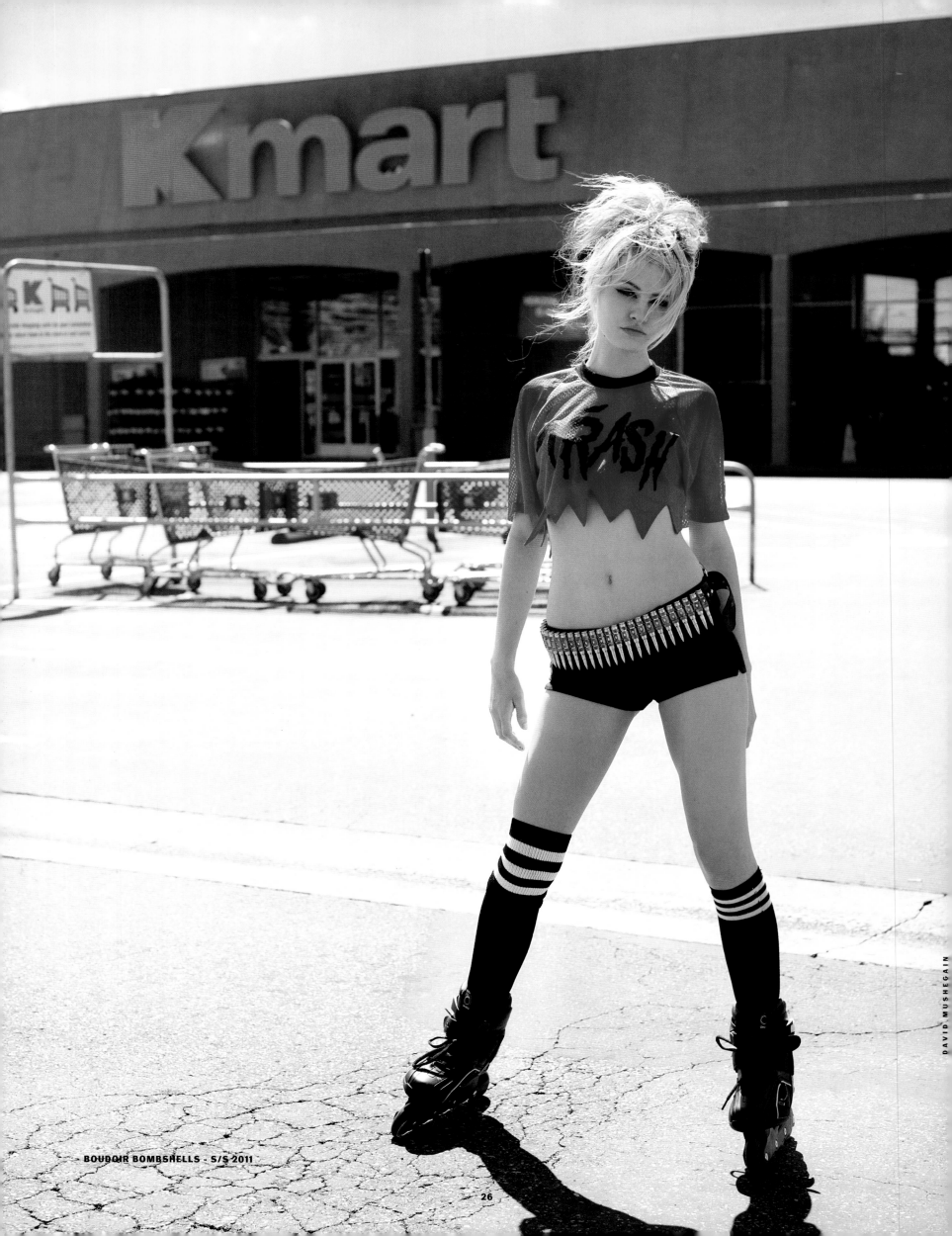

DAVID MUSHEGAIN

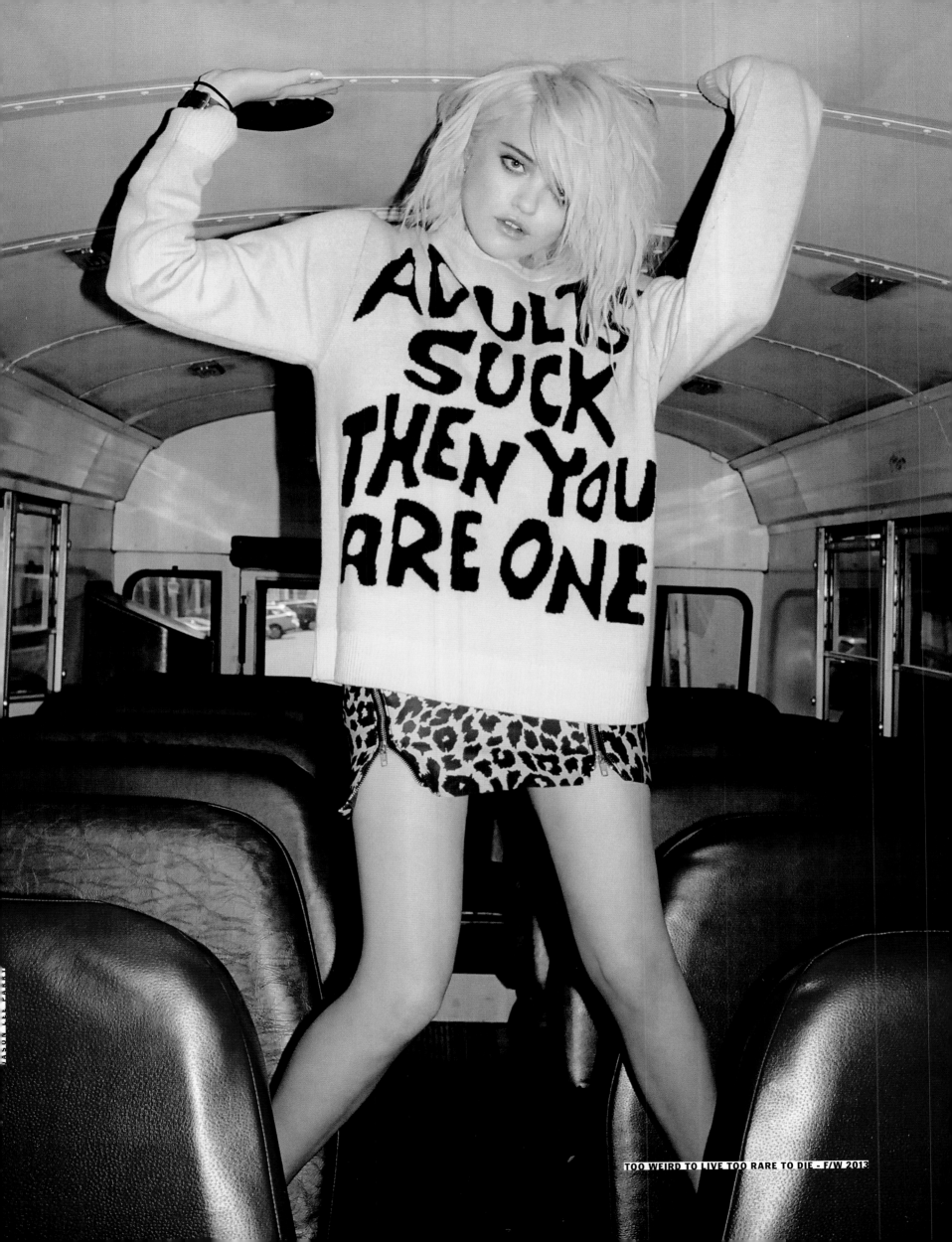

TOO WEIRD TO LIVE TOO RARE TO DIE - F/W 2013

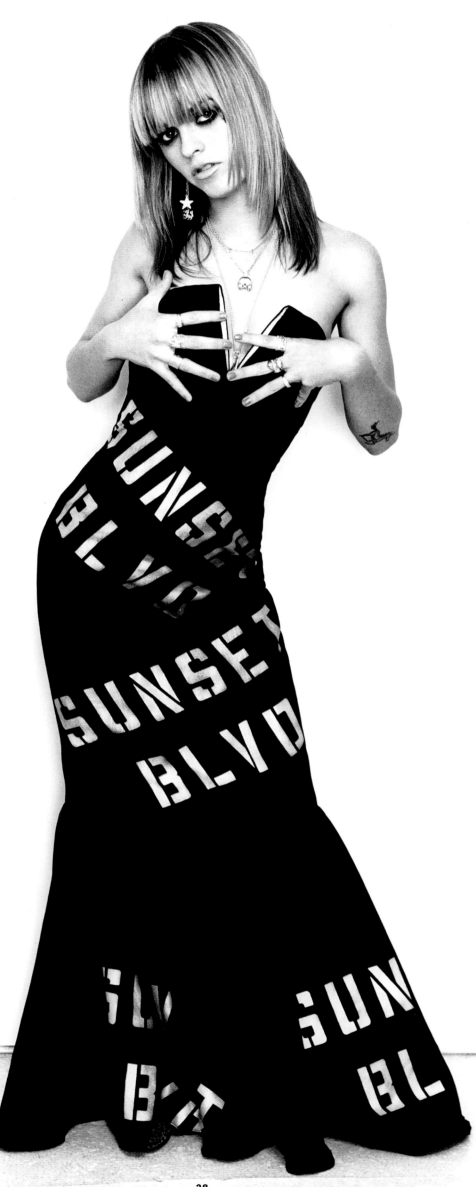

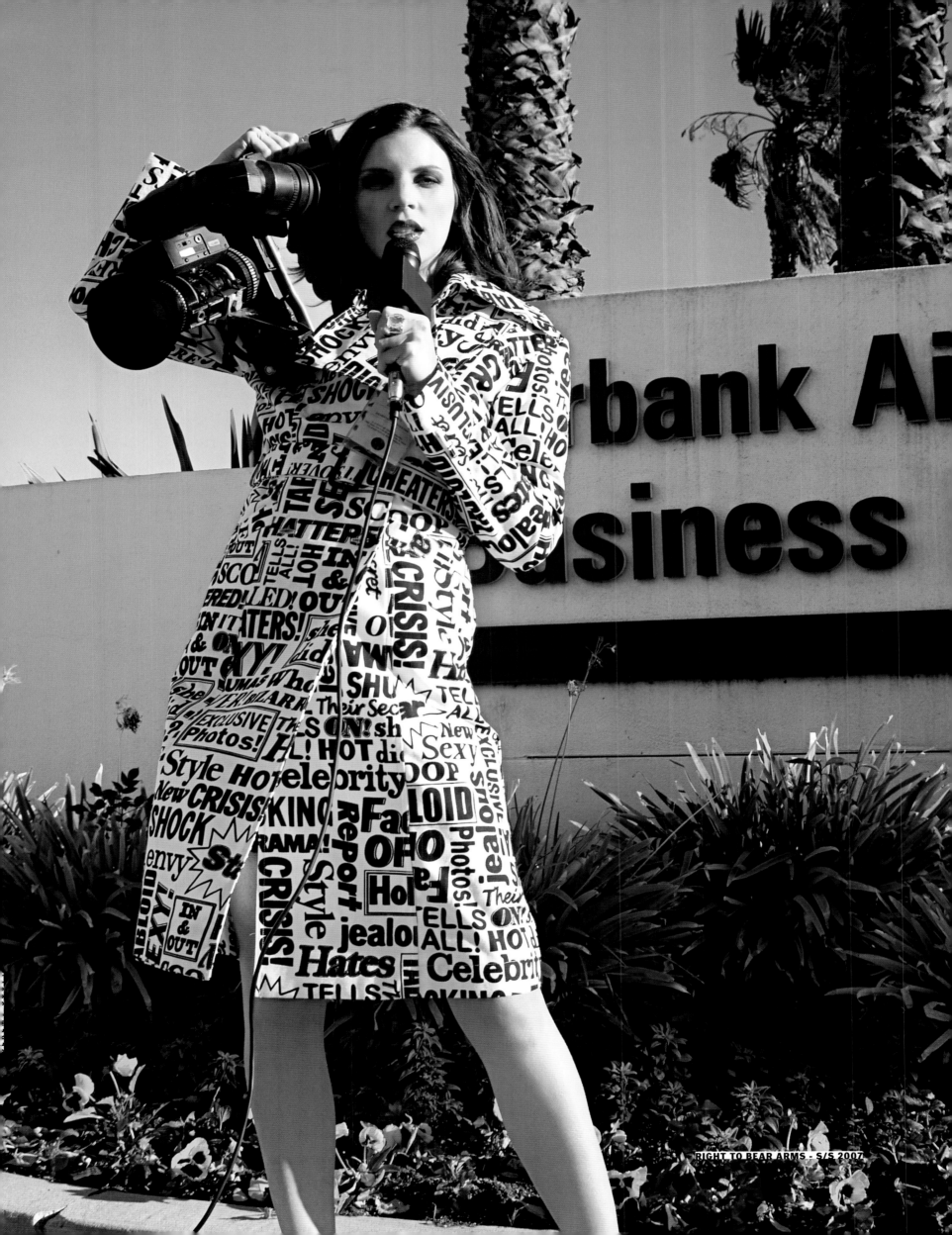

RIGHT TO BEAR ARMS · S/S 2007

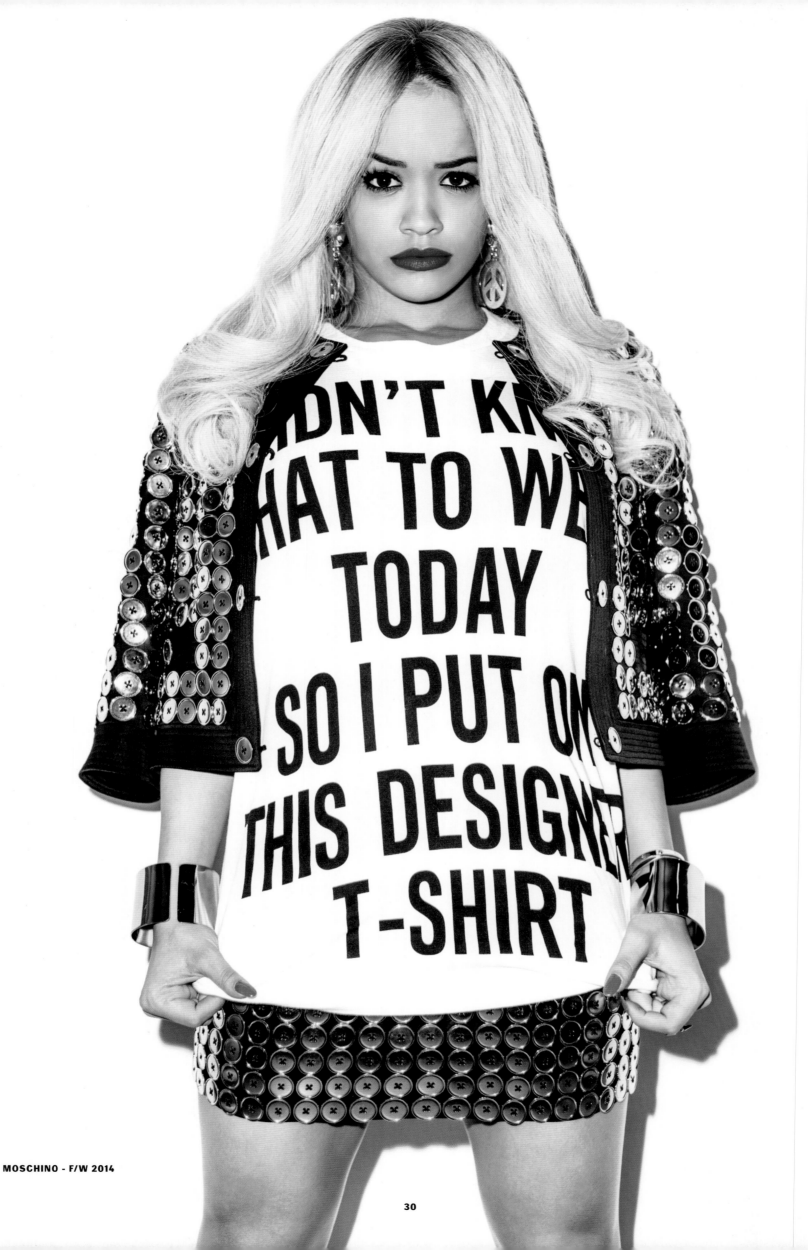

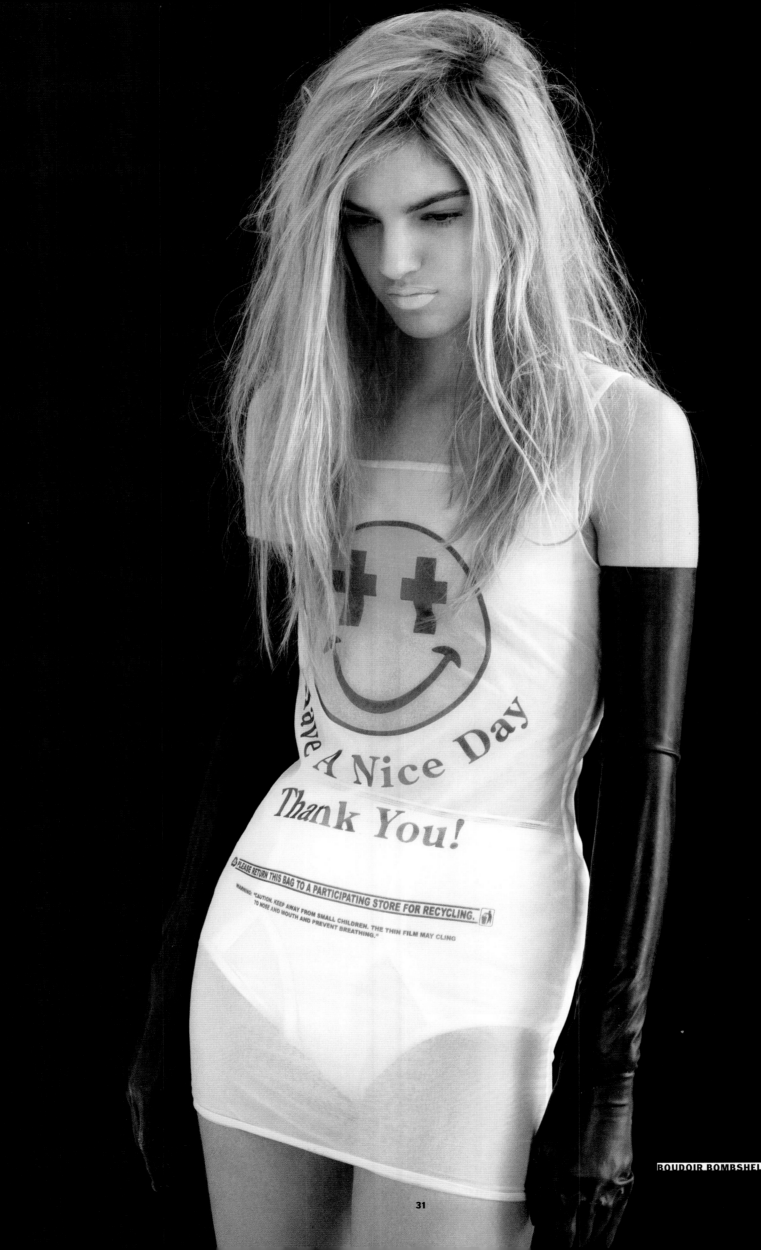

Have A Nice Day

Thank You!

⚠ PLEASE RETURN THIS BAG TO A PARTICIPATING STORE FOR RECYCLING.
WARNING: "CAUTION, KEEP AWAY FROM SMALL CHILDREN. THE THIN FILM MAY CLING
TO NOSE AND MOUTH AND PREVENT BREATHING."

WINGS & THINGS

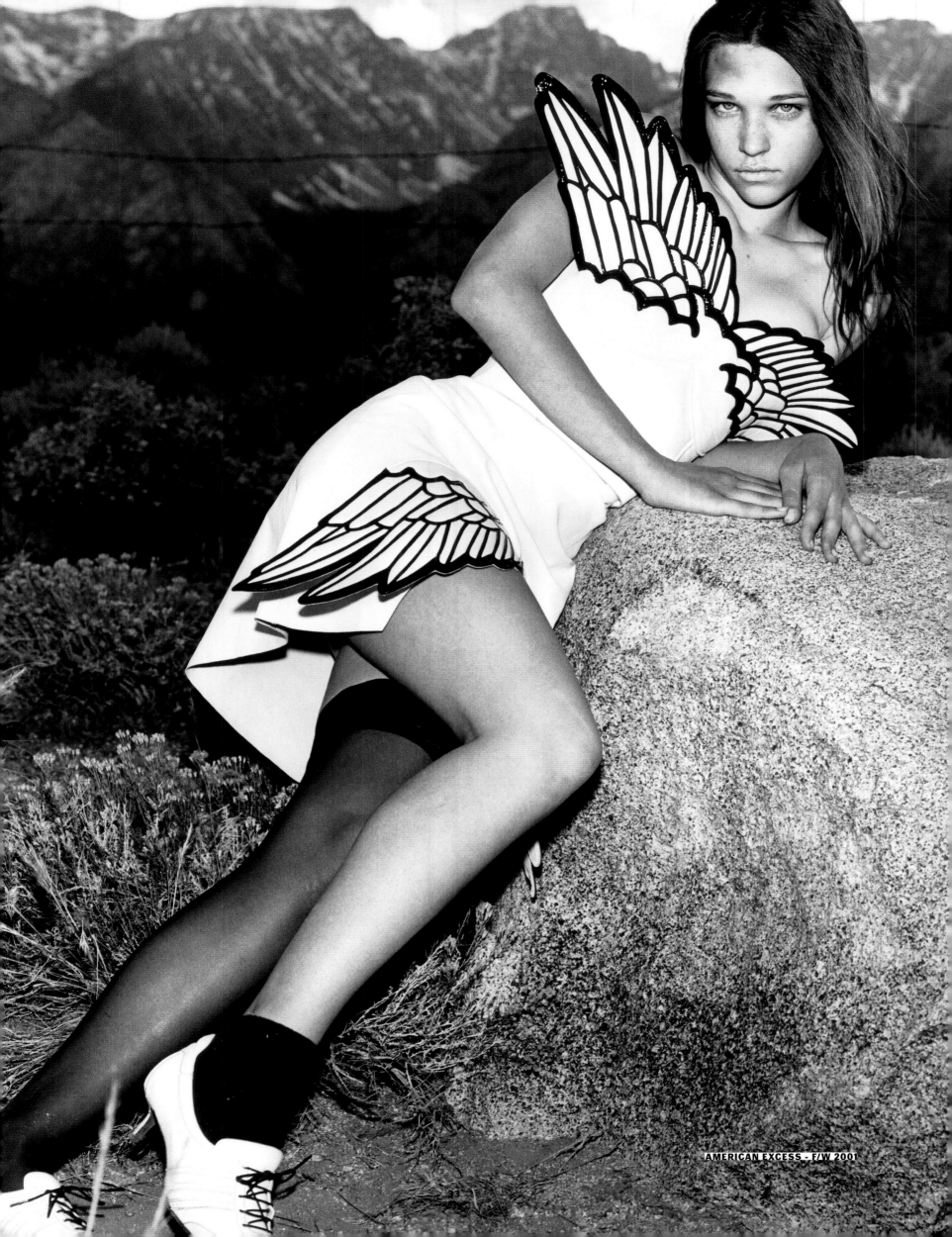

AMERICAN EXCESS - F/W 2001

 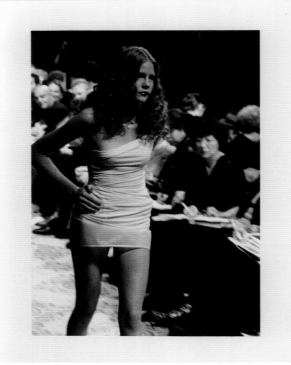 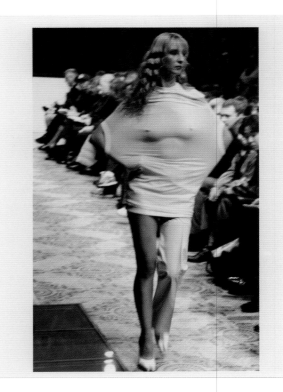

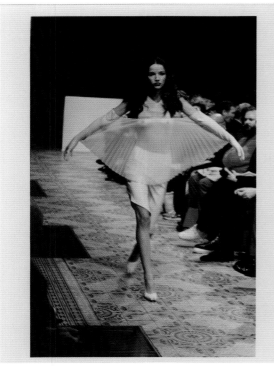 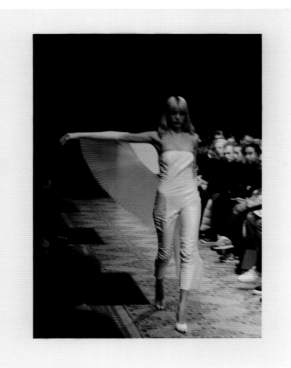 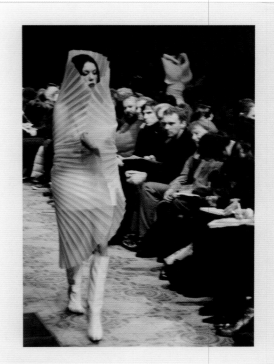

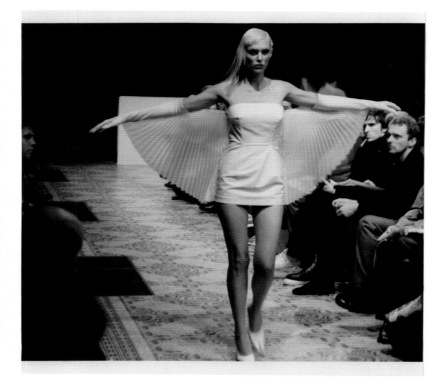

RICH WHITE WOMEN - S/S 1998

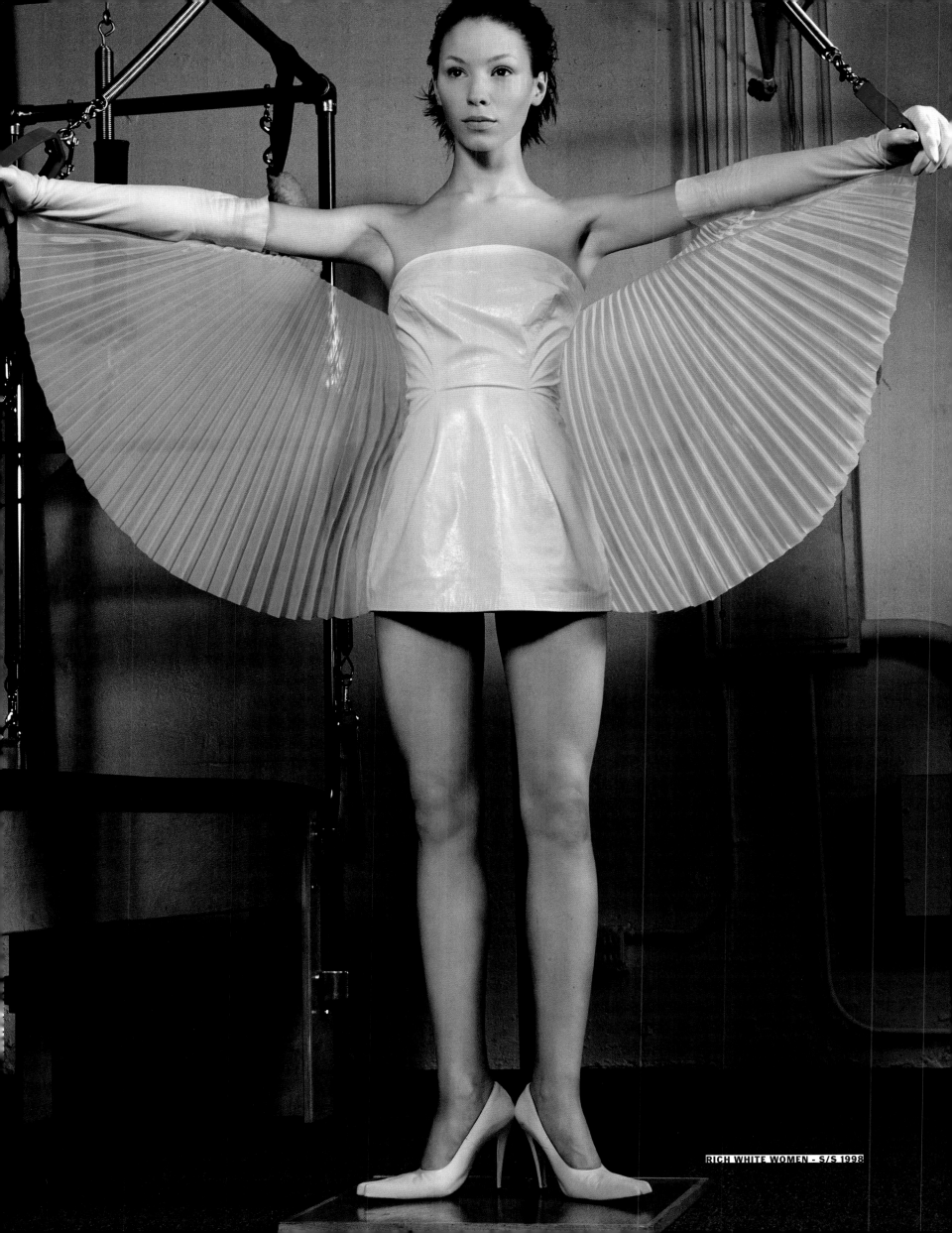

RICH WHITE WOMEN - S/S 1998

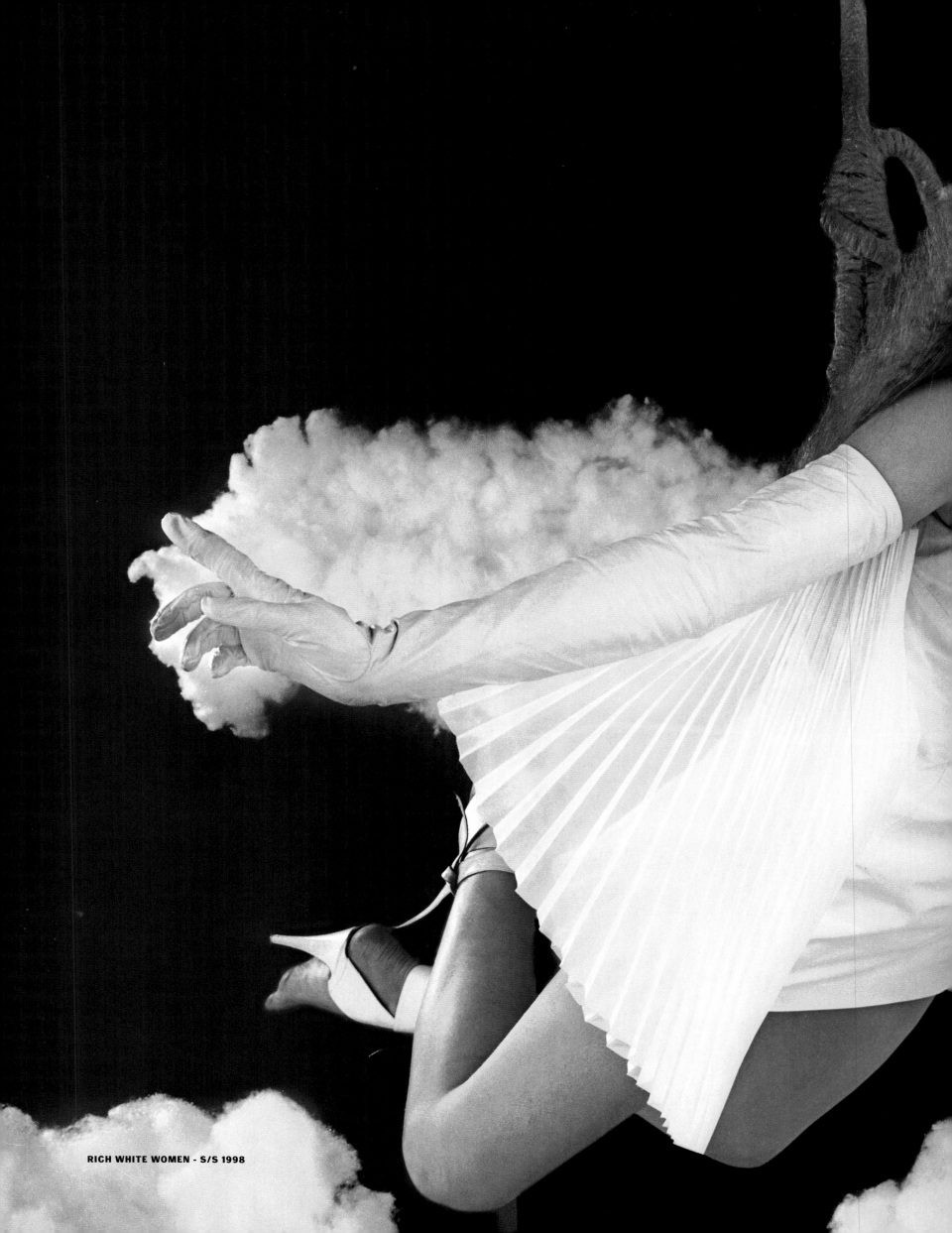

RICH WHITE WOMEN - S/S 1998

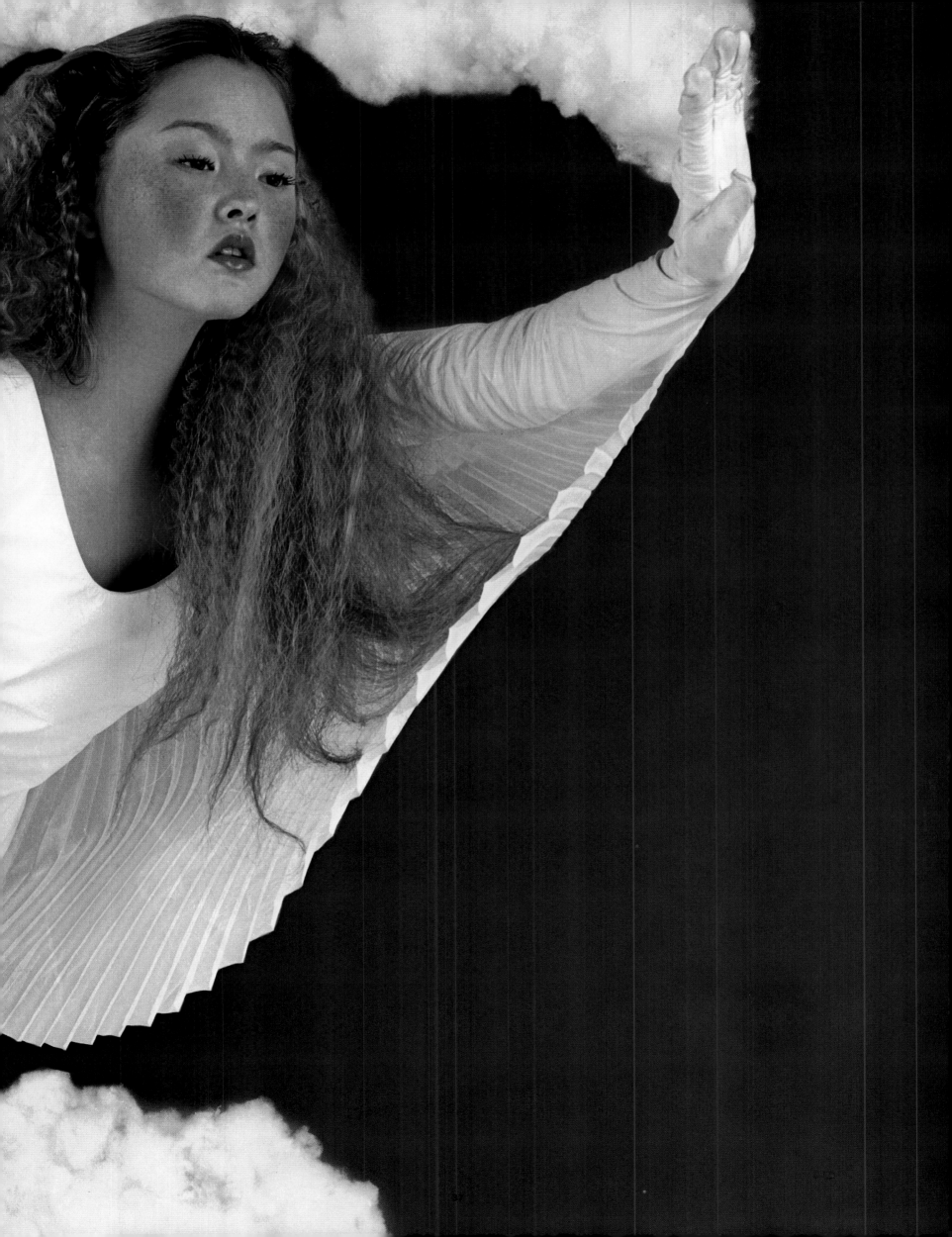

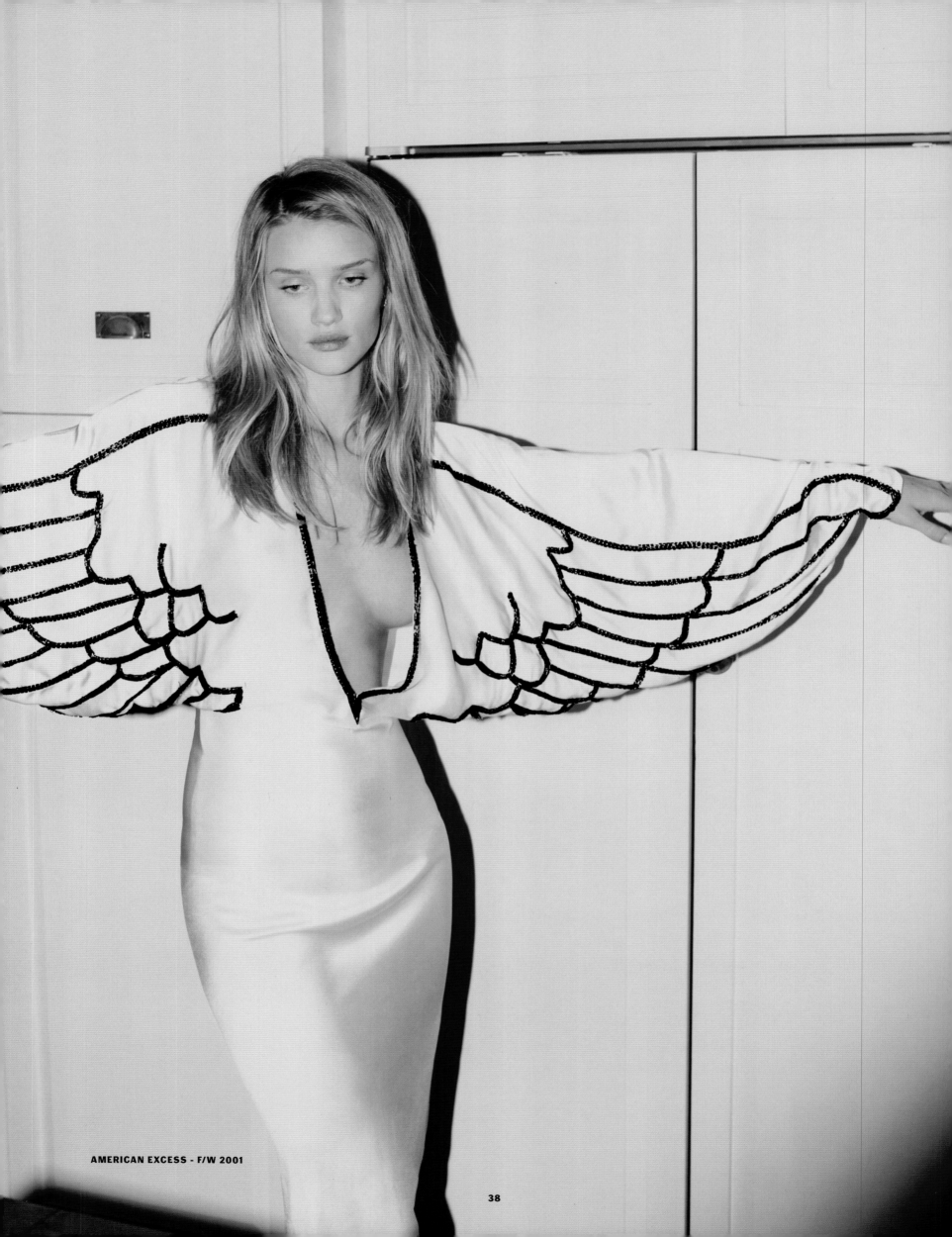

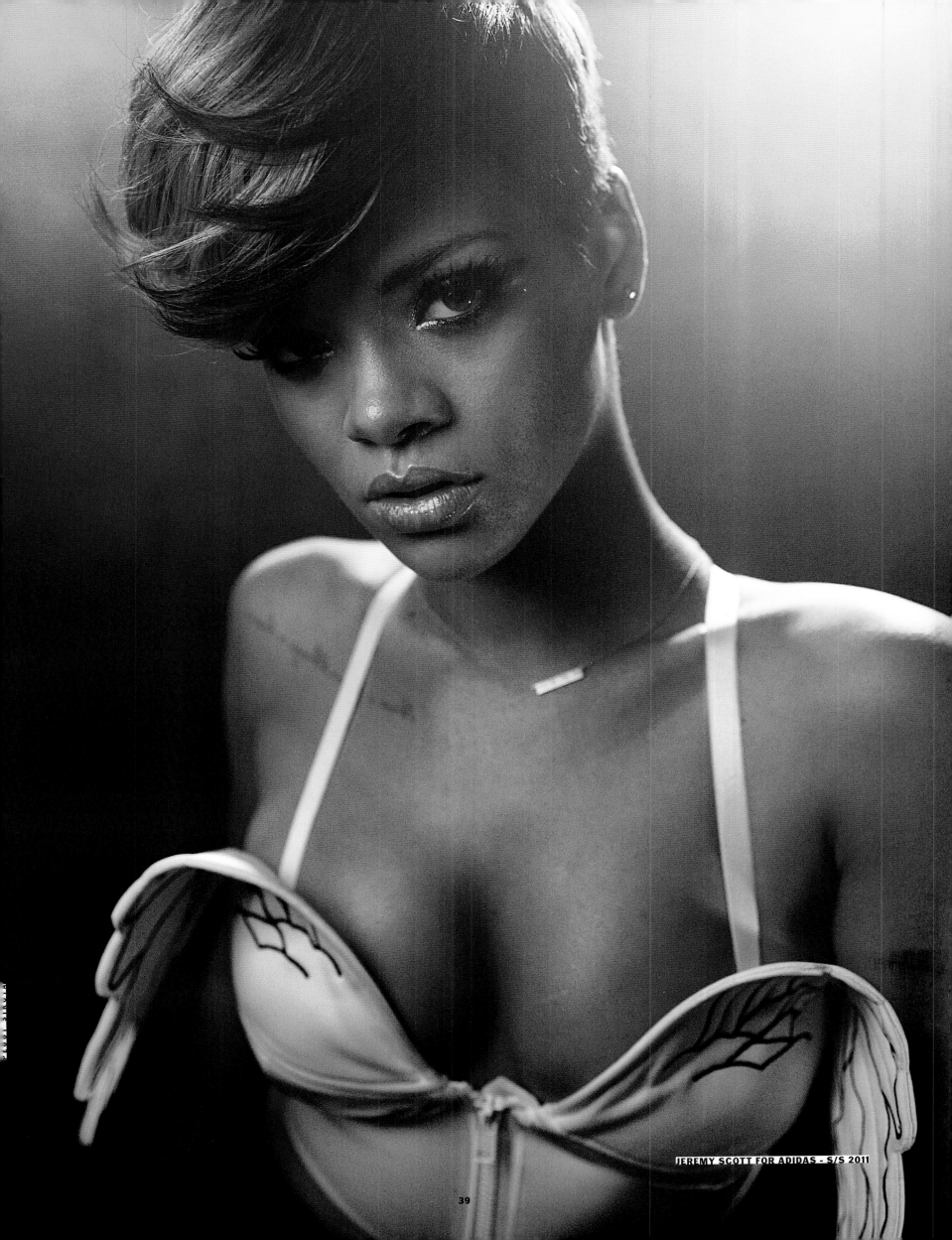

JEREMY SCOTT FOR ADIDAS - S/S 2011

40

GOLD WAR

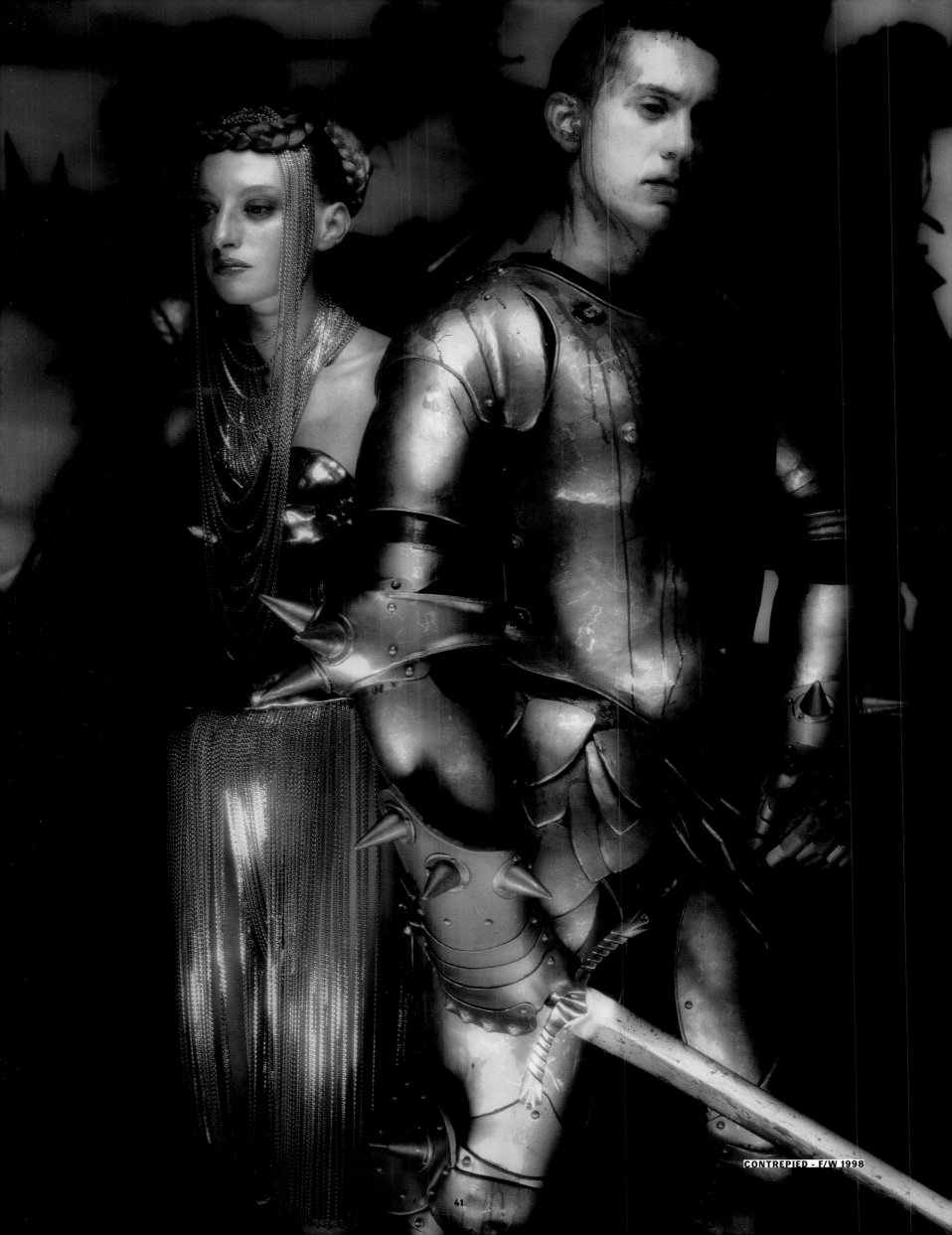

CONTREPIED - F/W 1998

41

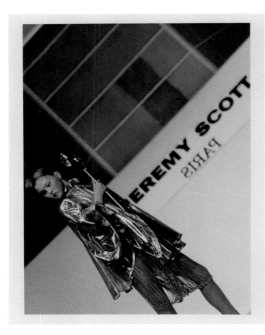
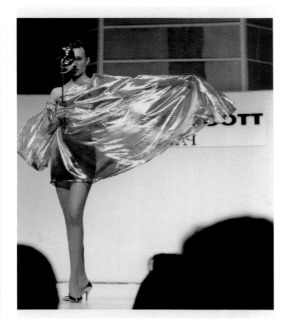
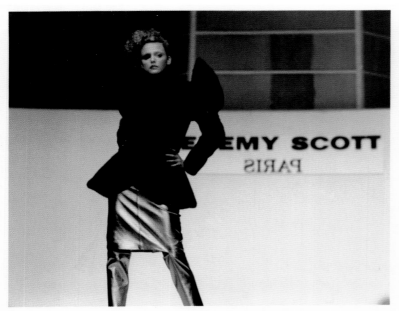
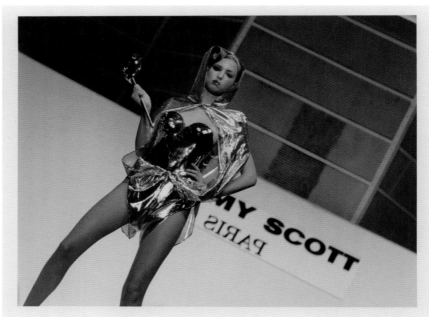
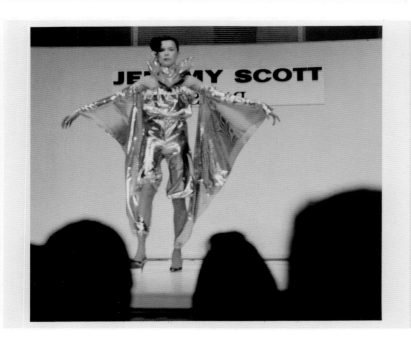
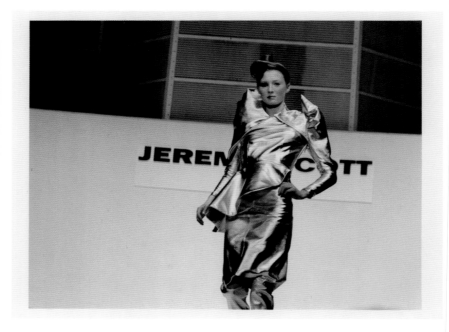

CONTREPIED - F/W 1998

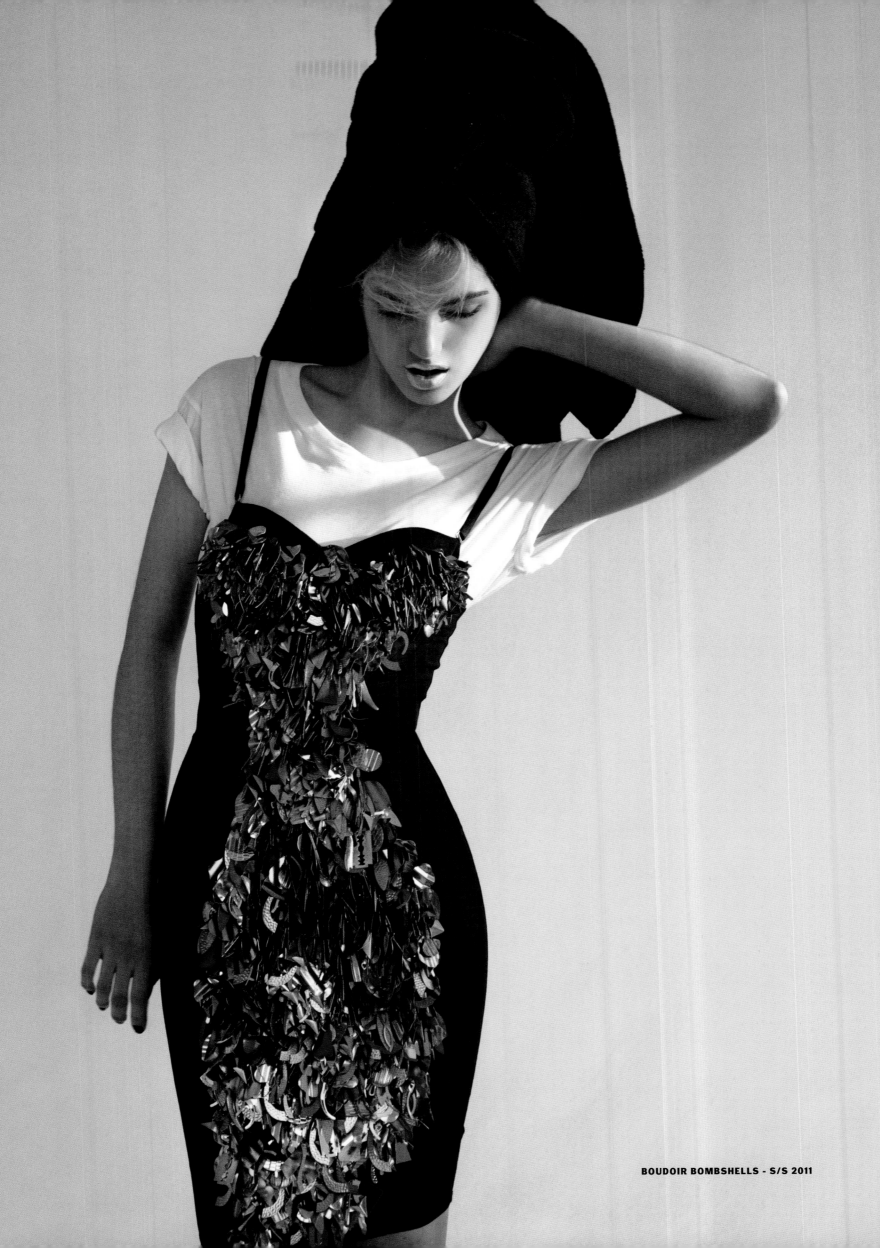

BOUDOIR BOMBSHELLS - S/S 2011

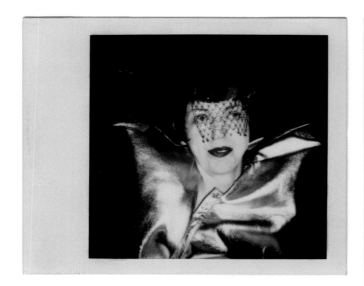 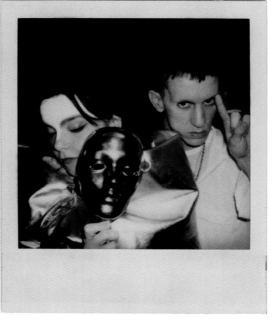

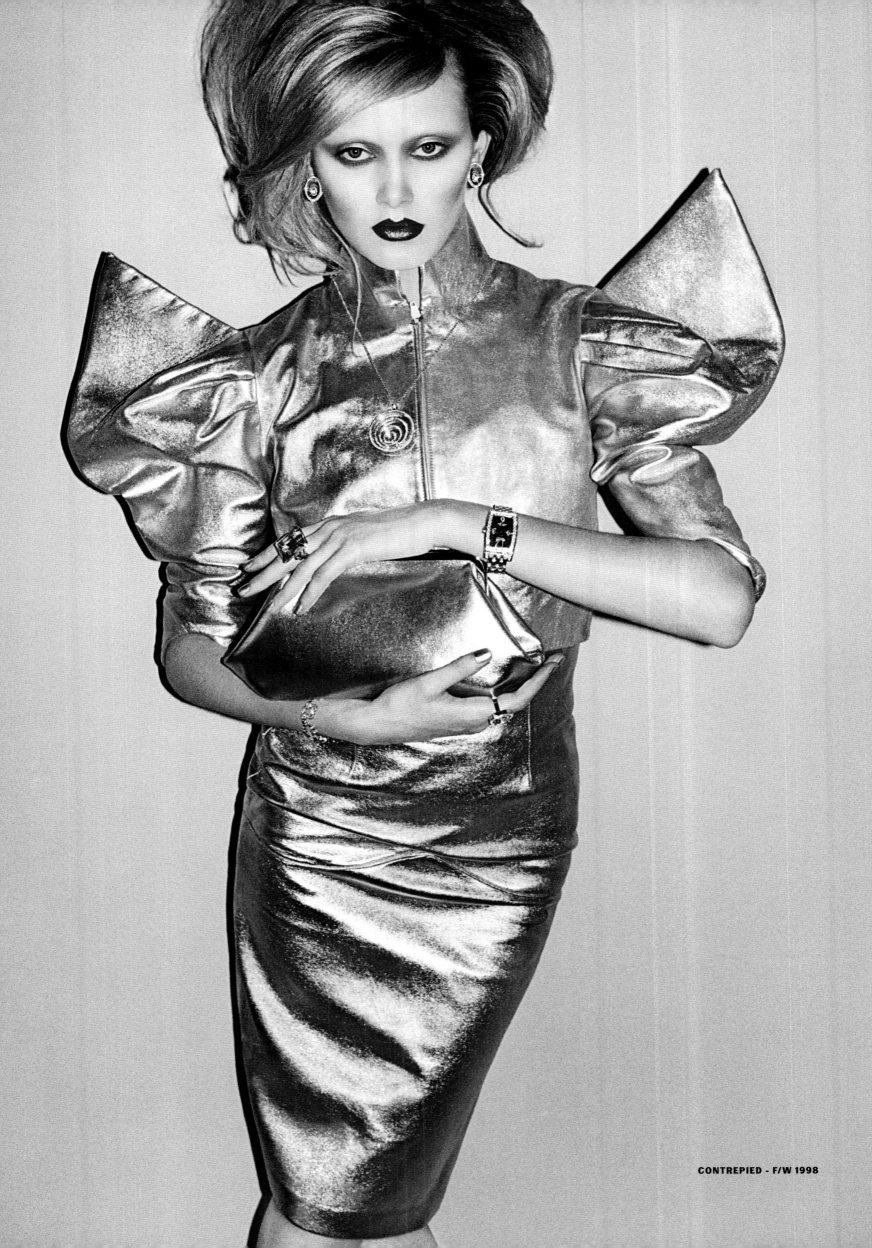

CONTREPIED - F/W 1998

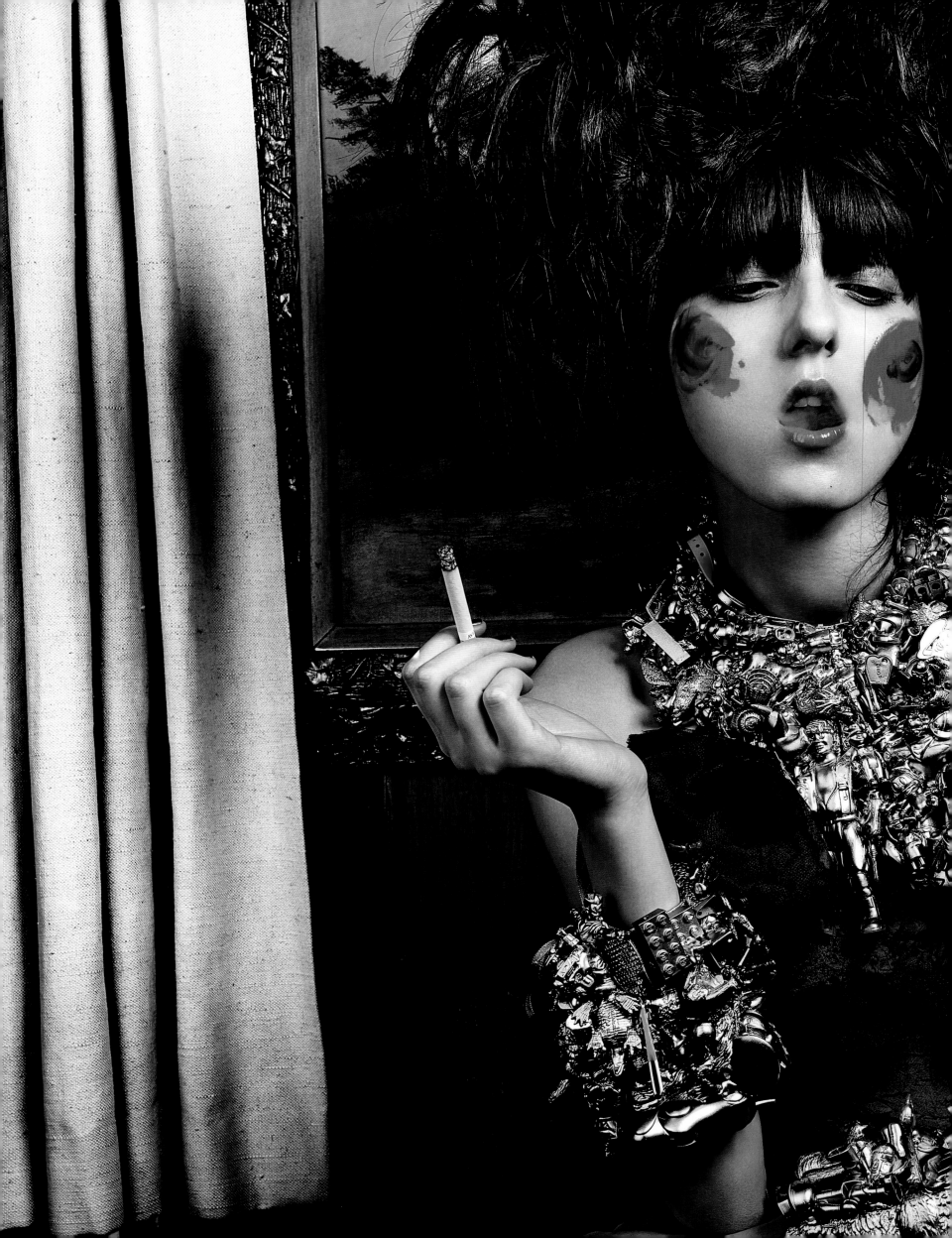

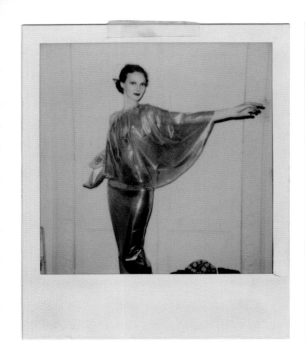 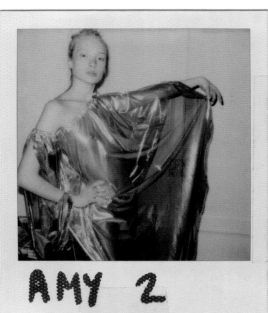 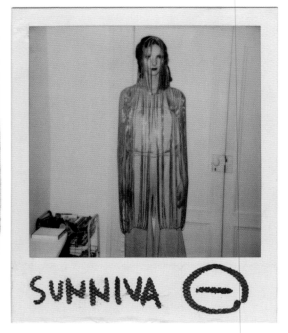

AMY 2

SUNNIVA ⊖

CONTREPIED - F/W 1998

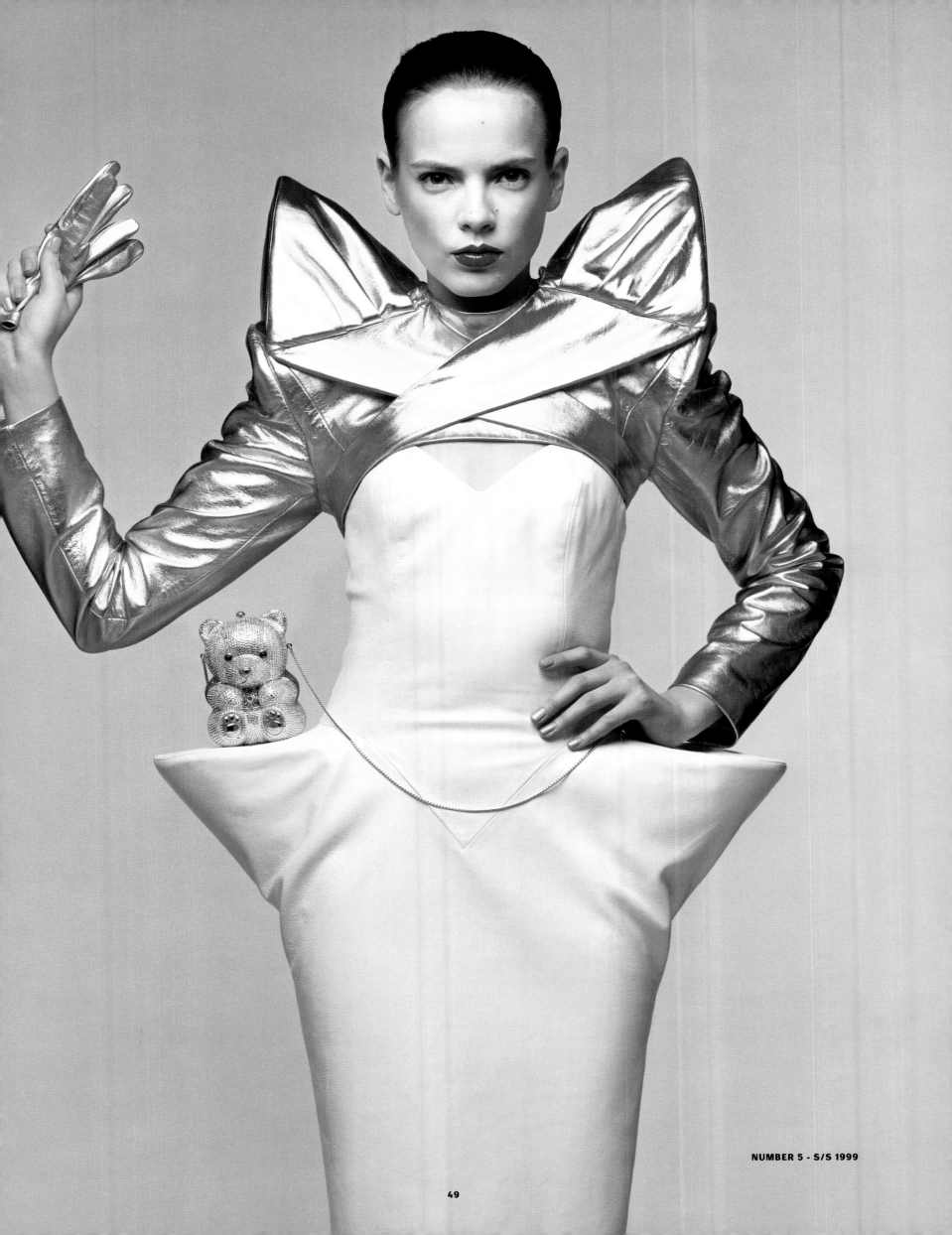

NUMBER 5 - S/S 1999

FIT TO PRINT

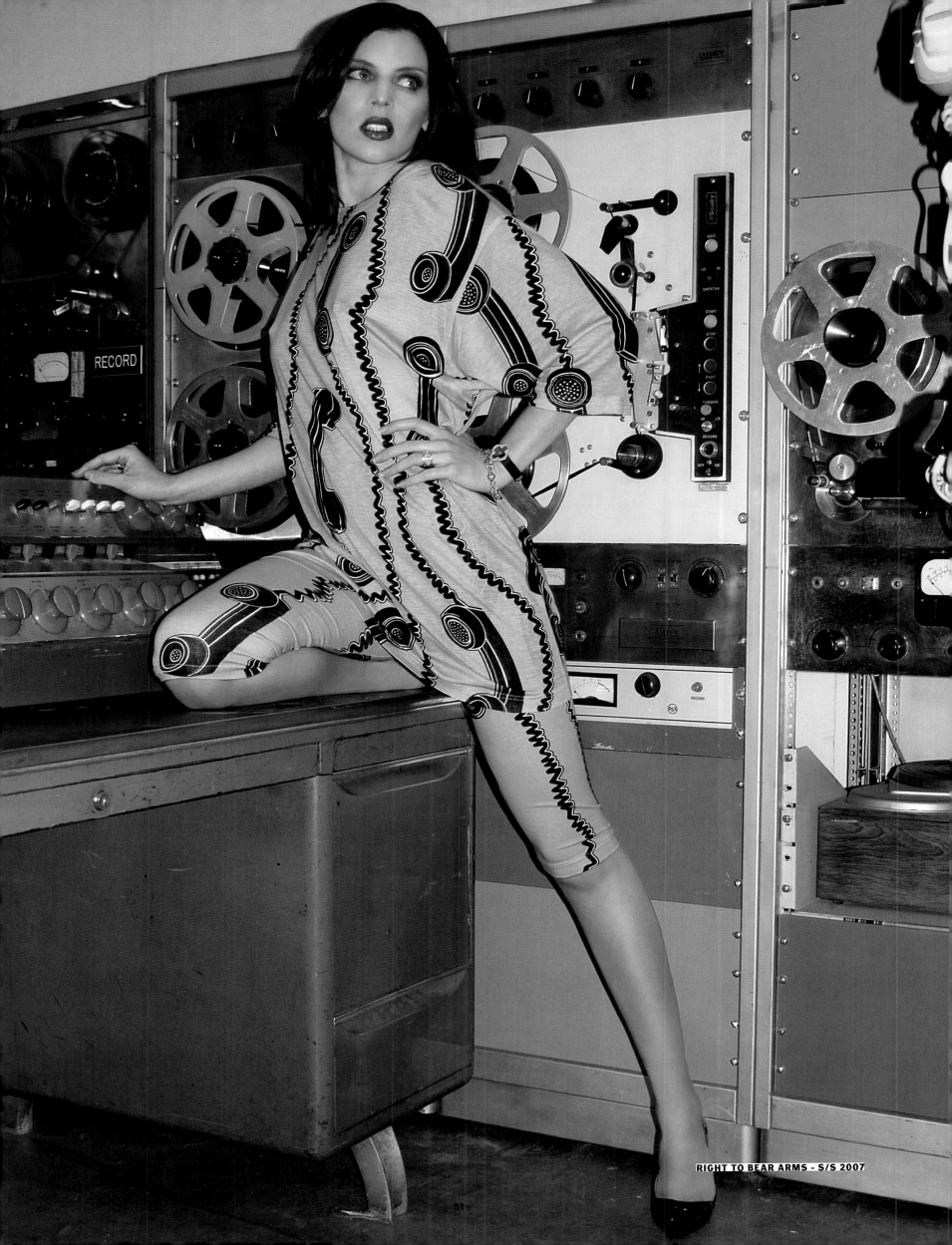

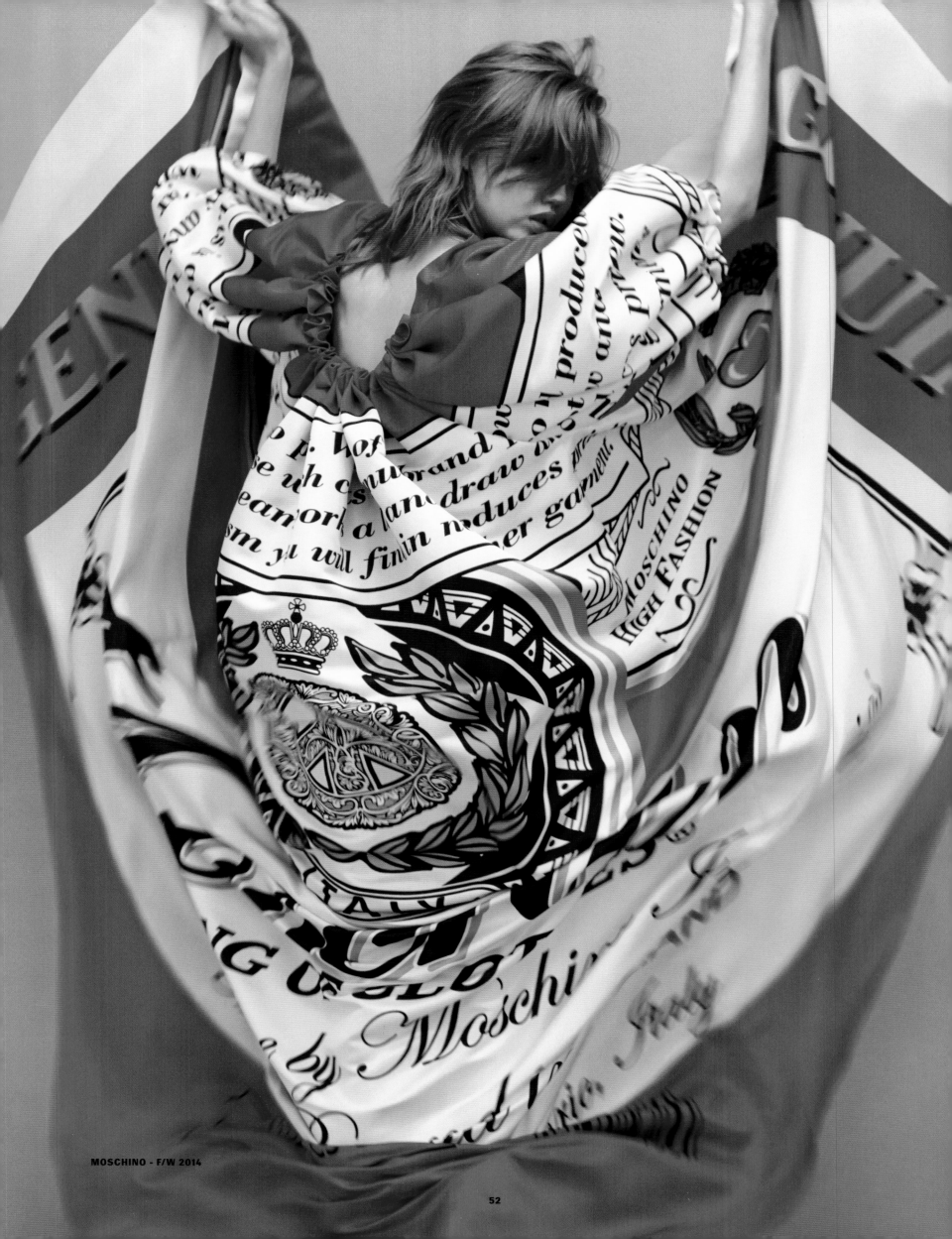

MOSCHINO - F/W 2014

52

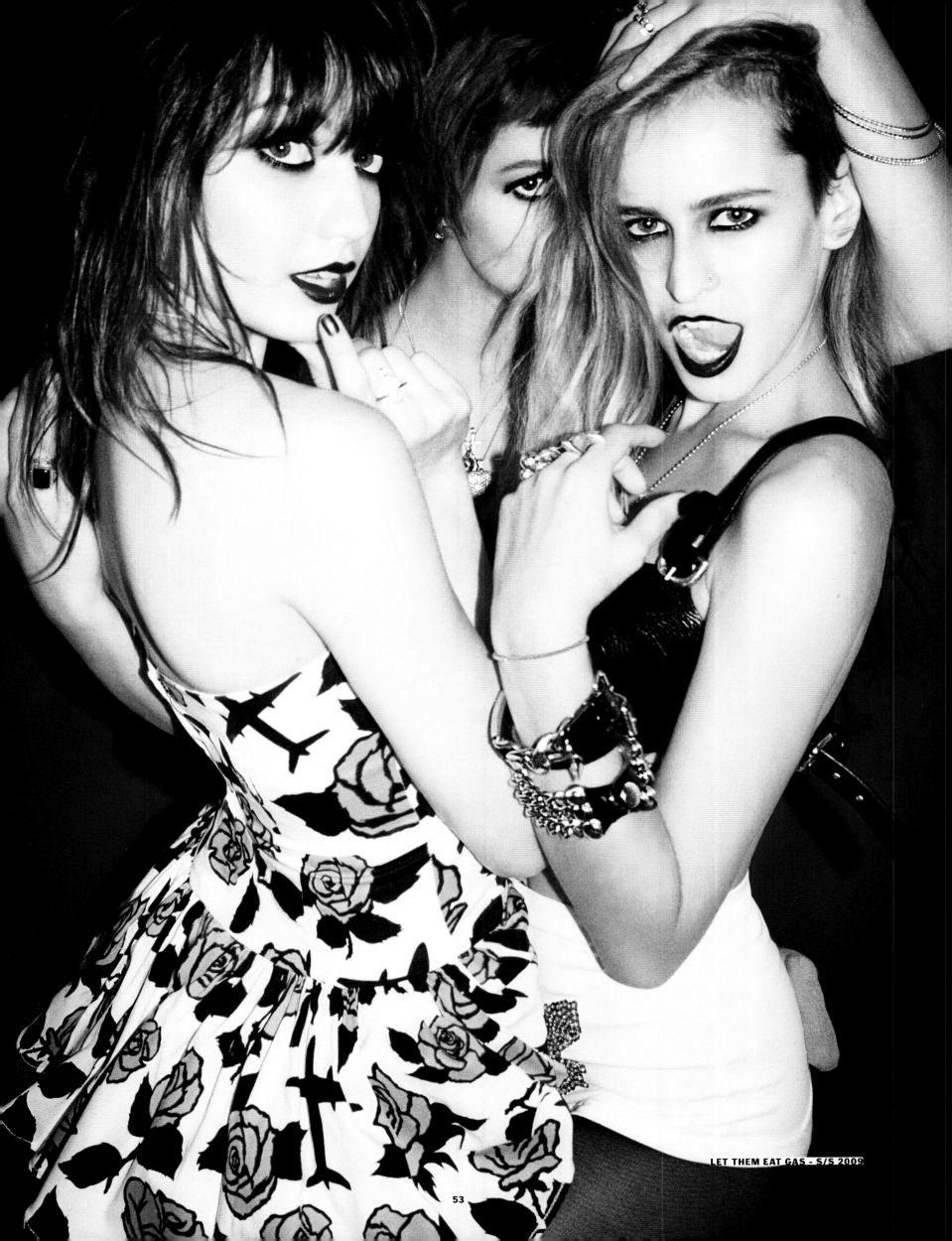

LET THEM EAT GAS - S/S 2009

53

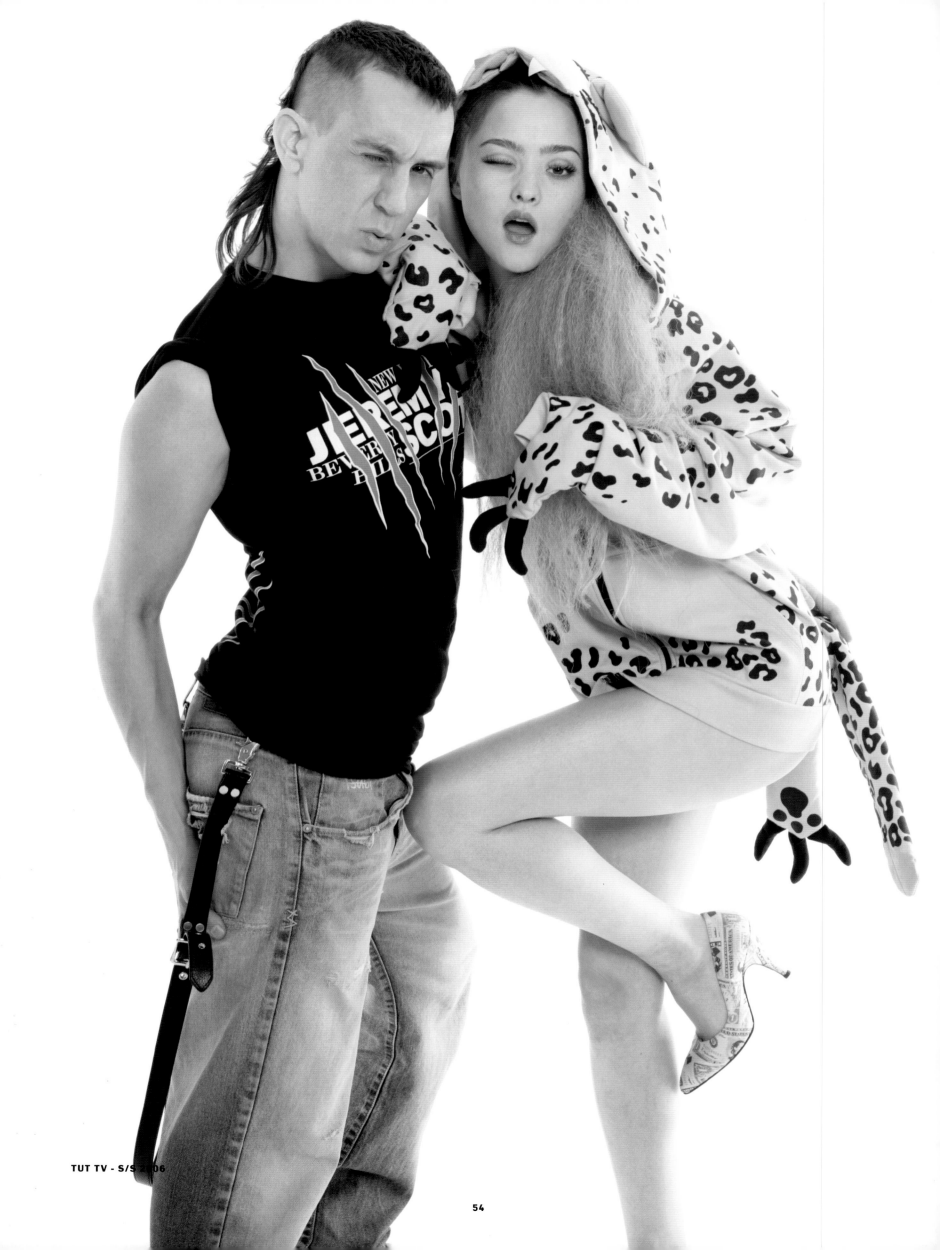

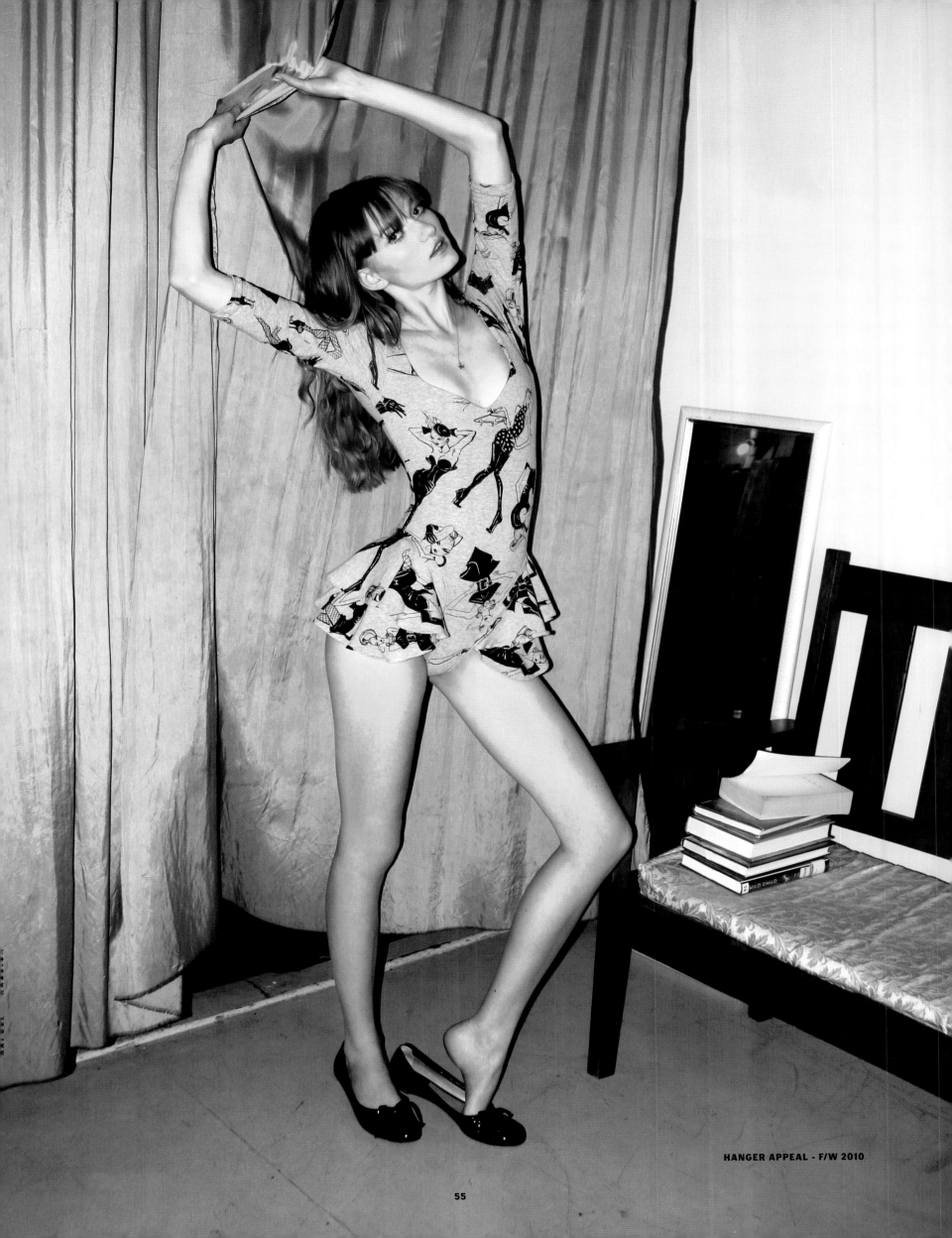

HANGER APPEAL - F/W 2010

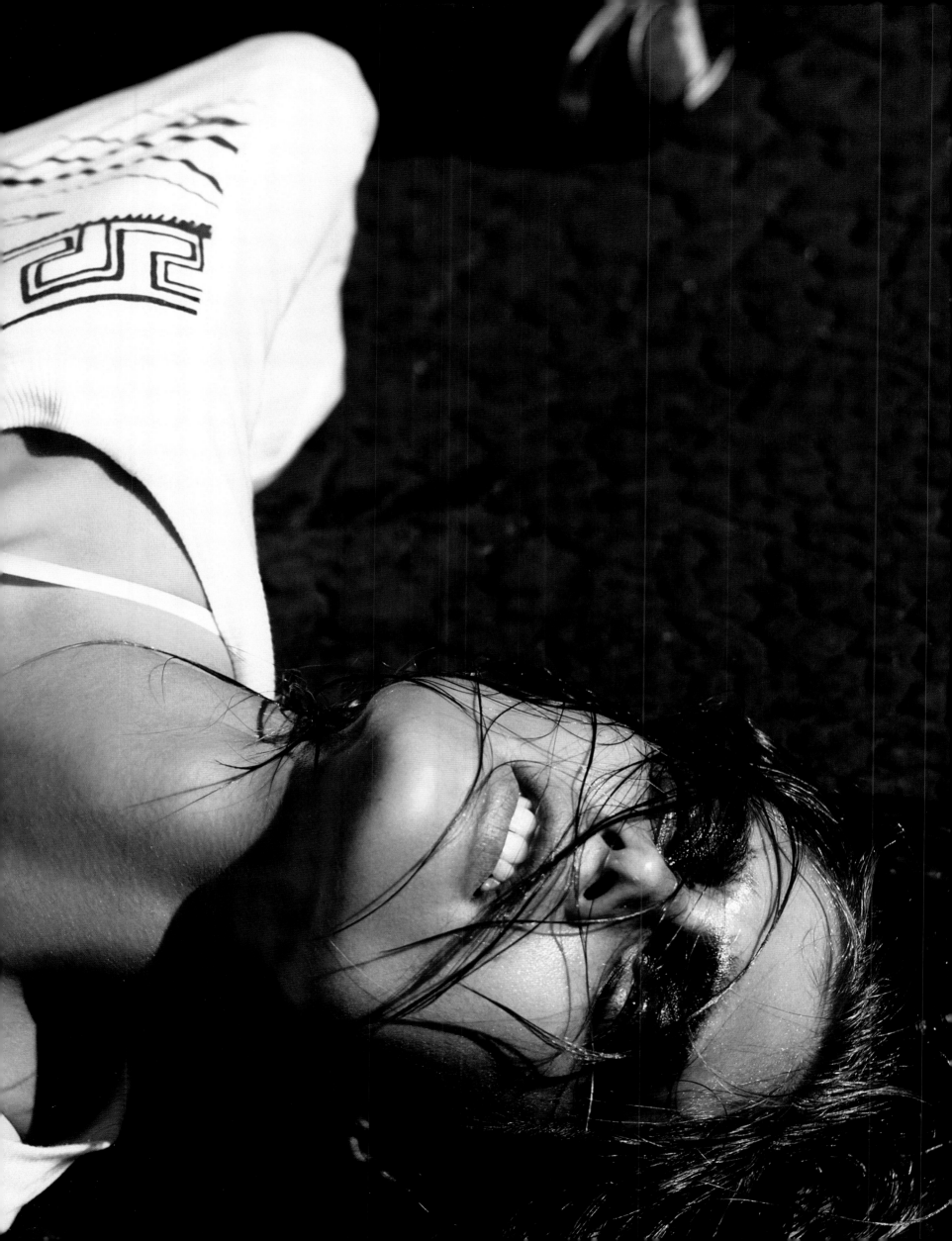

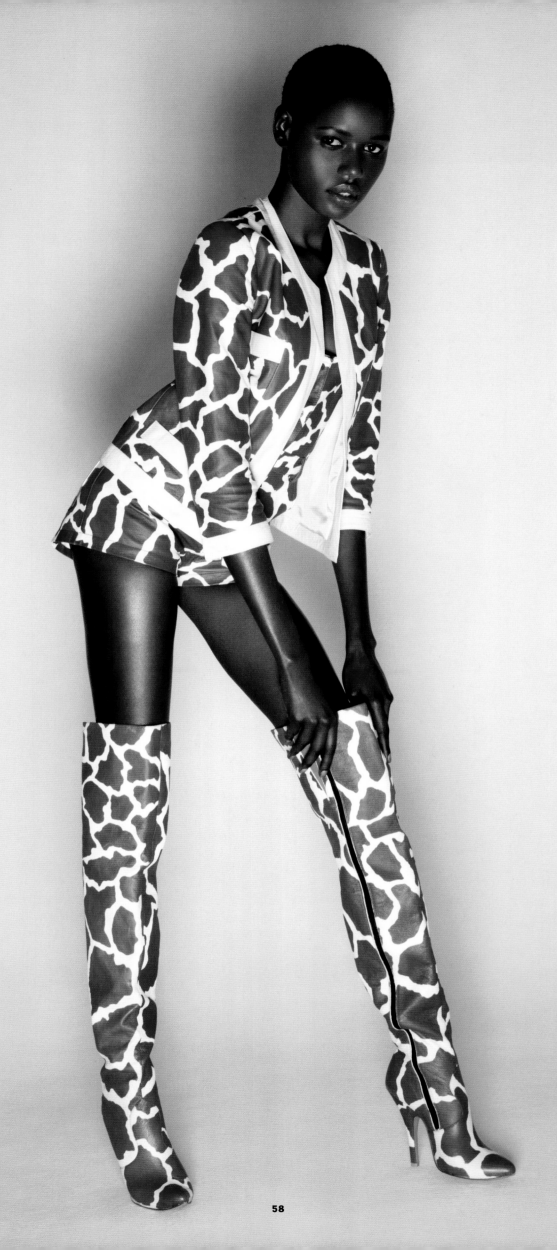

ARAB SPRING - S/S 2013

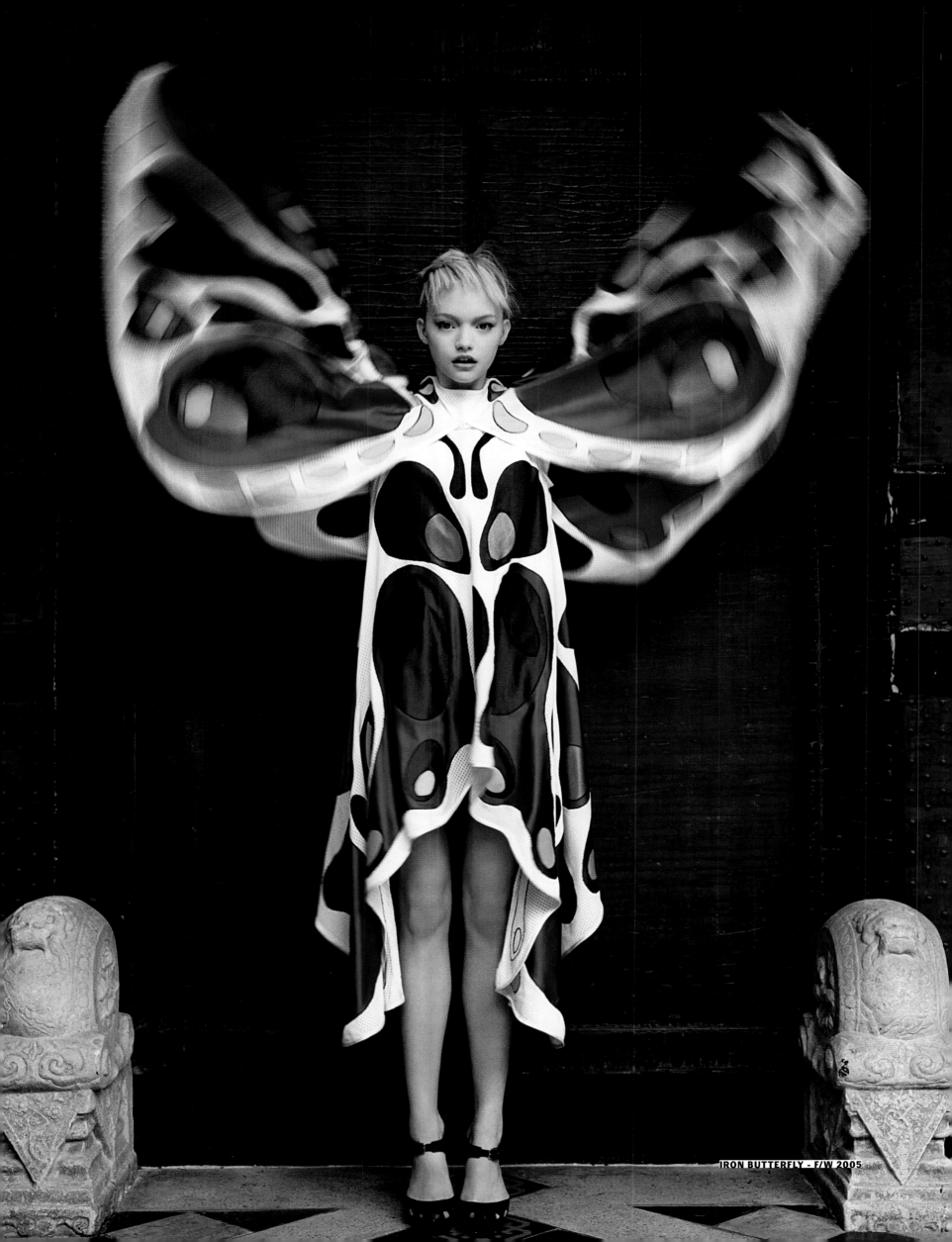

IRON BUTTERFLY - F/W 2005

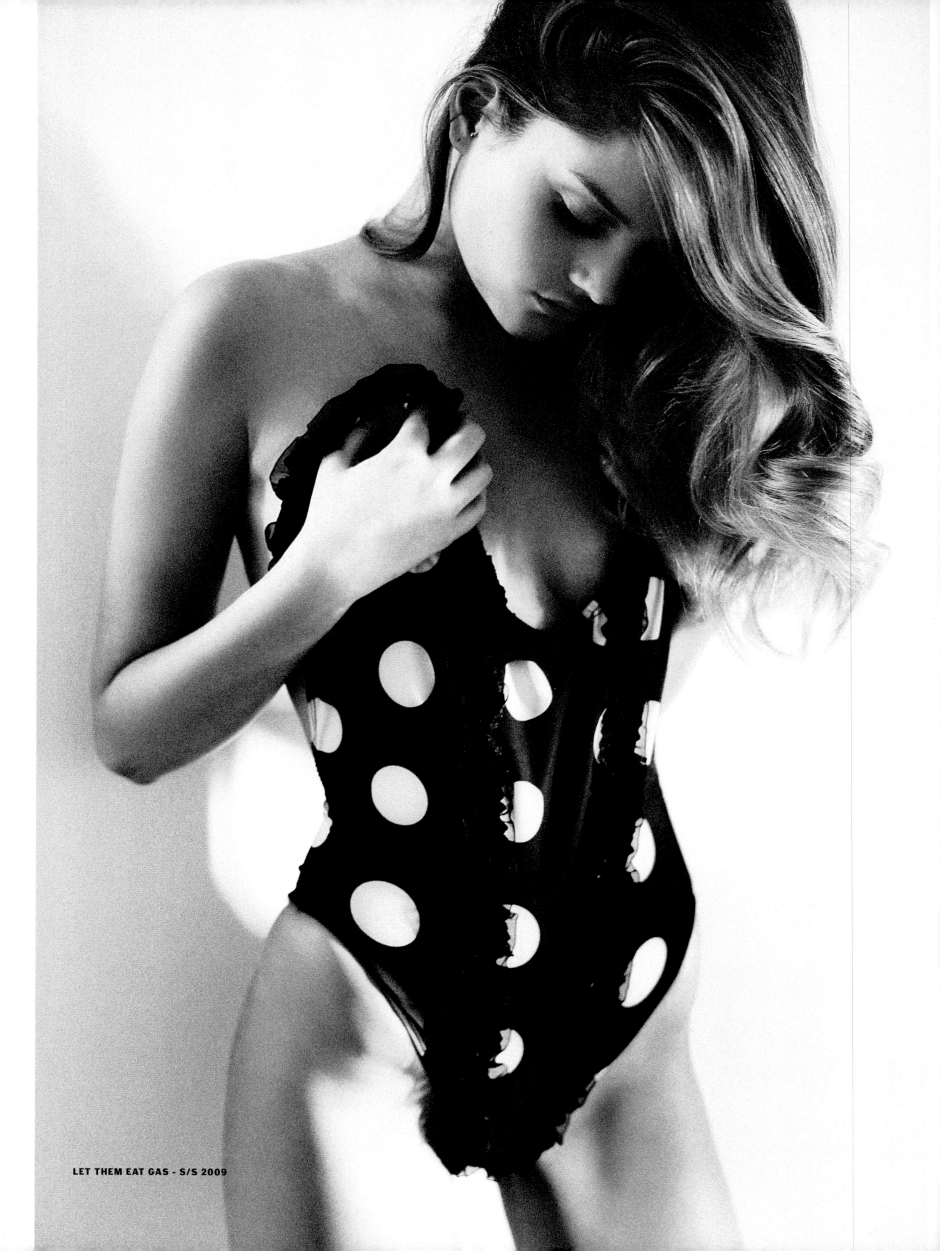

LET THEM EAT GAS - S/S 2009

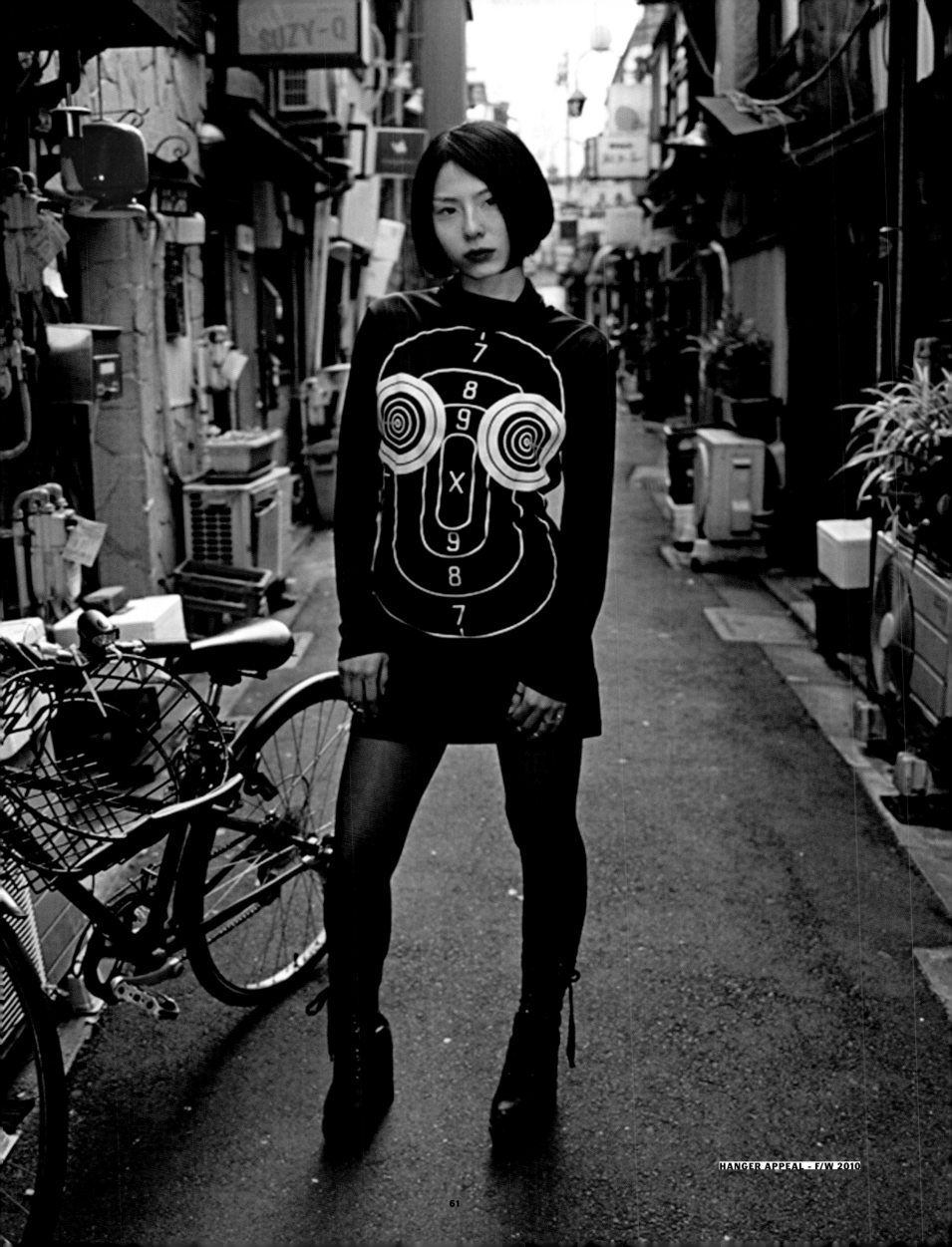

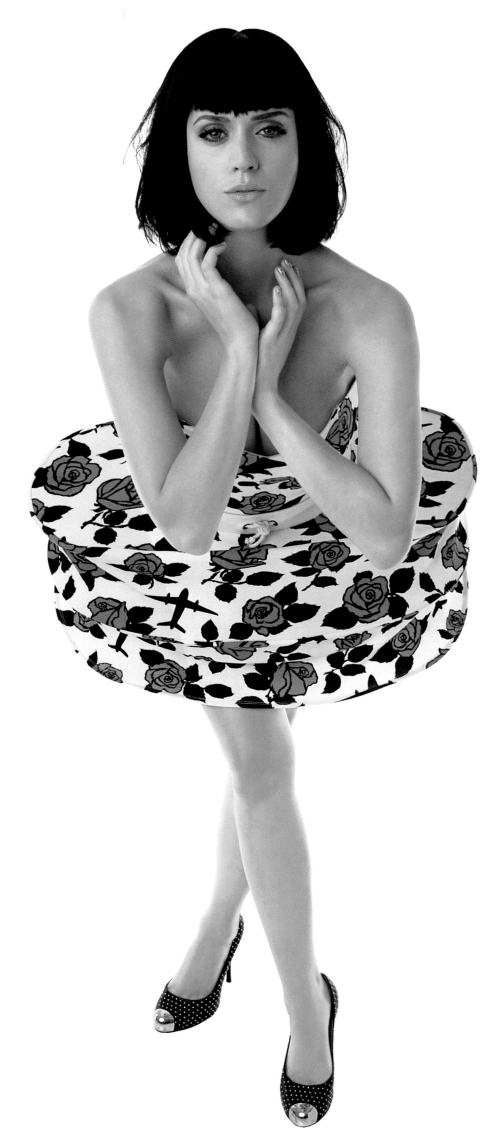

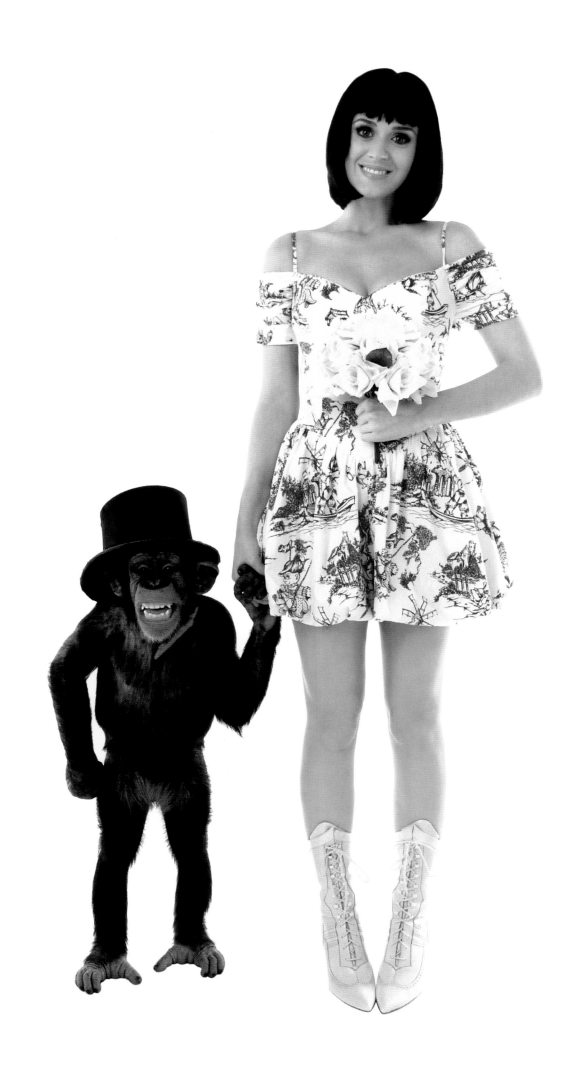

LET THEM EAT GAS - S/S 2009

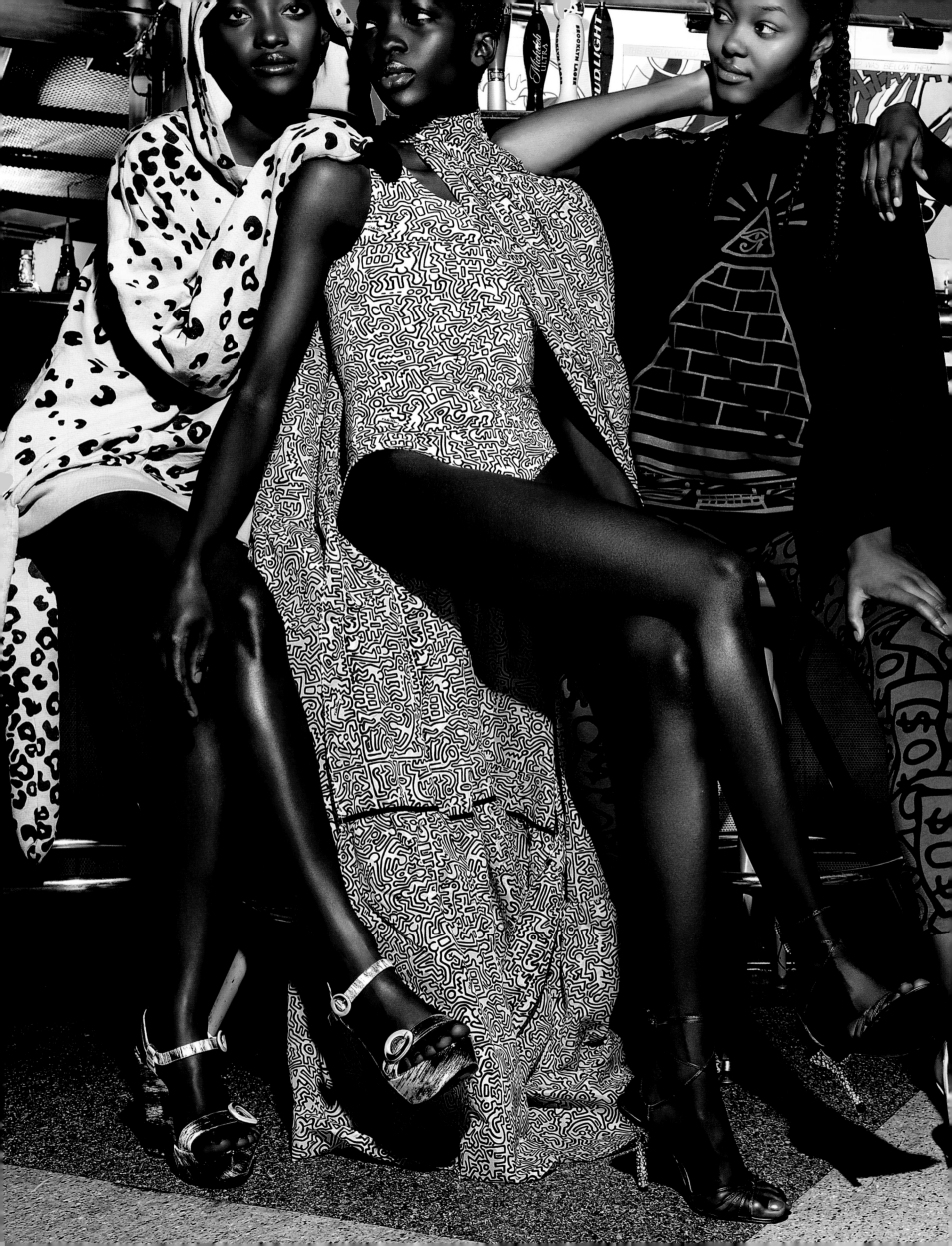

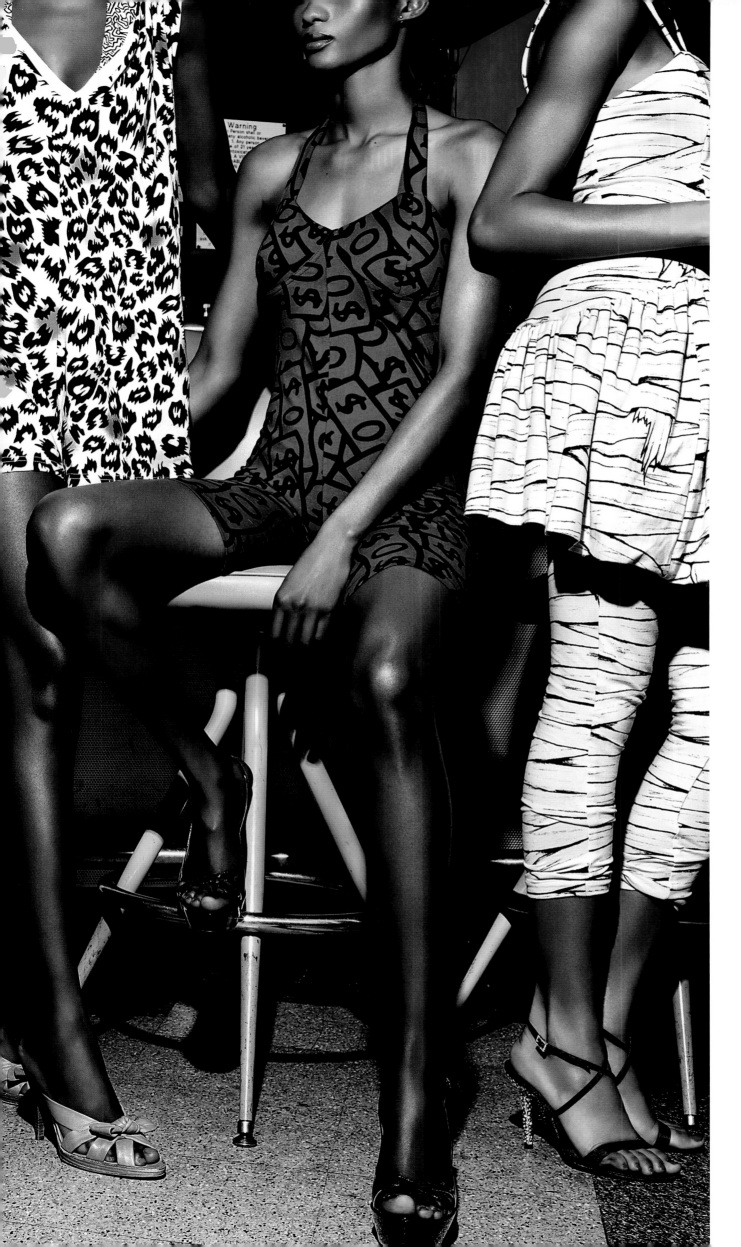

TUT TV - S/S 2006

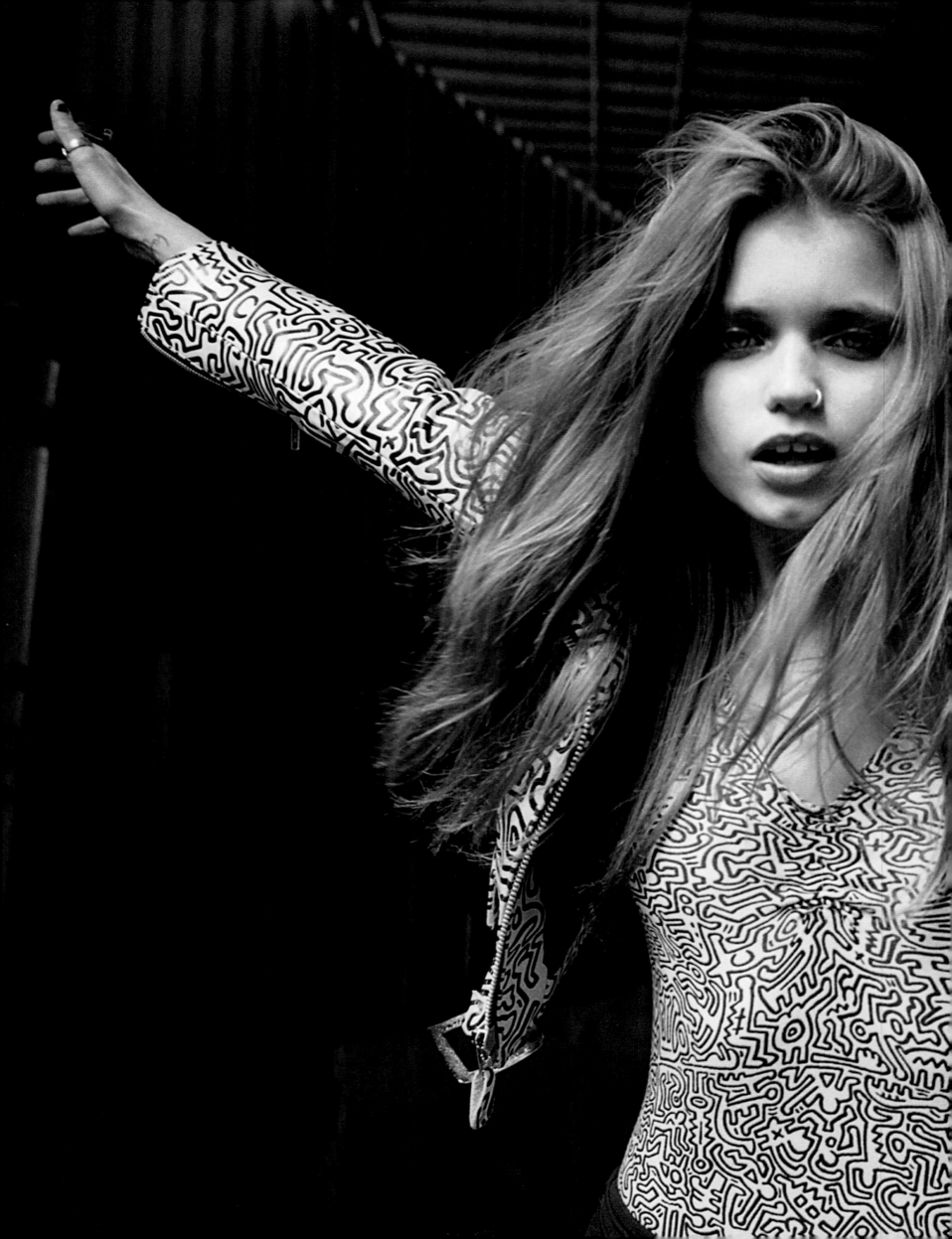

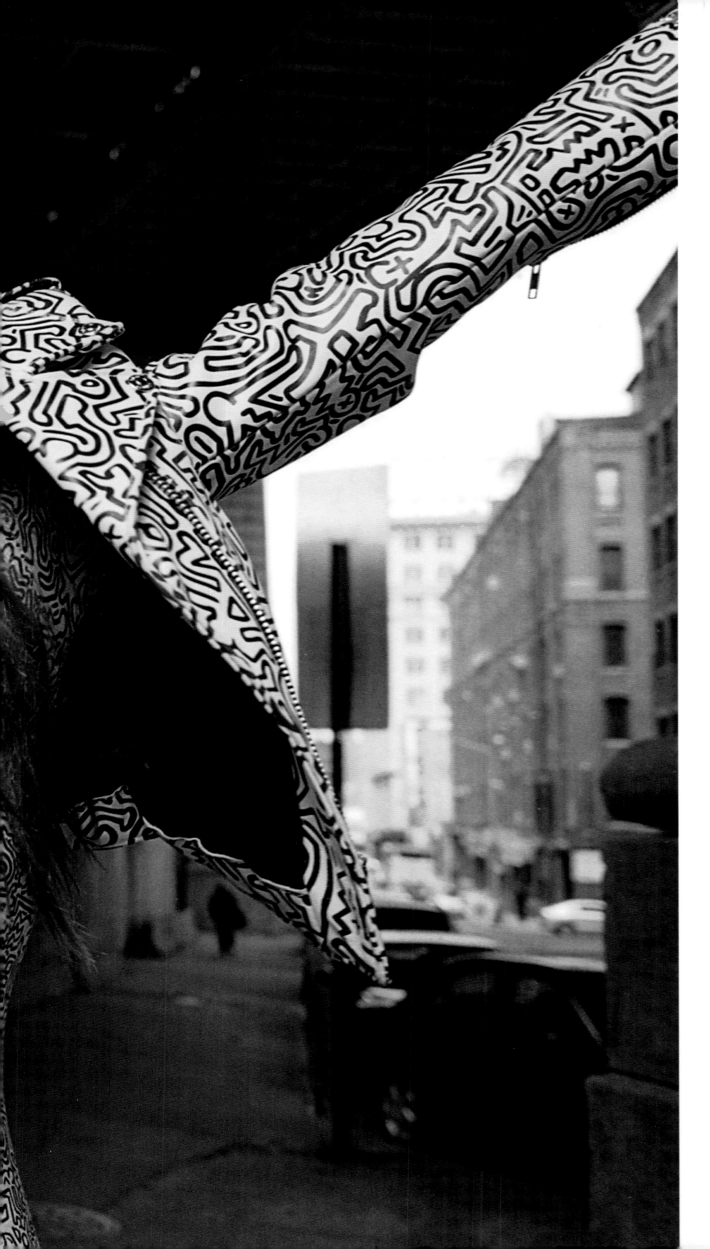

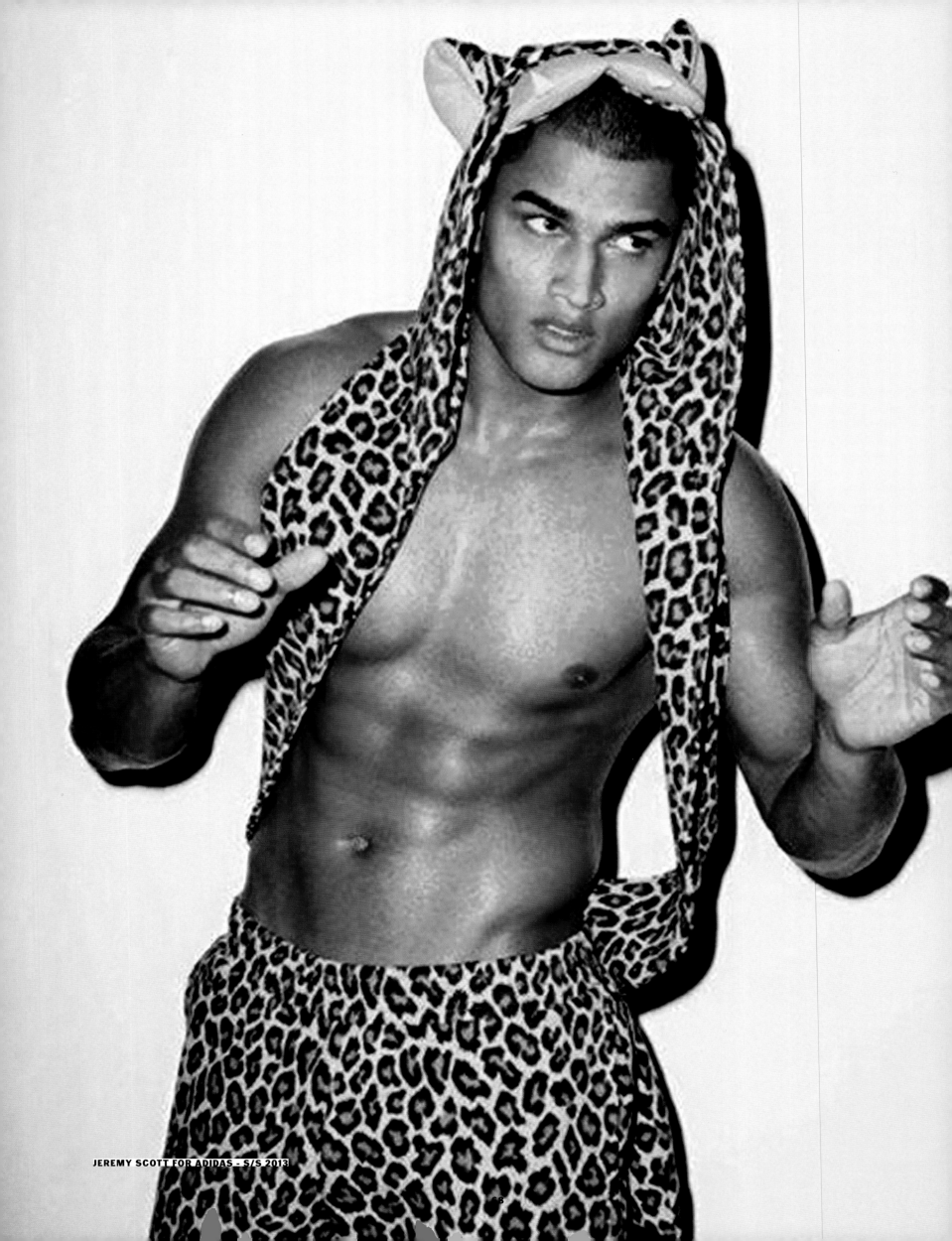

JEREMY SCOTT FOR ADIDAS - S/S 2013

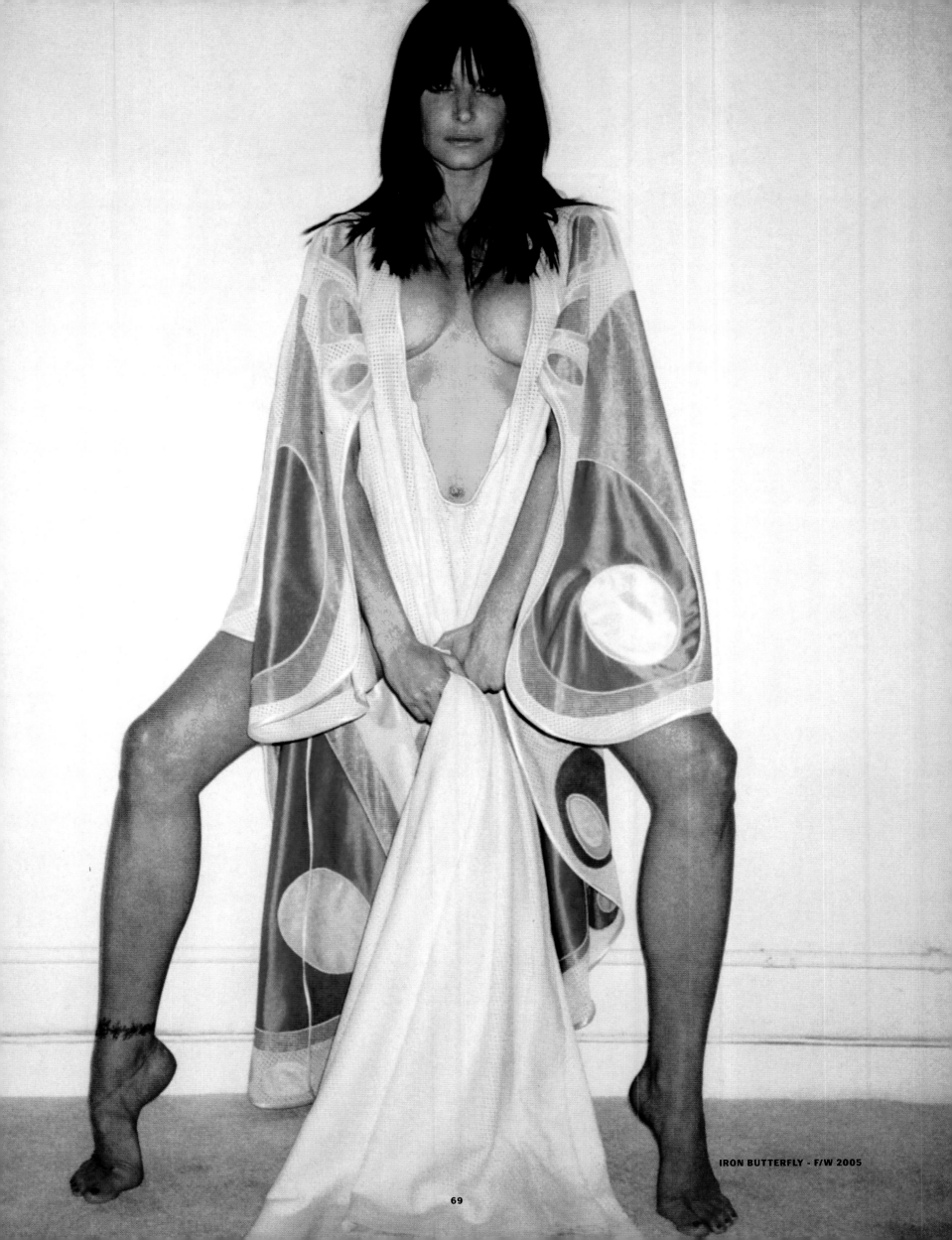

IRON BUTTERFLY - F/W 2005

69

70

SNOW

WHITE

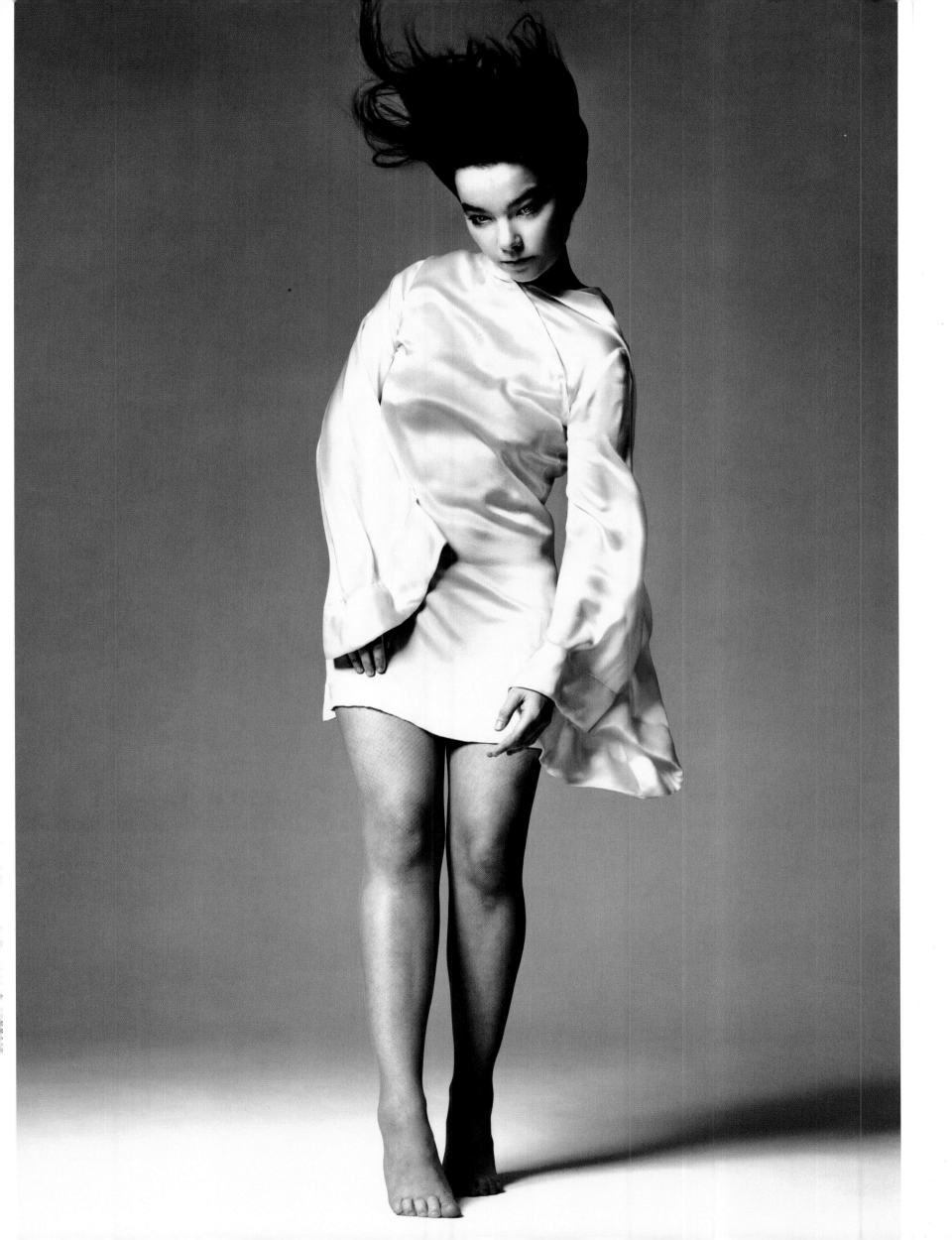

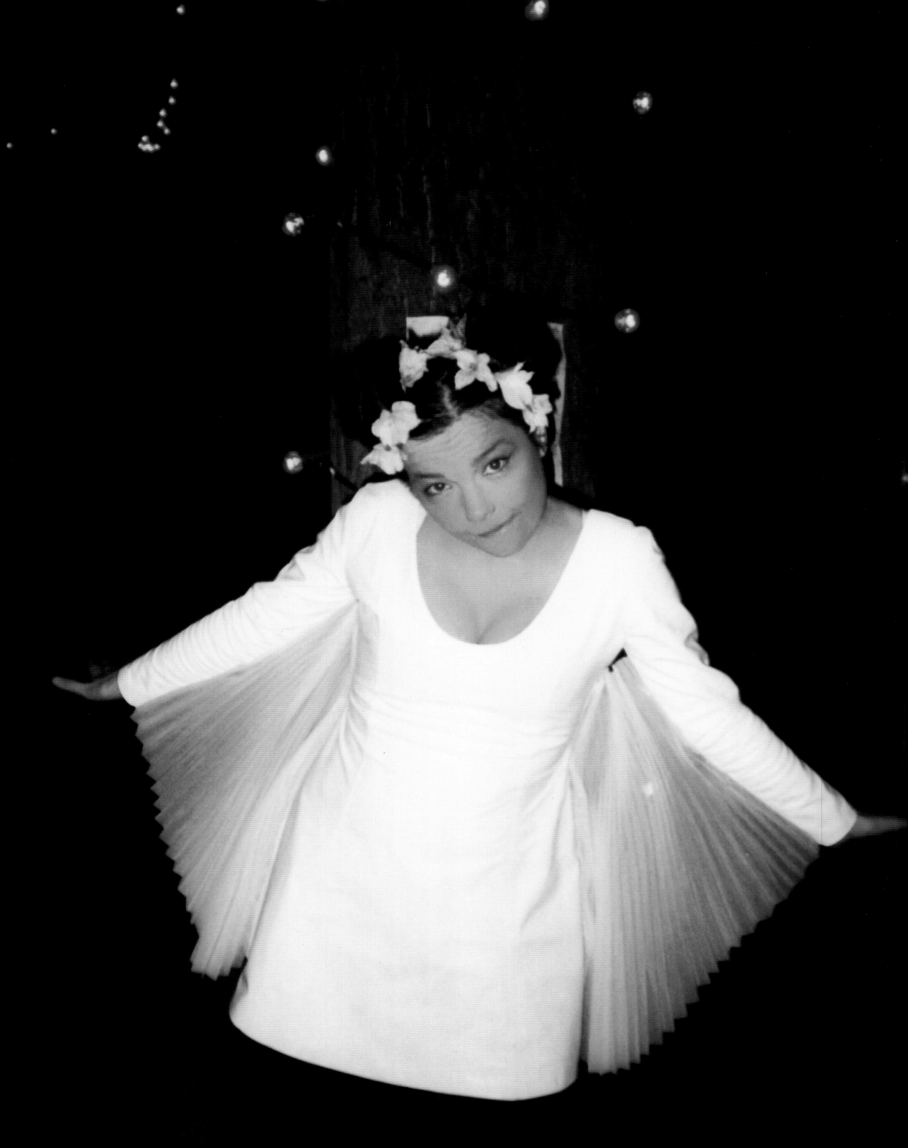

RICH WHITE WOMEN - S/S 1998

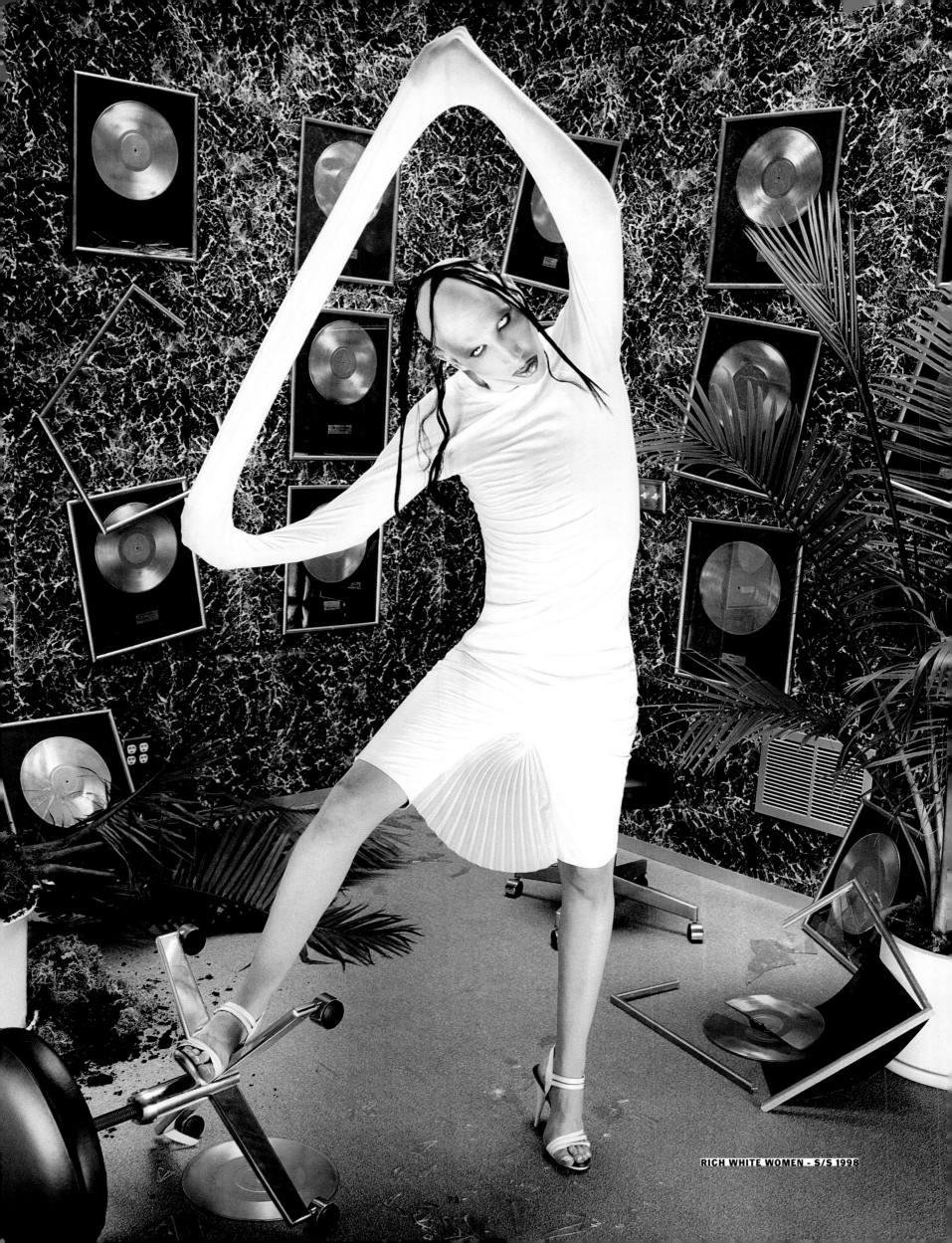

RICH WHITE WOMEN - S/S 1998

TALE OF THREE CITIES - F/W 2000
RICH WHITE WOMEN - S/S 1998

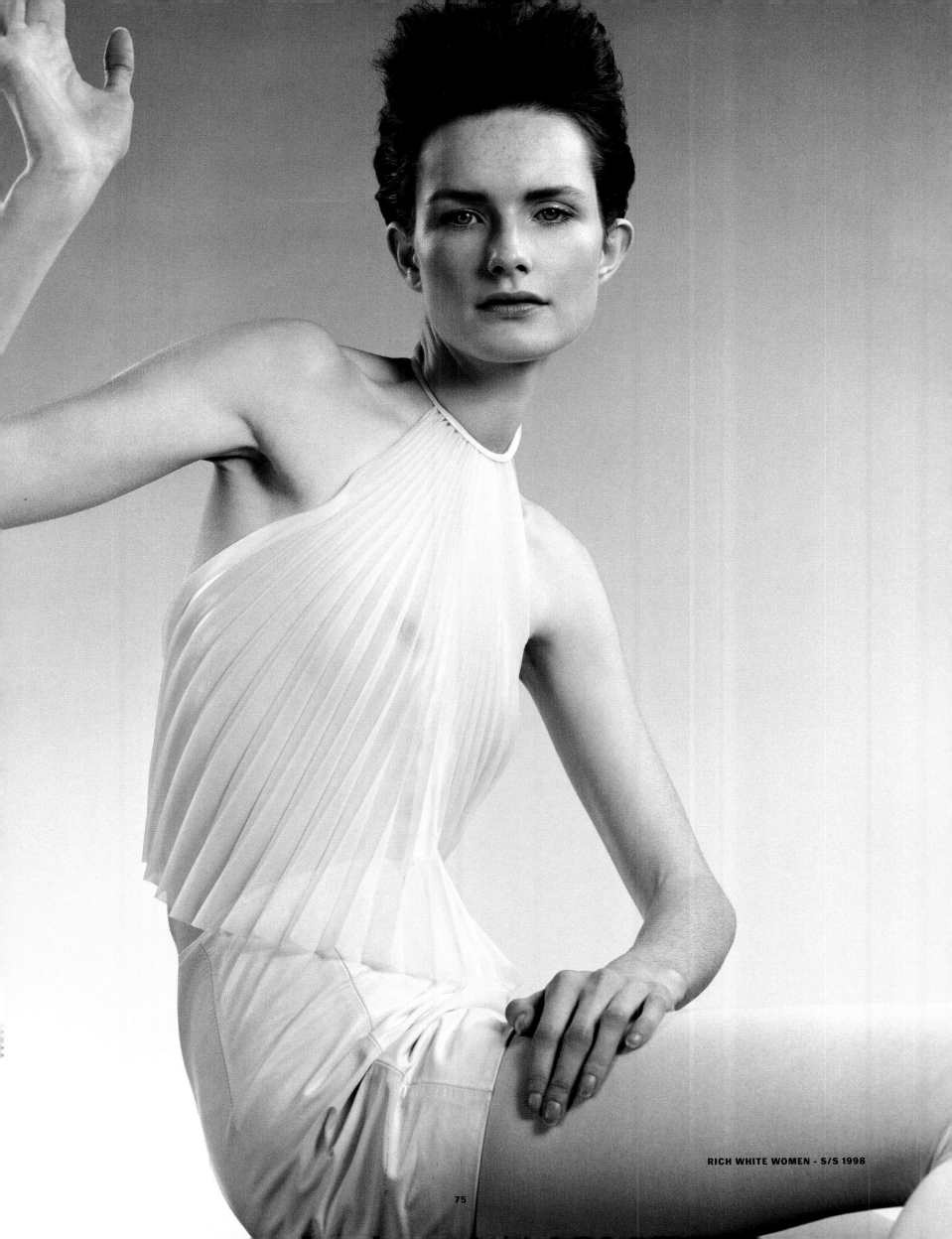

75

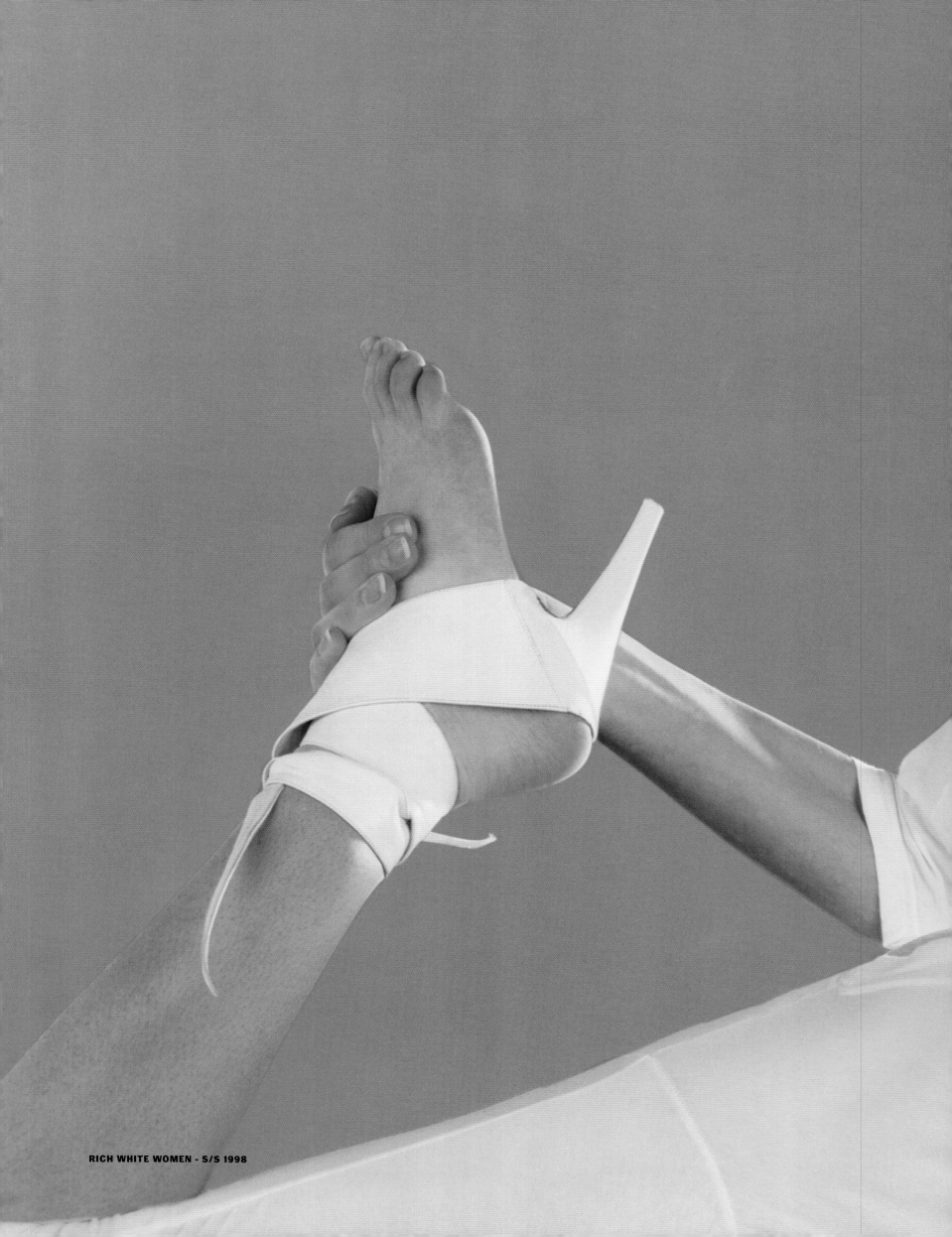

RICH WHITE WOMEN - S/S 1998

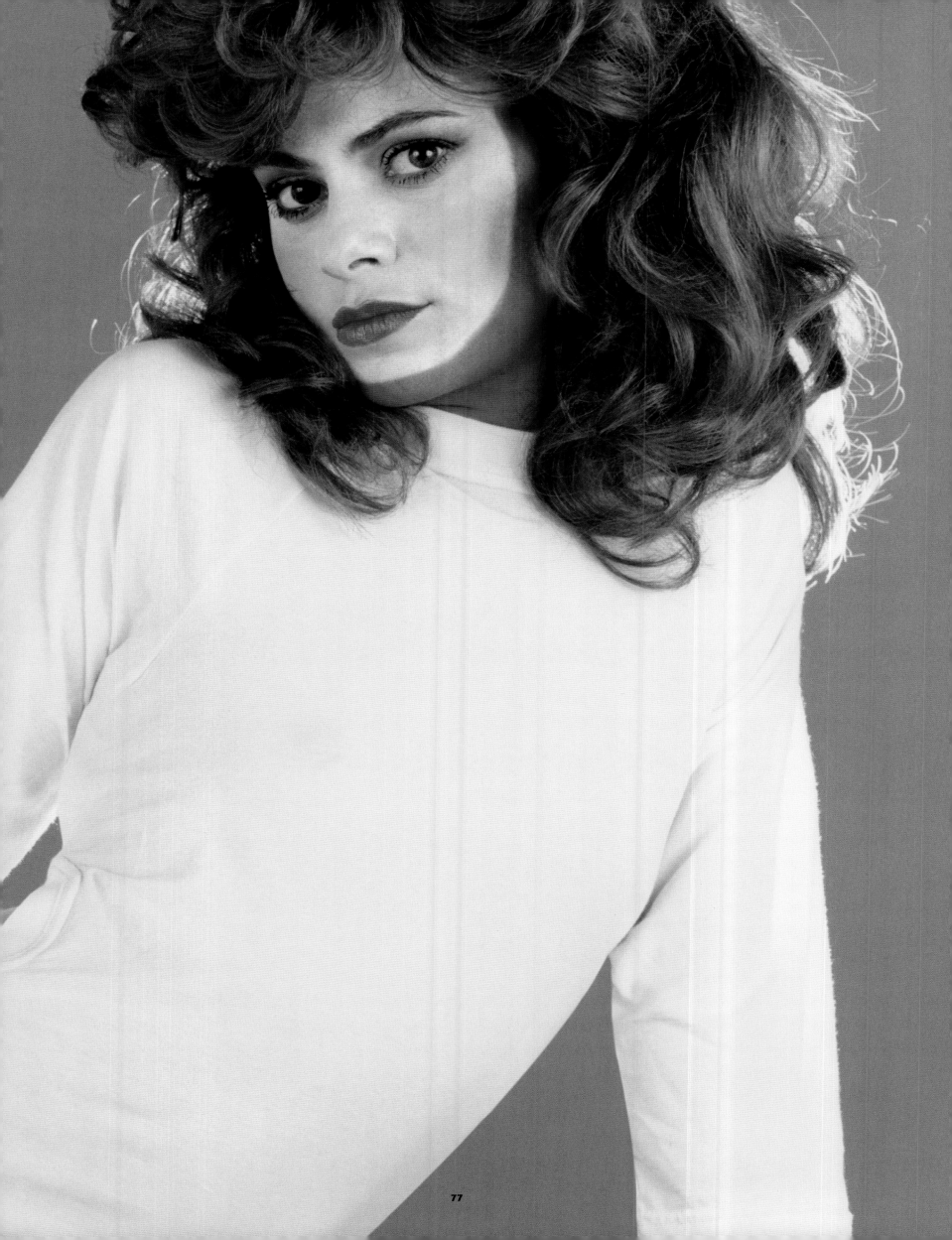

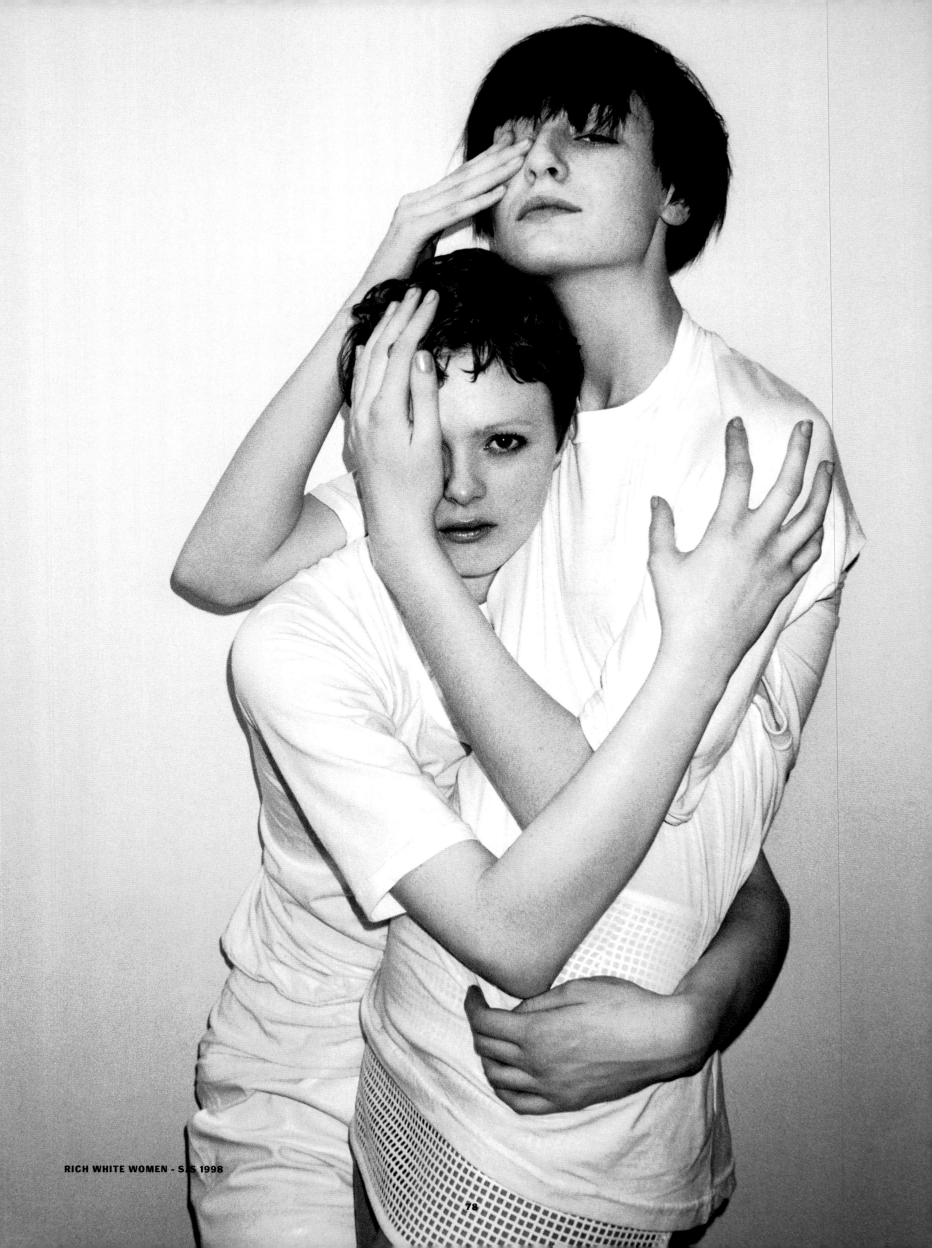

RICH WHITE WOMEN - S/S 1998

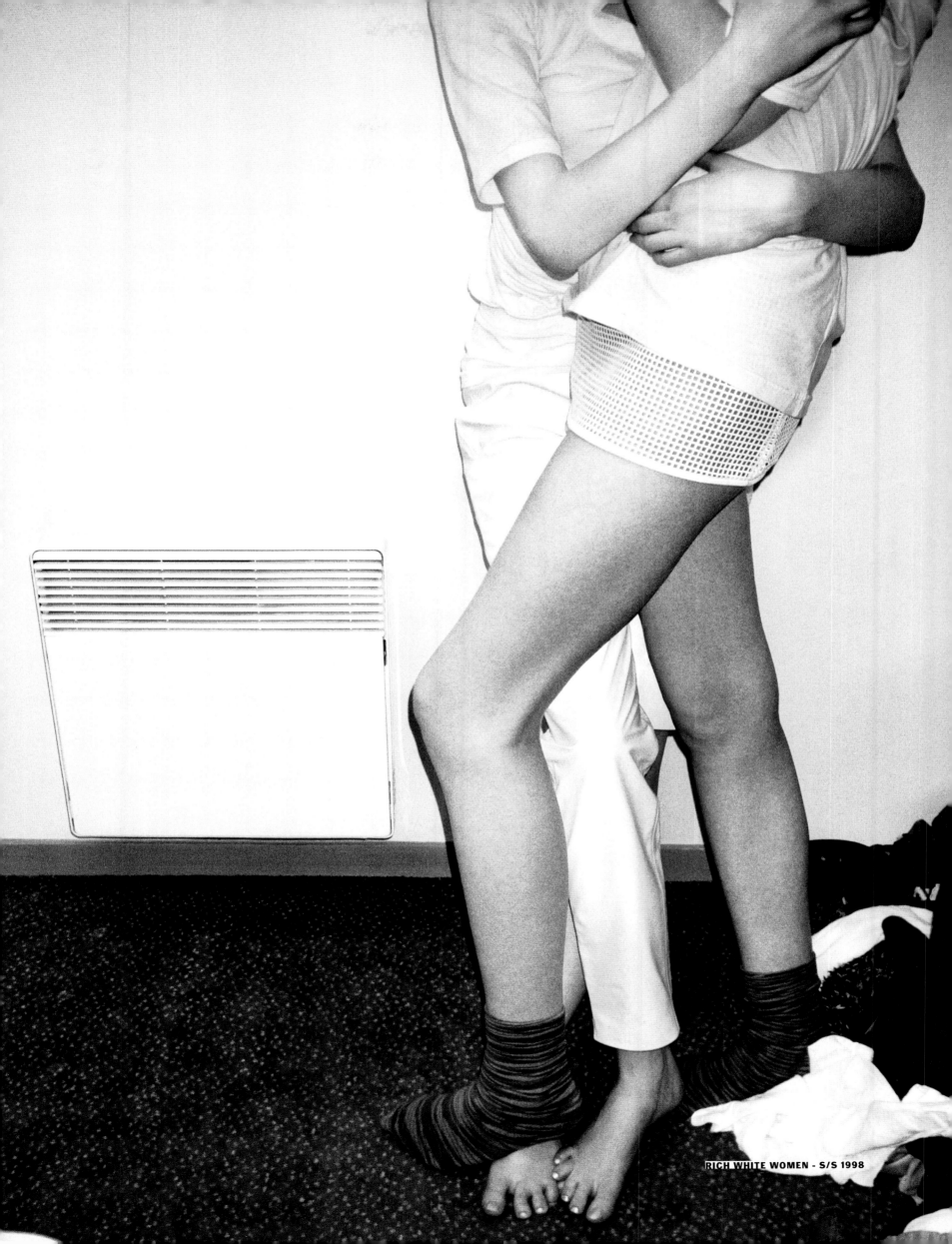

RICH WHITE WOMEN - S/S 1998

80

TECHNO
COLOR

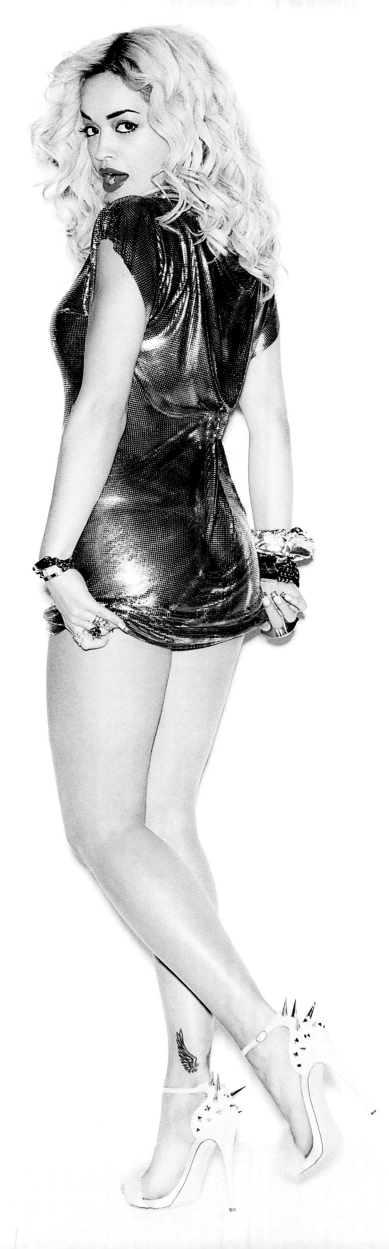

DELETE HISTORY - F/W 2012

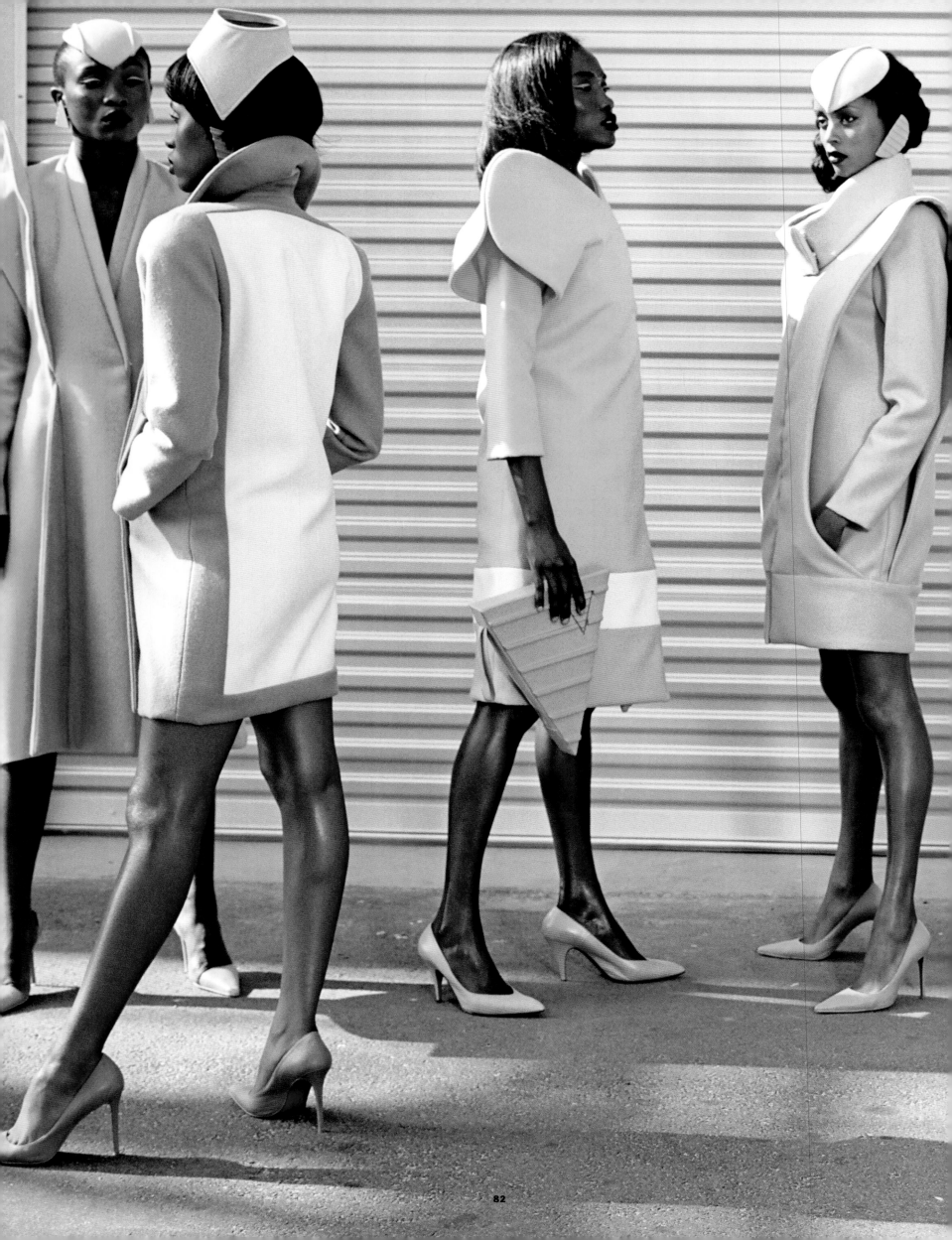

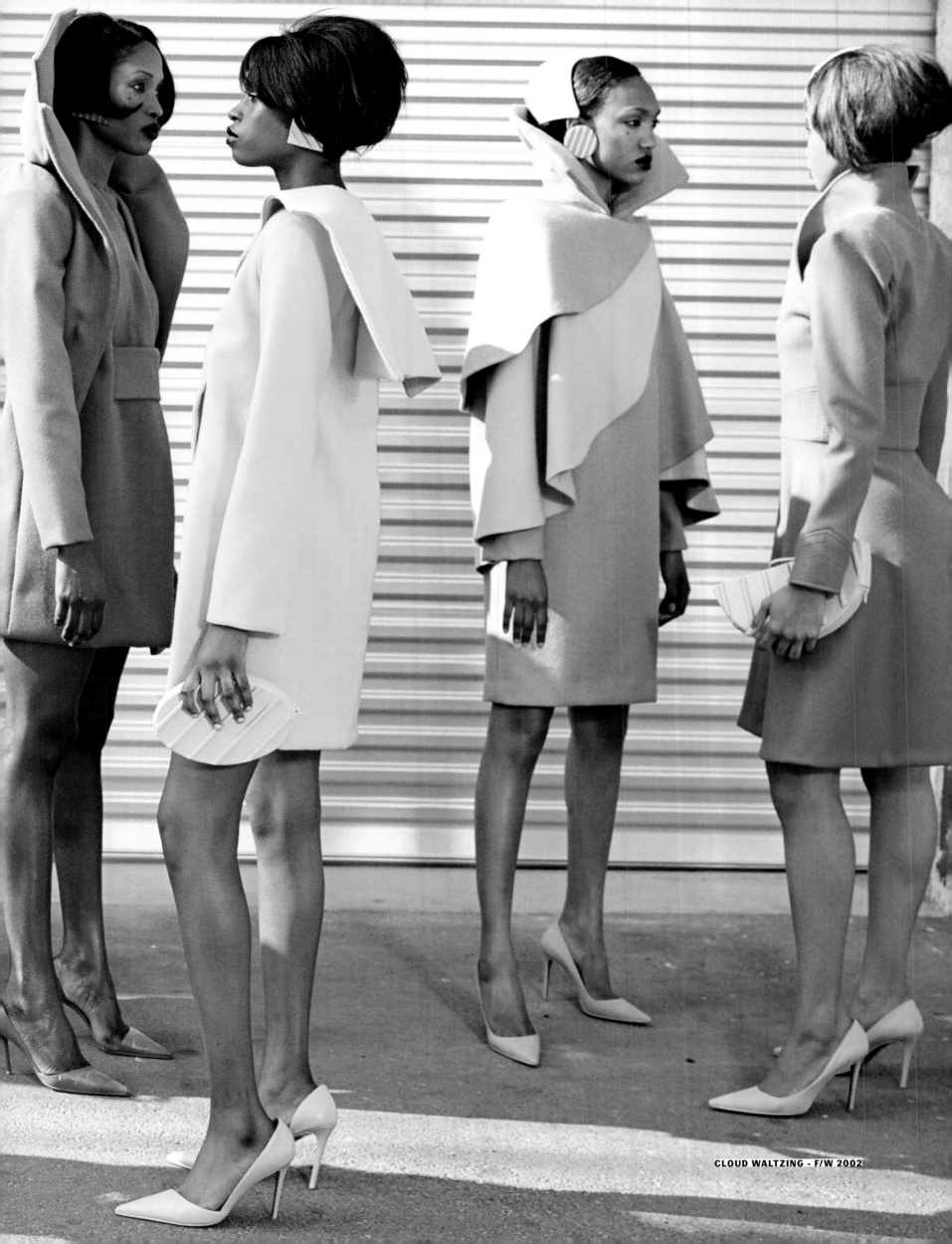

CLOUD WALTZING - F/W 2002

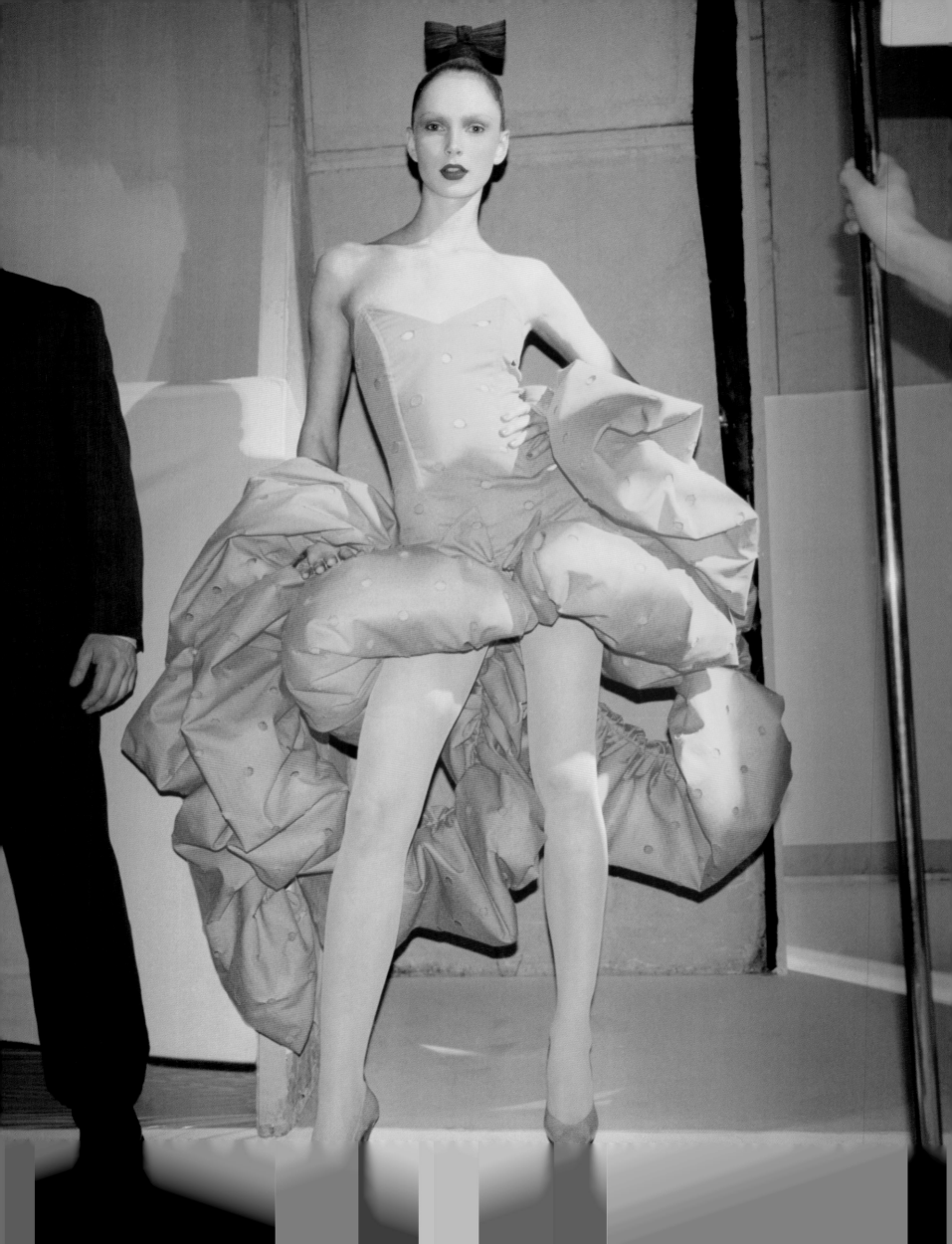

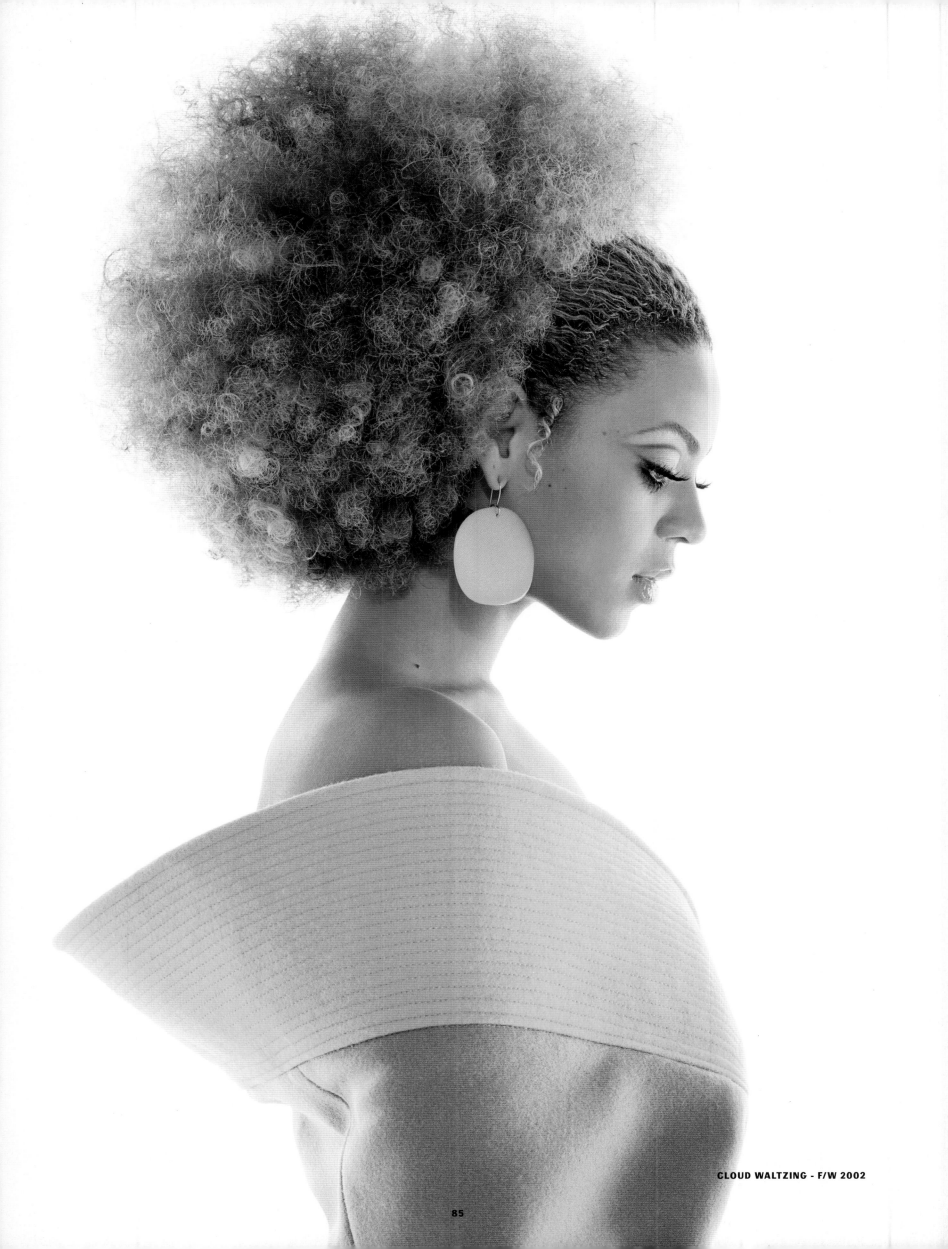

CLOUD WALTZING - F/W 2002

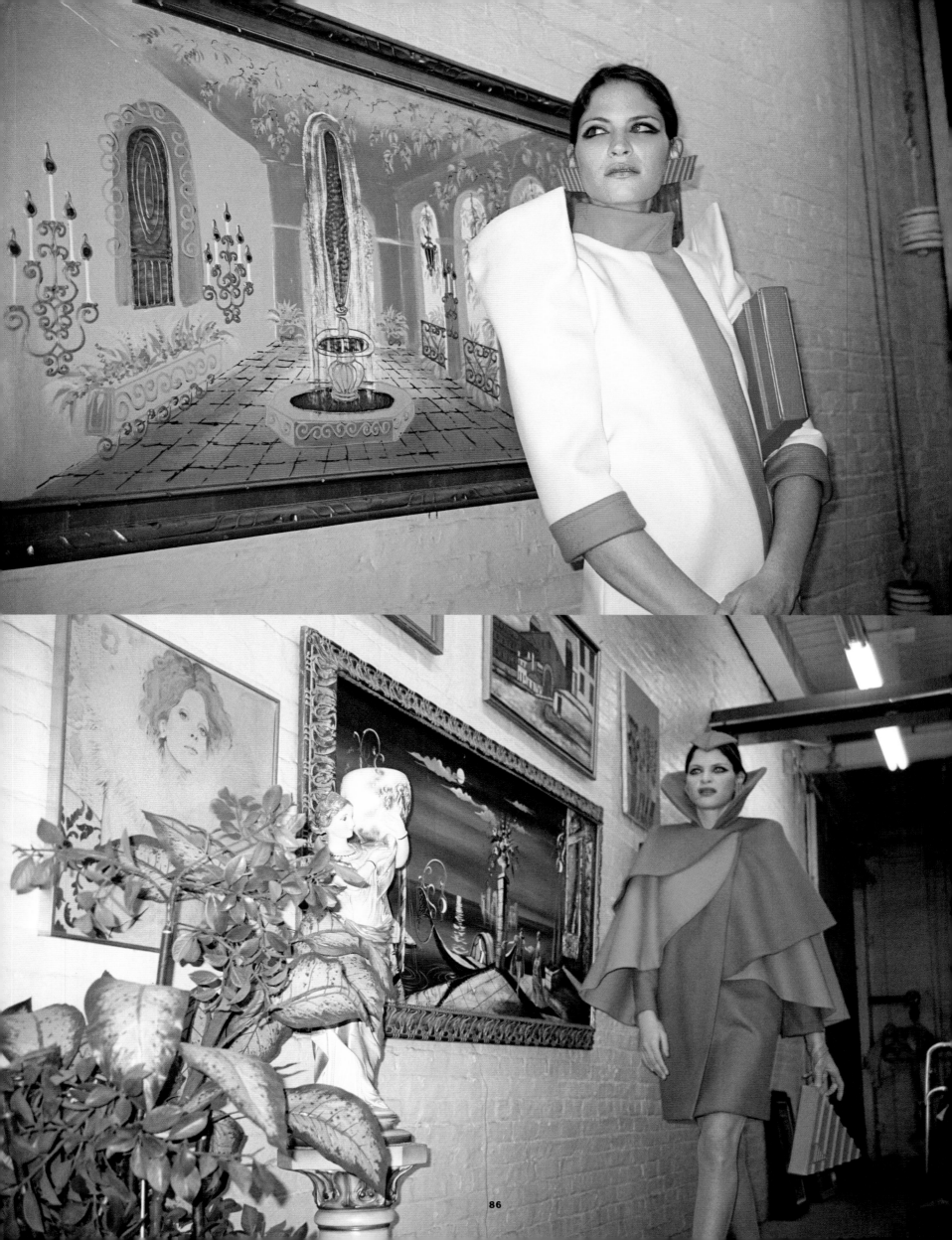

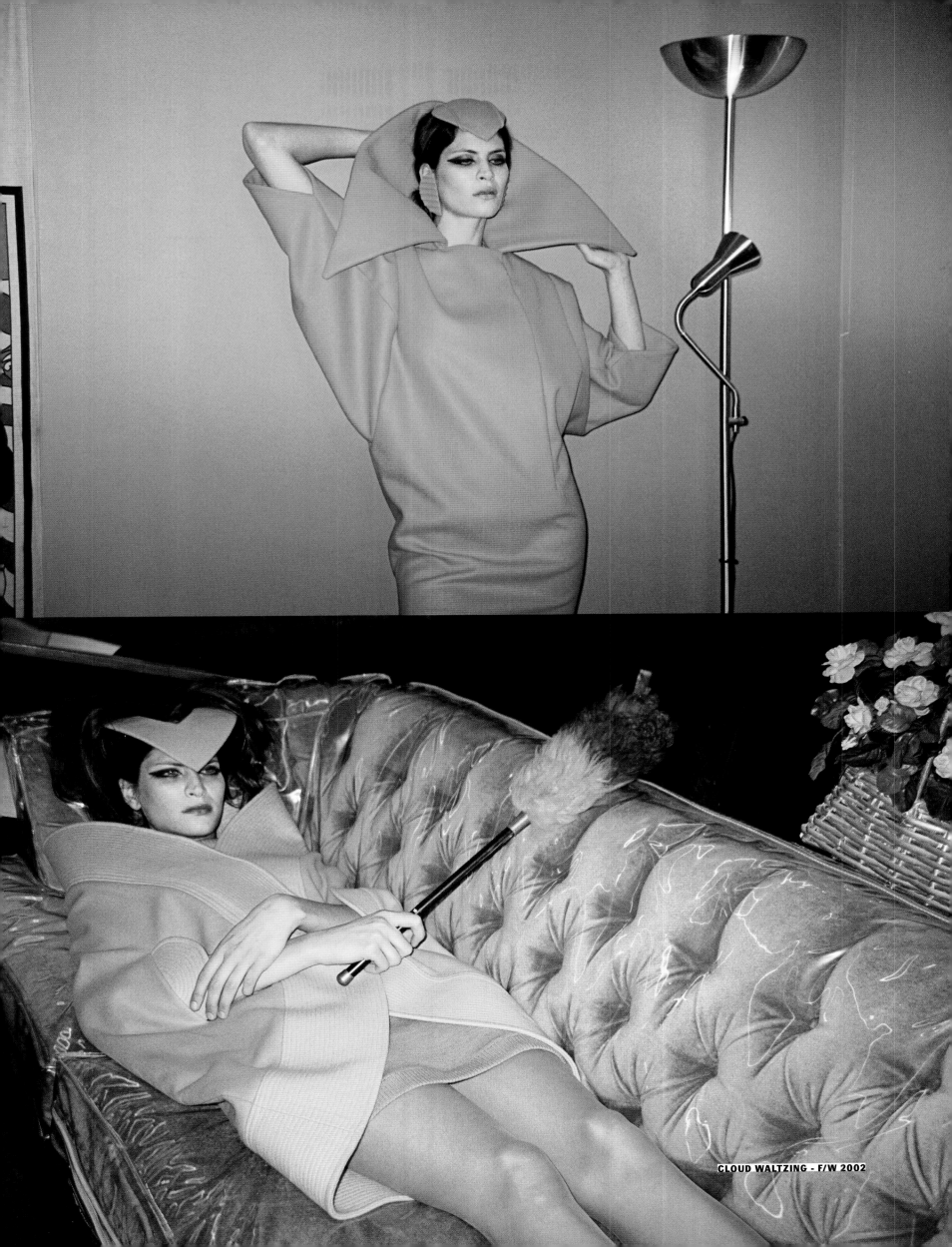

CLOUD WALTZING - F/W 2002

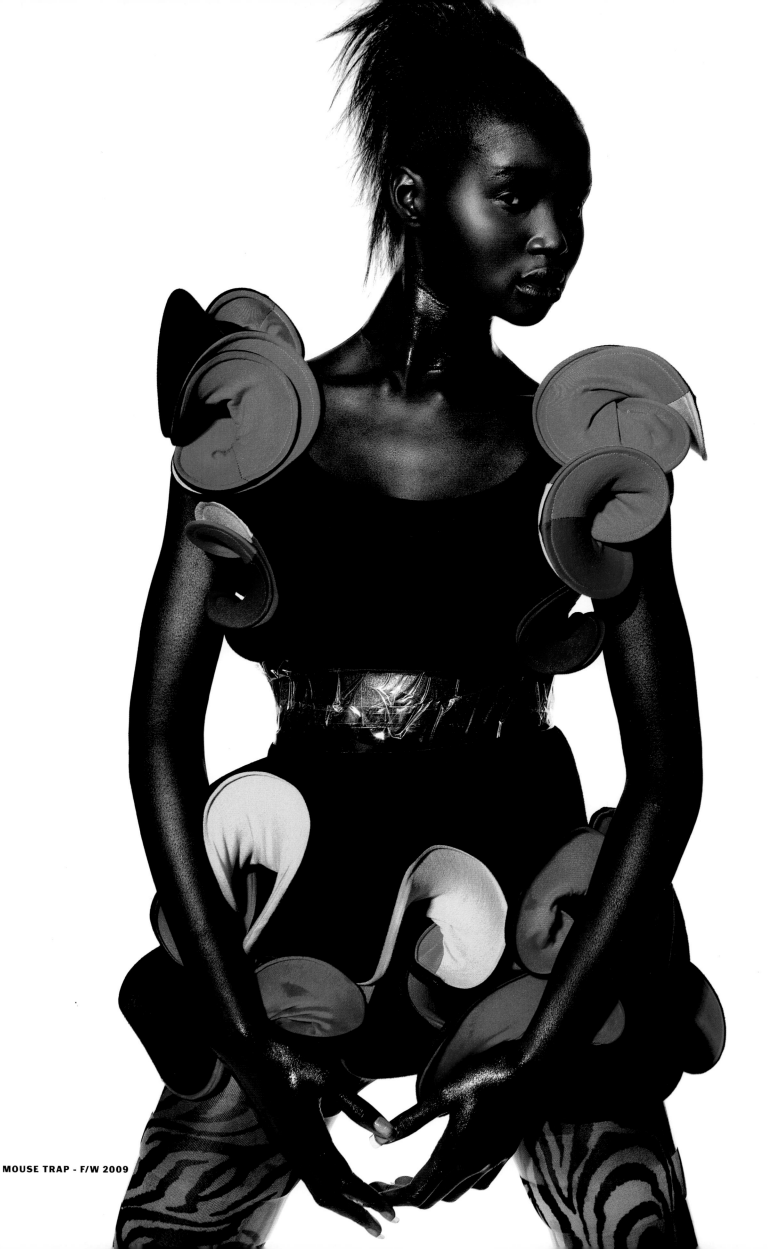

MOUSE TRAP - F/W 2009

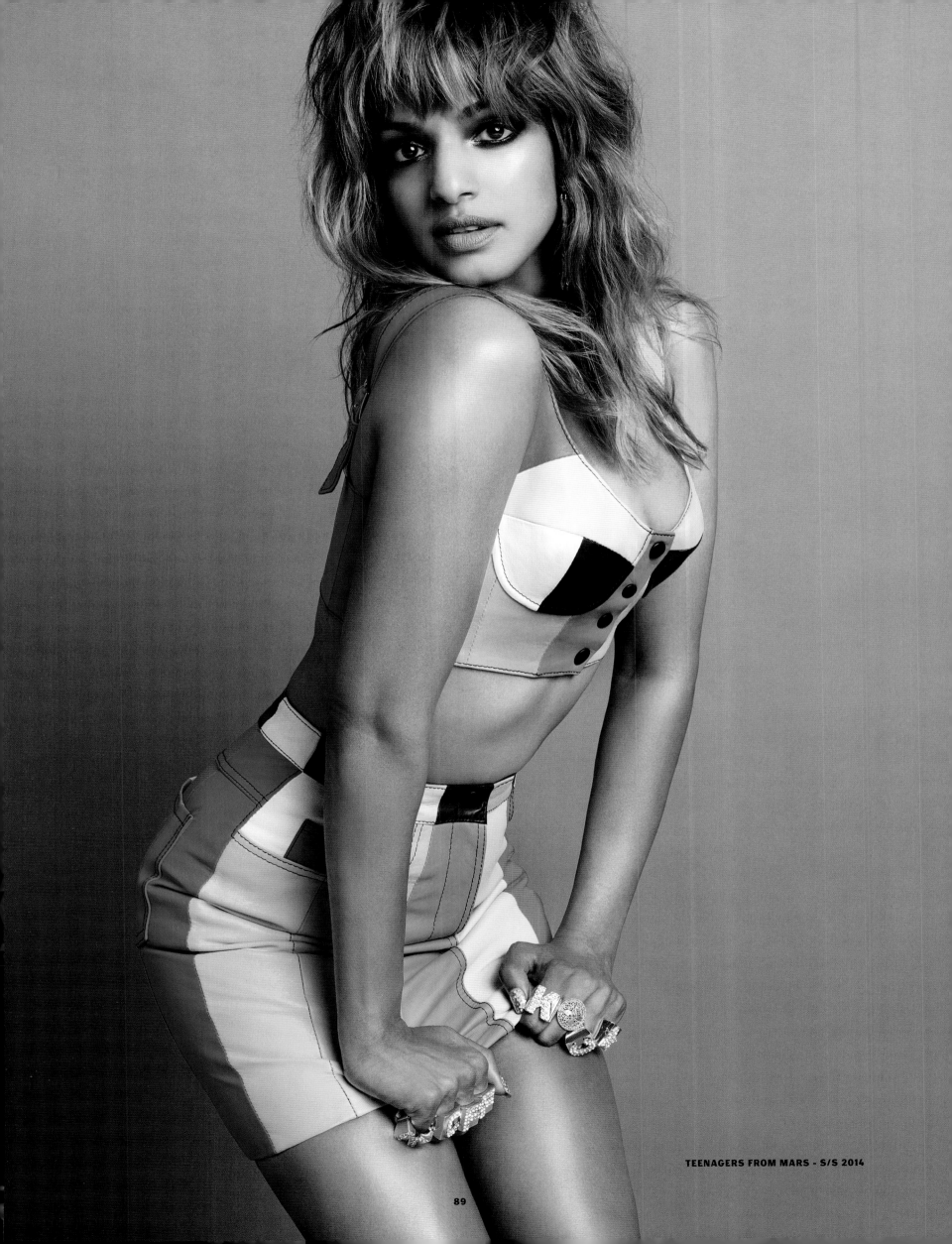

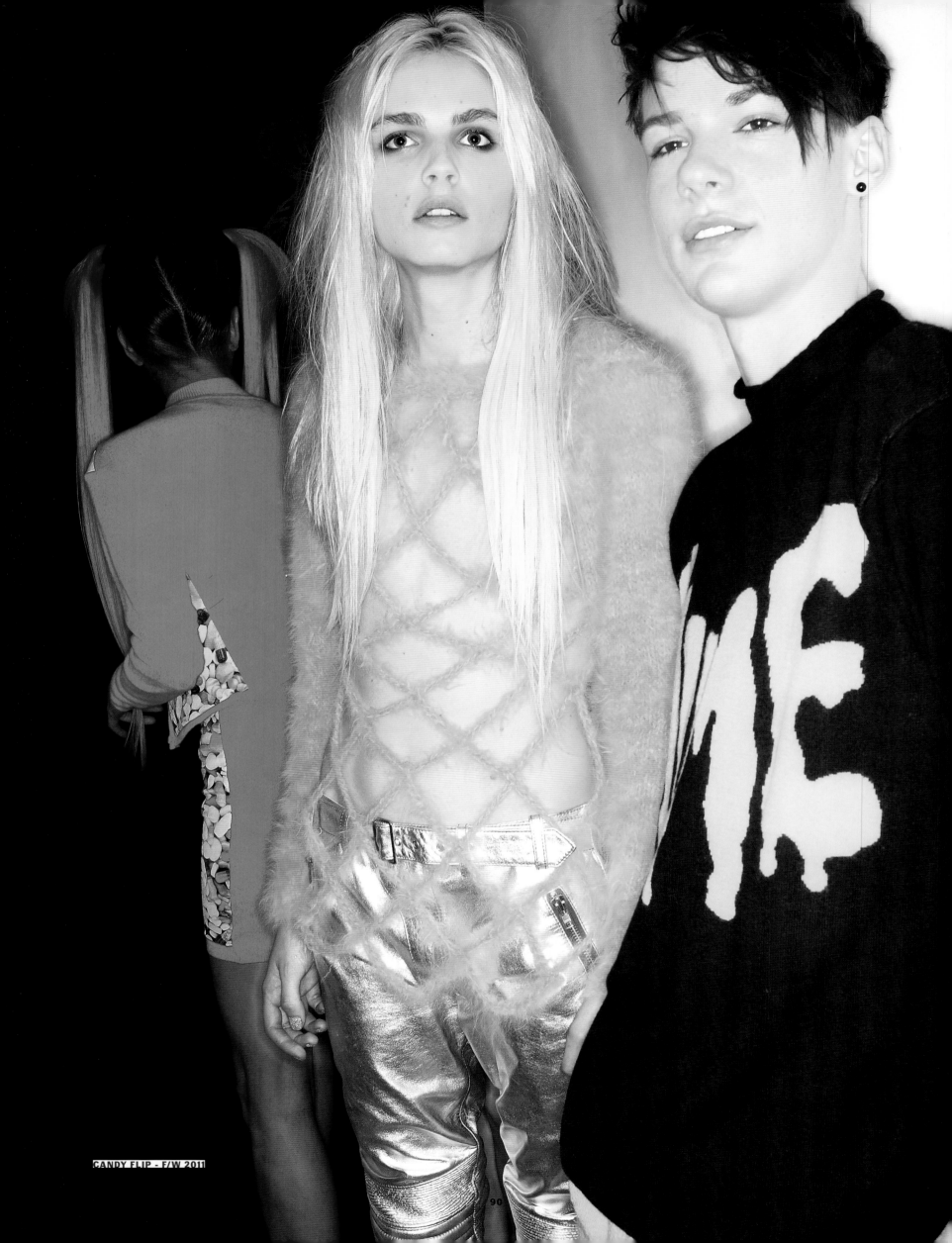

CANDY FLIP - F/W 2011

90

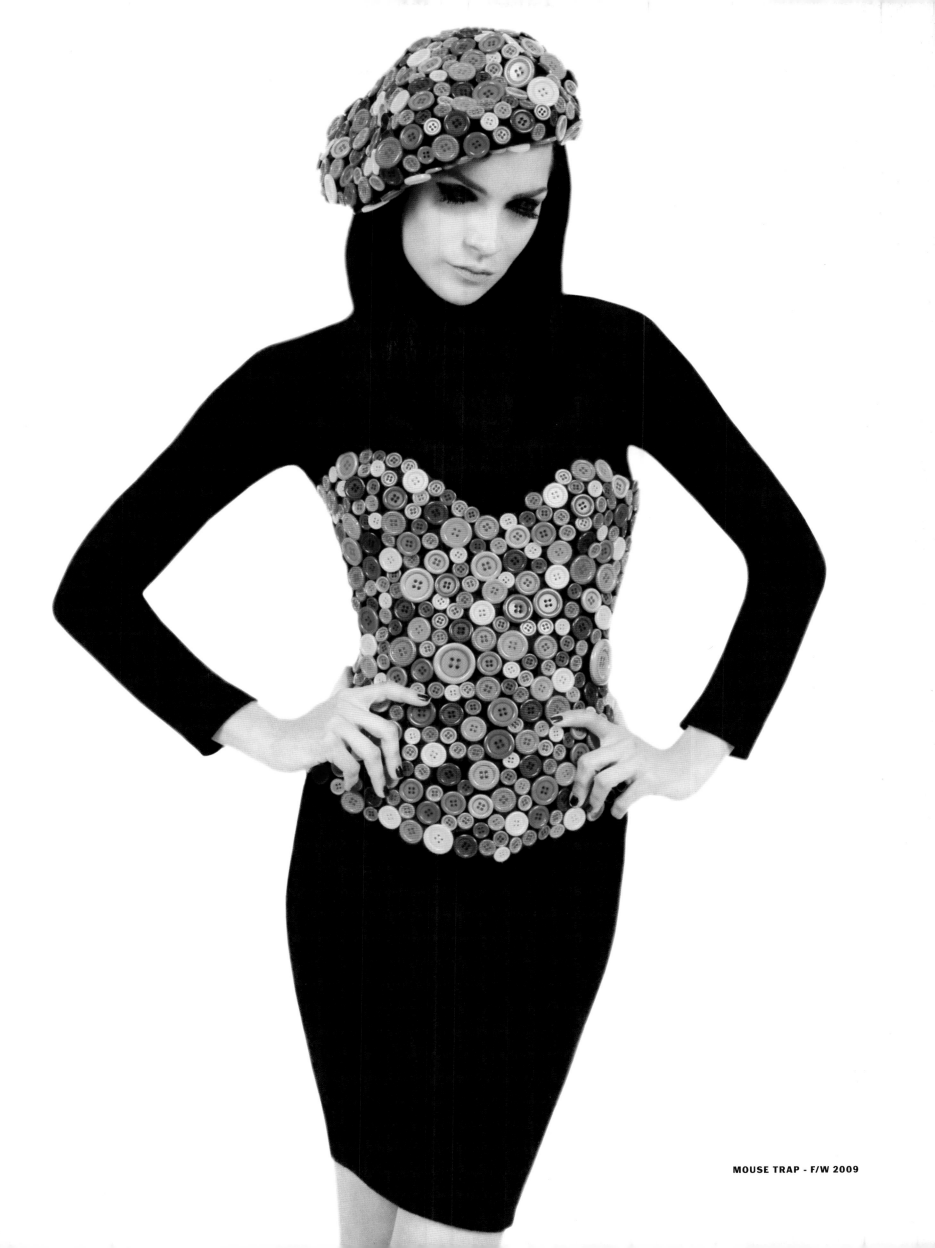

MOUSE TRAP - F/W 2009

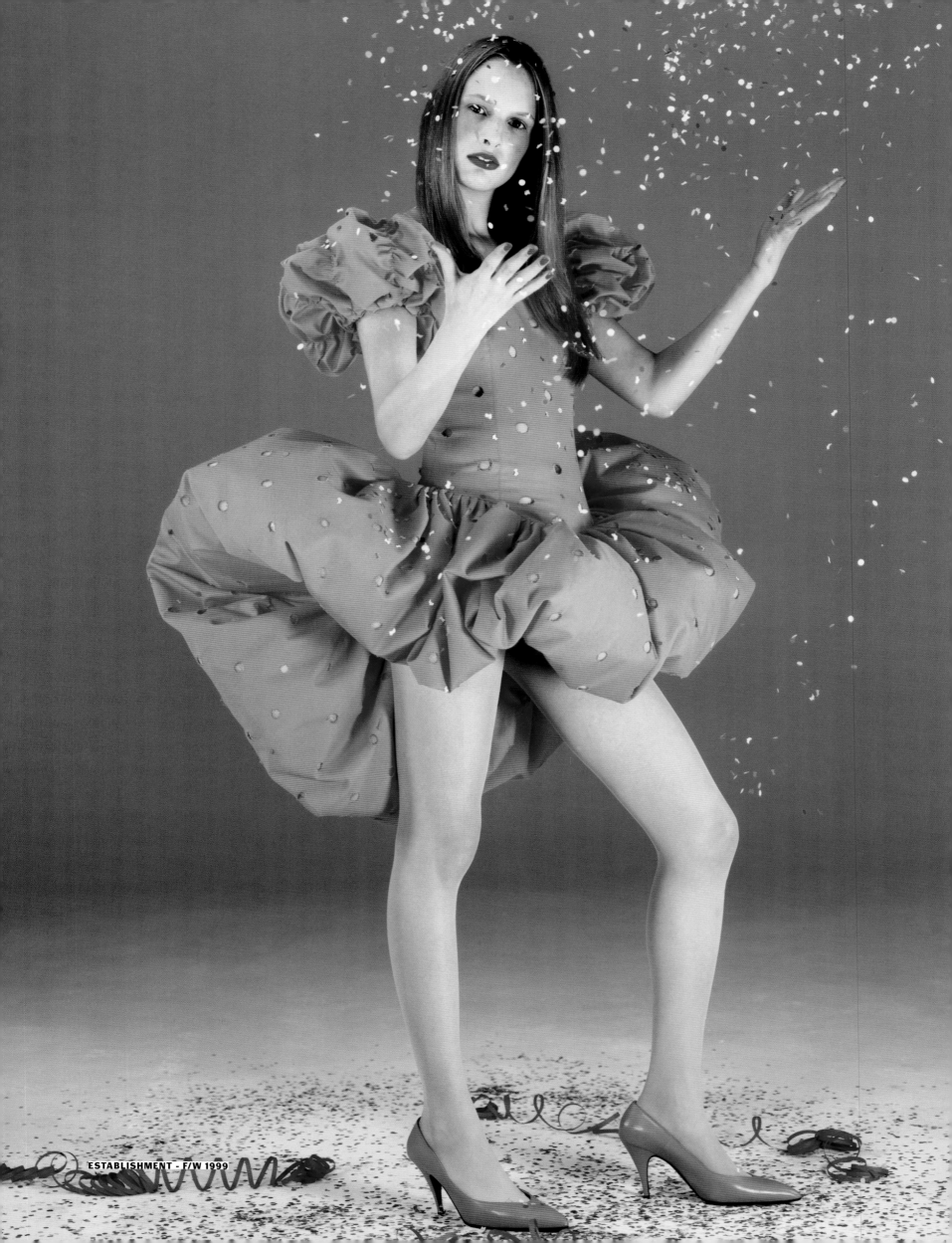

ESTABLISHMENT - F/W 1999

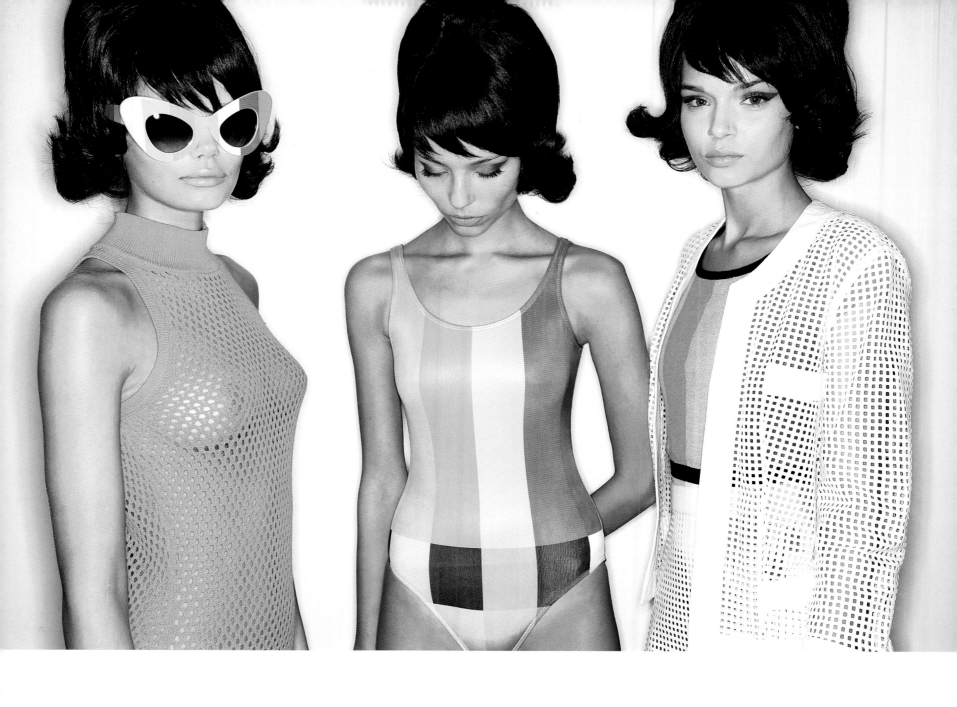

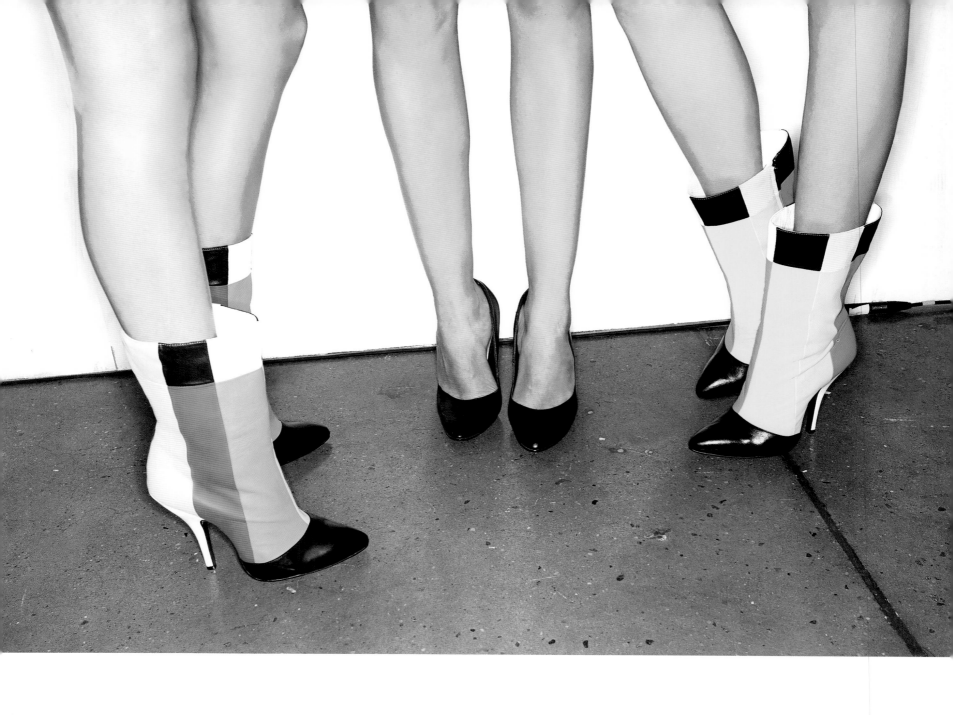

TEENAGERS FROM MARS - S/S 2014

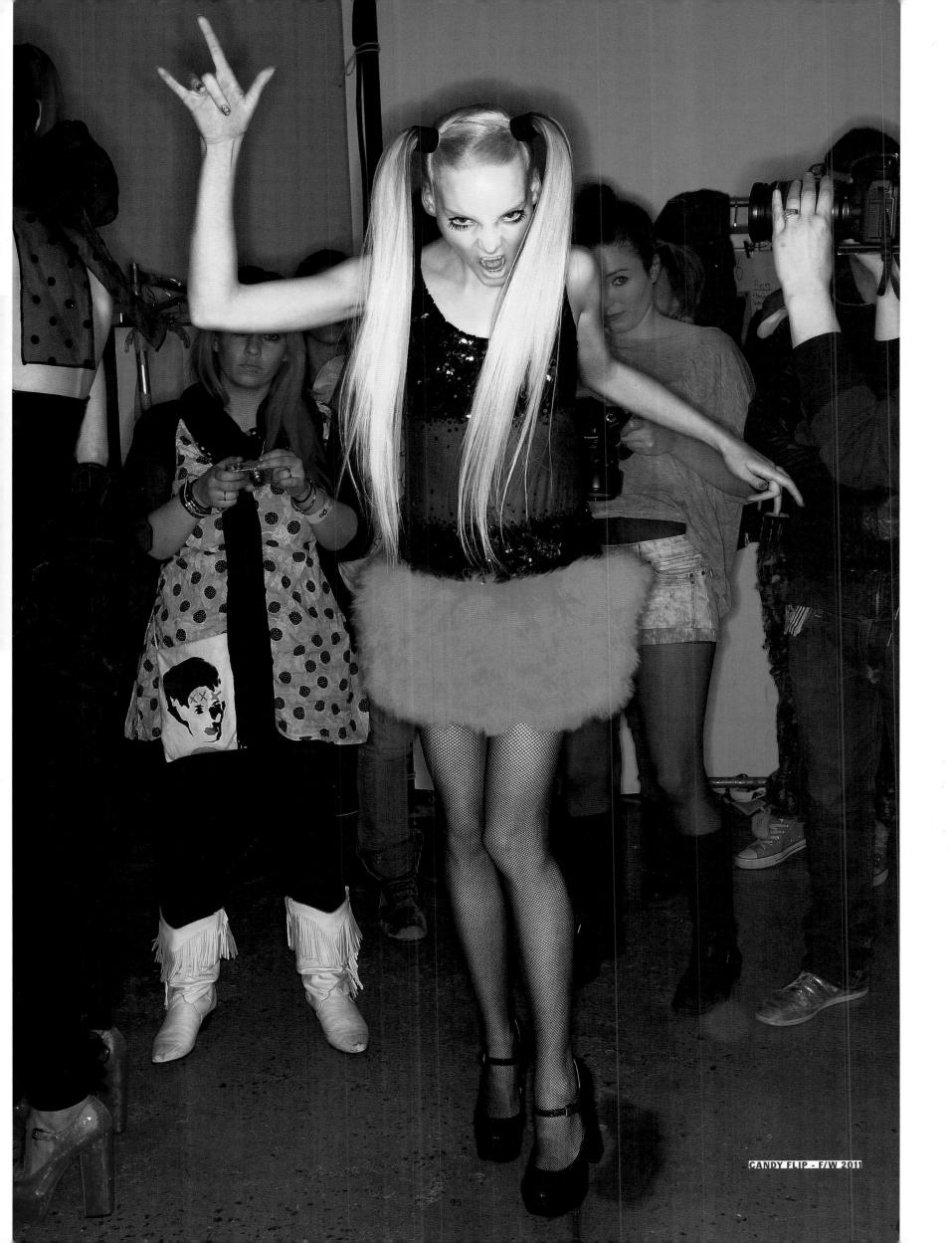

CANDY FLIP - F/W 2011

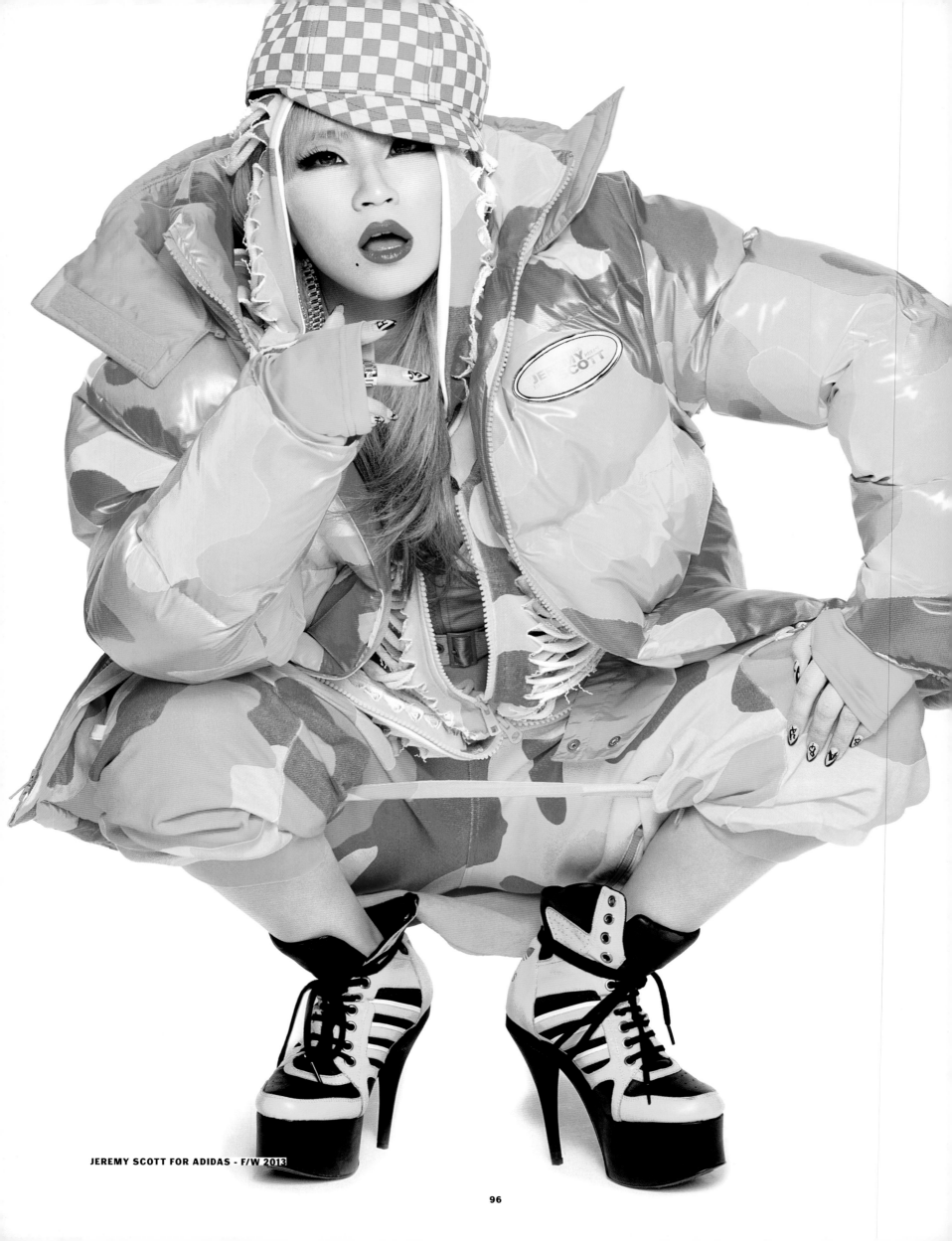

JEREMY SCOTT FOR ADIDAS - F/W 2013

96

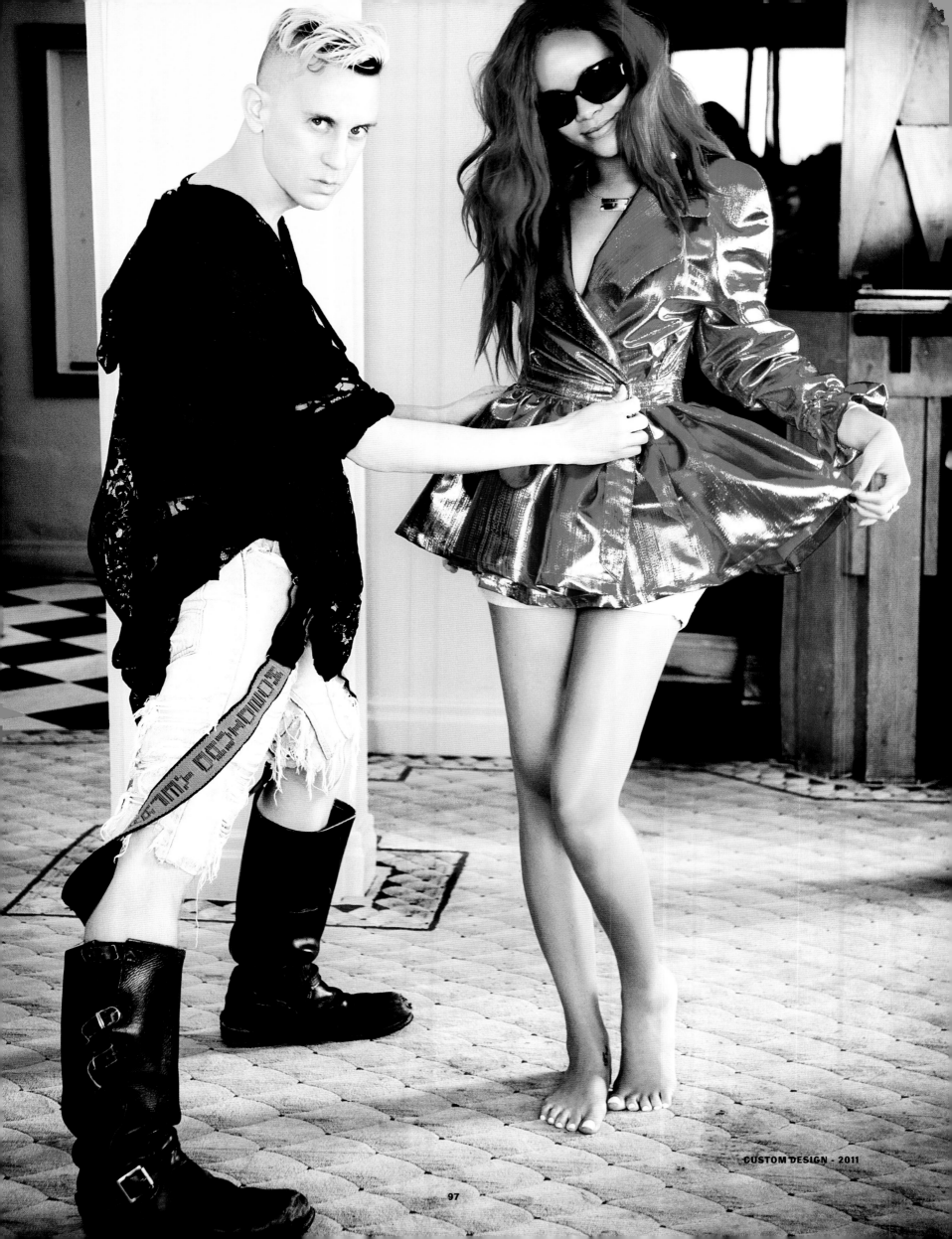

CUSTOM DESIGN - 2011

LOGO STATUS

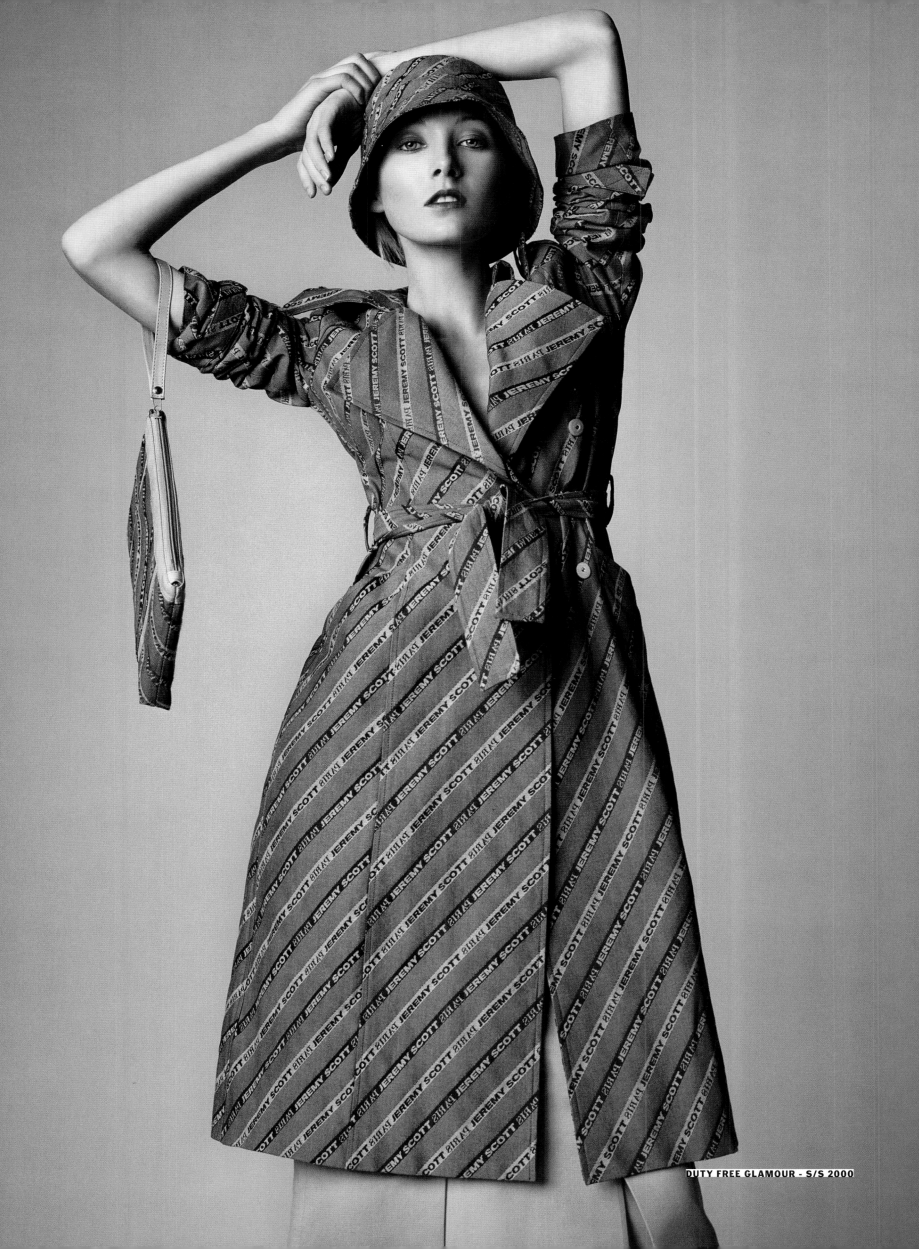

DUTY FREE GLAMOUR - S/S 2000

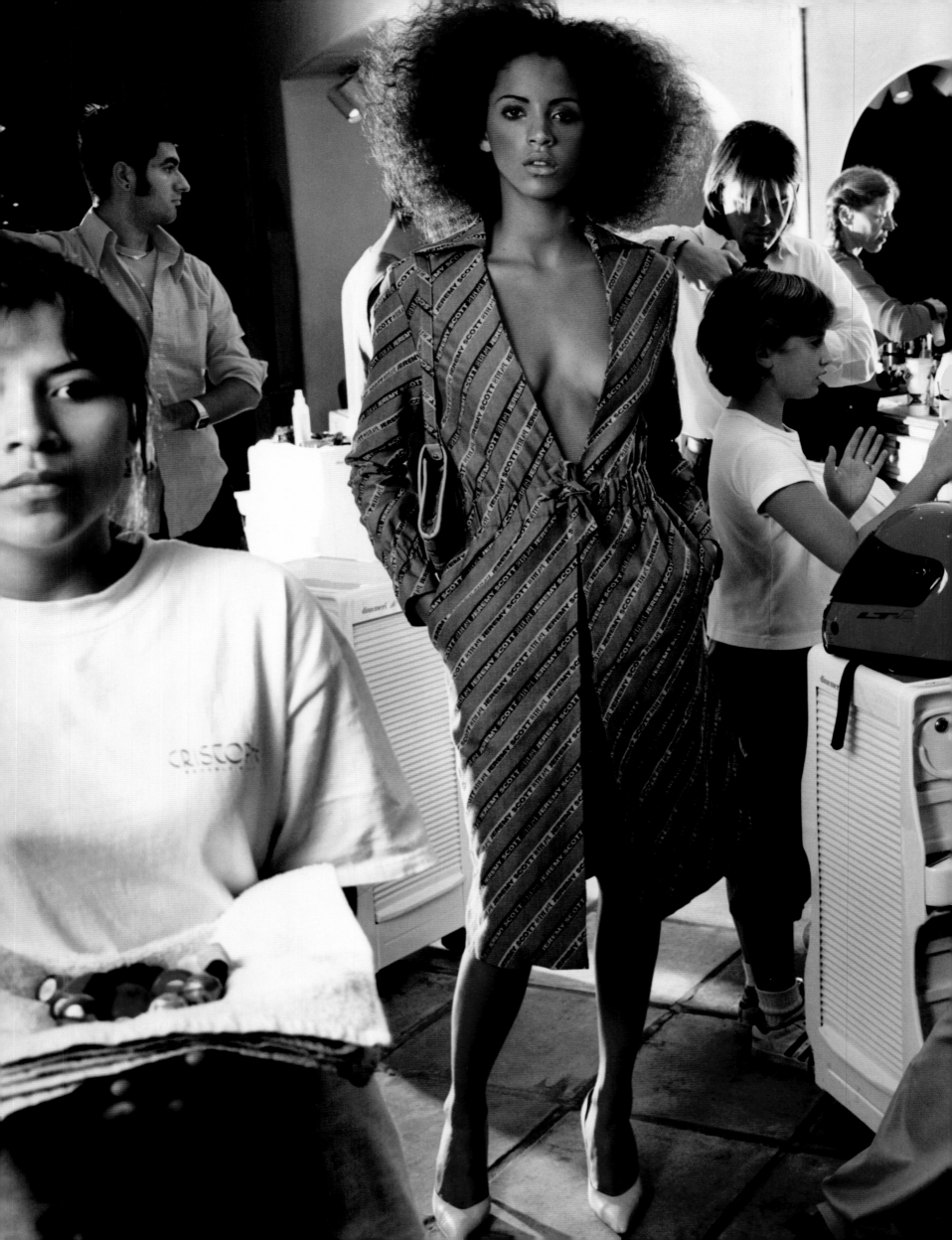

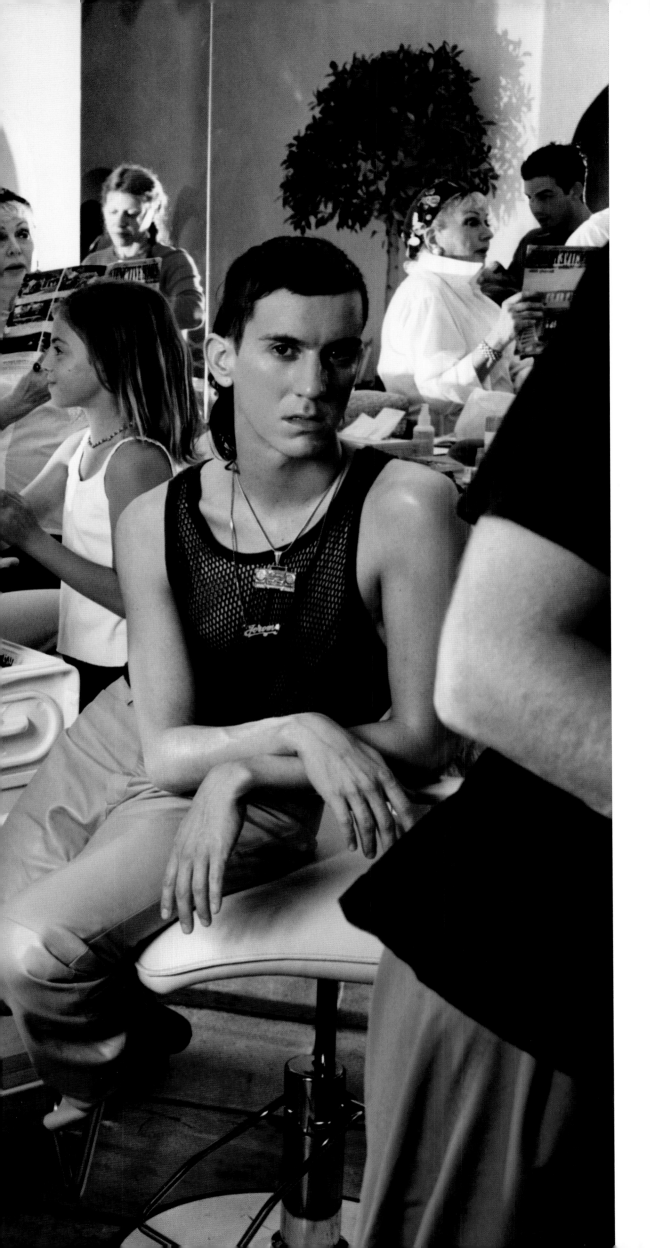

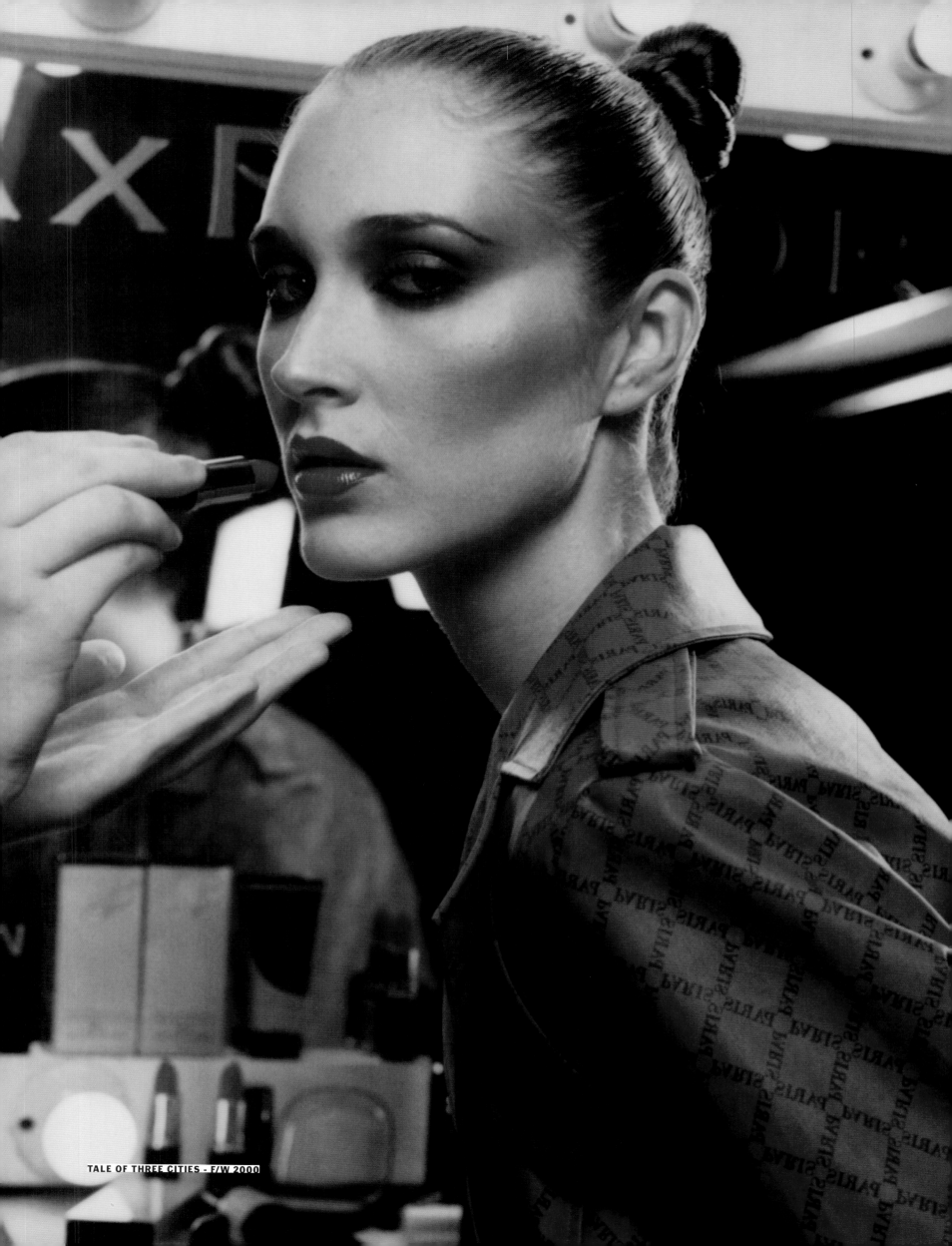

TALE OF THREE CITIES - F/W 2000

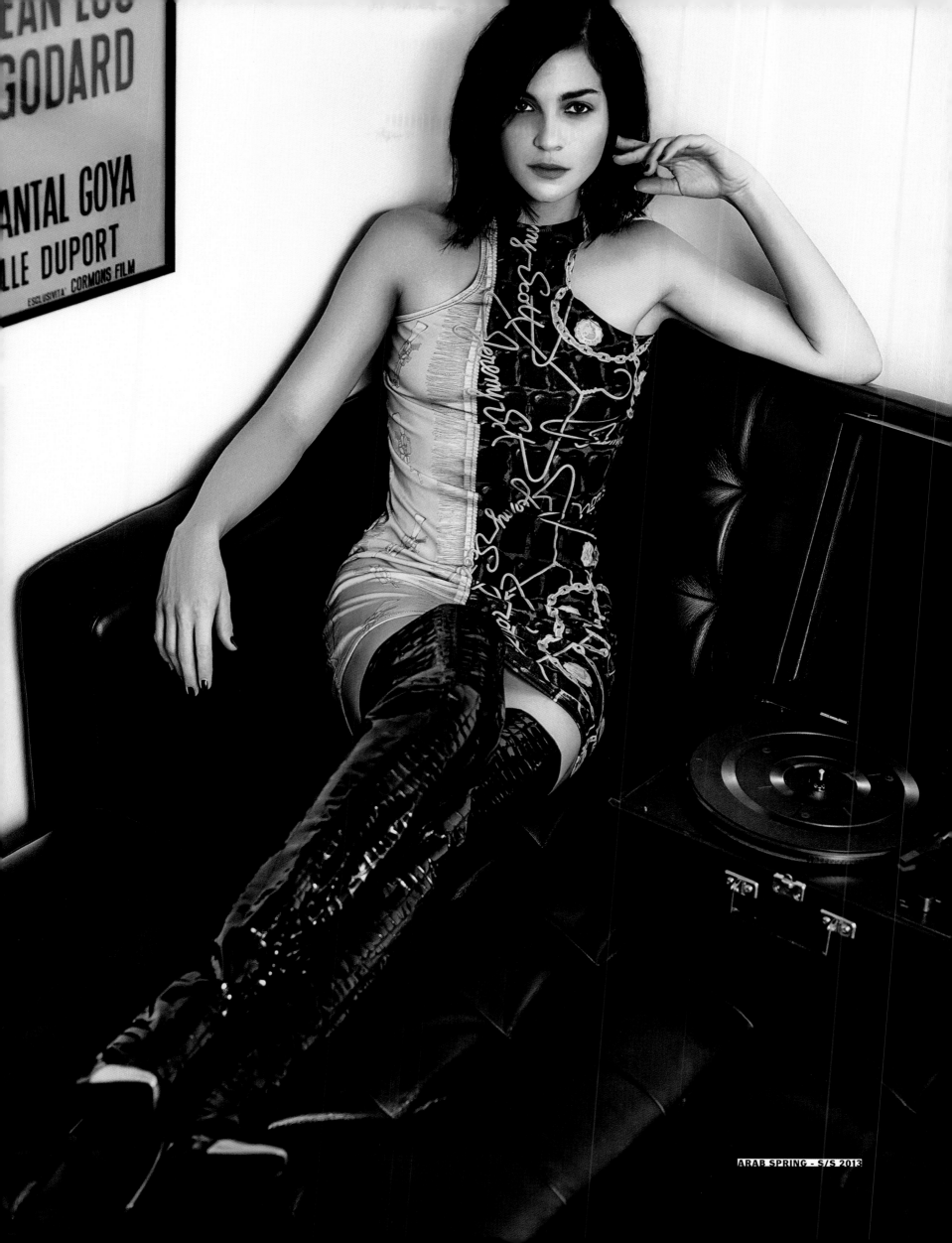

ARAB SPRING - S/S 2013

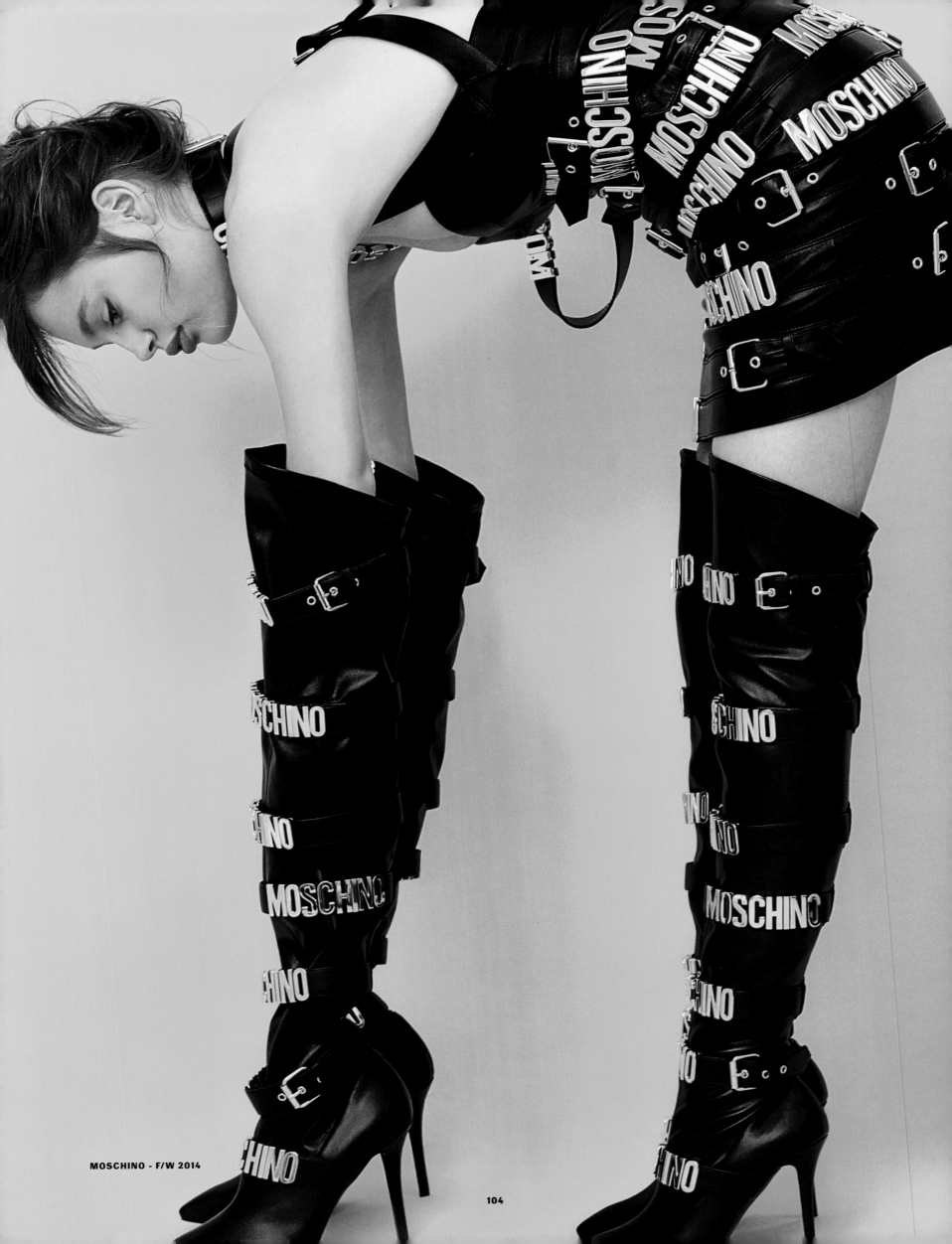

MOSCHINO - F/W 2014

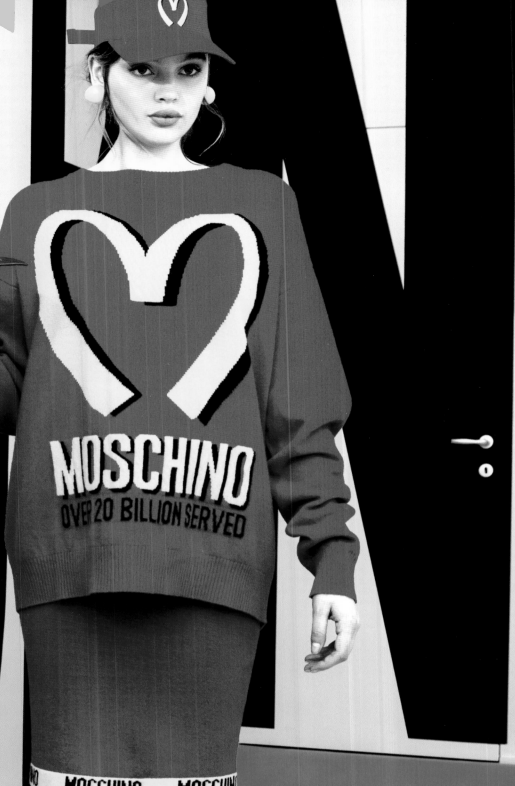

MOSCHINO - F/W 2014

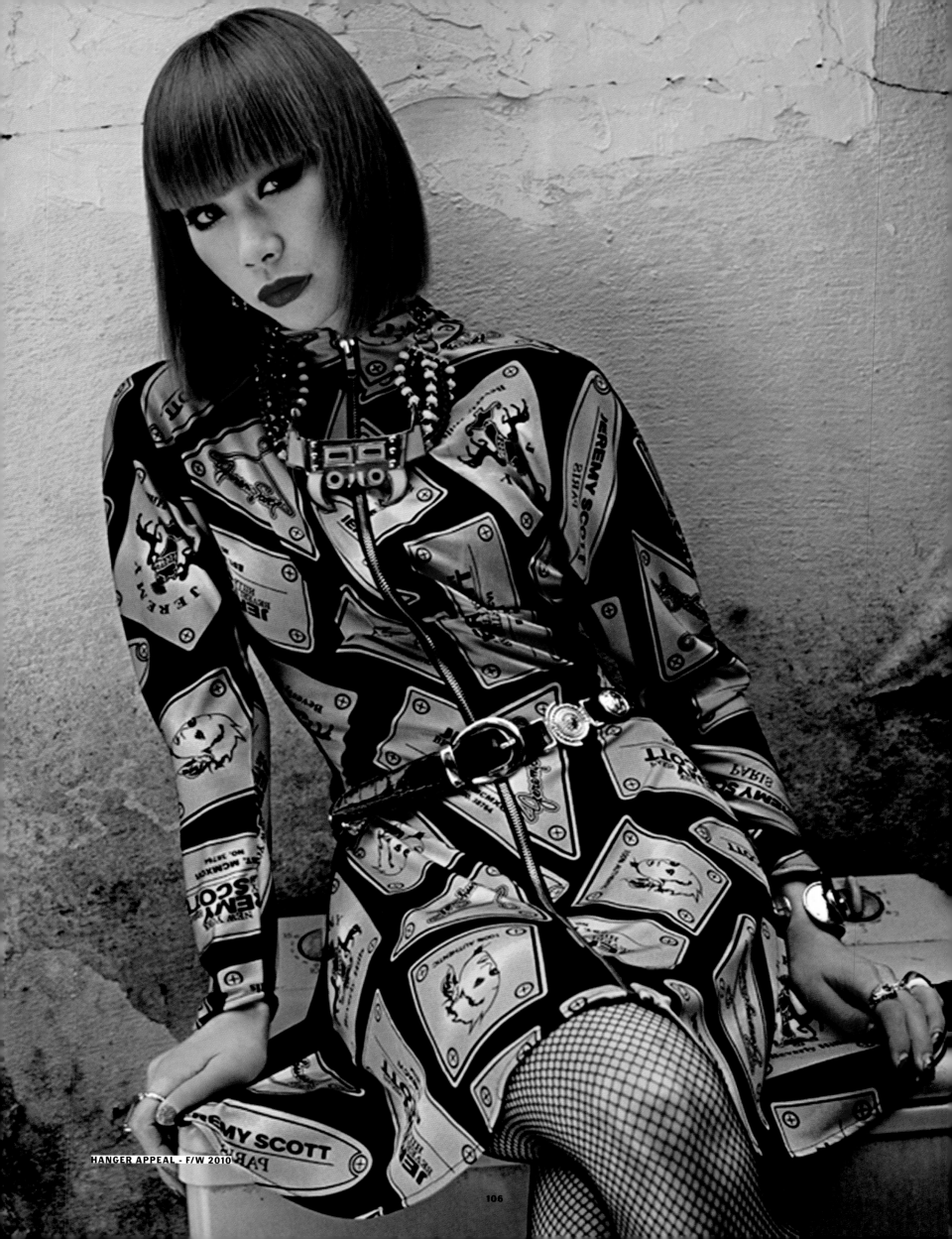

HANGER APPEAL - F/W 2010

106

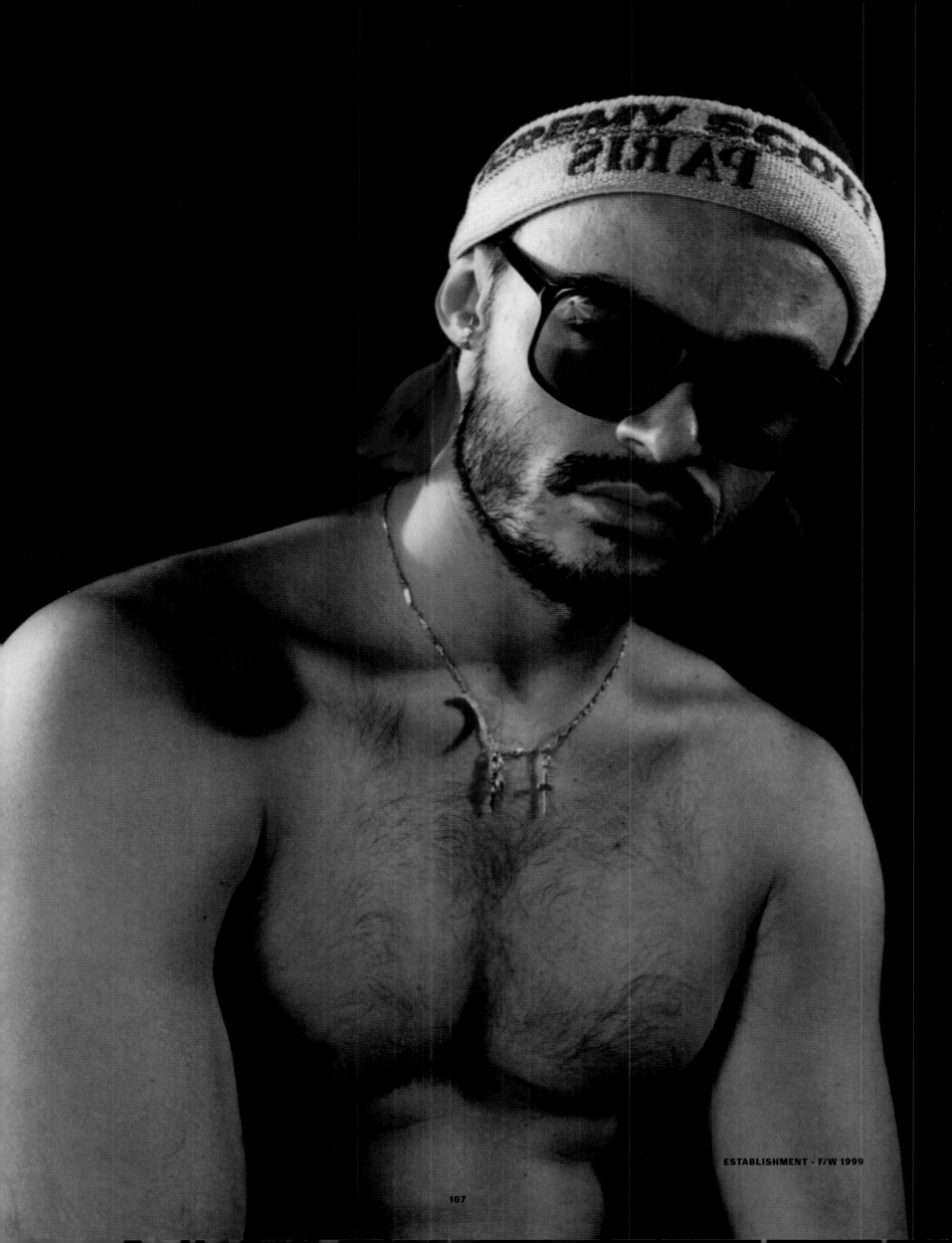

ESTABLISHMENT - F/W 1999

107

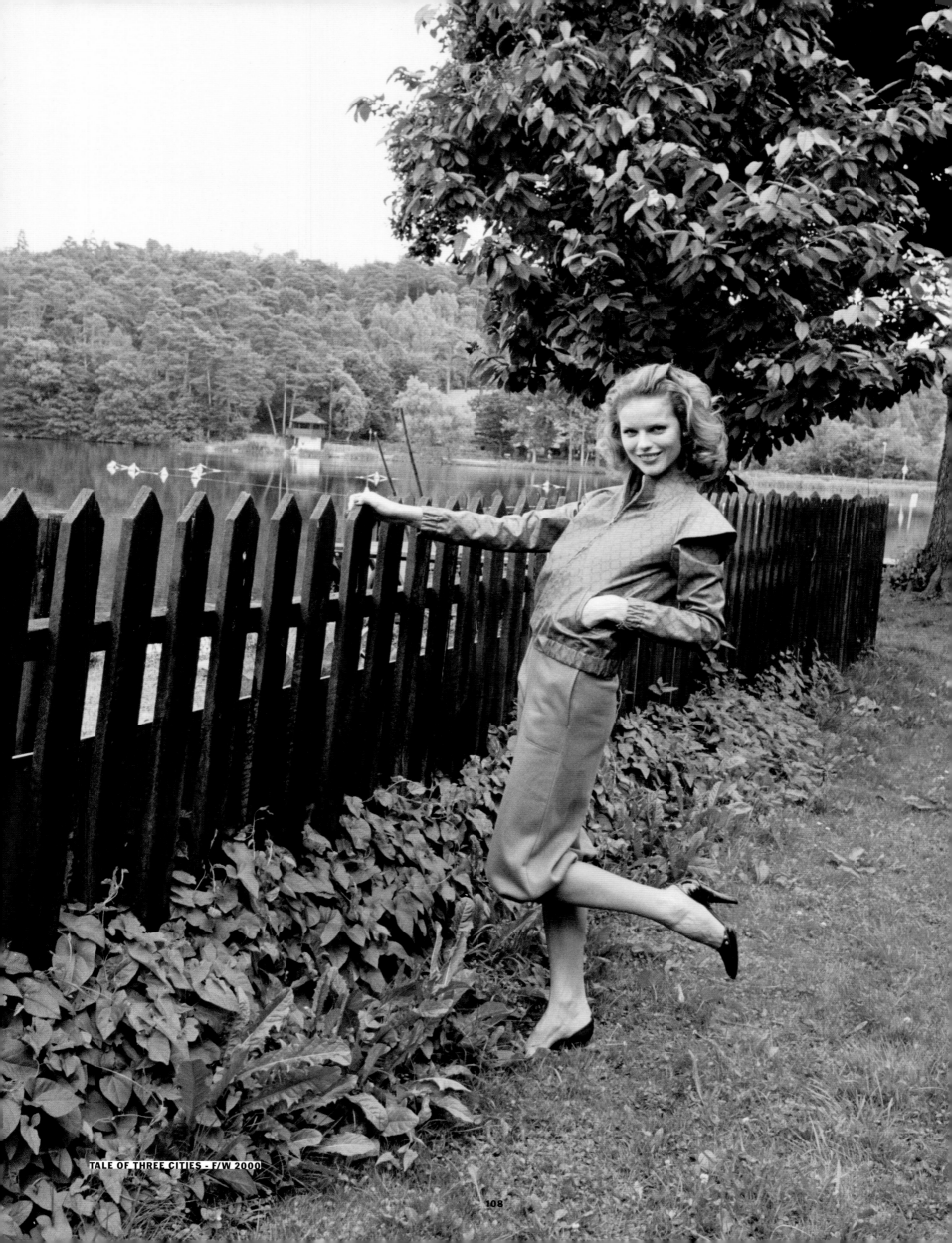

TALE OF THREE CITIES - F/W 2000

108

HEROES
&
CARTOONS

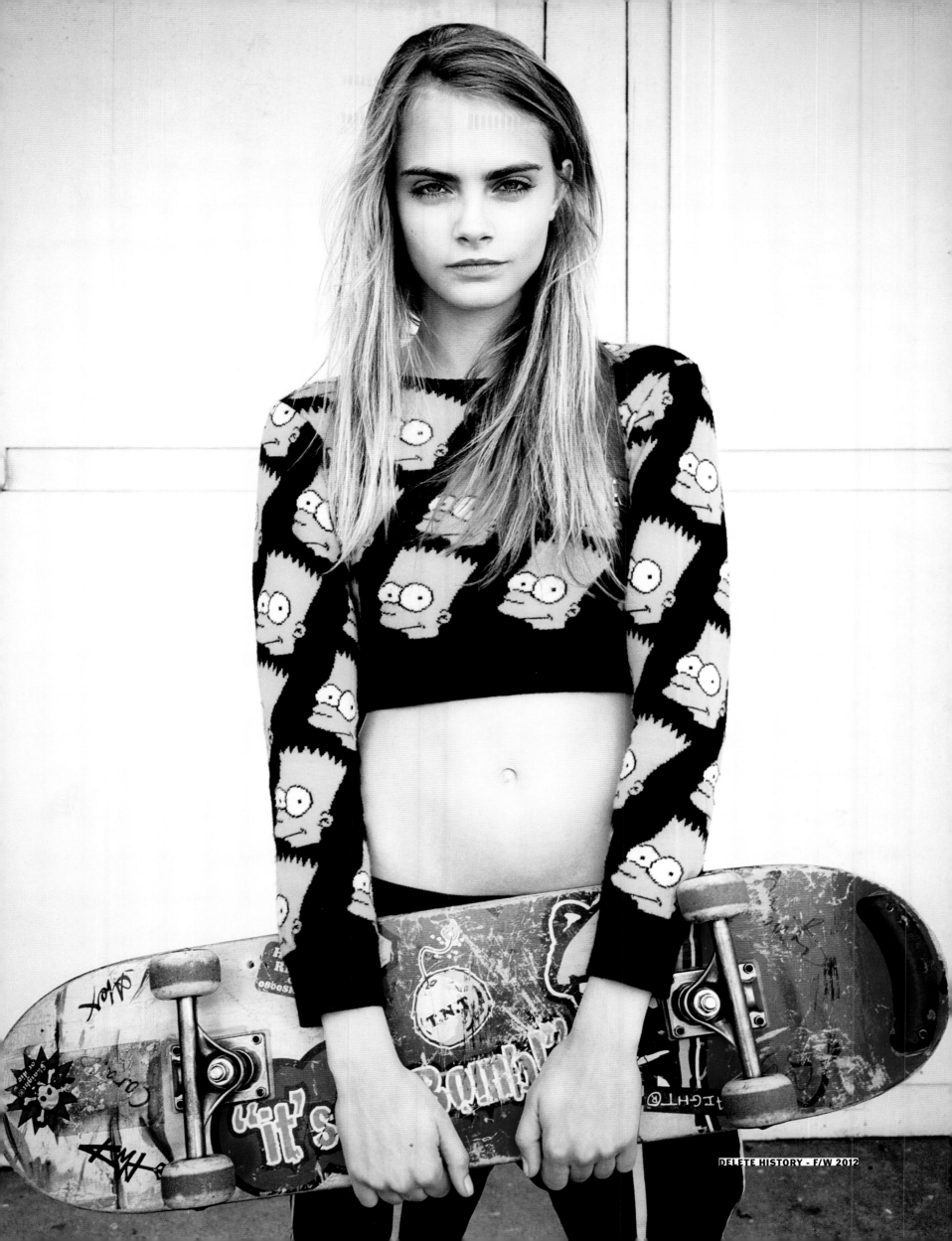

DELETE HISTORY - F/W 2012

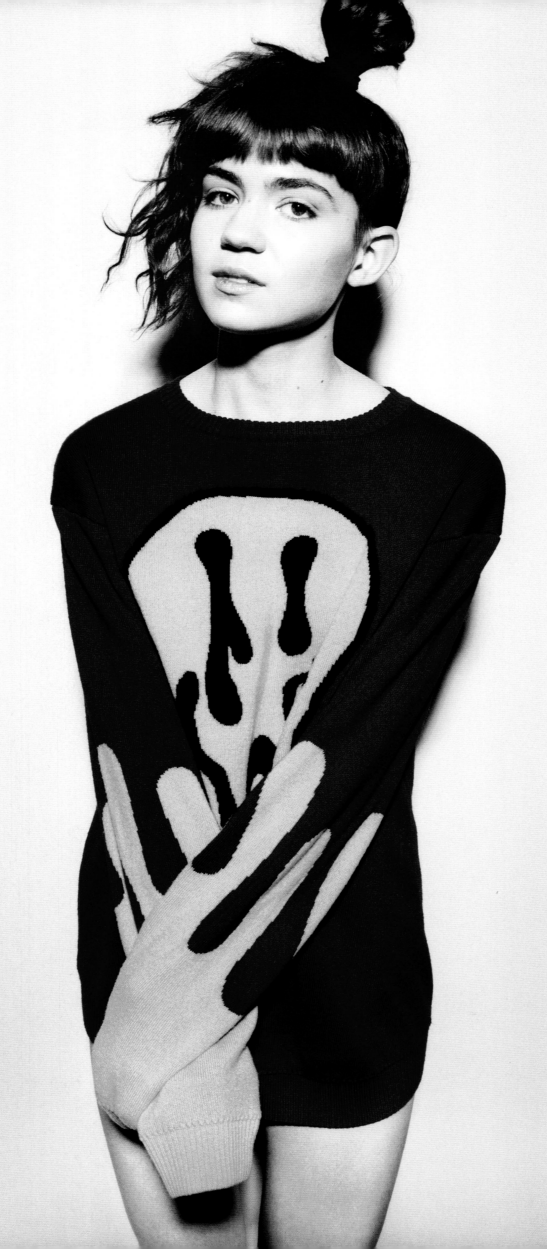

DELETE HISTORY - F/W 2012

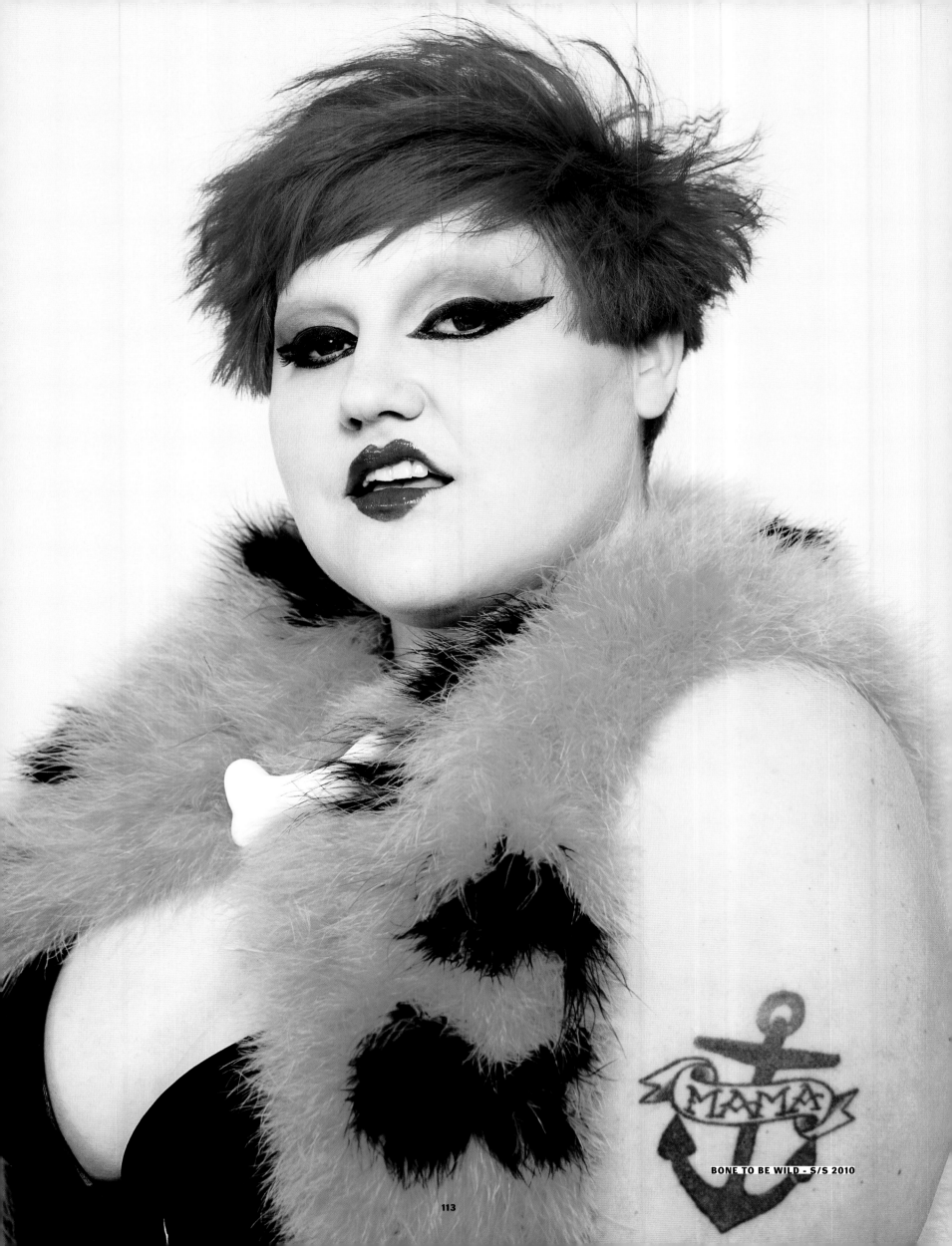

BONE TO BE WILD - S/S 2010

113

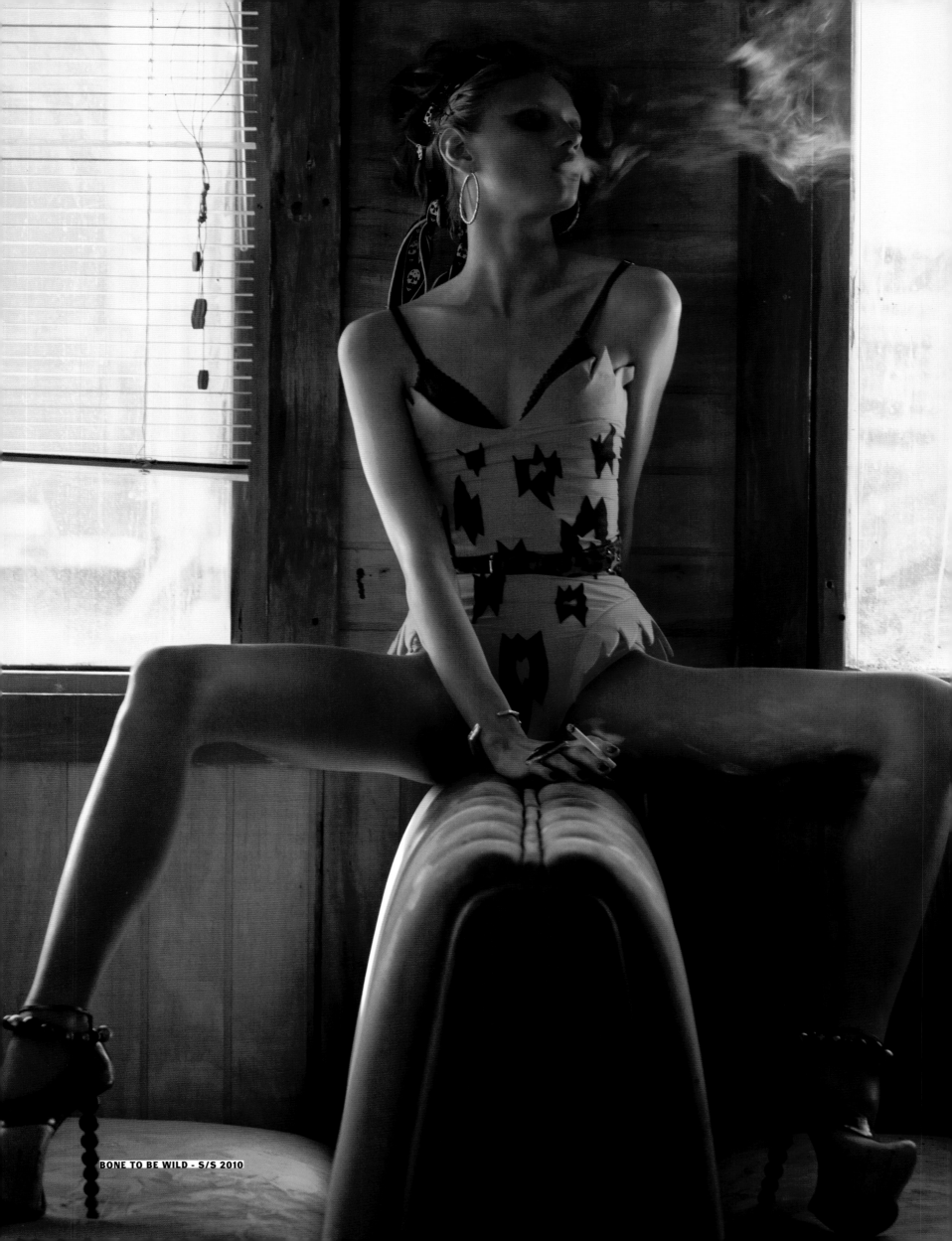

BONE TO BE WILD - S/S 2010

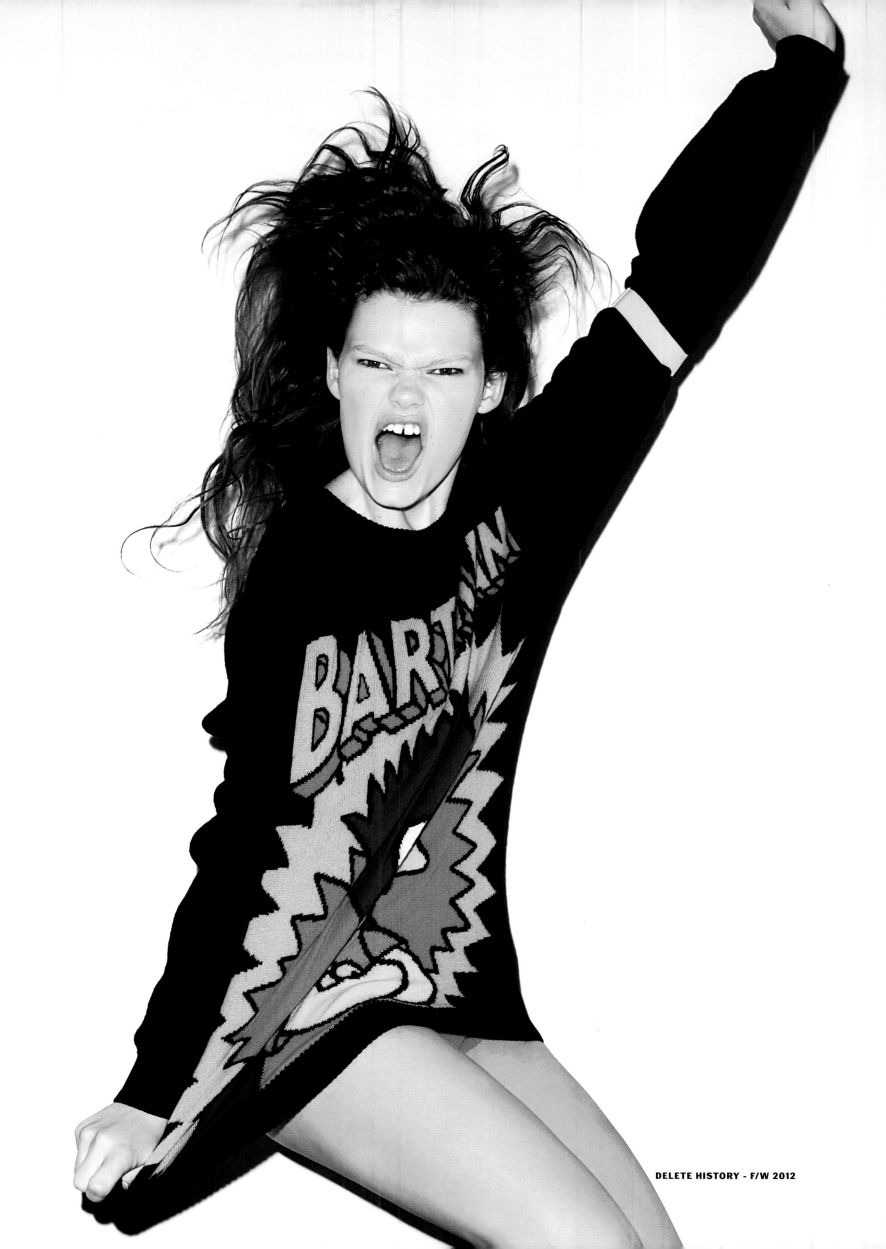

DELETE HISTORY - F/W 2012

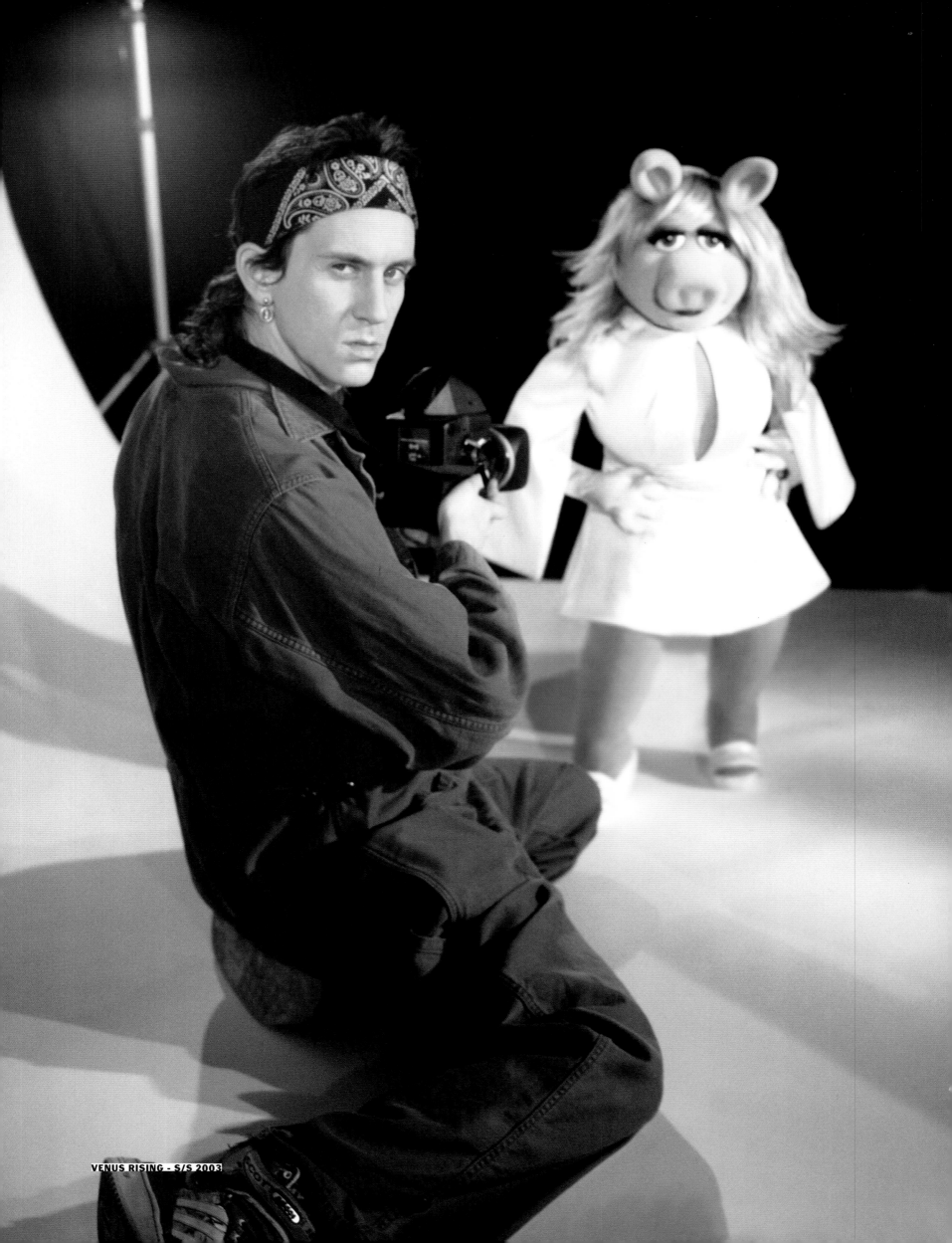

VENUS RISING - S/S 2003

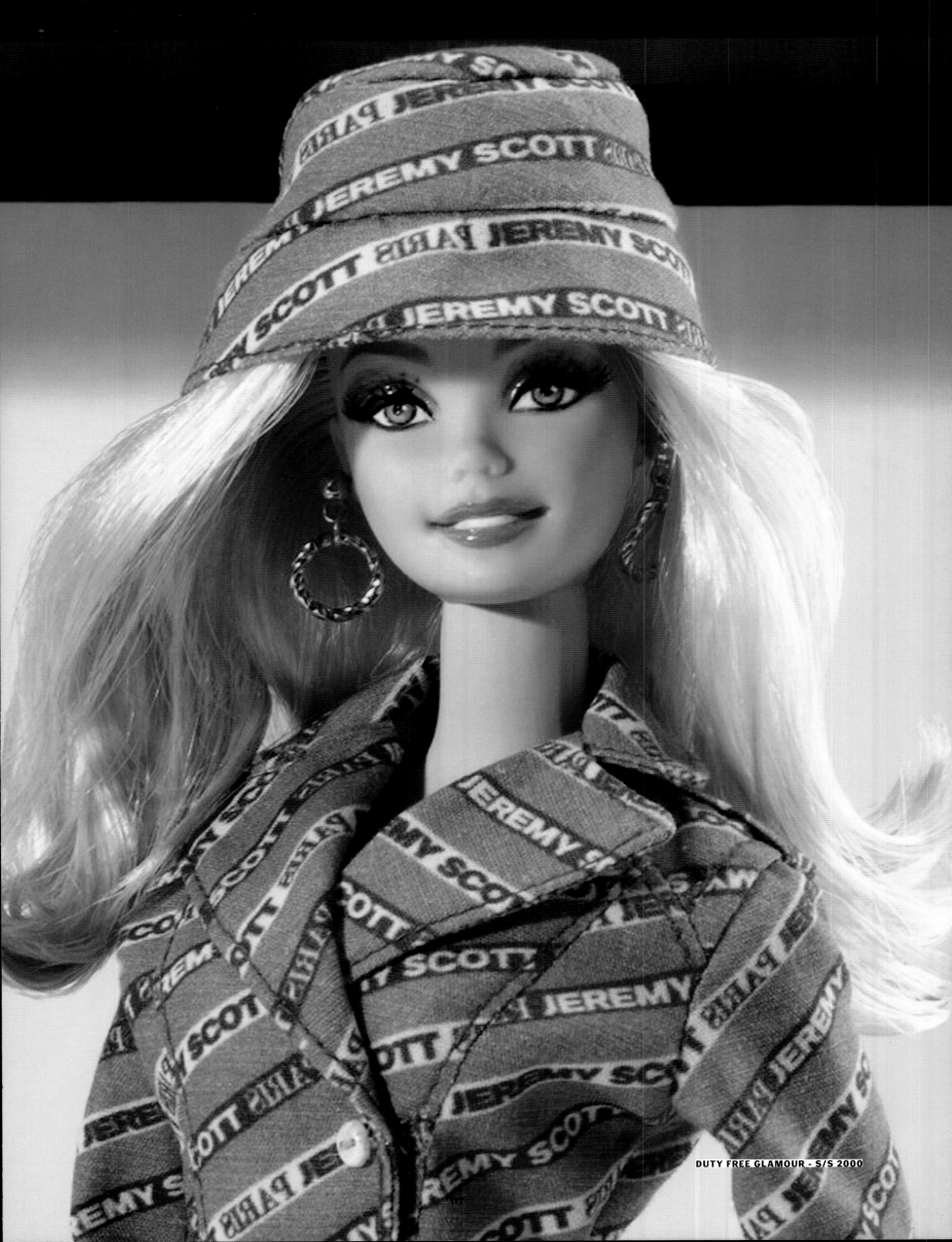

DUTY FREE GLAMOUR - S/S 2000

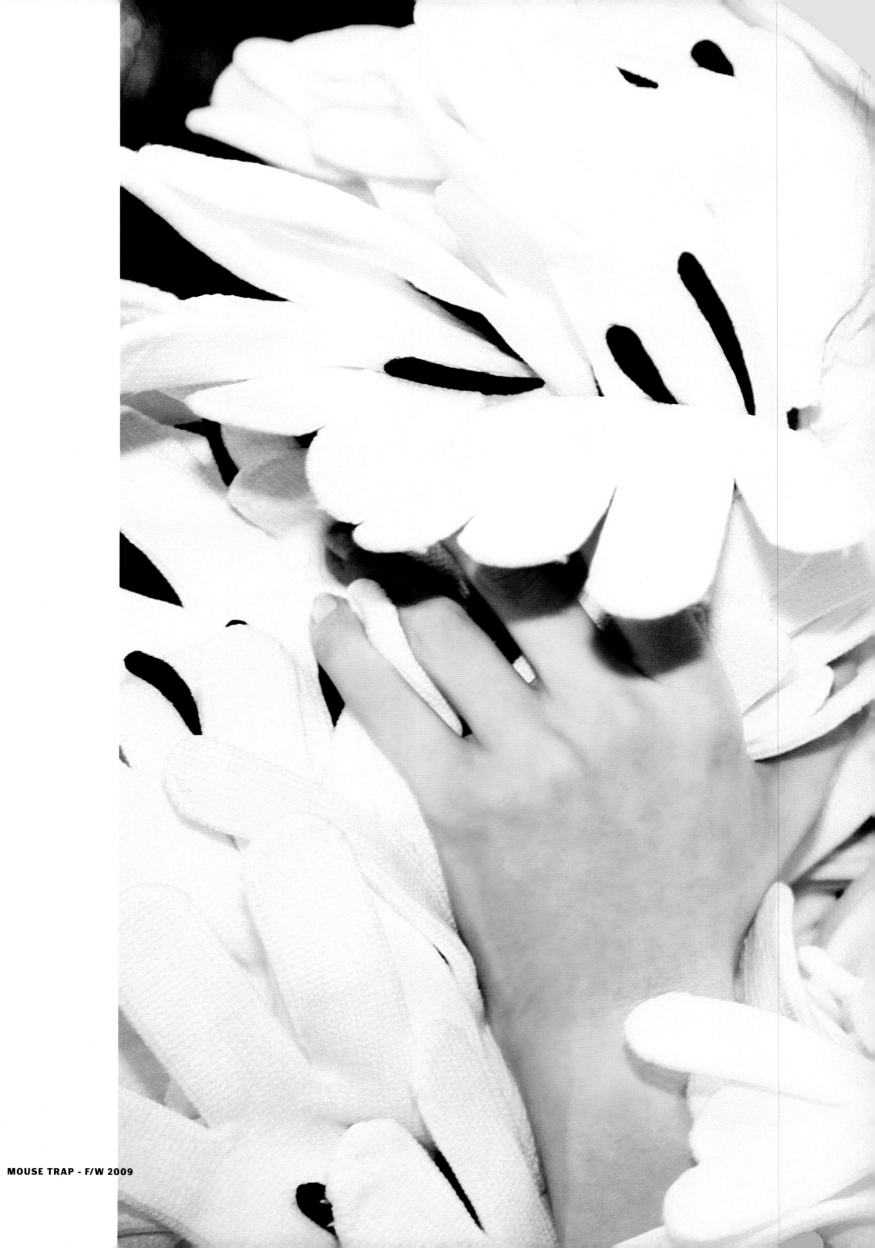

MOUSE TRAP - F/W 2009

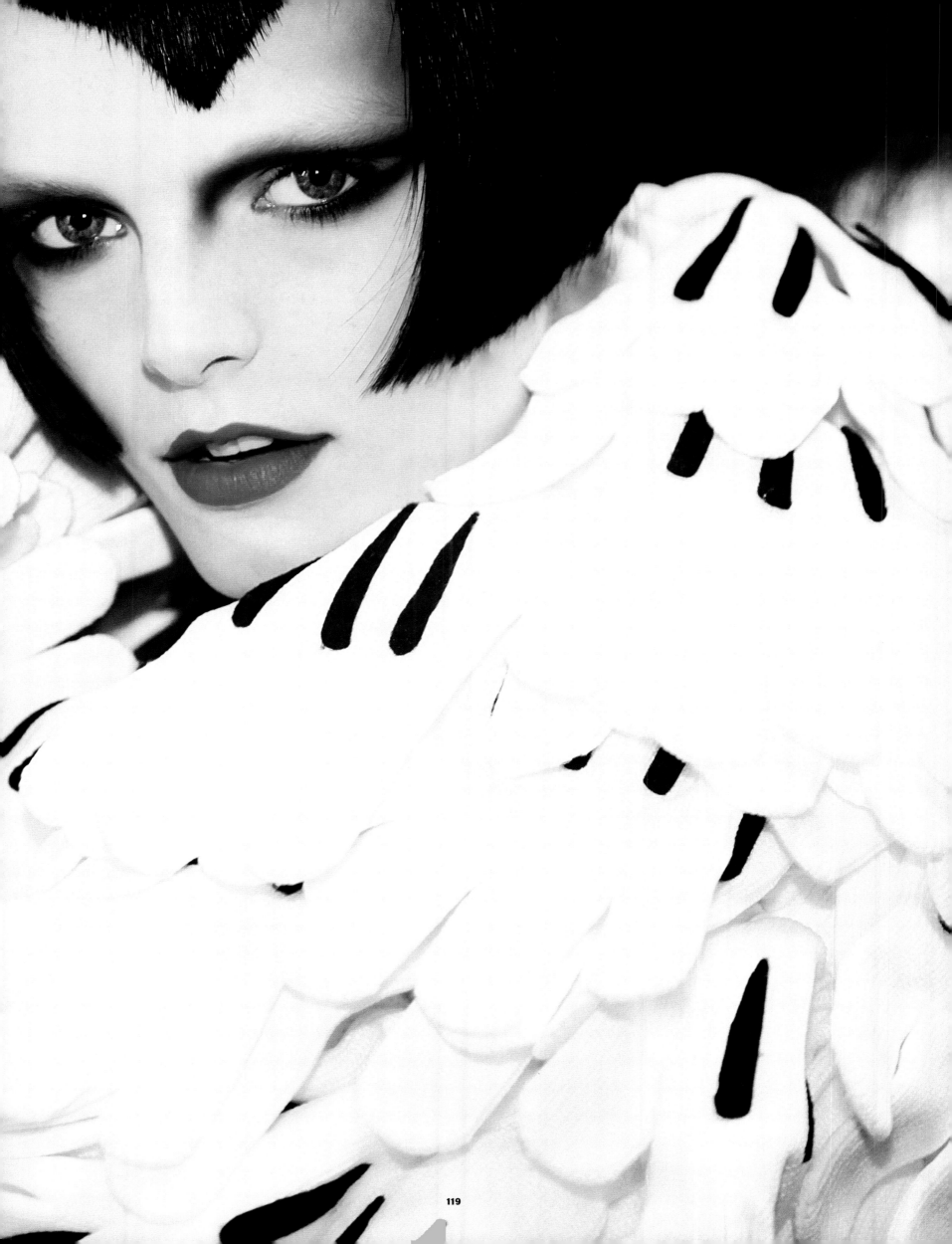

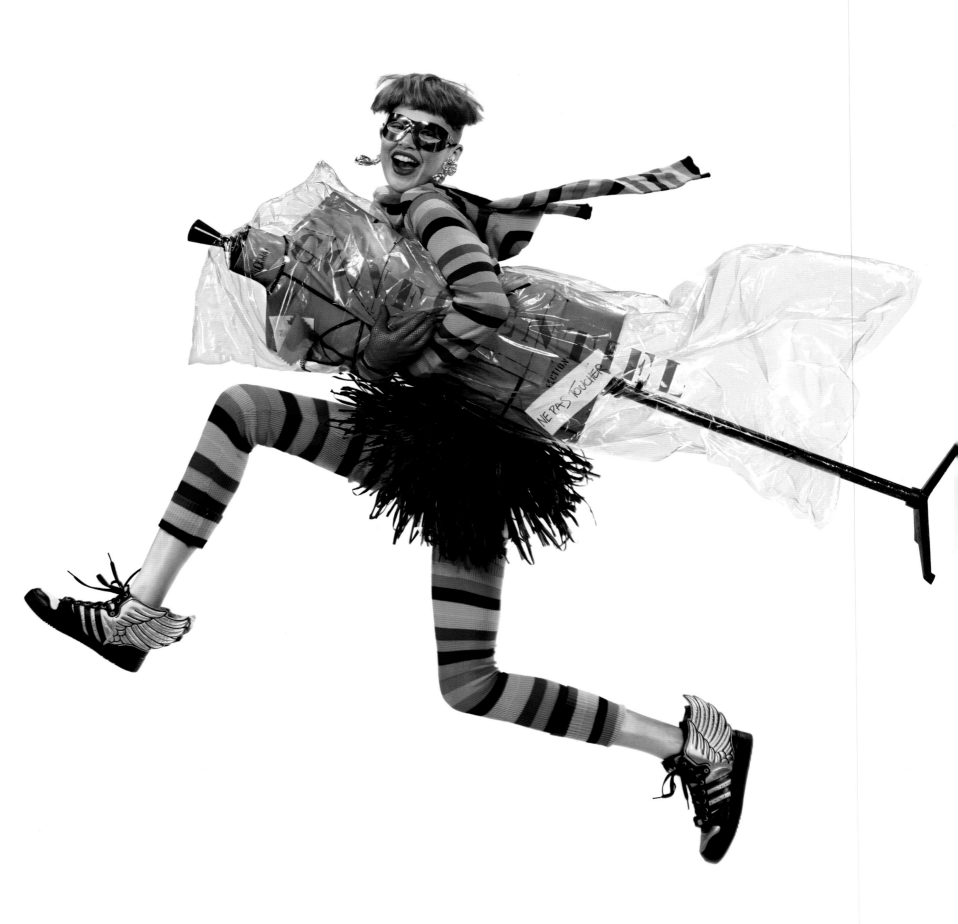

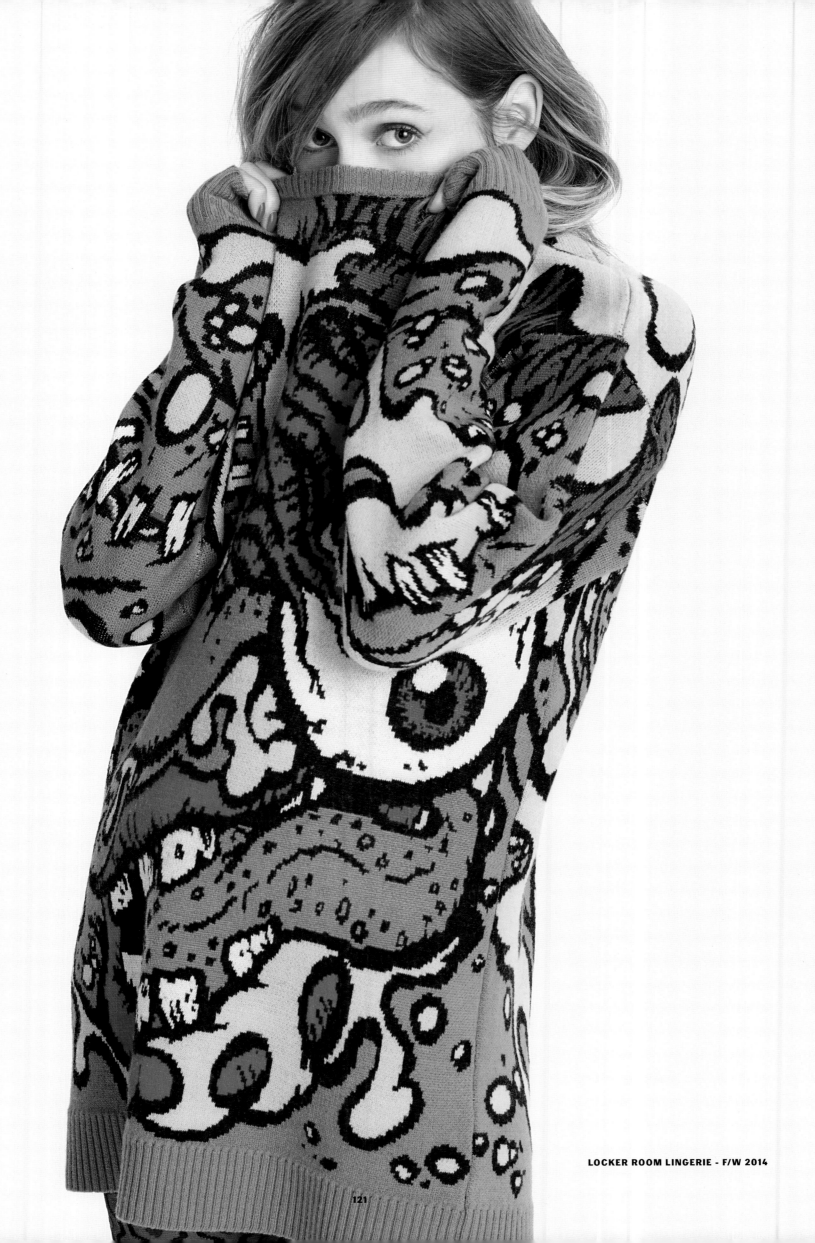

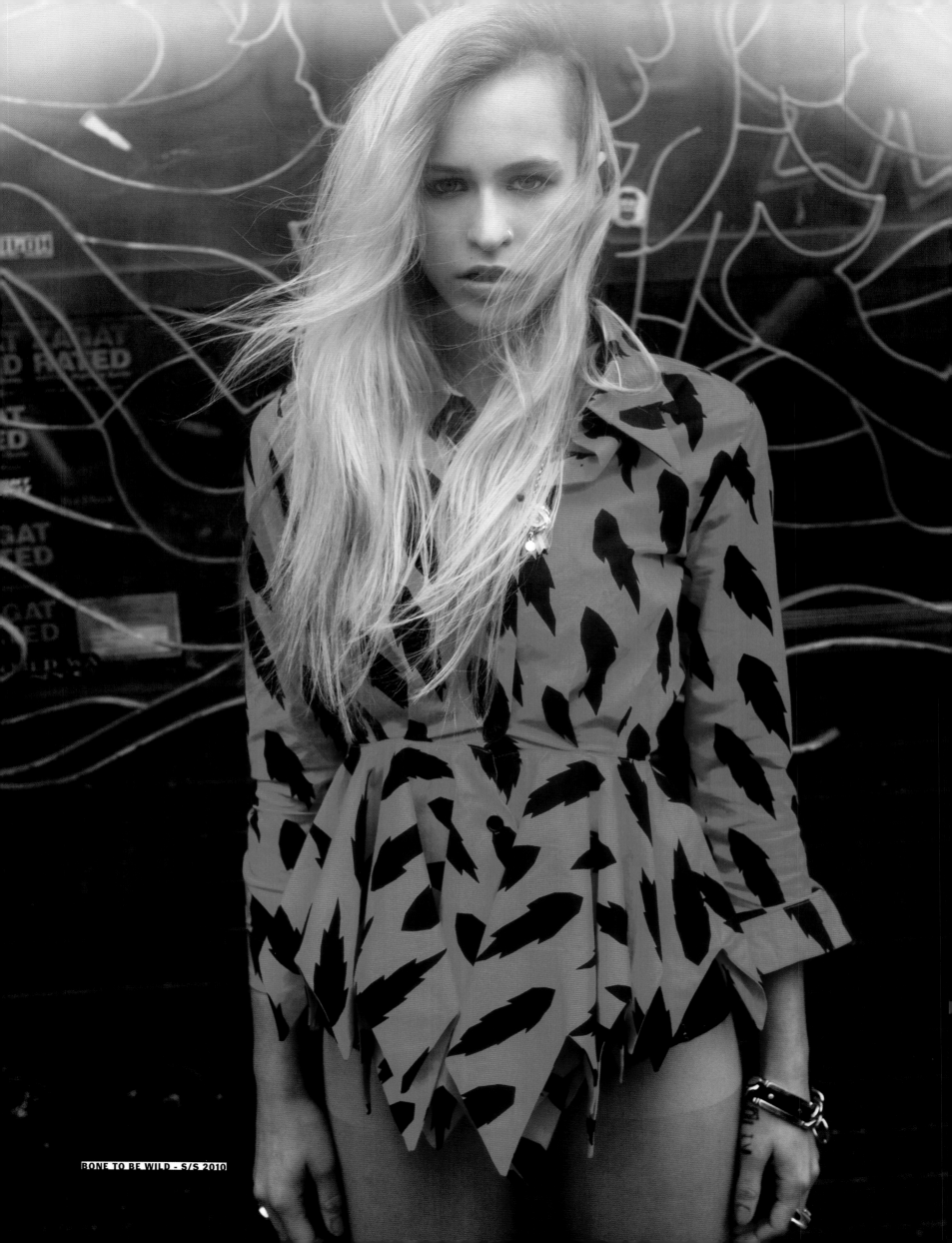

BONE TO BE WILD - S/S 2010

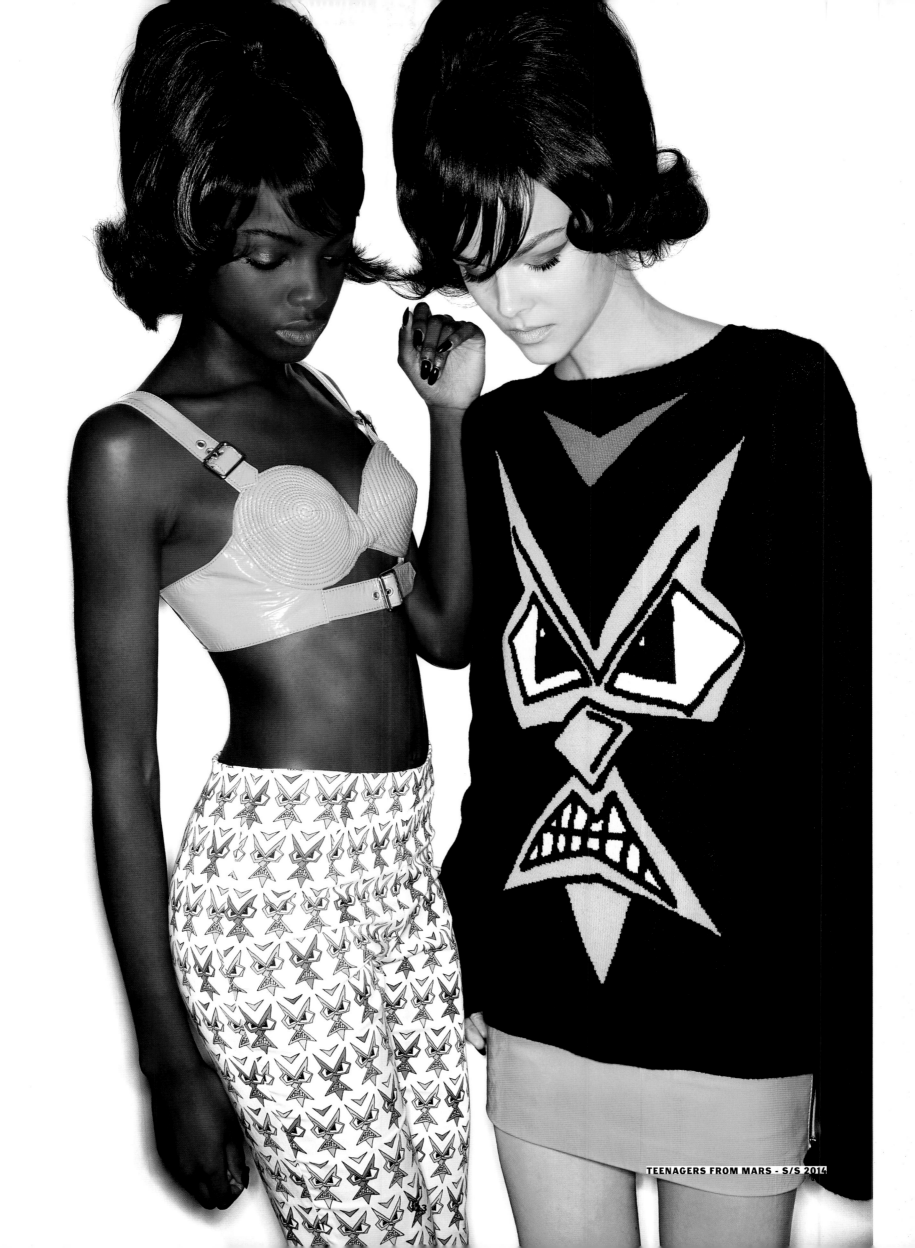

TEENAGERS FROM MARS - S/S 2014

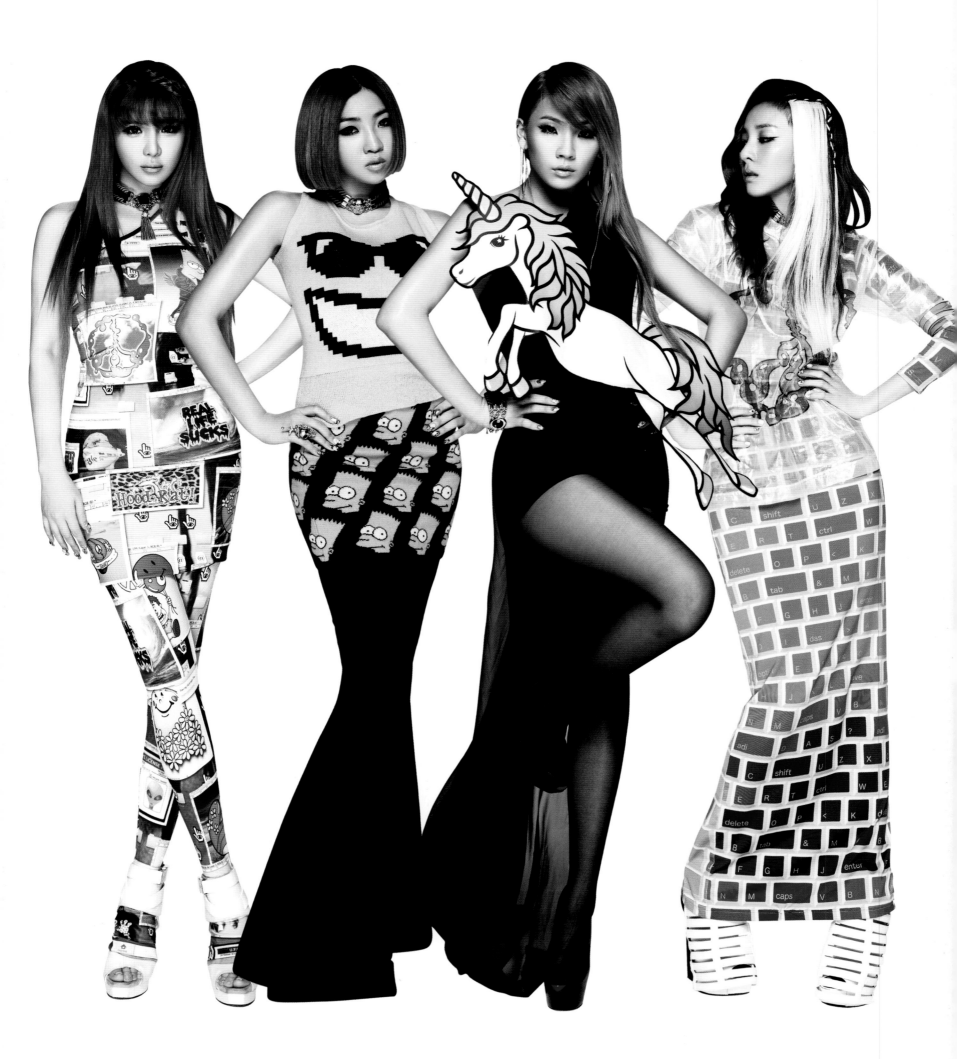

DELETE HISTORY - F/W 2012

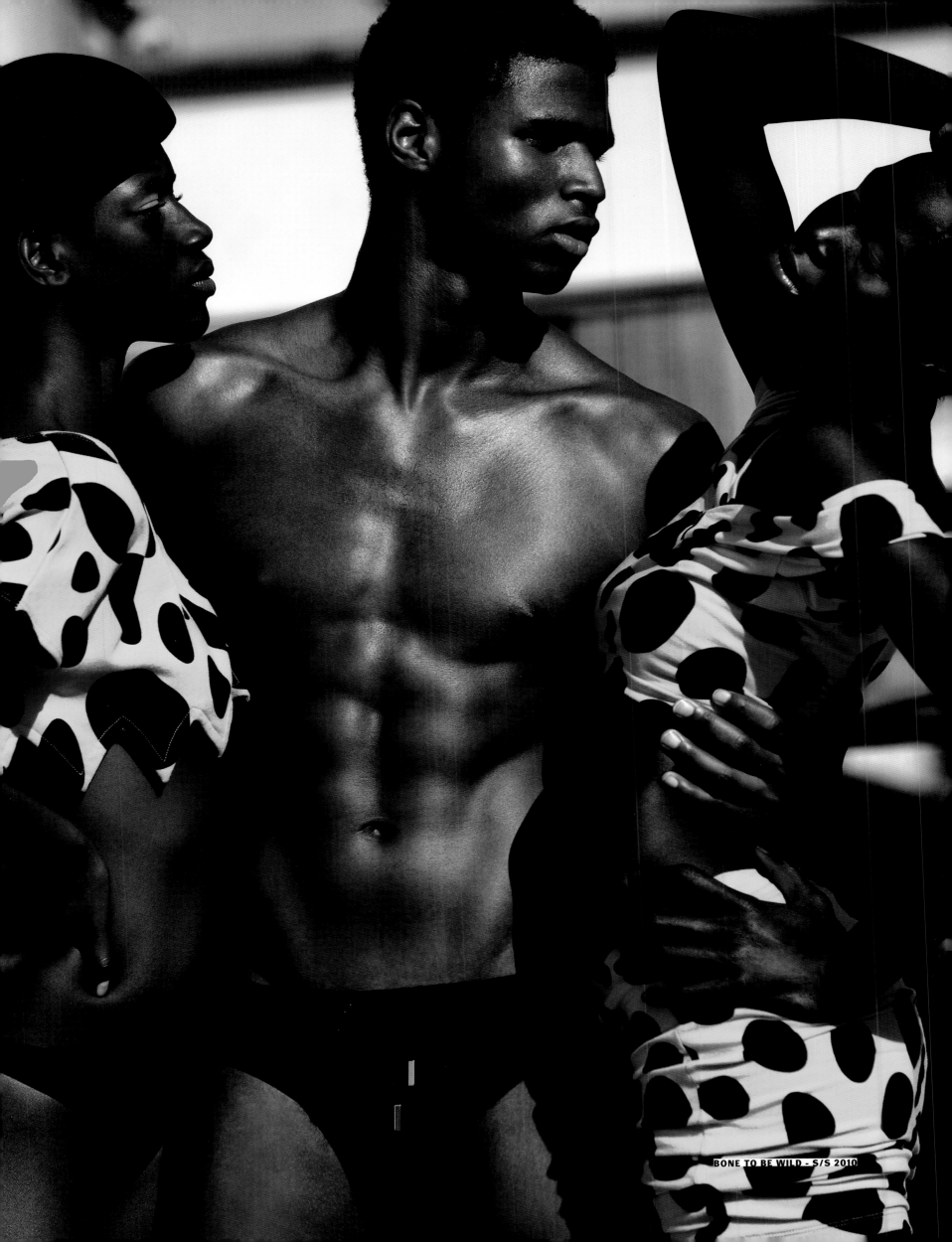

BONE TO BE WILD - S/S 2010

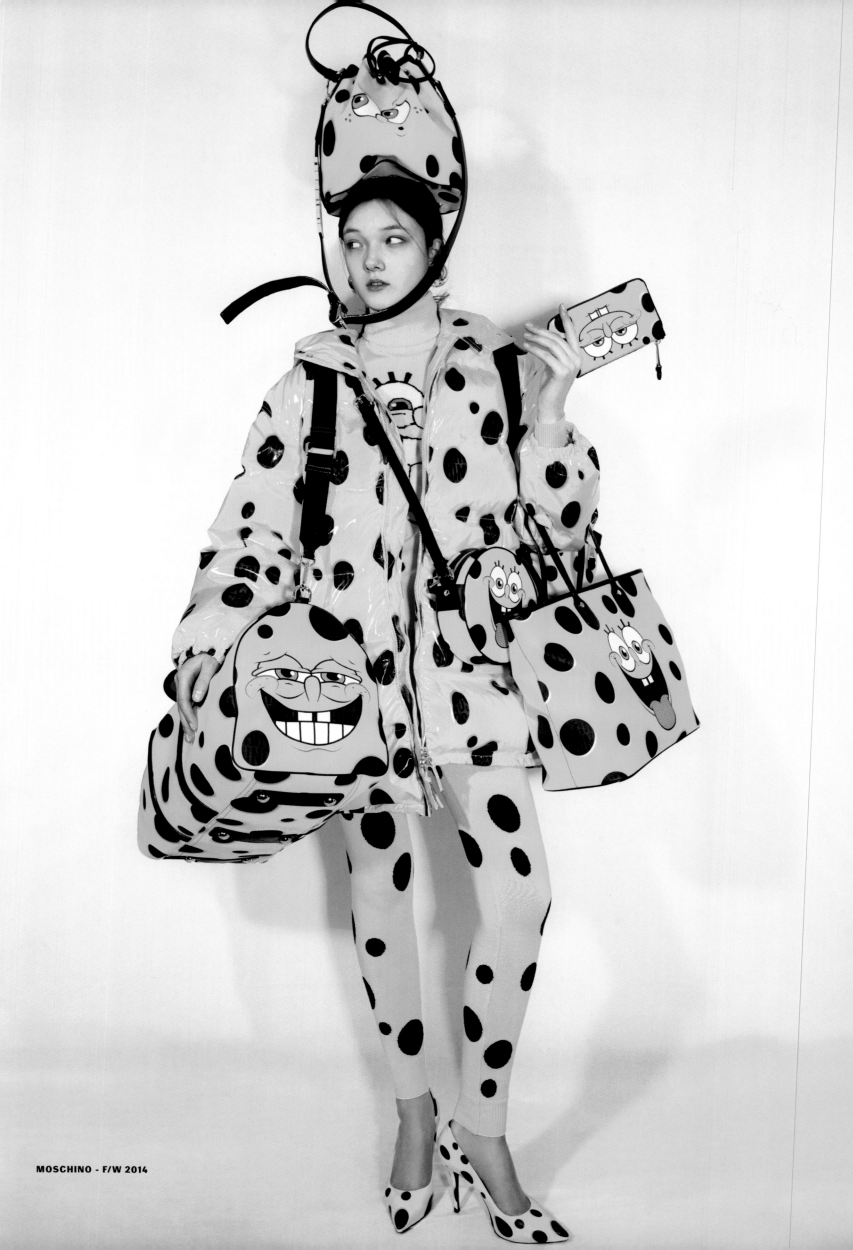

MOSCHINO - F/W 2014

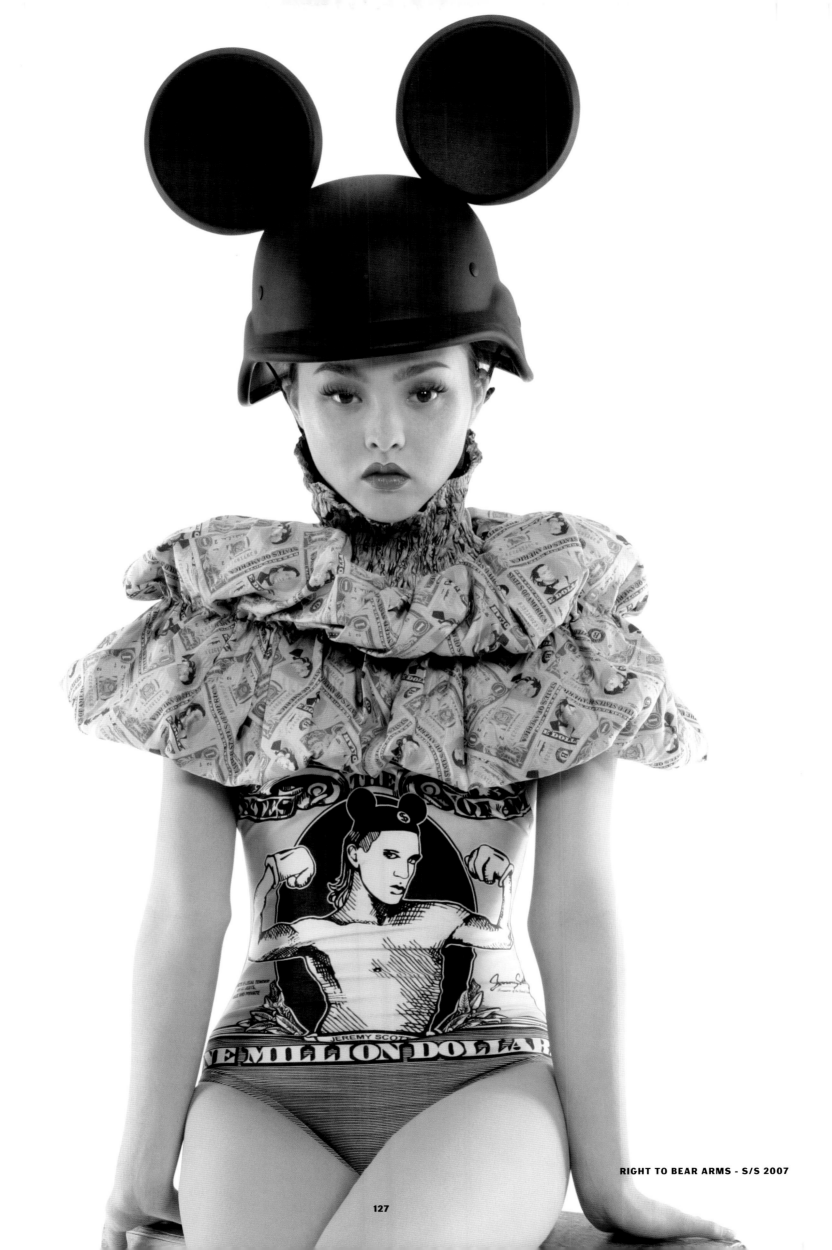

RIGHT TO BEAR ARMS - S/S 2007

127

MUSE INC.

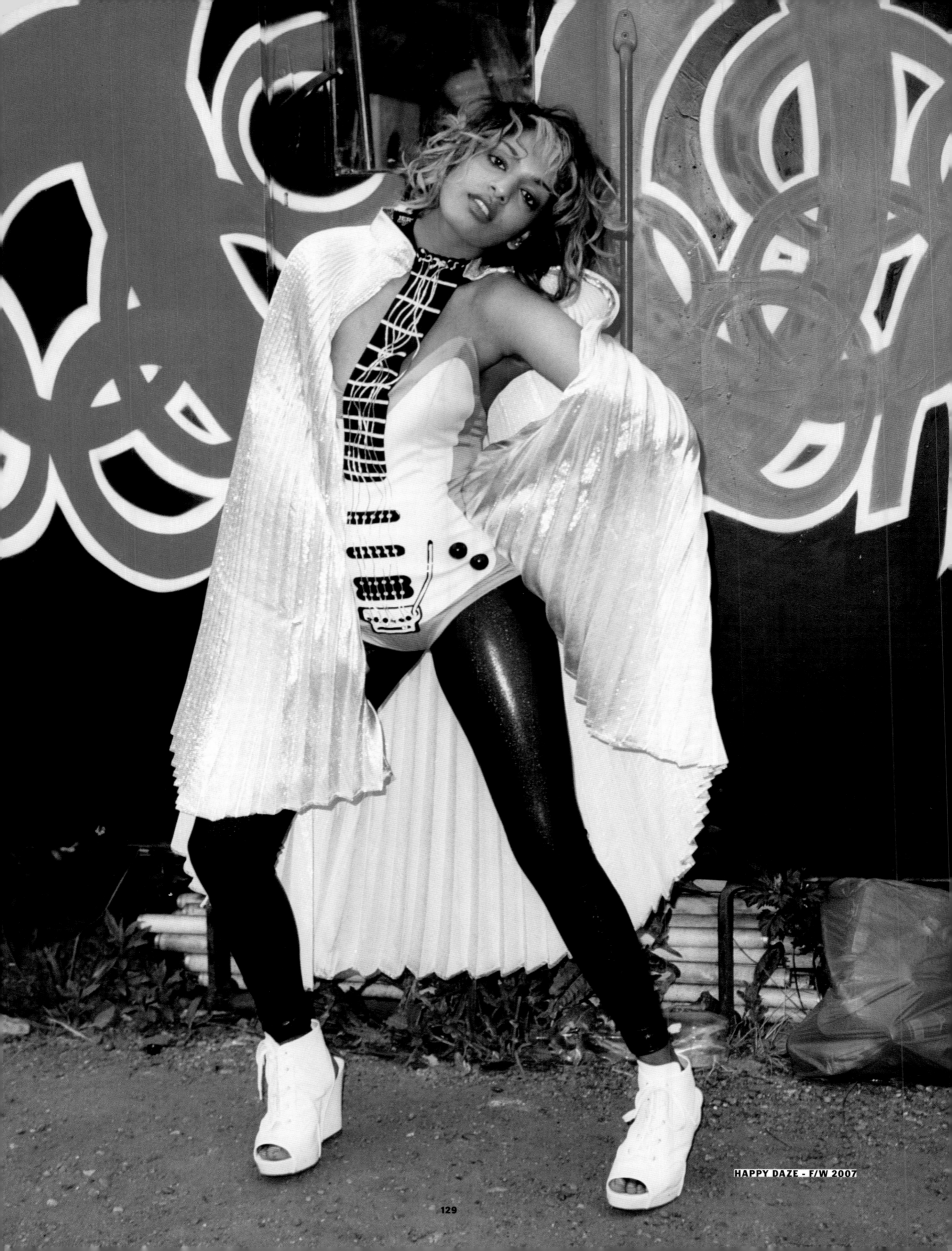

HAPPY DAZE - F/W 2007

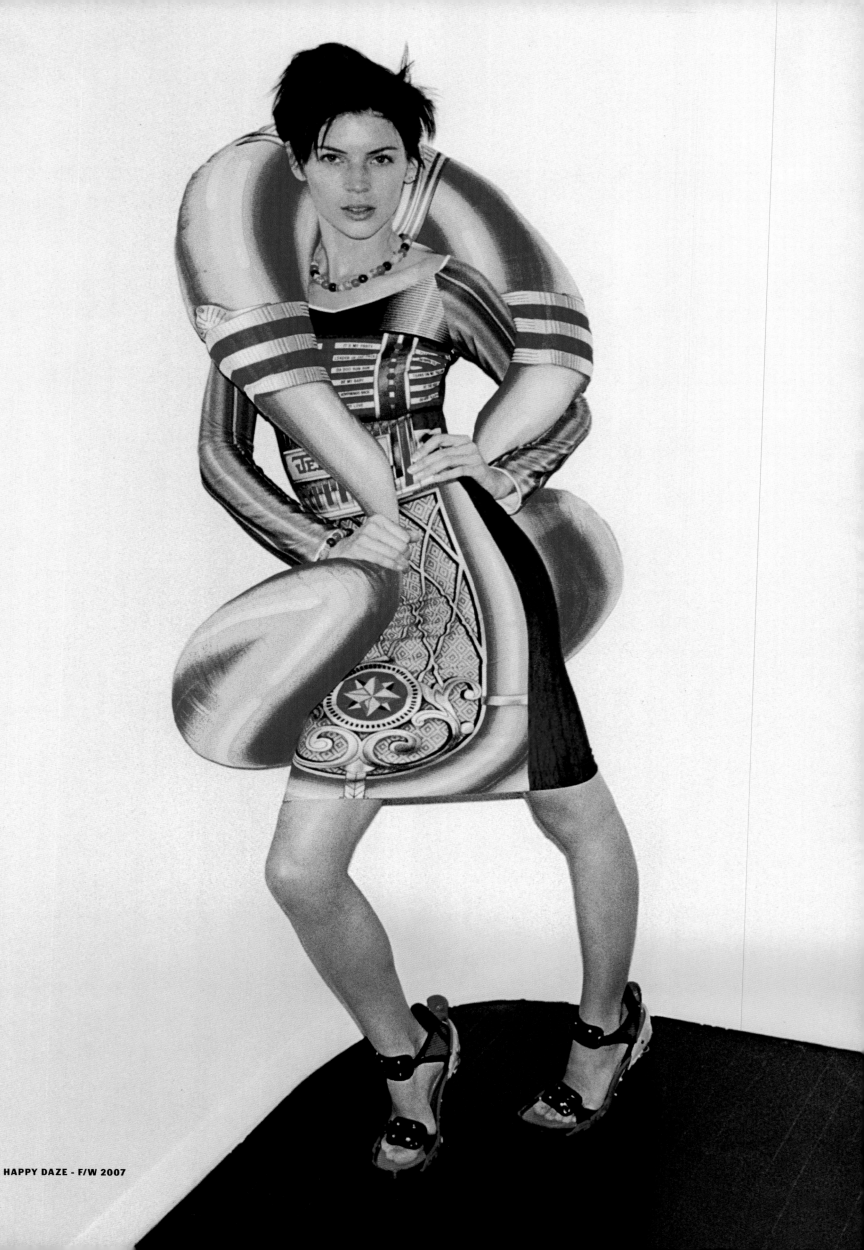

HAPPY DAZE - F/W 2007

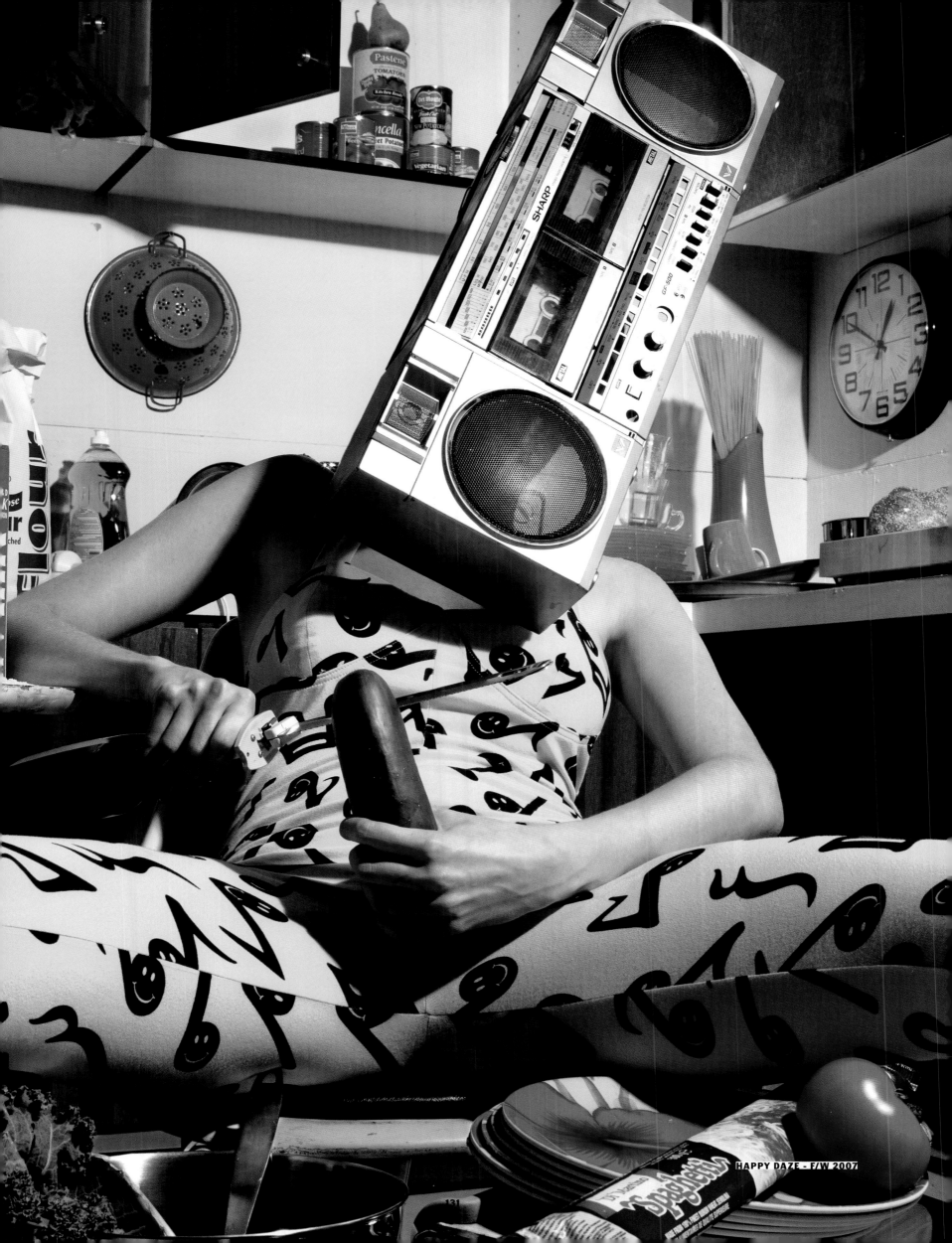

HAPPY DAZE – F/W 2007

131

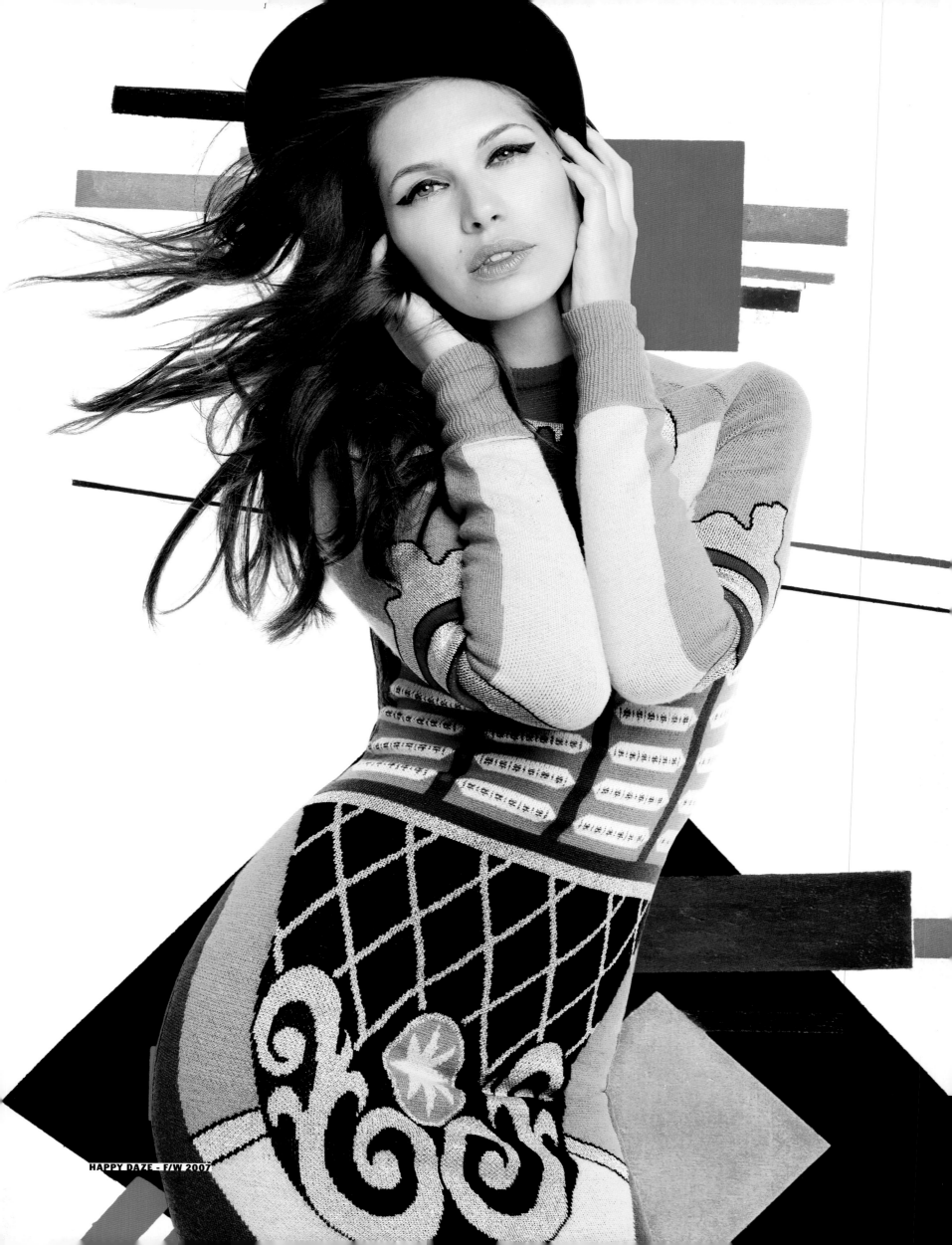

HAPPY DAZE - F/W 2007

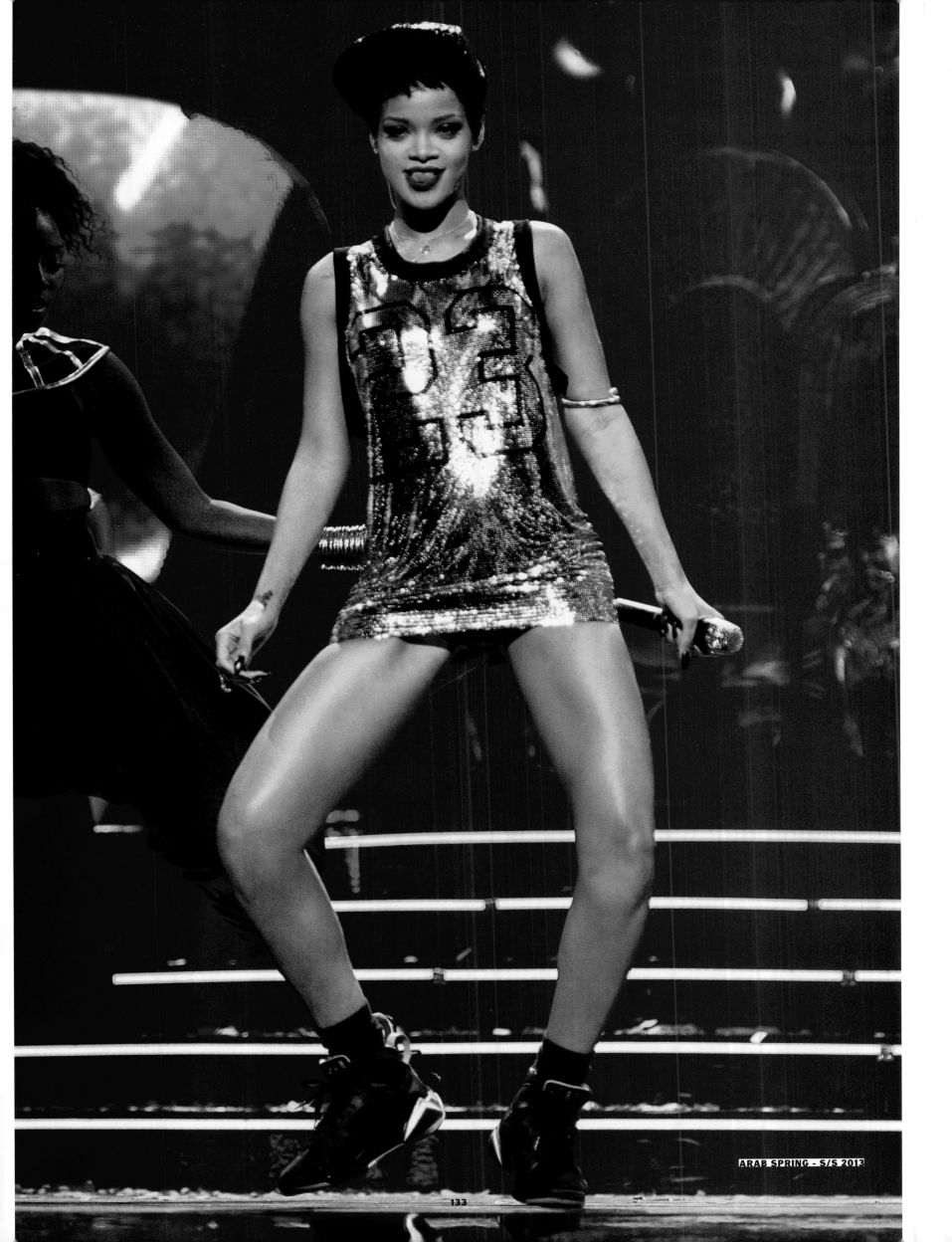

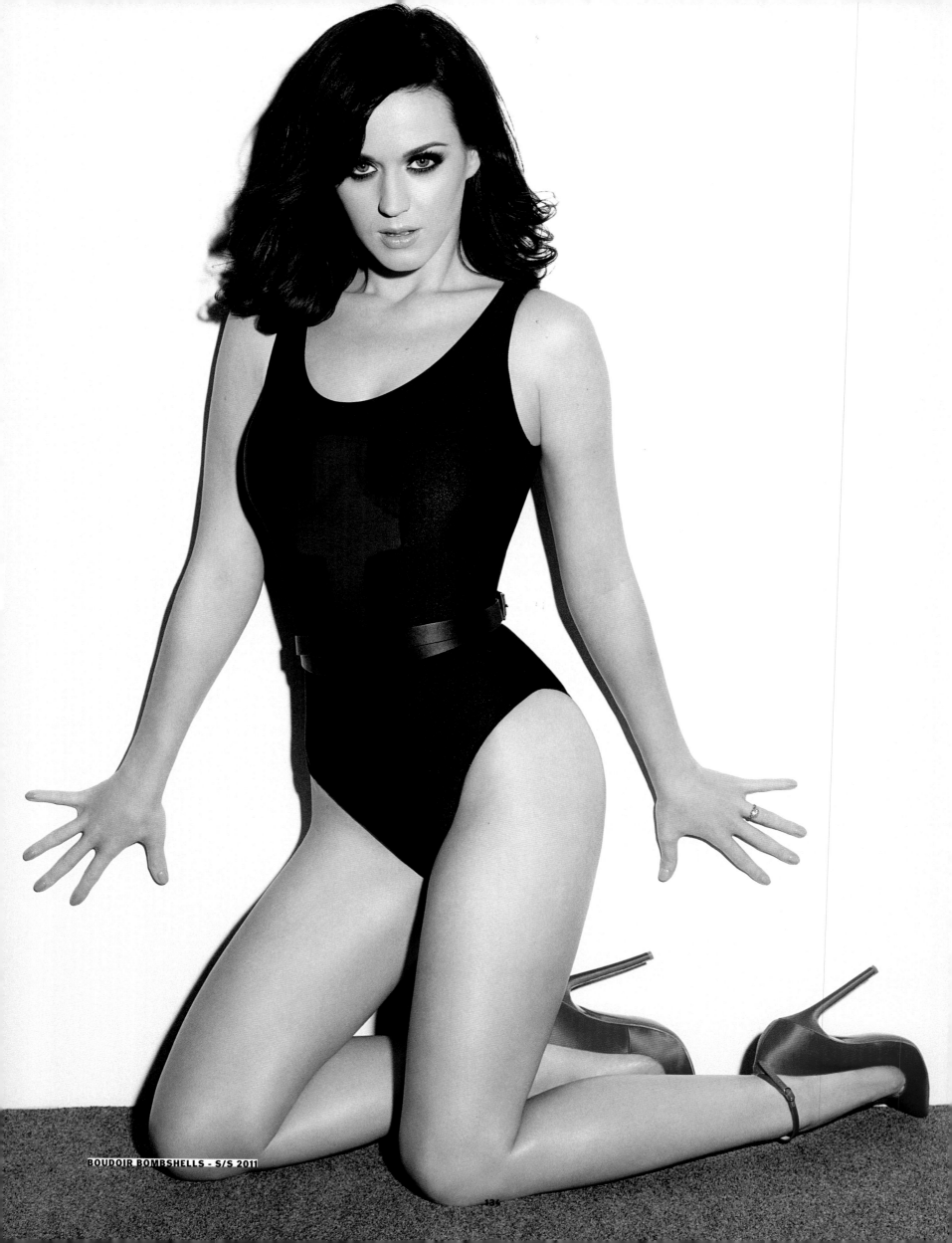

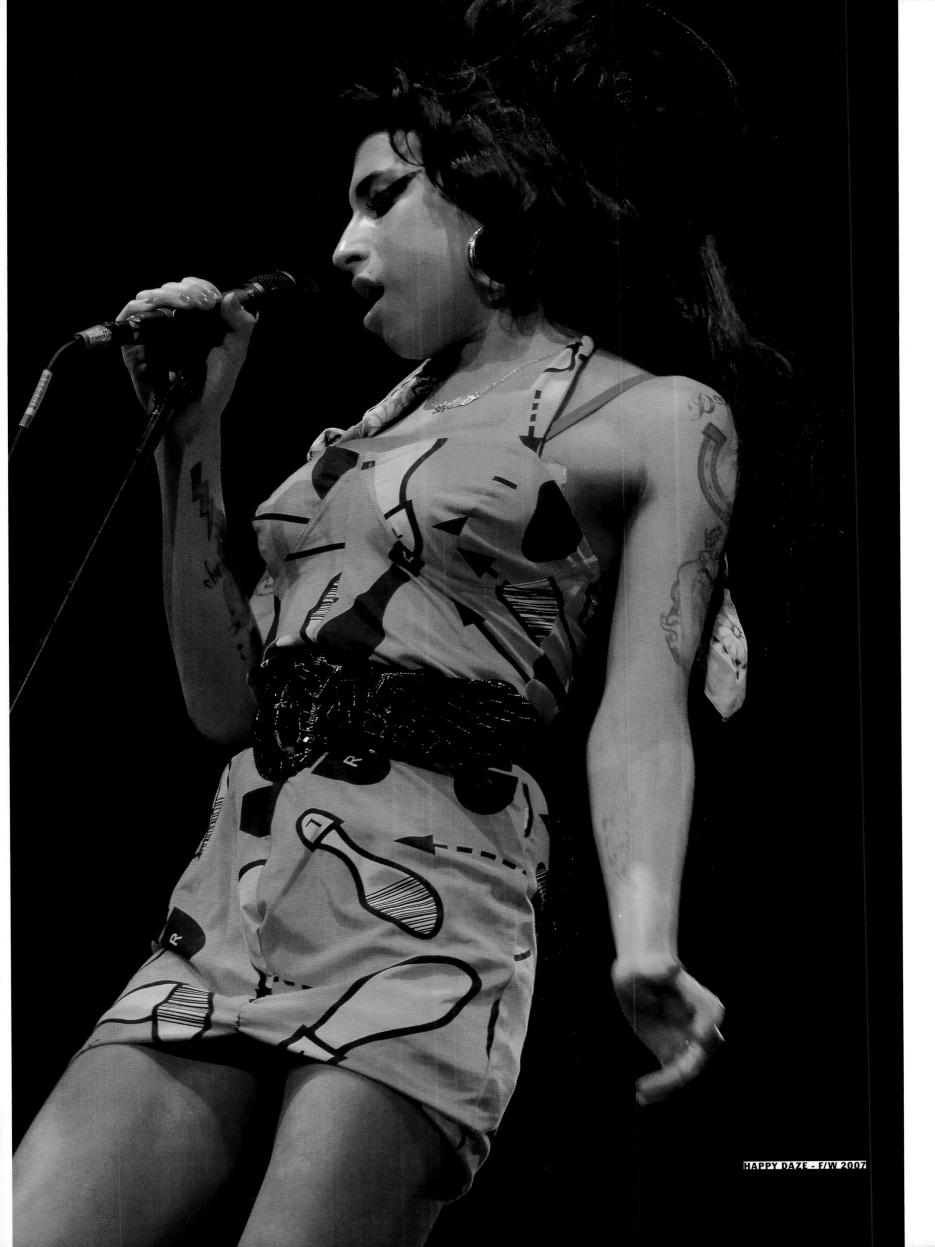

HAPPY DAZE - F/W 2007

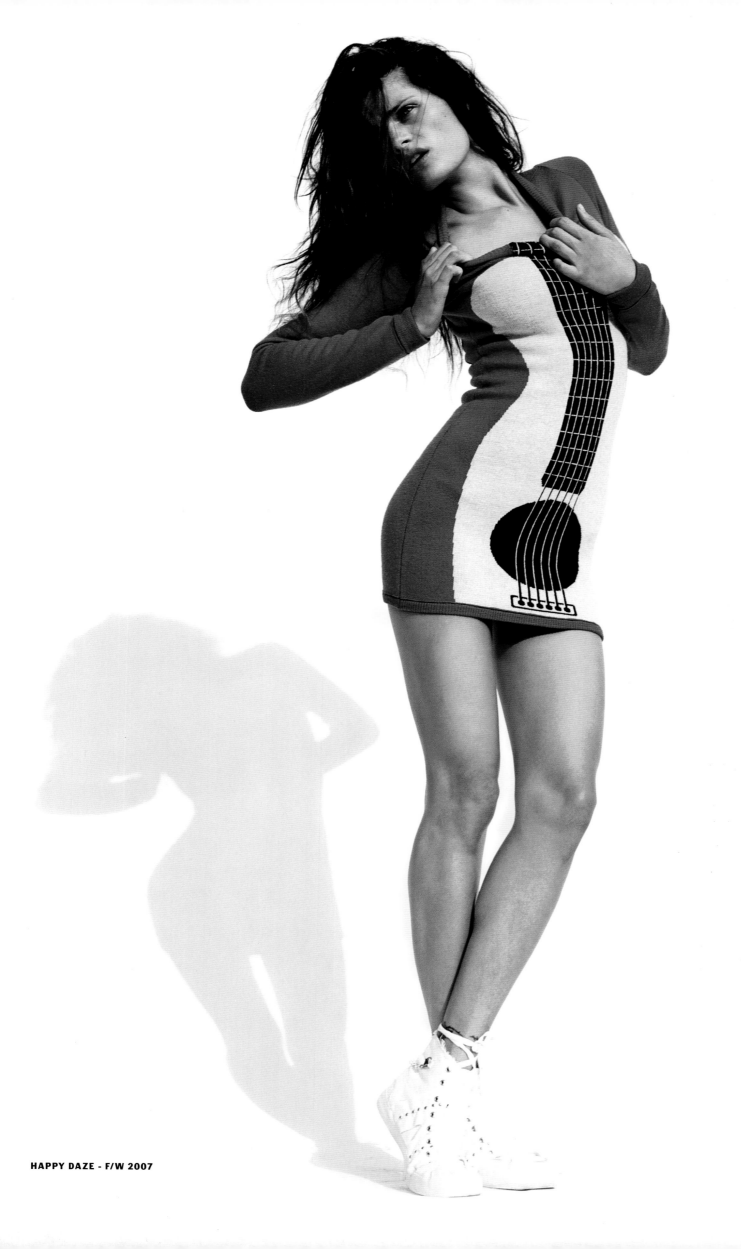

HAPPY DAZE - F/W 2007

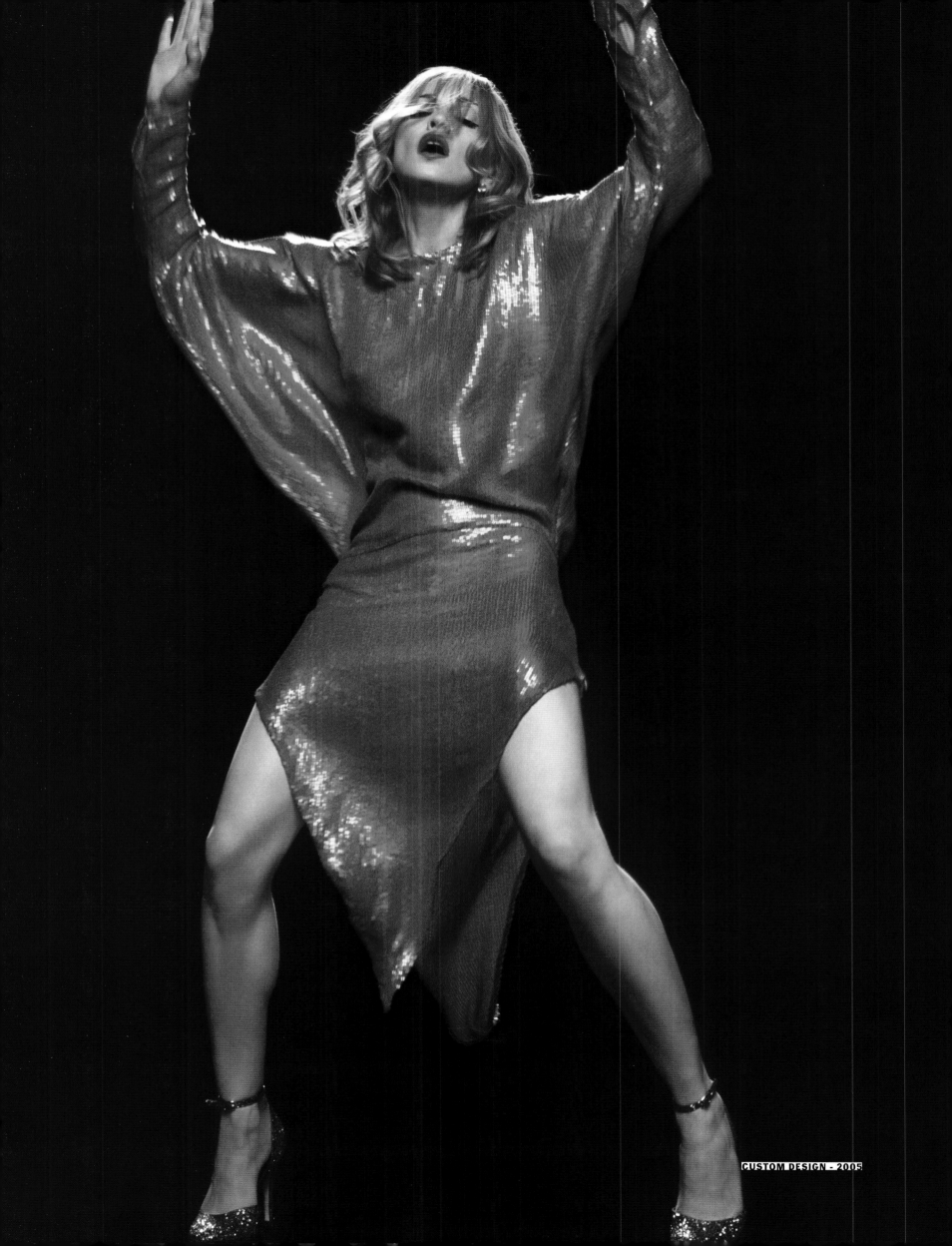

CUSTOM DESIGN - 2005

SPORTS
WHERE

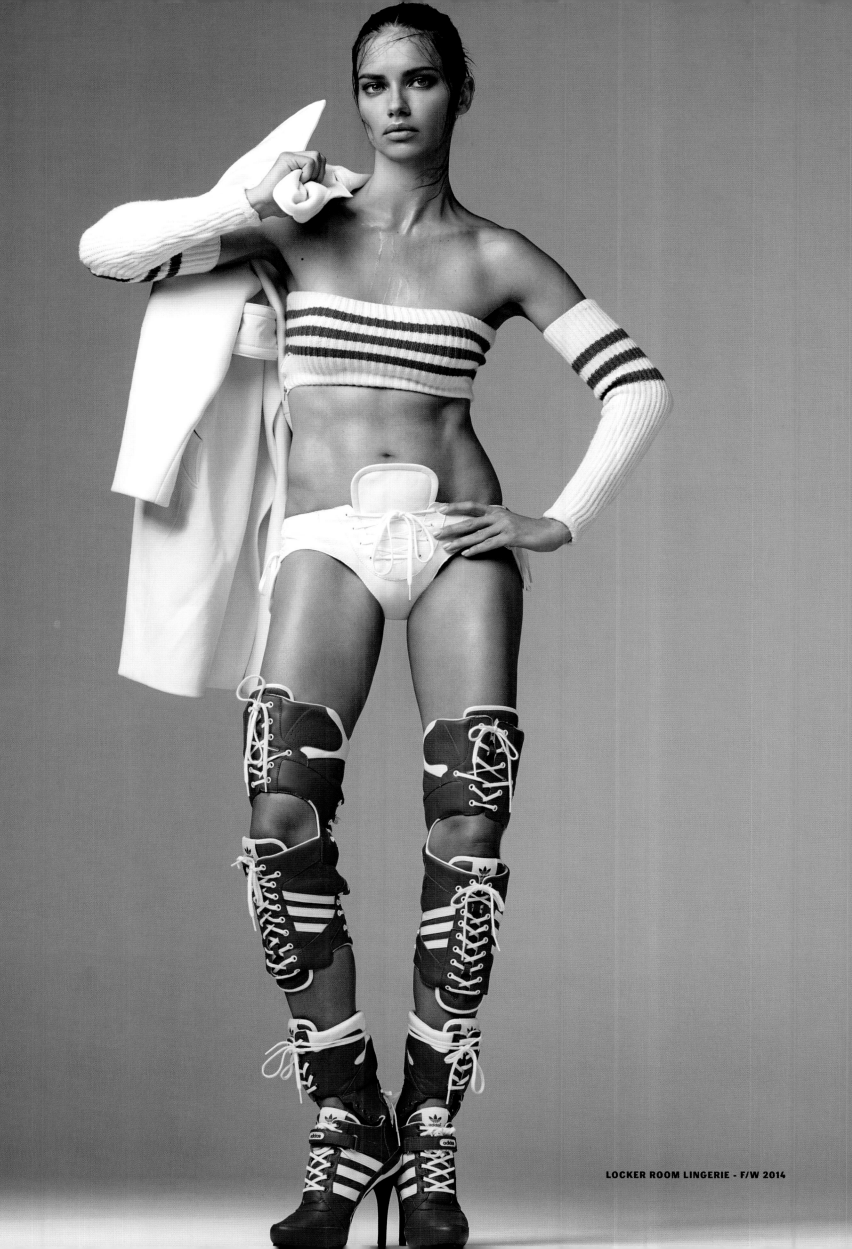

LOCKER ROOM LINGERIE - F/W 2014

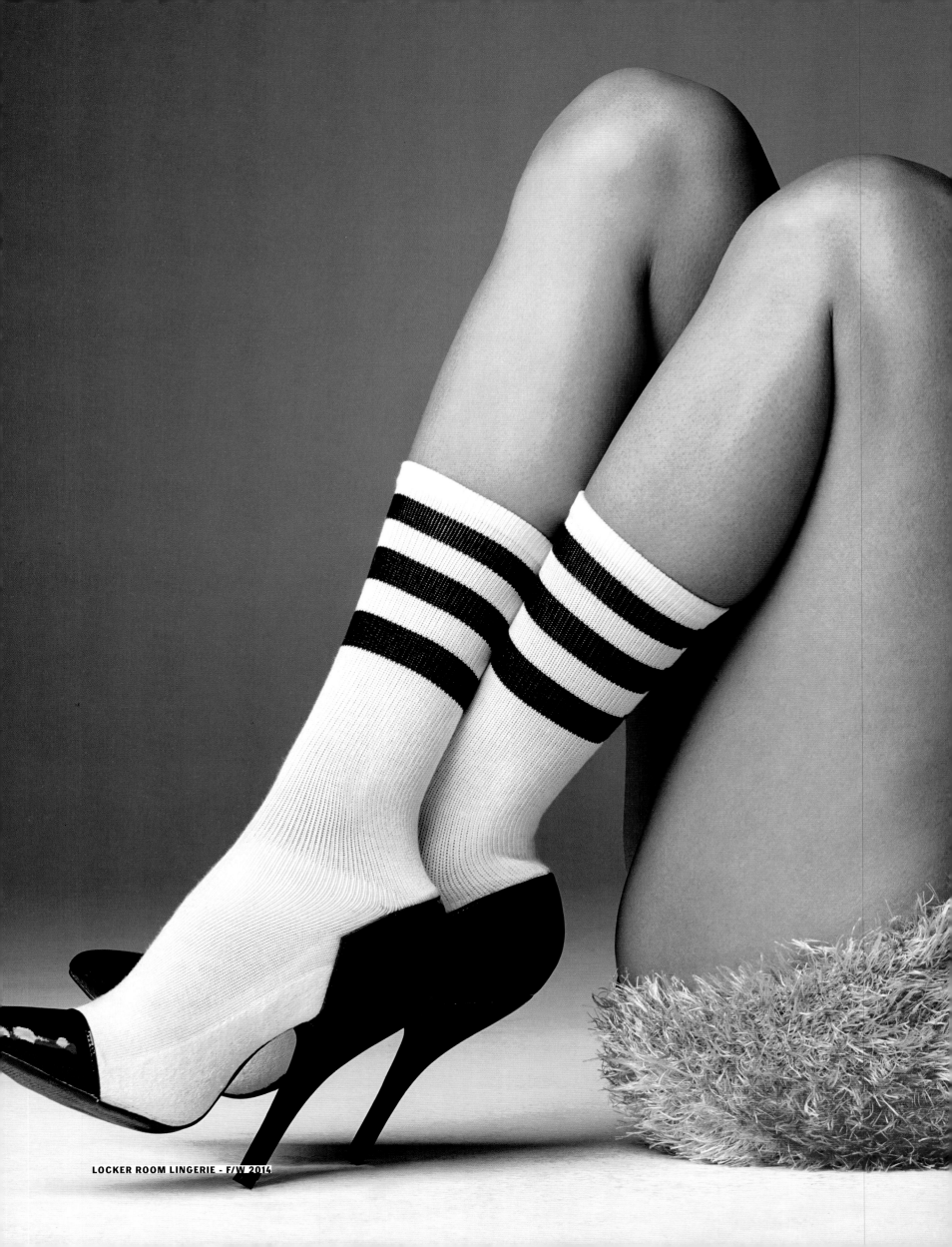

LOCKER ROOM LINGERIE - F/W 2014

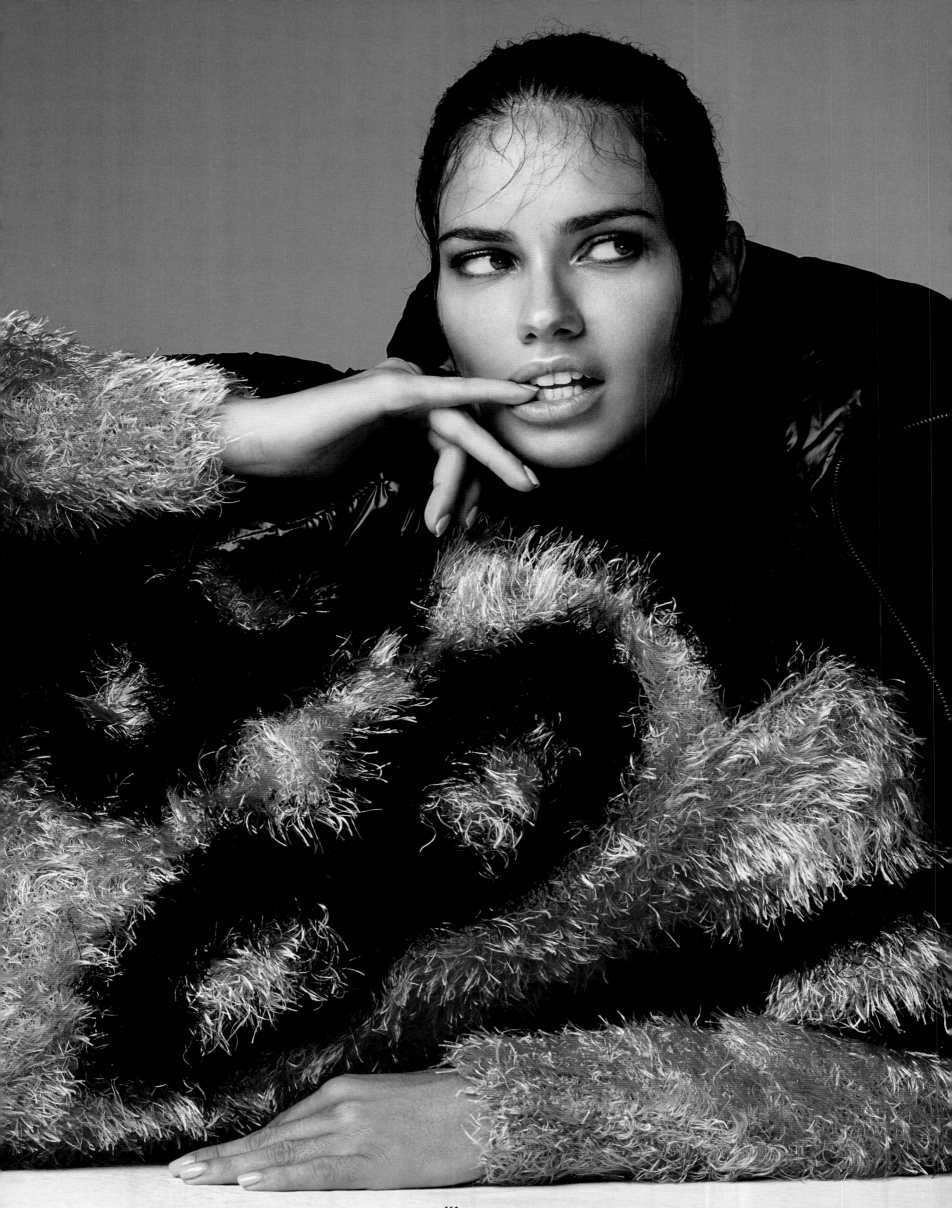

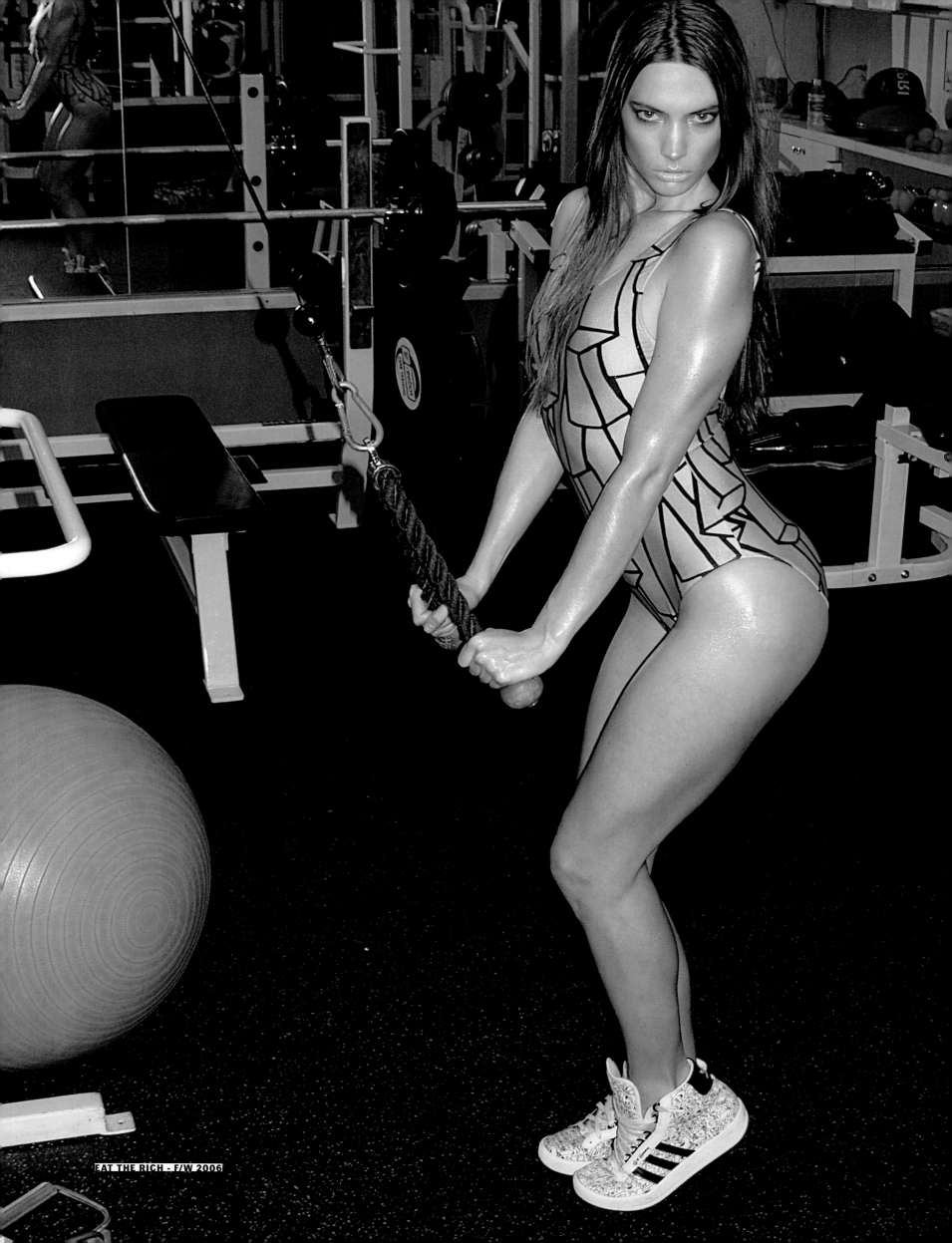

EAT THE RICH - F/W 2006

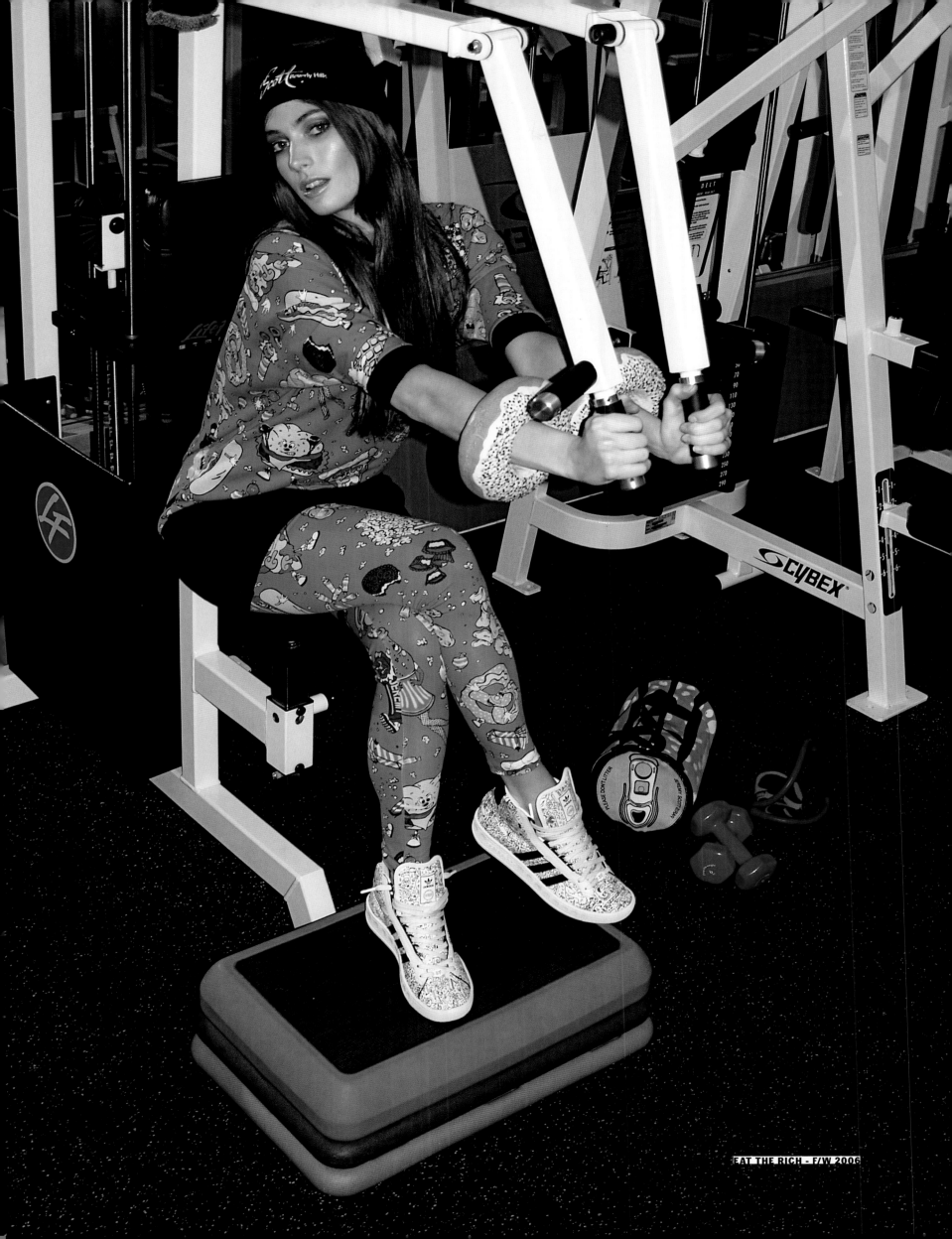

EAT THE RICH - F/W 2006

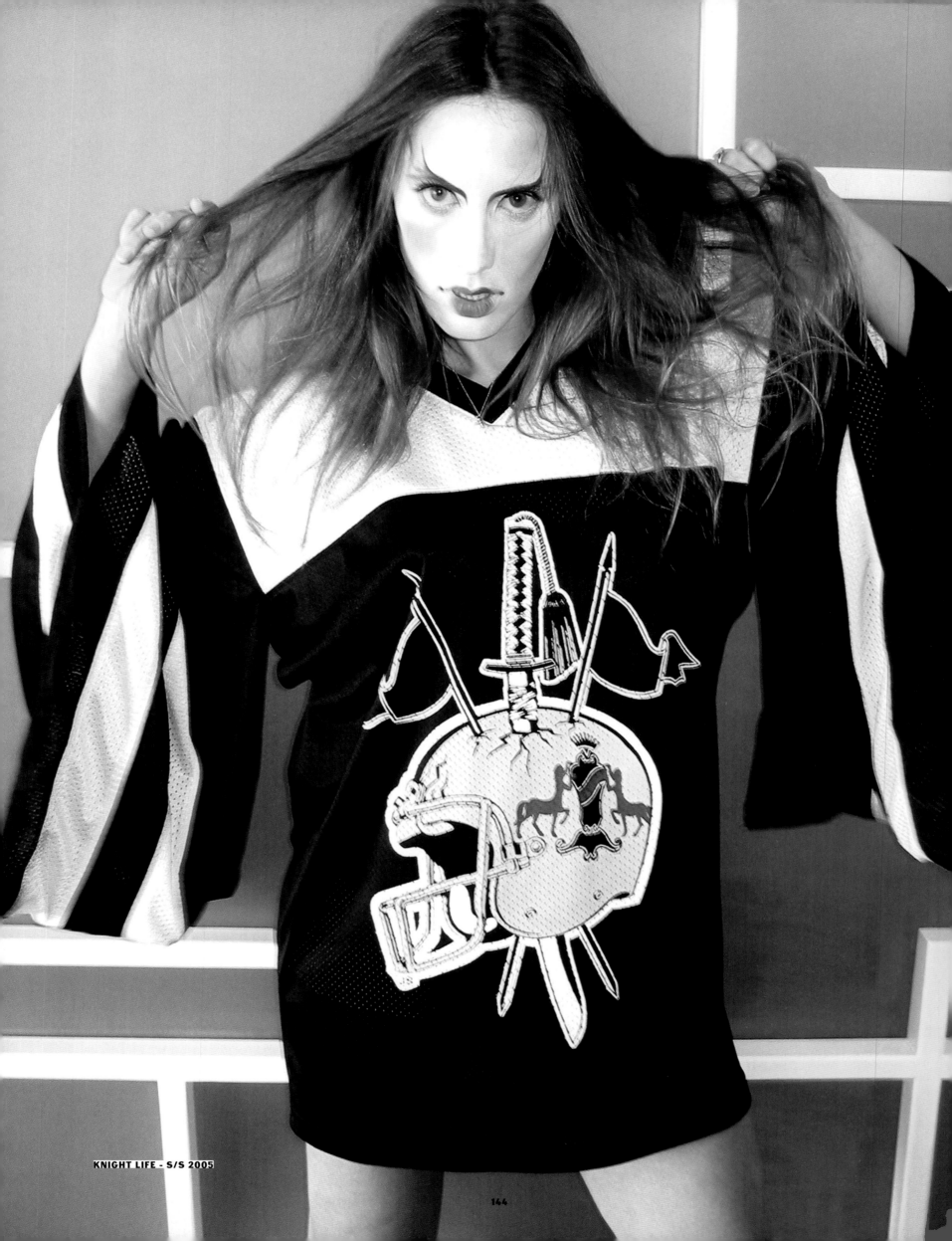

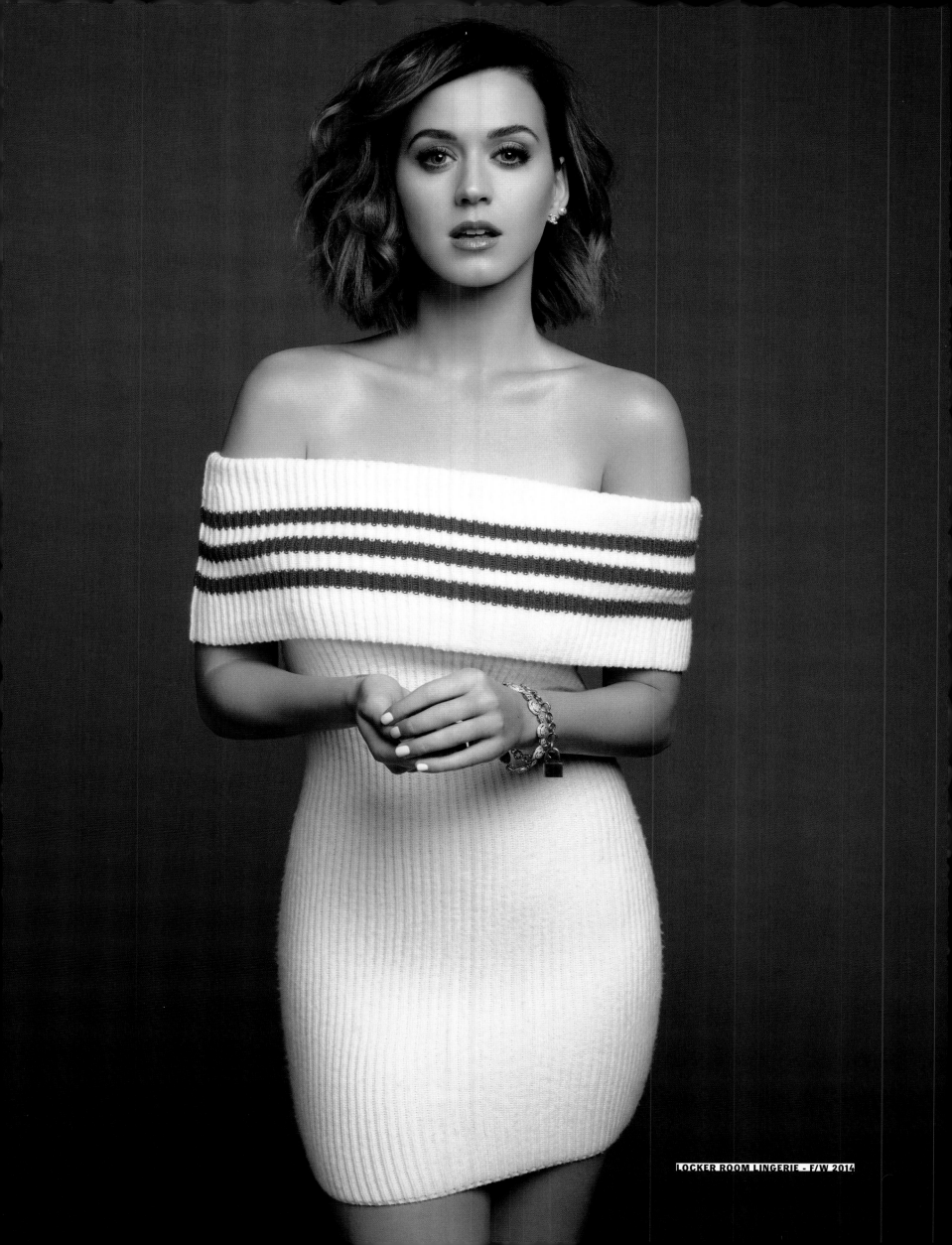

LOCKER ROOM LINGERIE - F/W 2014

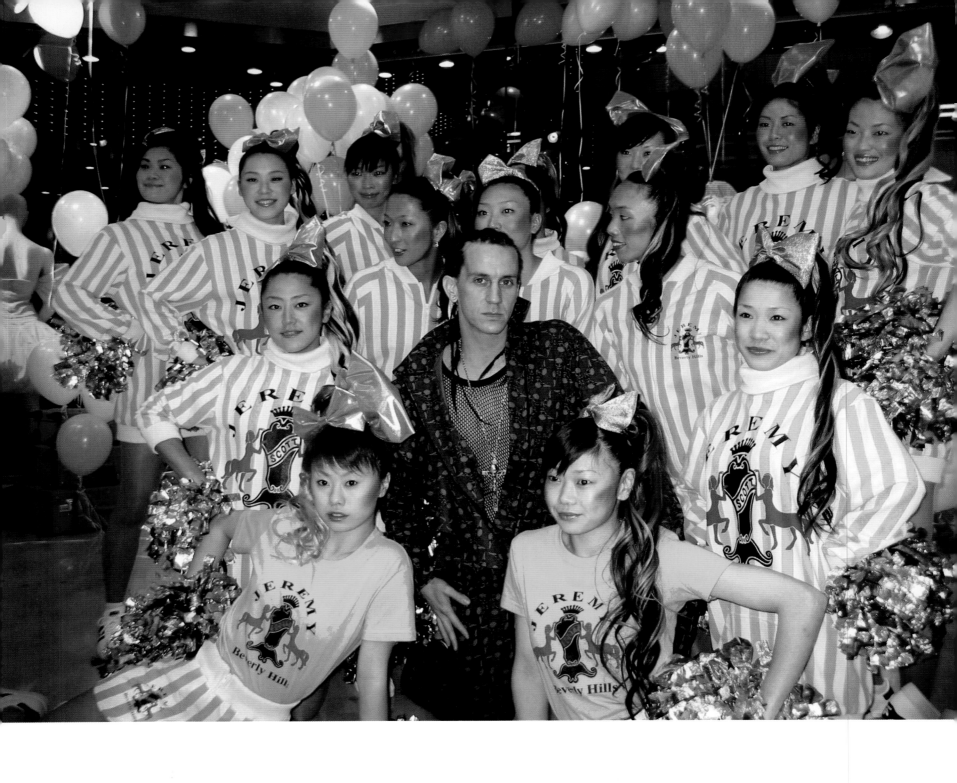

TEAM SPIRIT - F/W 2004

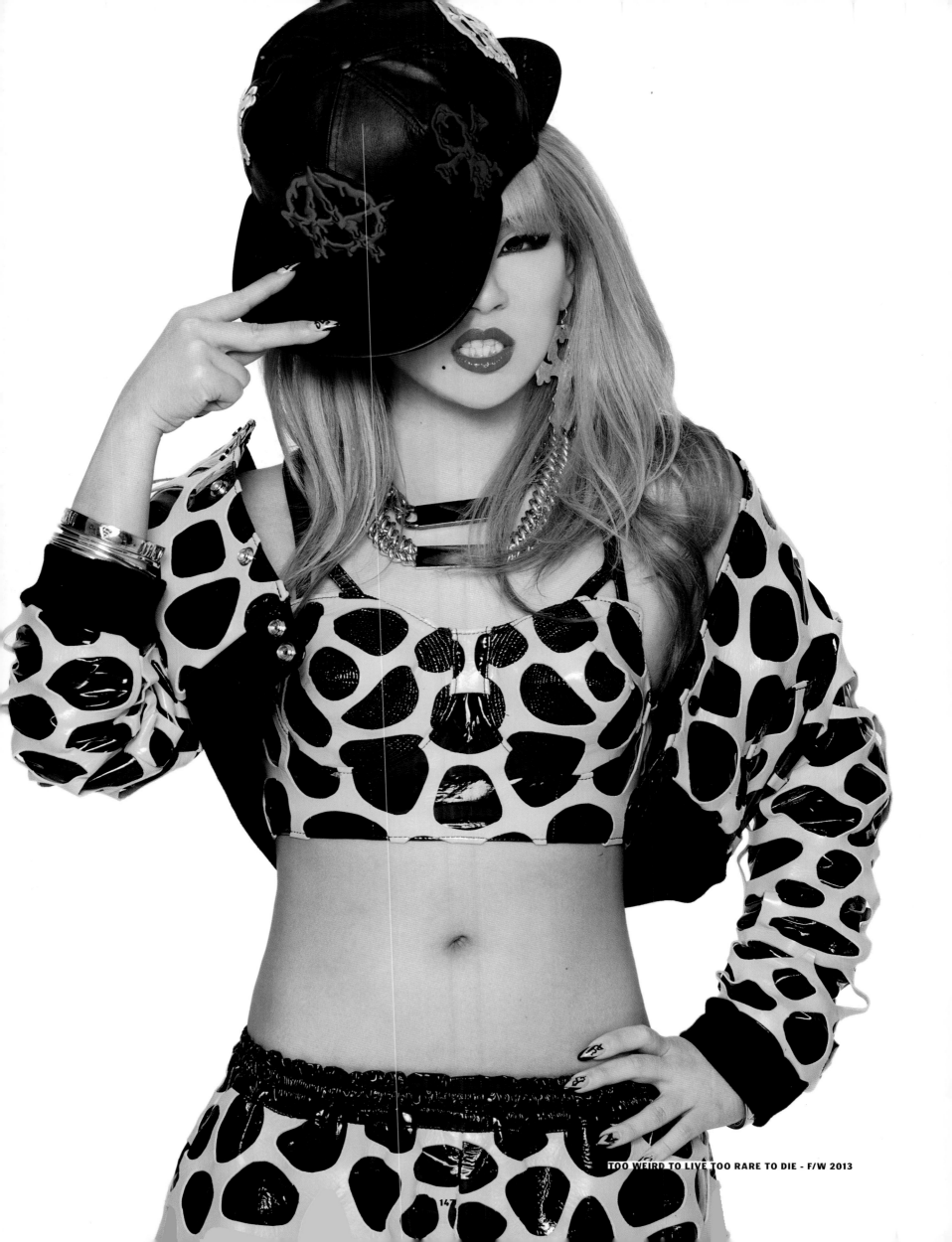

TOO WEIRD TO LIVE TOO RARE TO DIE - F/W 2013

147

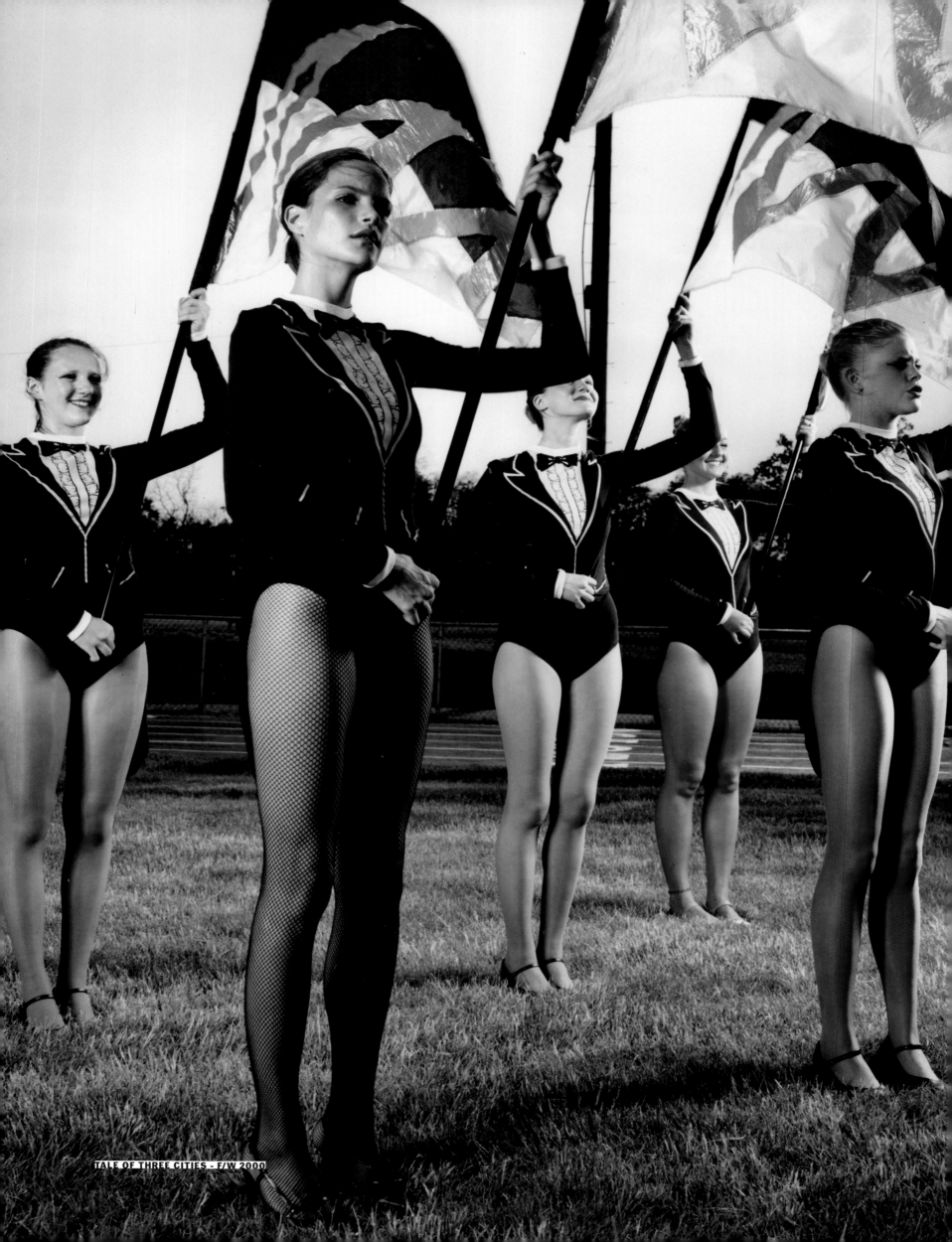

TALE OF THREE CITIES - F/W 2000

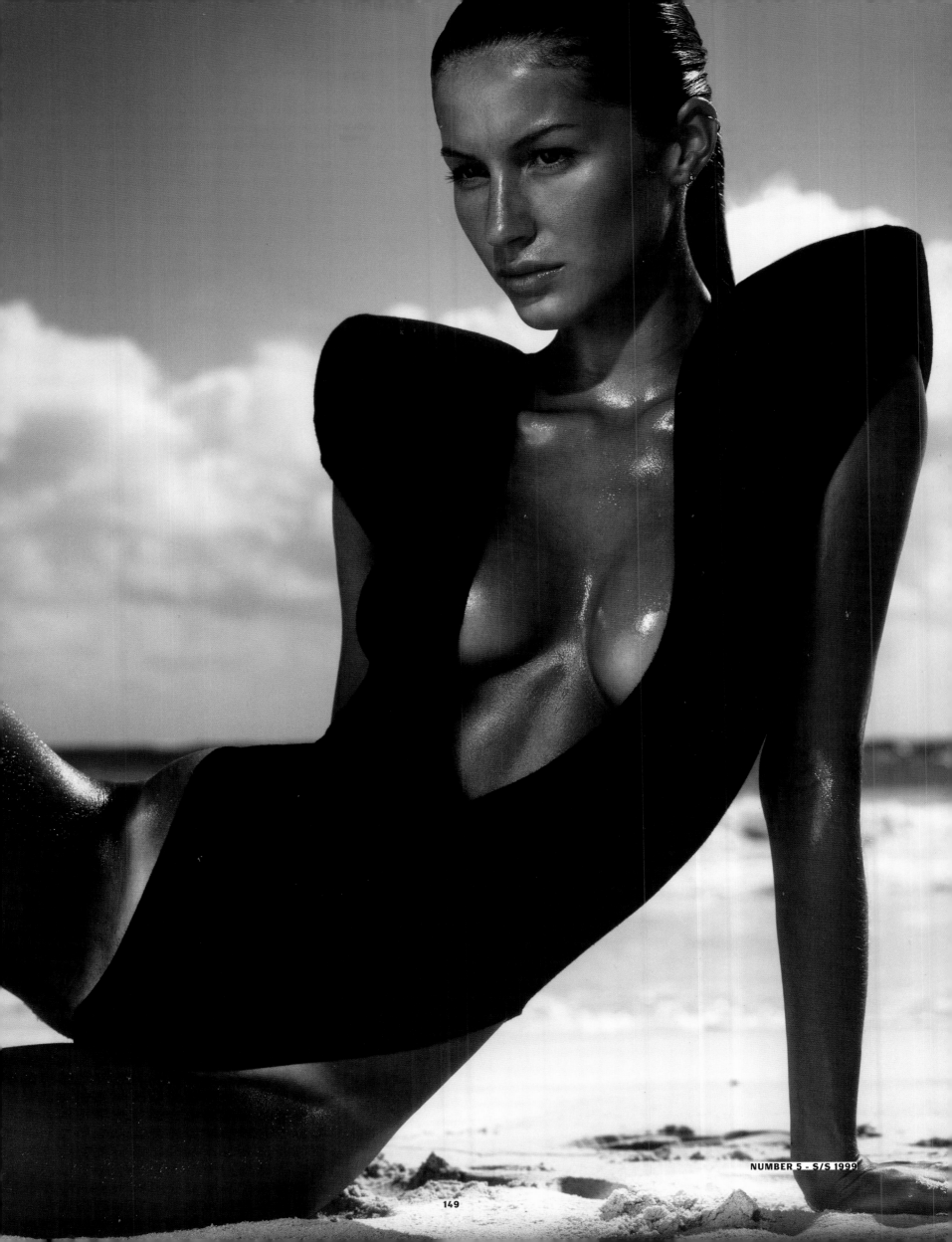

NUMBER 5 - S/S 1999

150

SUR REAL

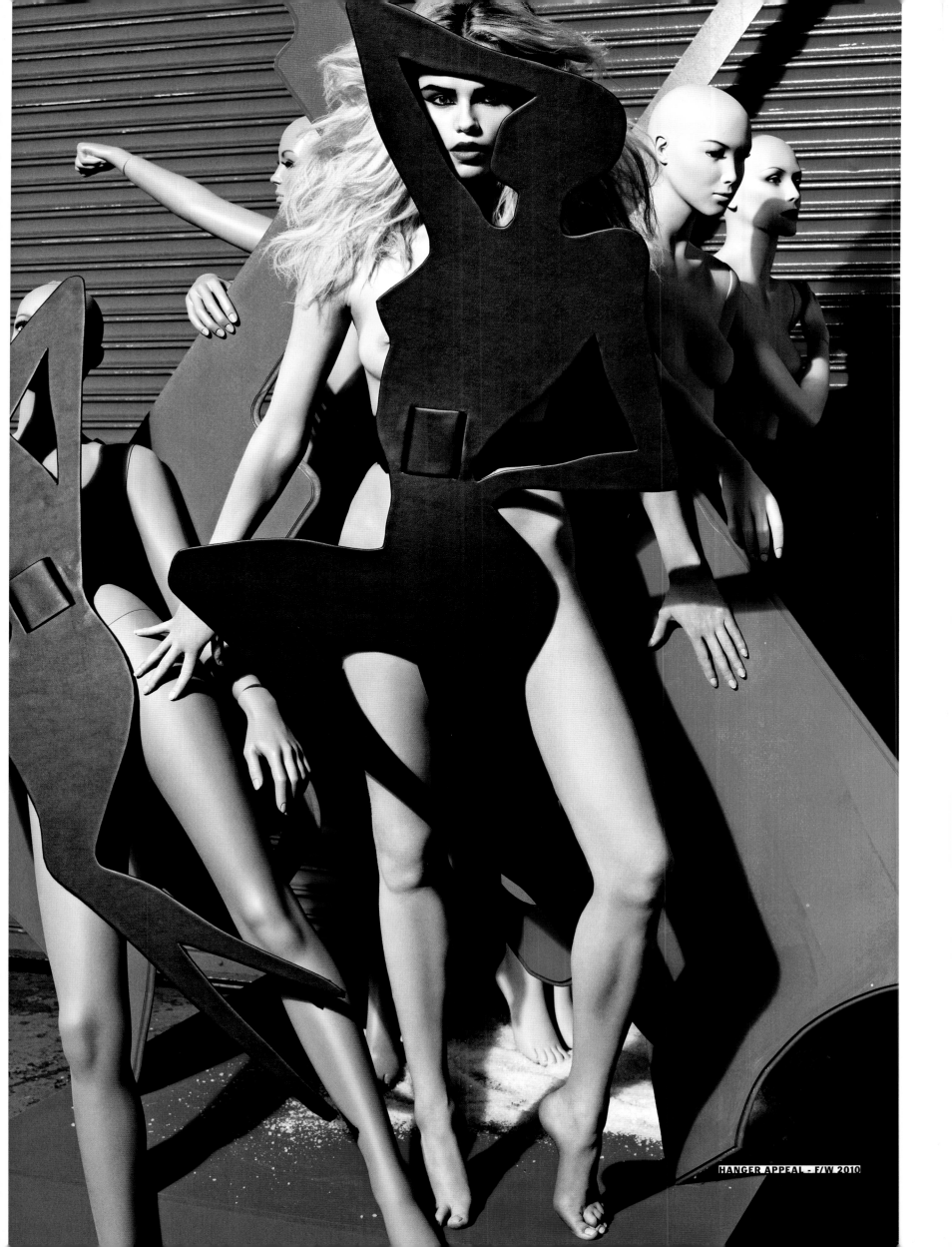

HANGER APPEAL - F/W 2010

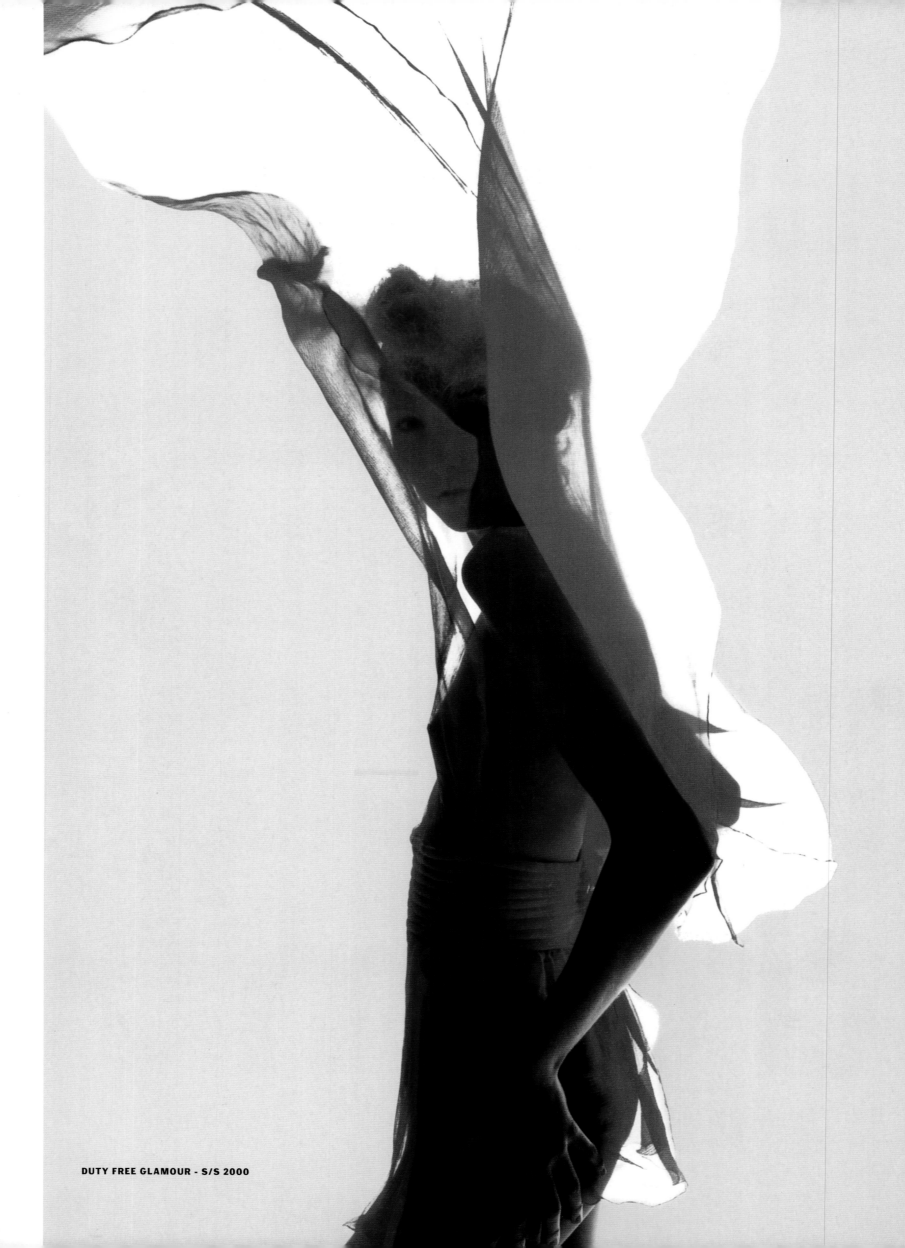

DUTY FREE GLAMOUR - S/S 2000

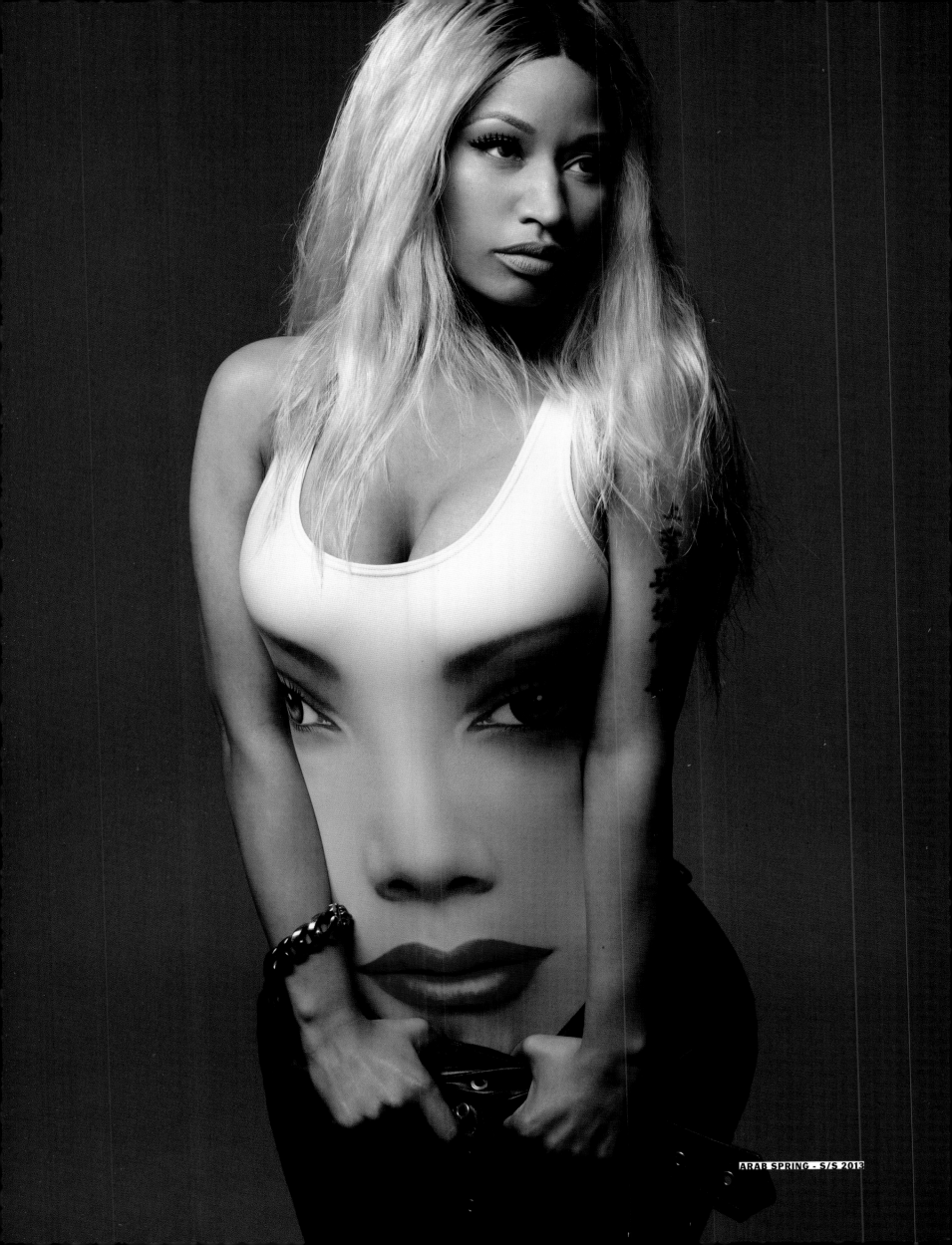

ARAB SPRING - S/S 2013

RHEA

HELLE

MARY ANNE

ZORA

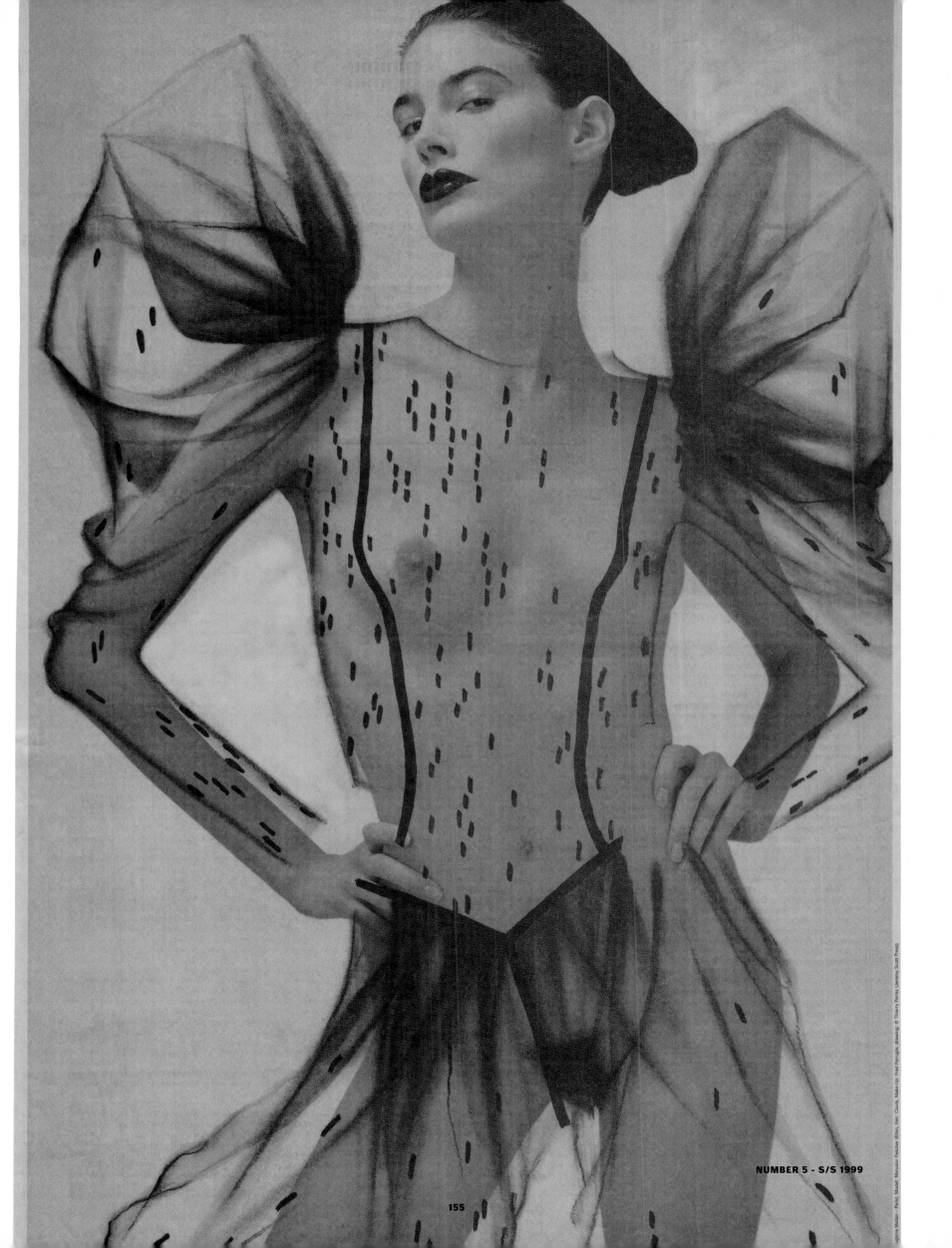

NUMBER 5 - S/S 1999

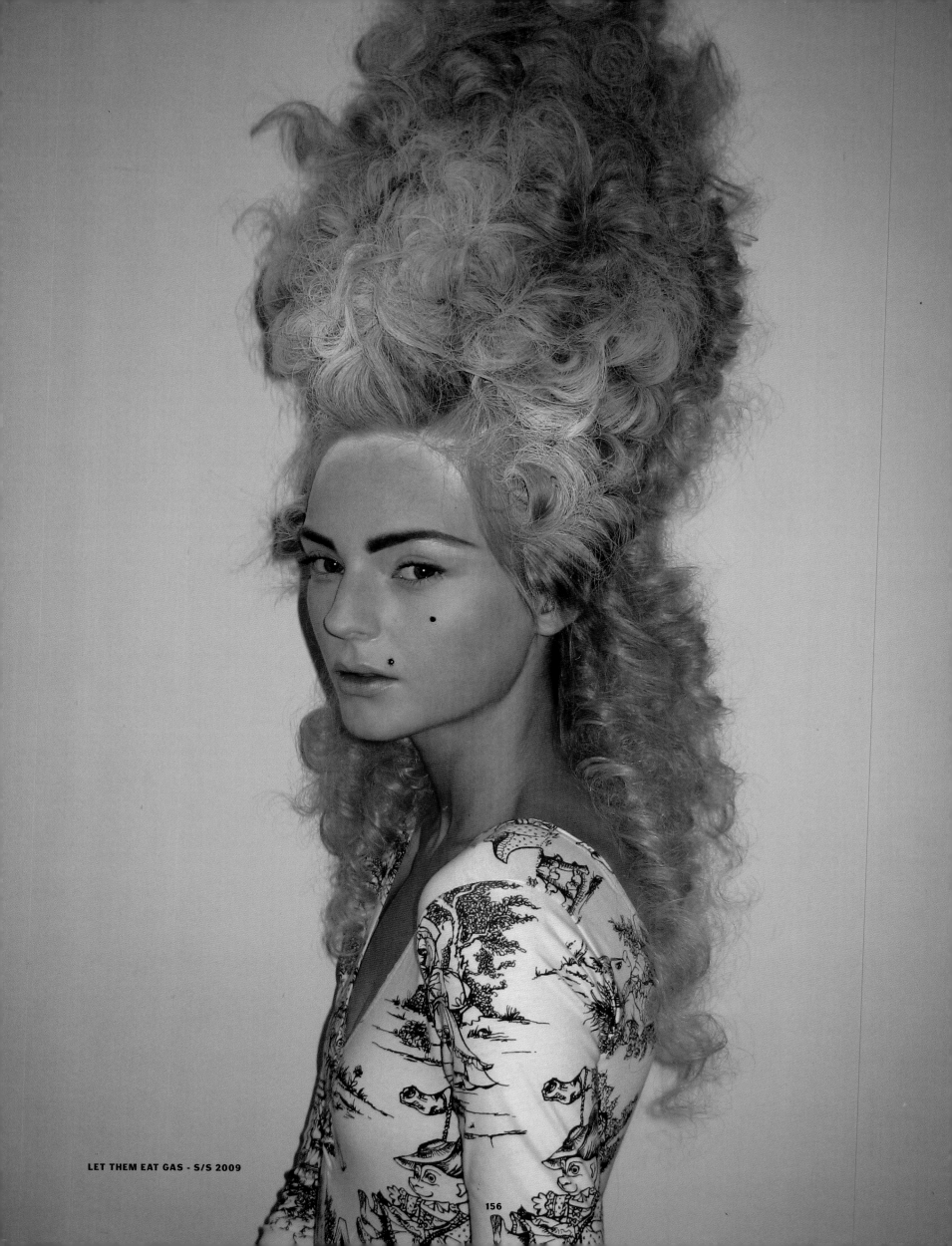

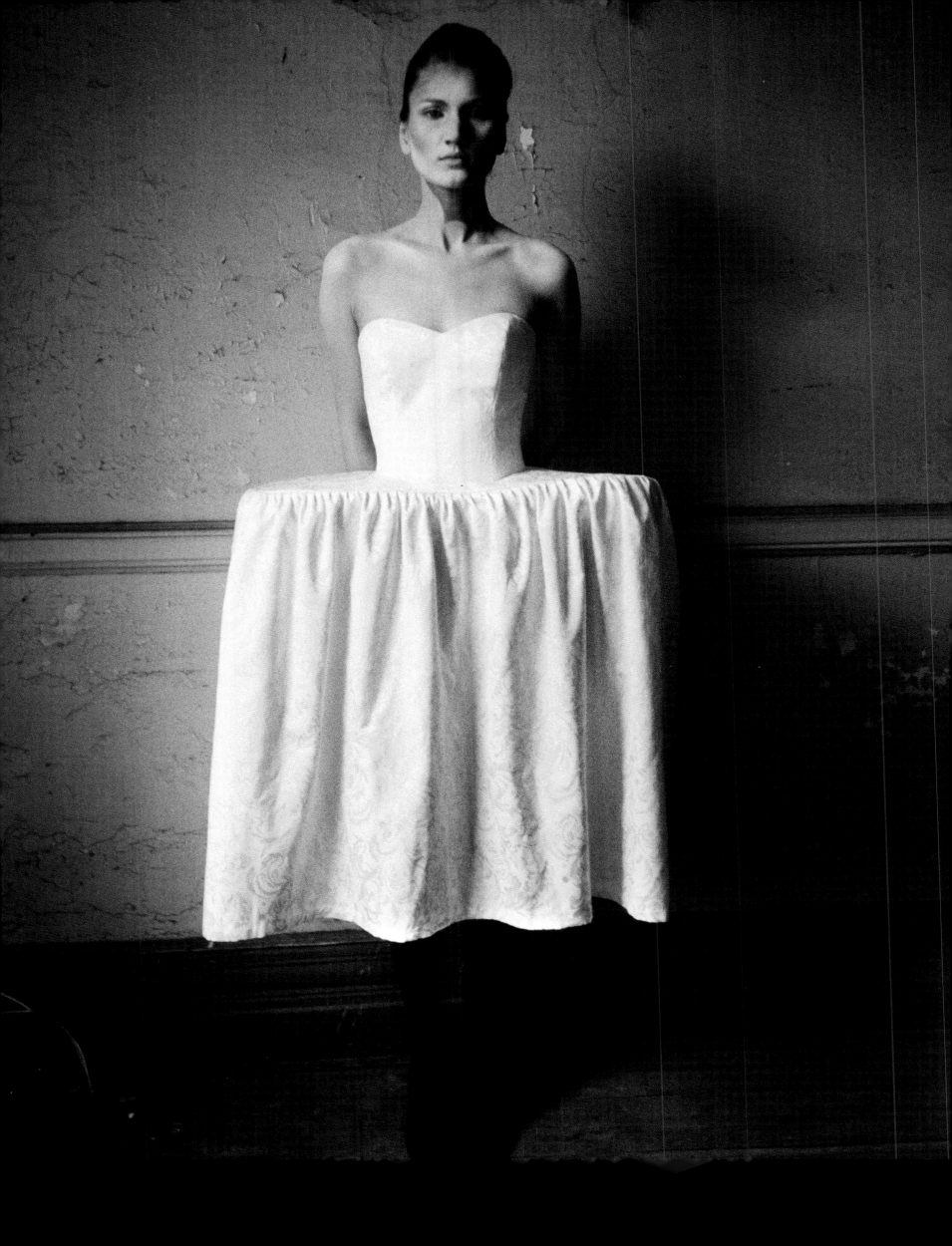

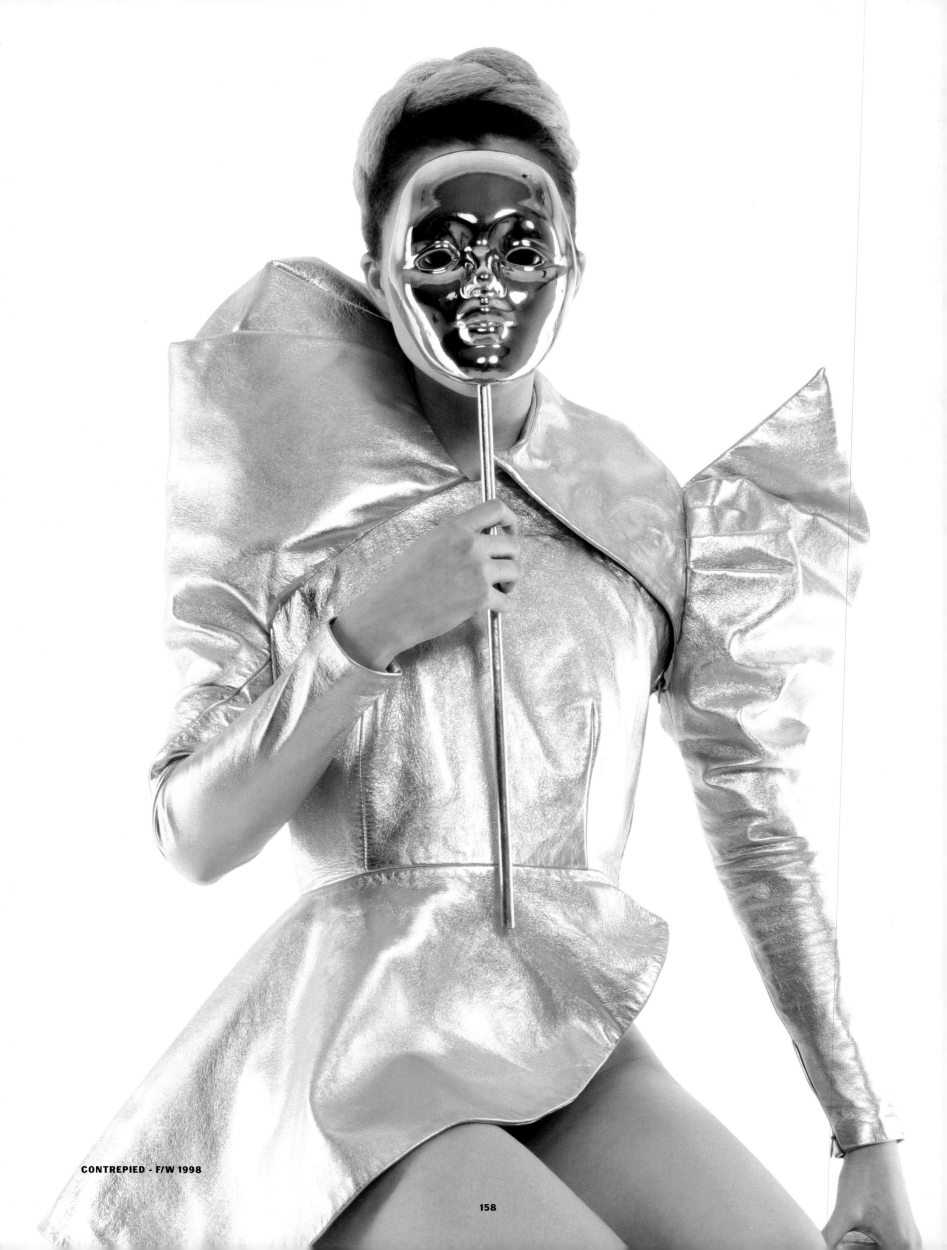

CONTREPIED - F/W 1998

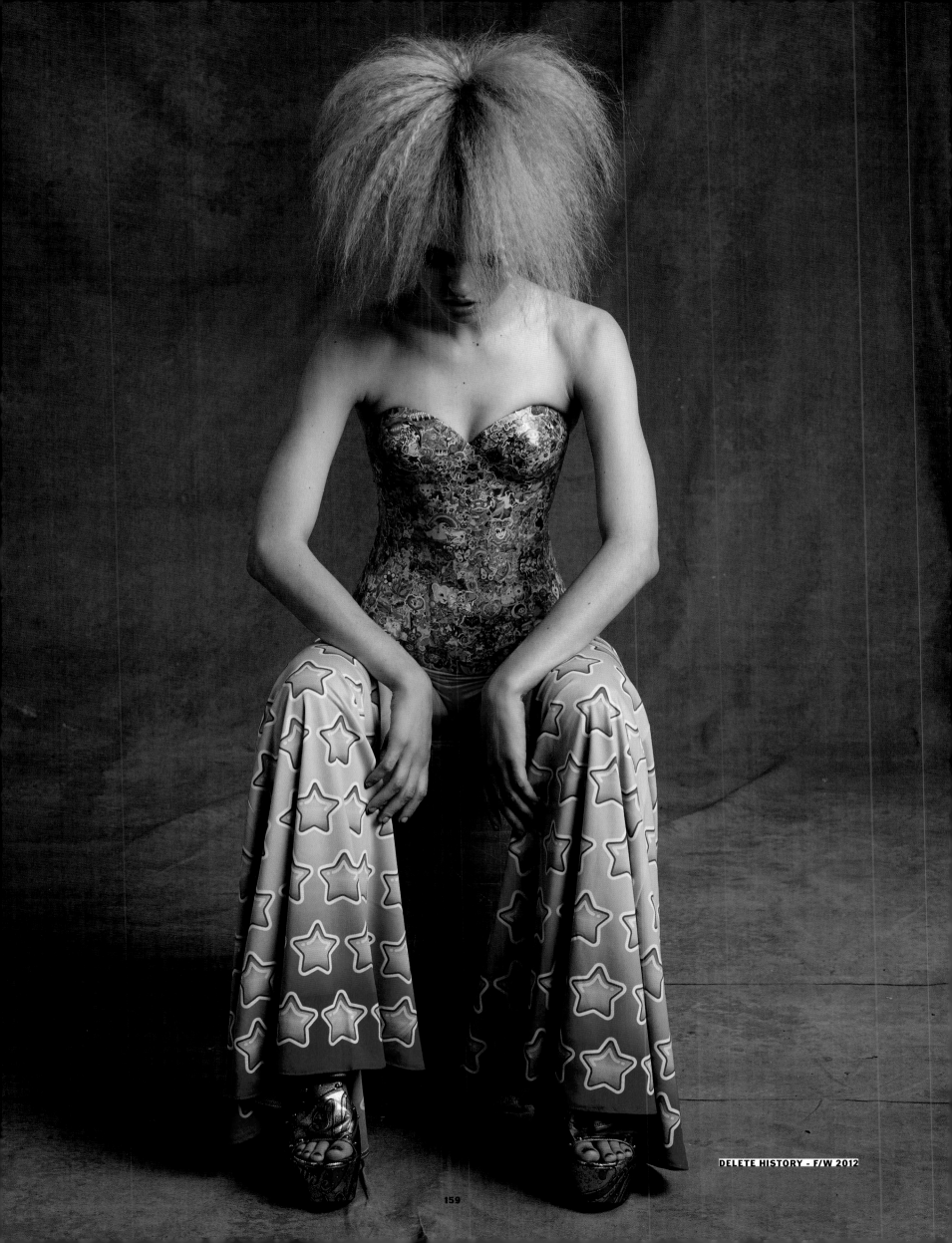

DELETE HISTORY - F/W 2012

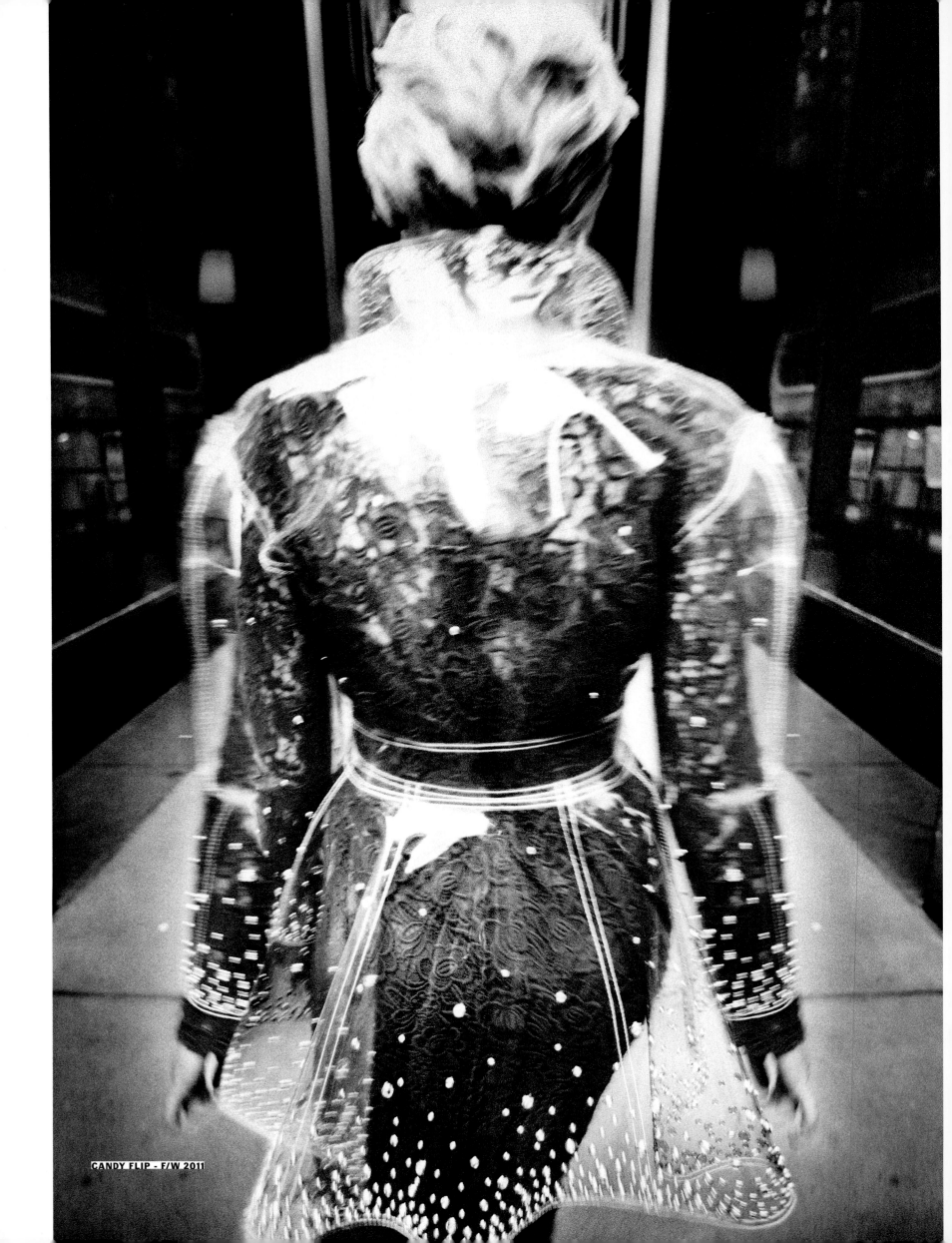

CANDY FLIP - F/W 2011

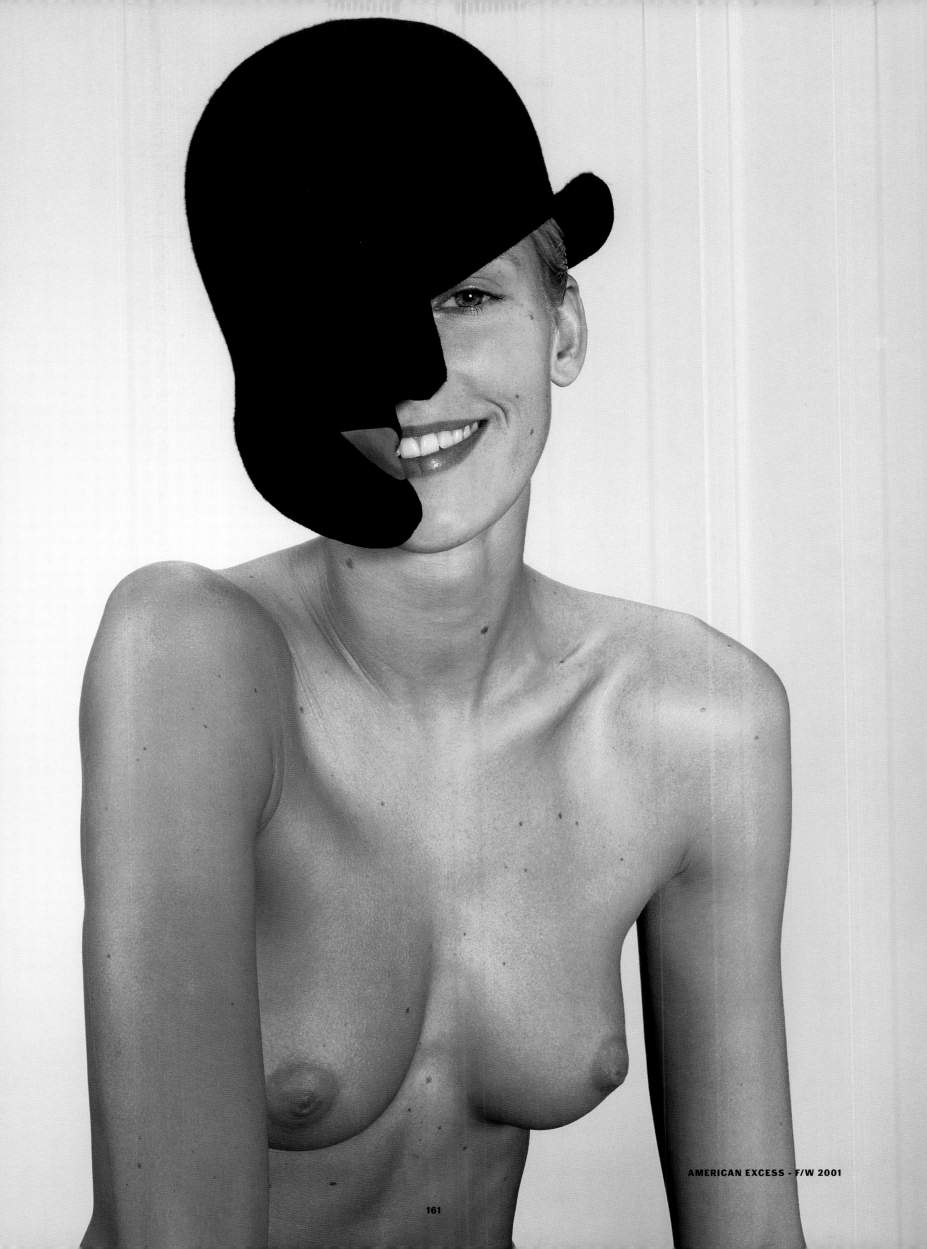

AMERICAN EXCESS - F/W 2001

161

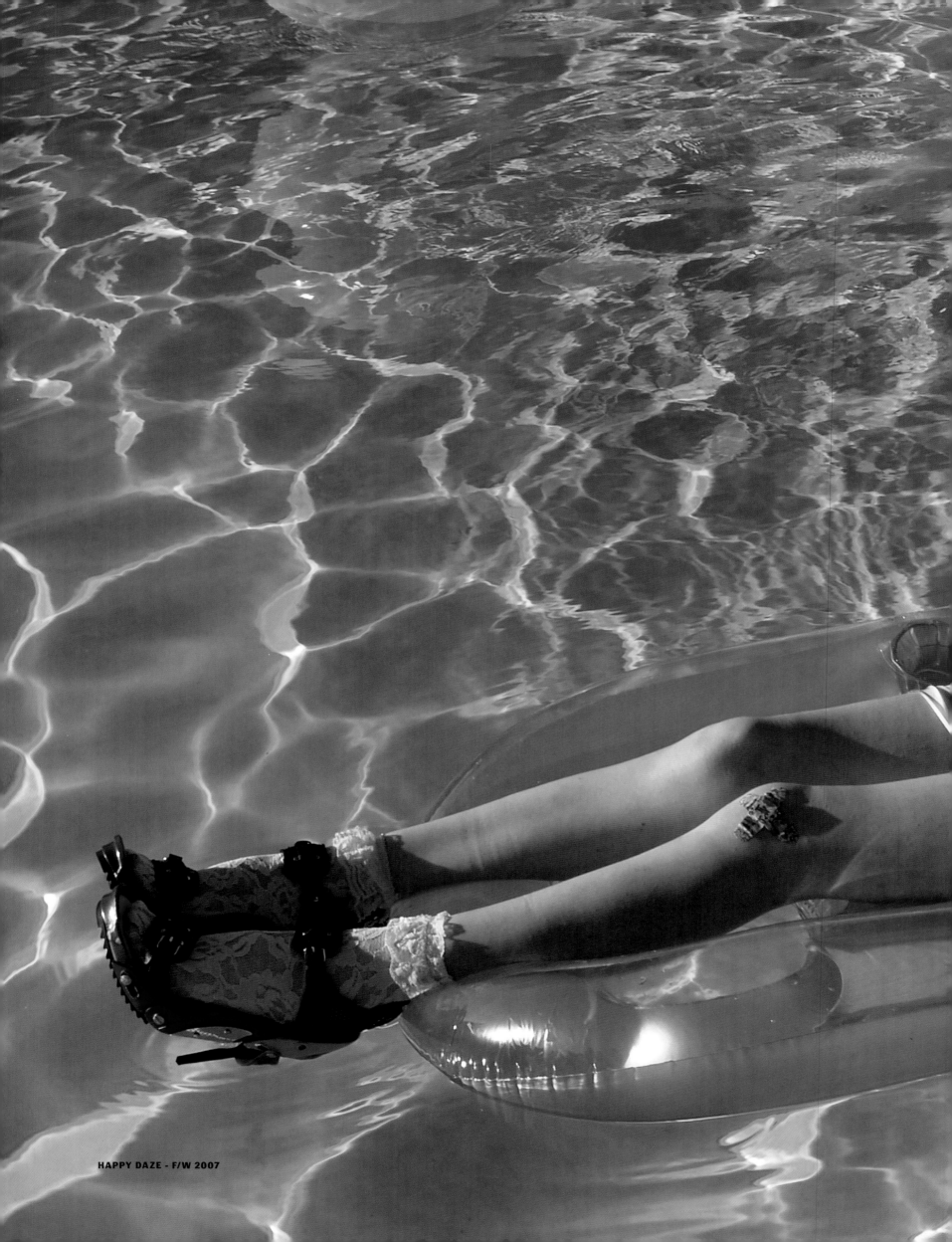

HAPPY DAZE - F/W 2007

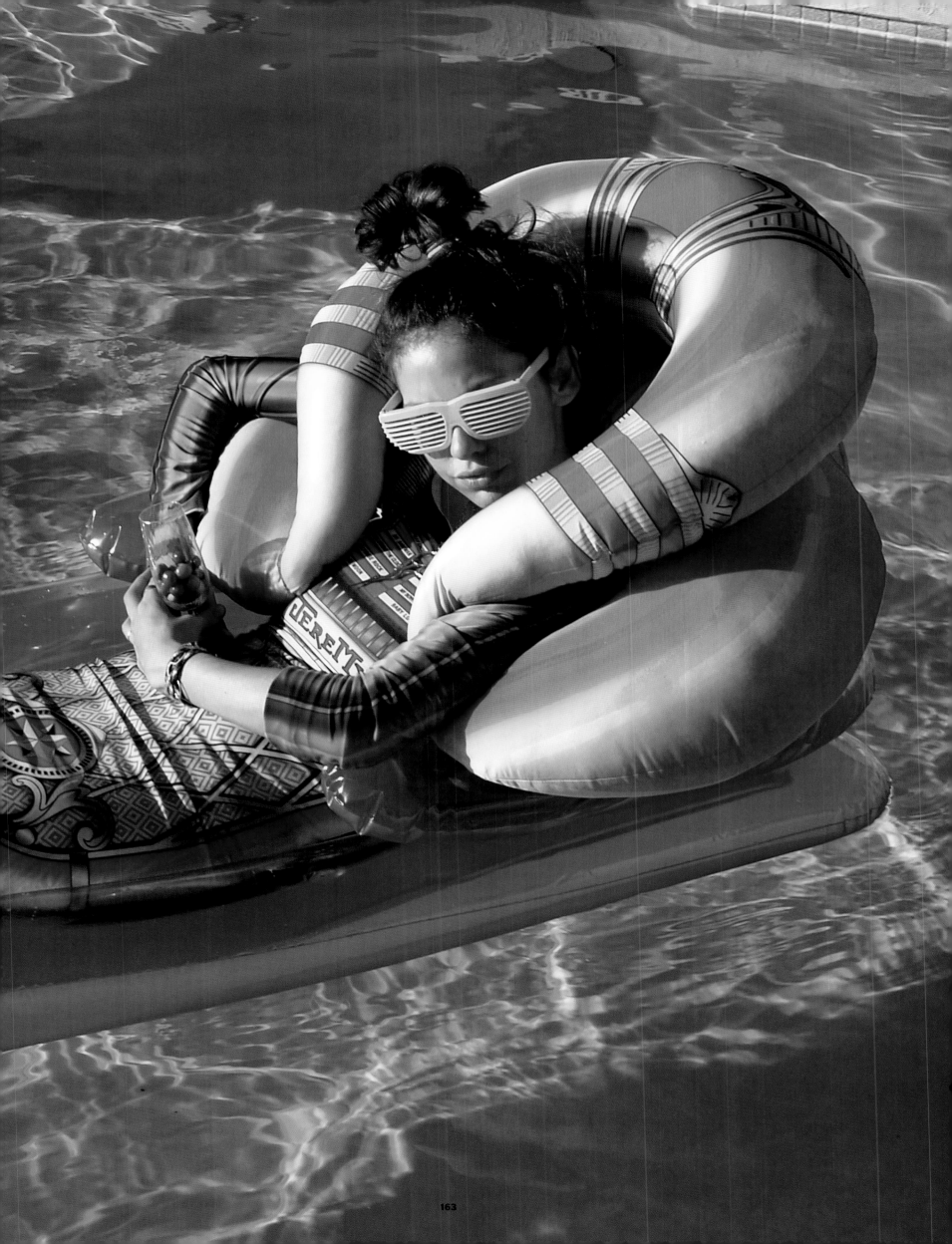

ESTABLISHMENT - F/W 1999

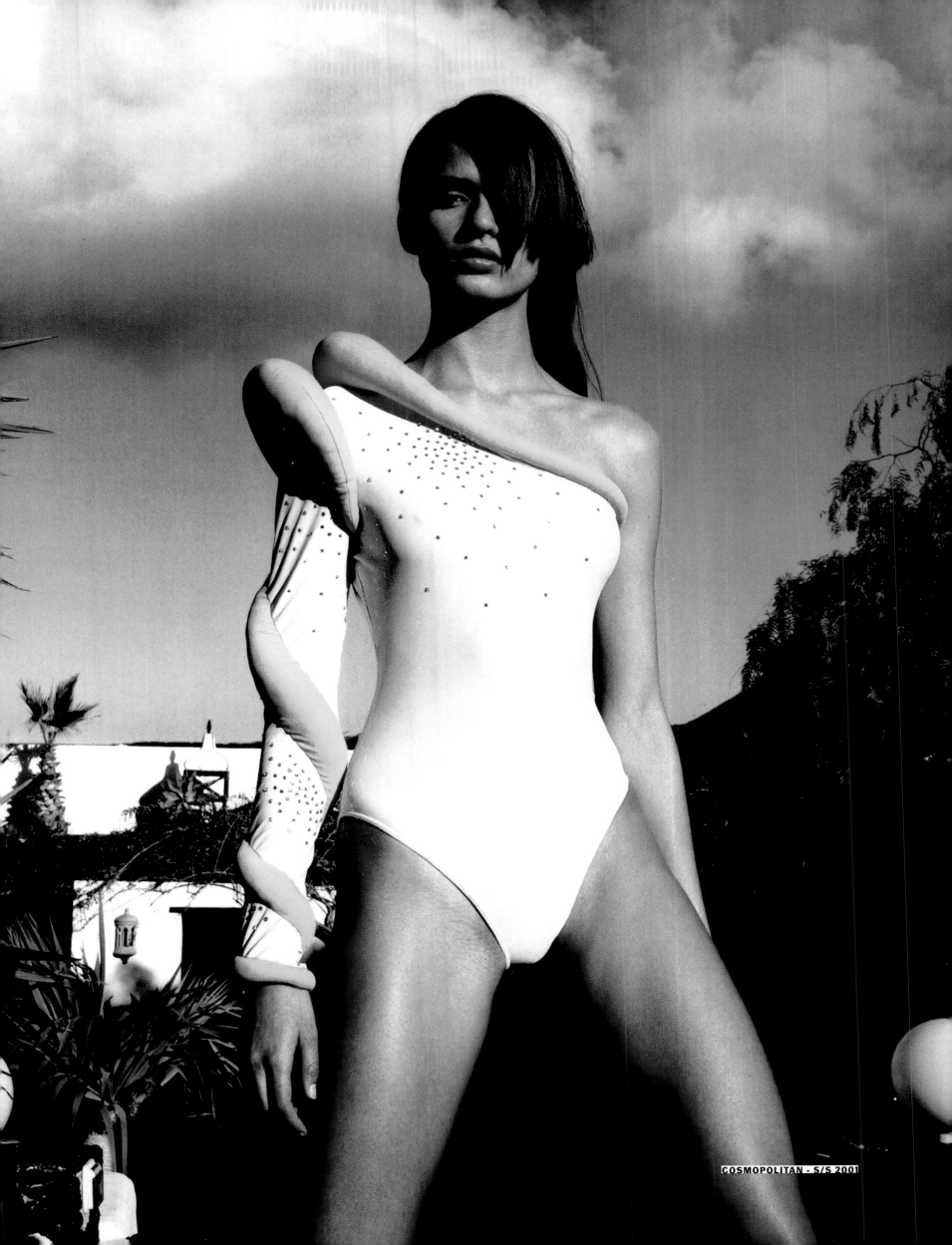

COSMOPOLITAN - S/S 2001

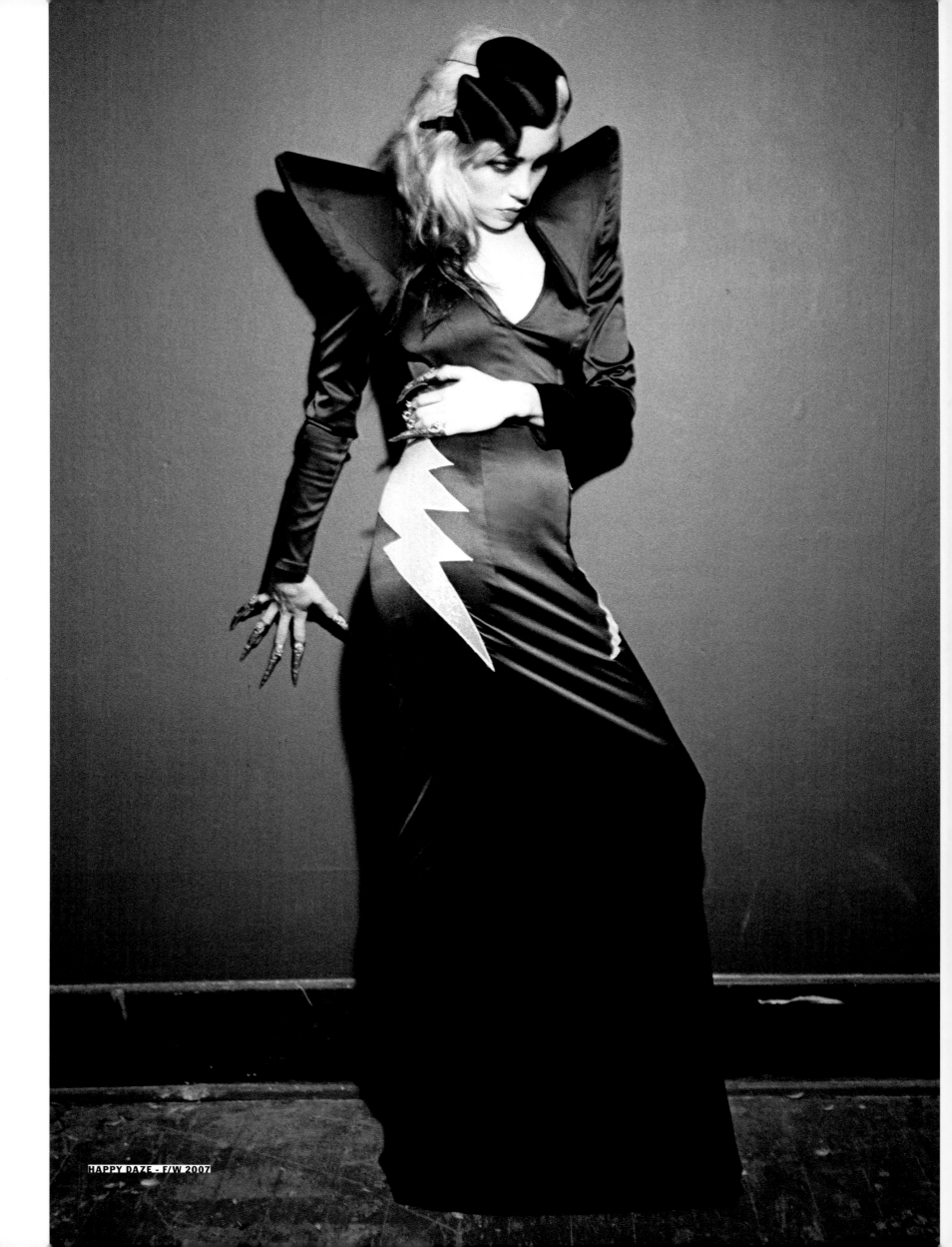

HAPPY DAZE - F/W 2007

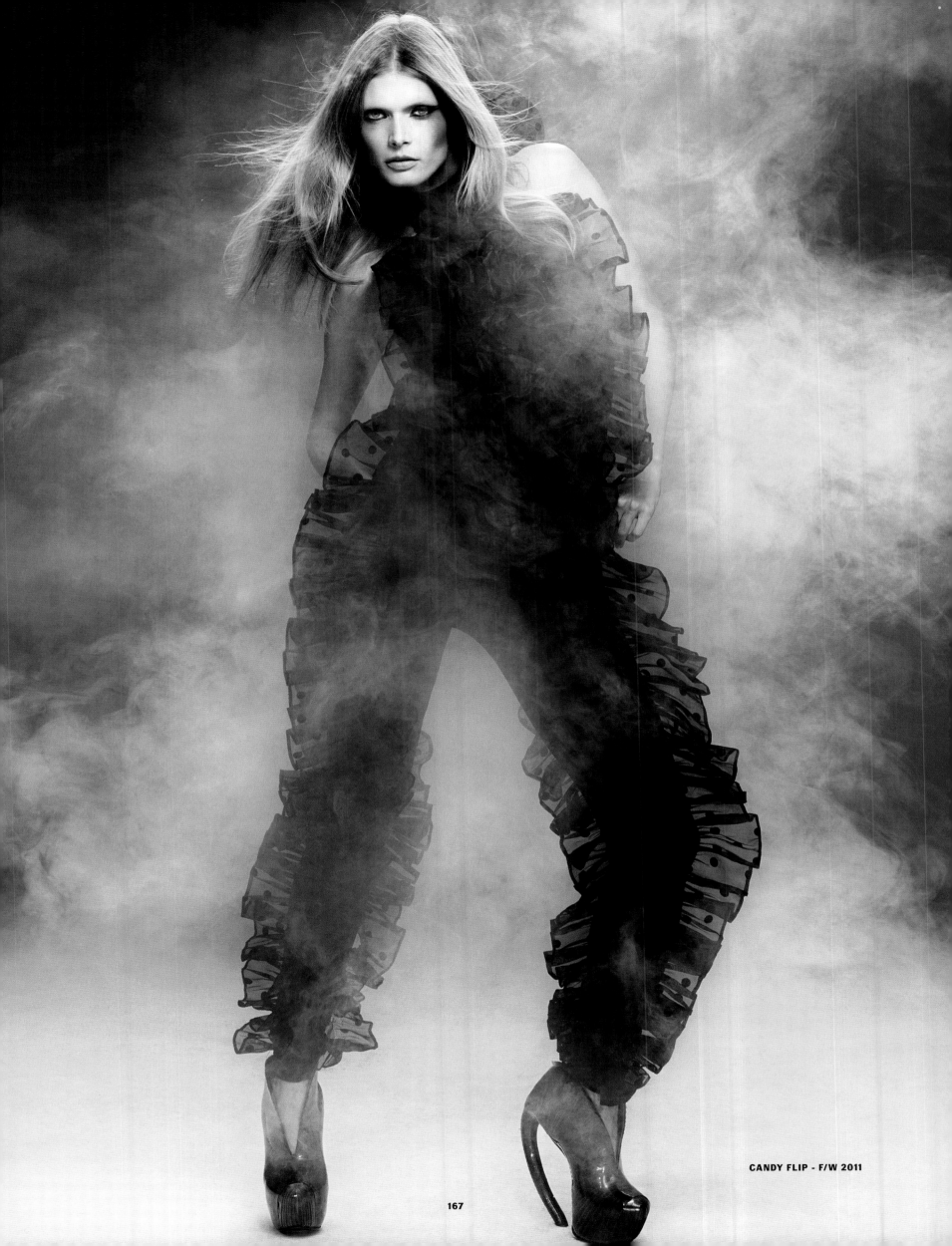

CANDY FLIP - F/W 2011

167

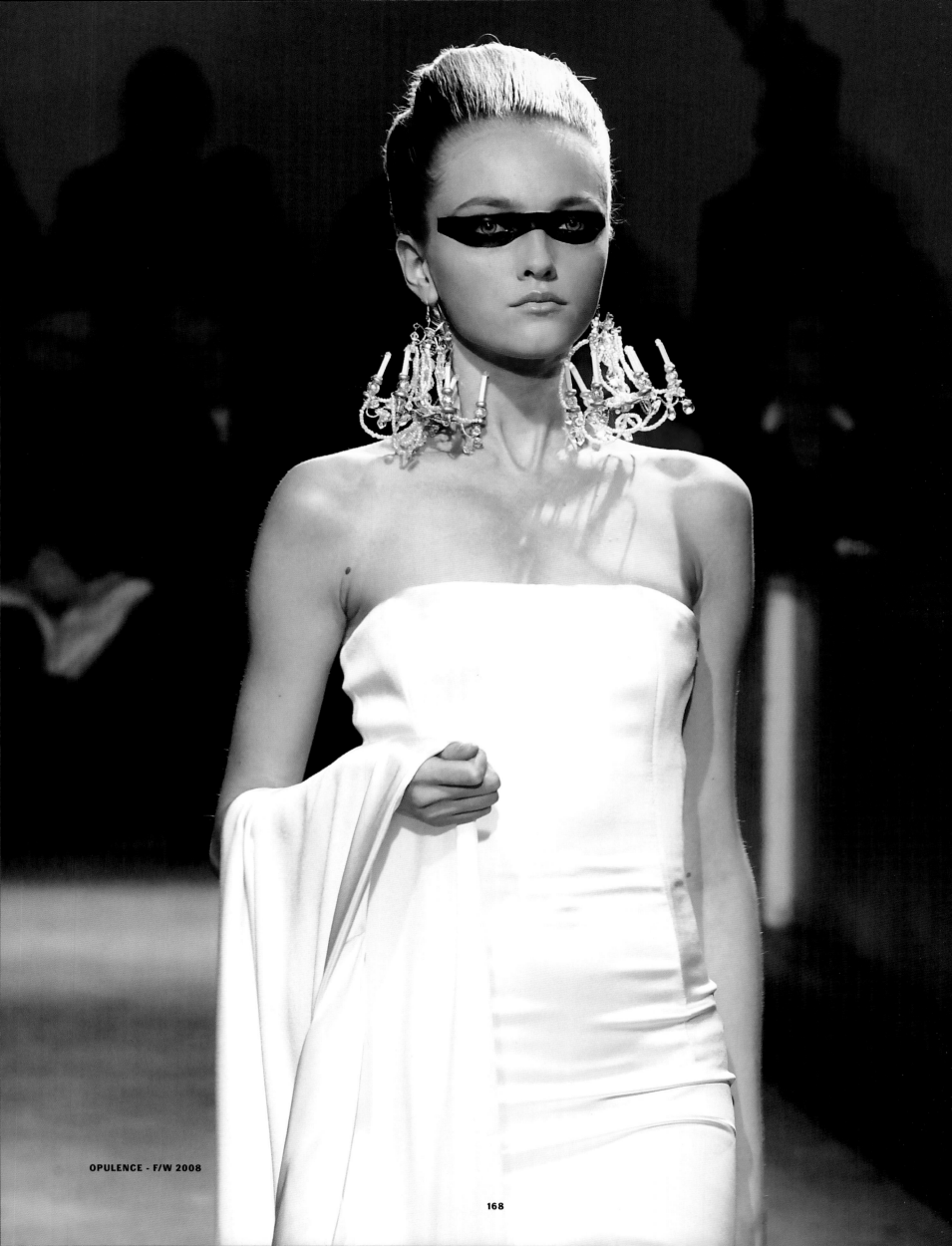

OPULENCE - F/W 2008

168

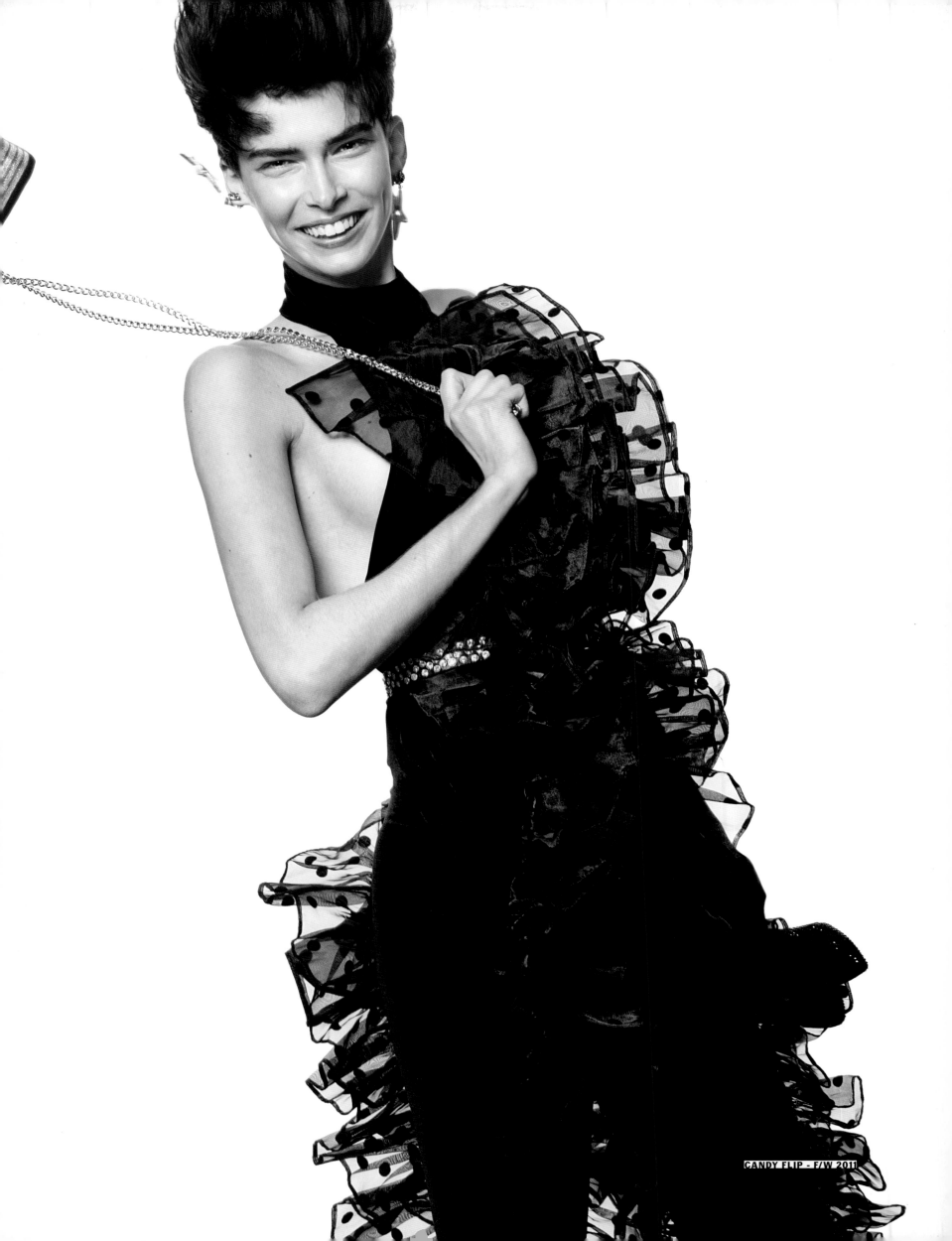

CANDY FLIP - F/W 2011

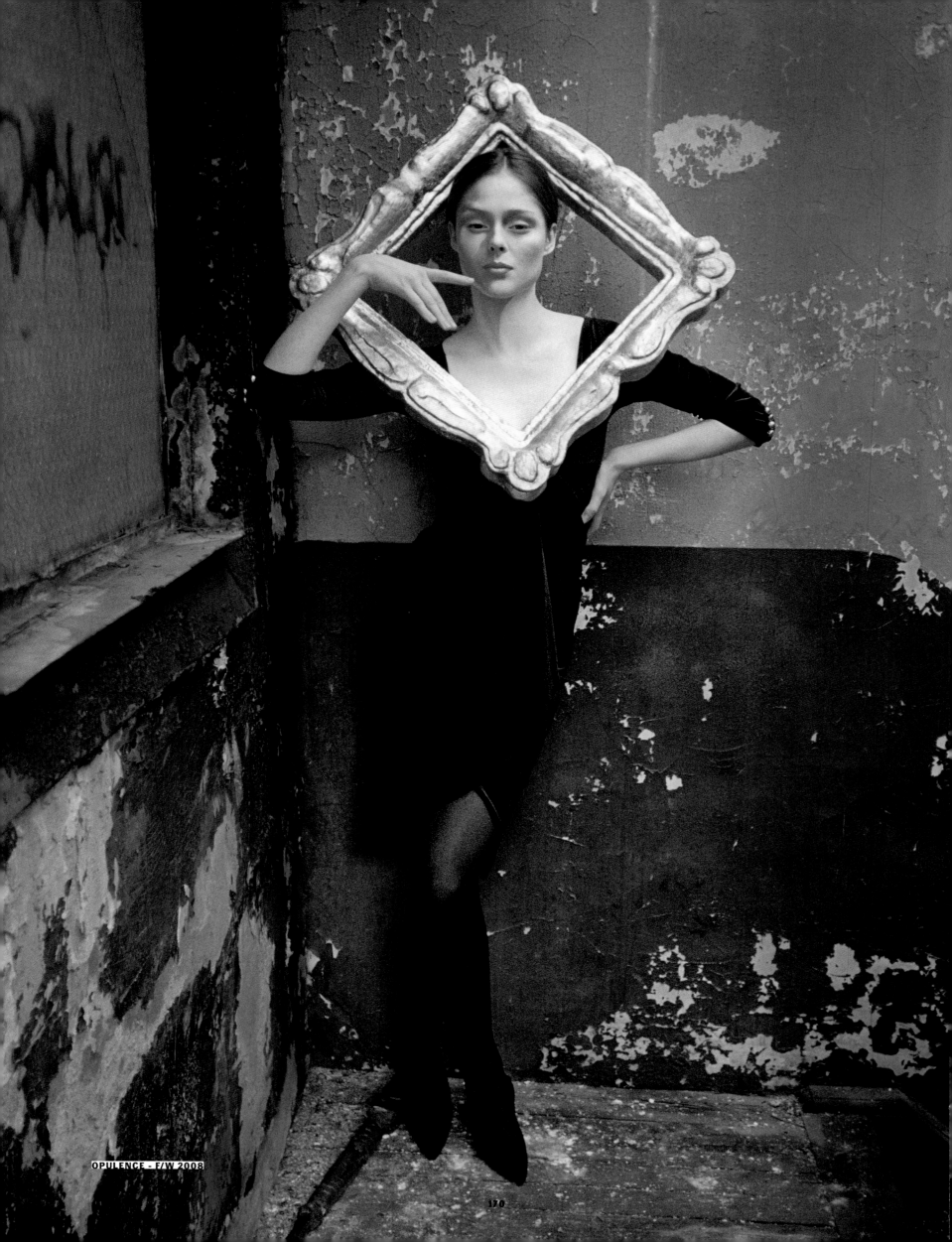

OPULENCE - F/W 2008

170

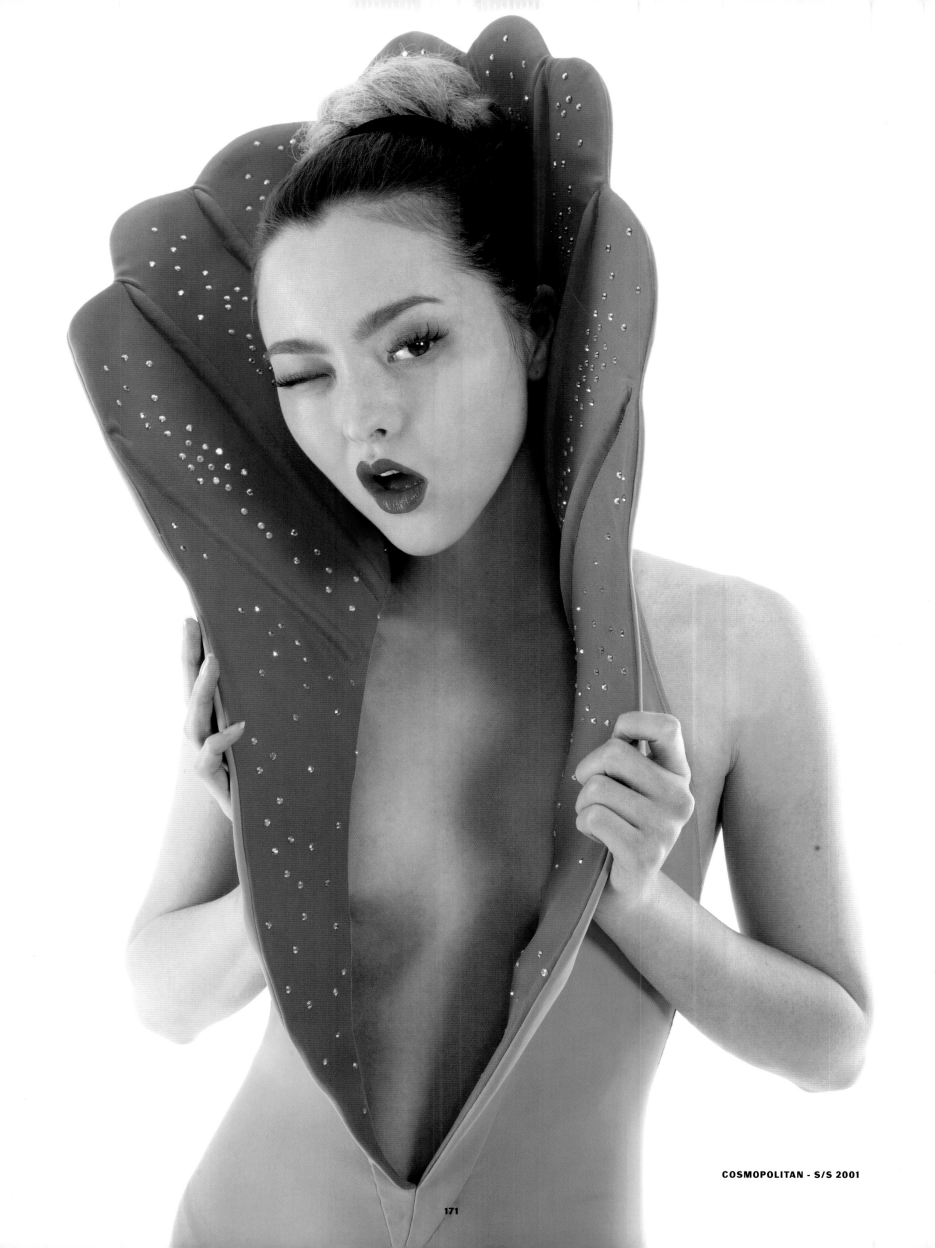

COSMOPOLITAN - S/S 2001

171

FOOD 4 THOUGHT

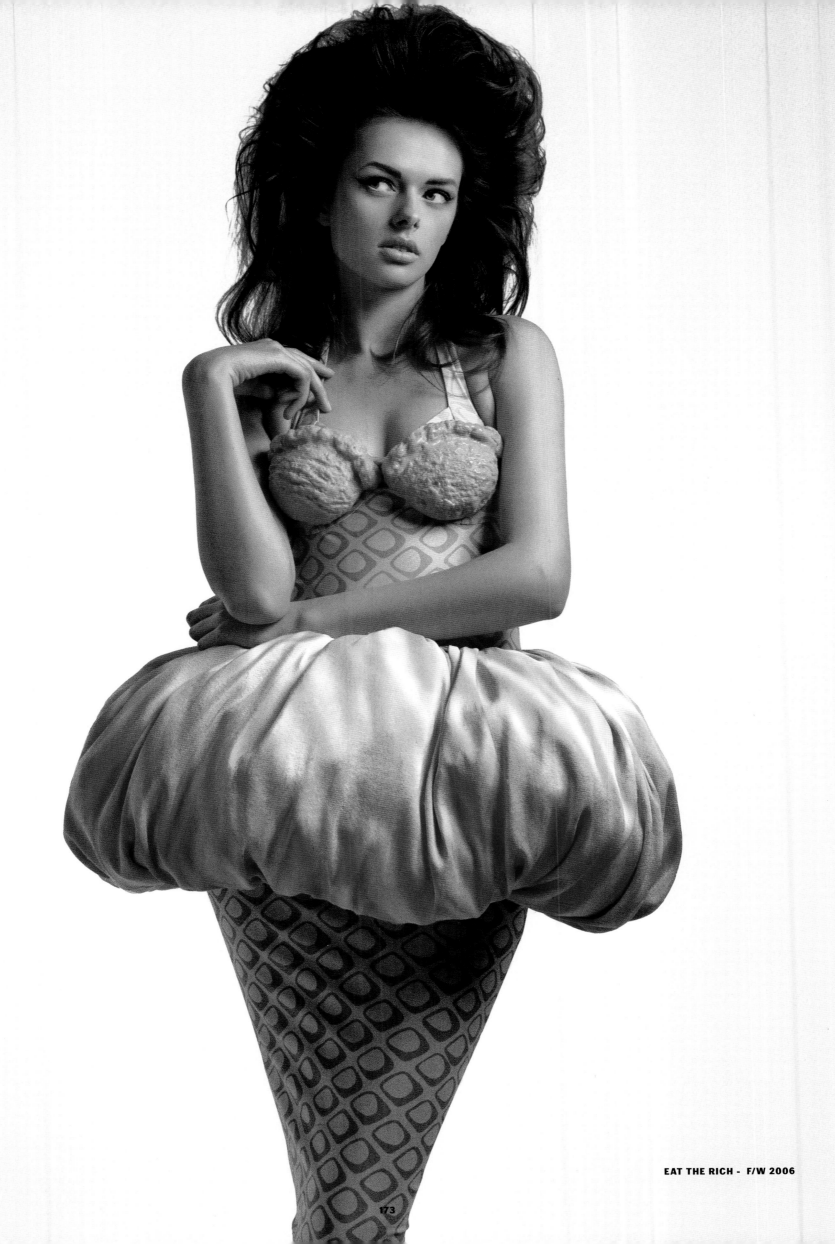

EAT THE RICH - F/W 2006

173

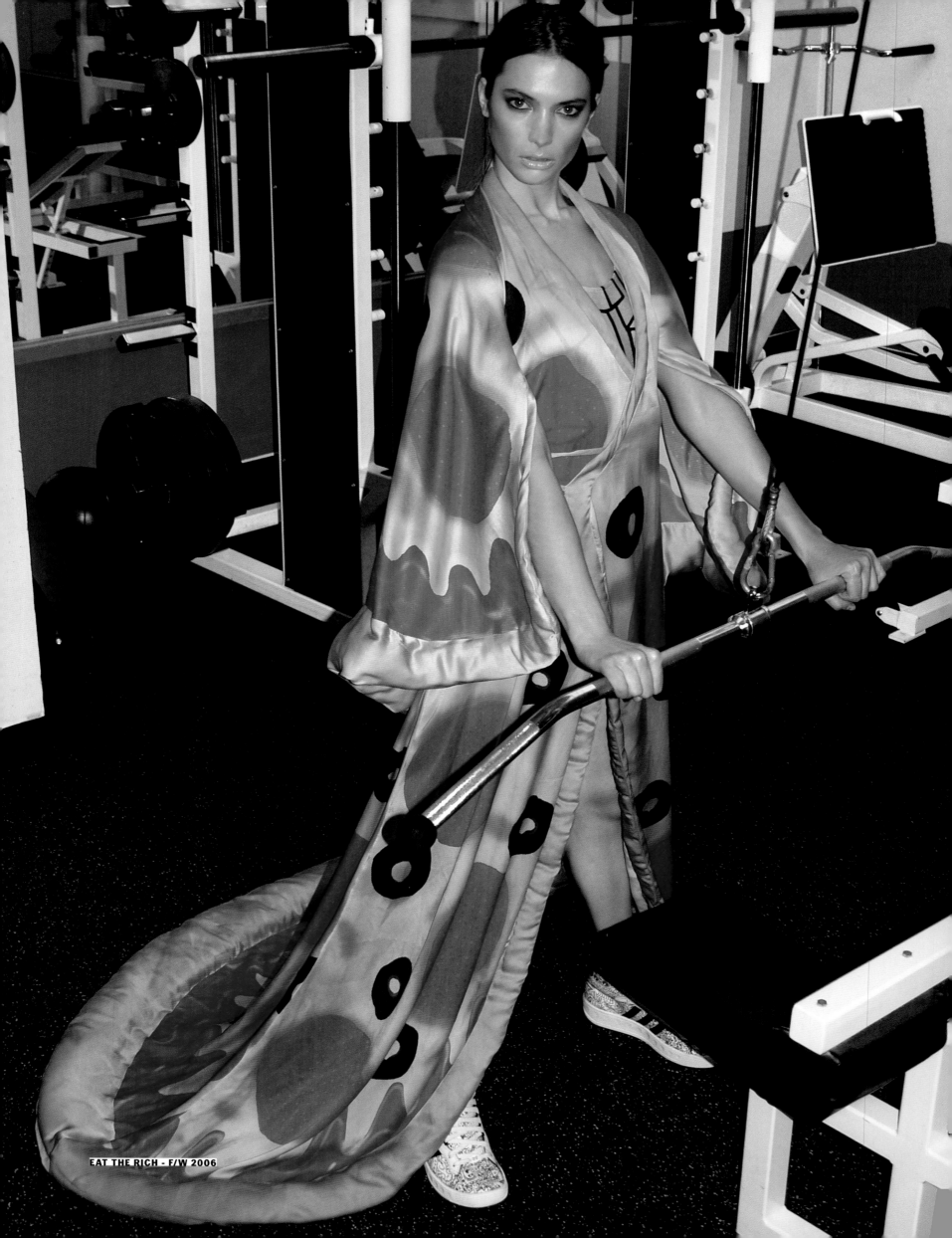

EAT THE RICH - F/W 2006

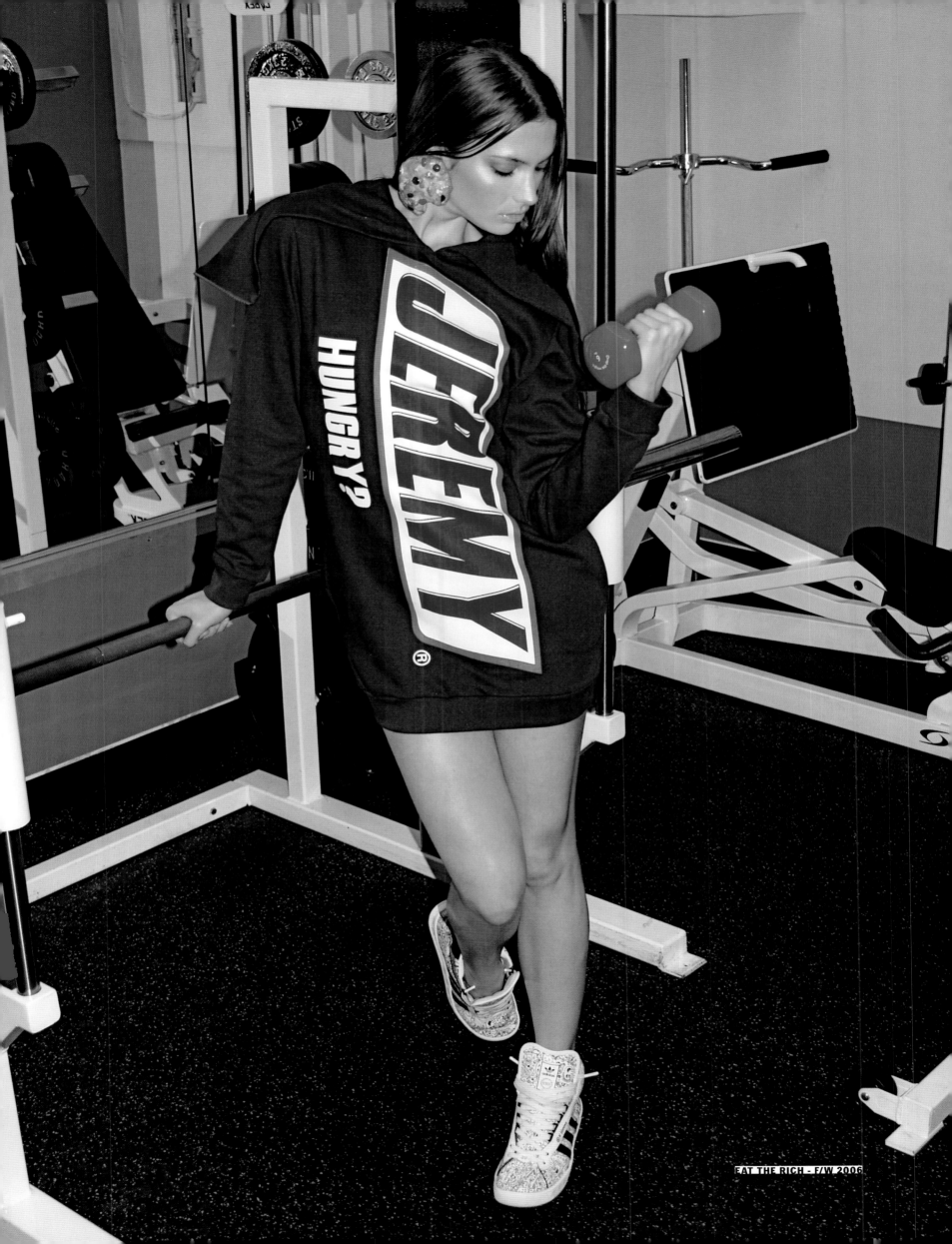

EAT THE RICH - F/W 2006

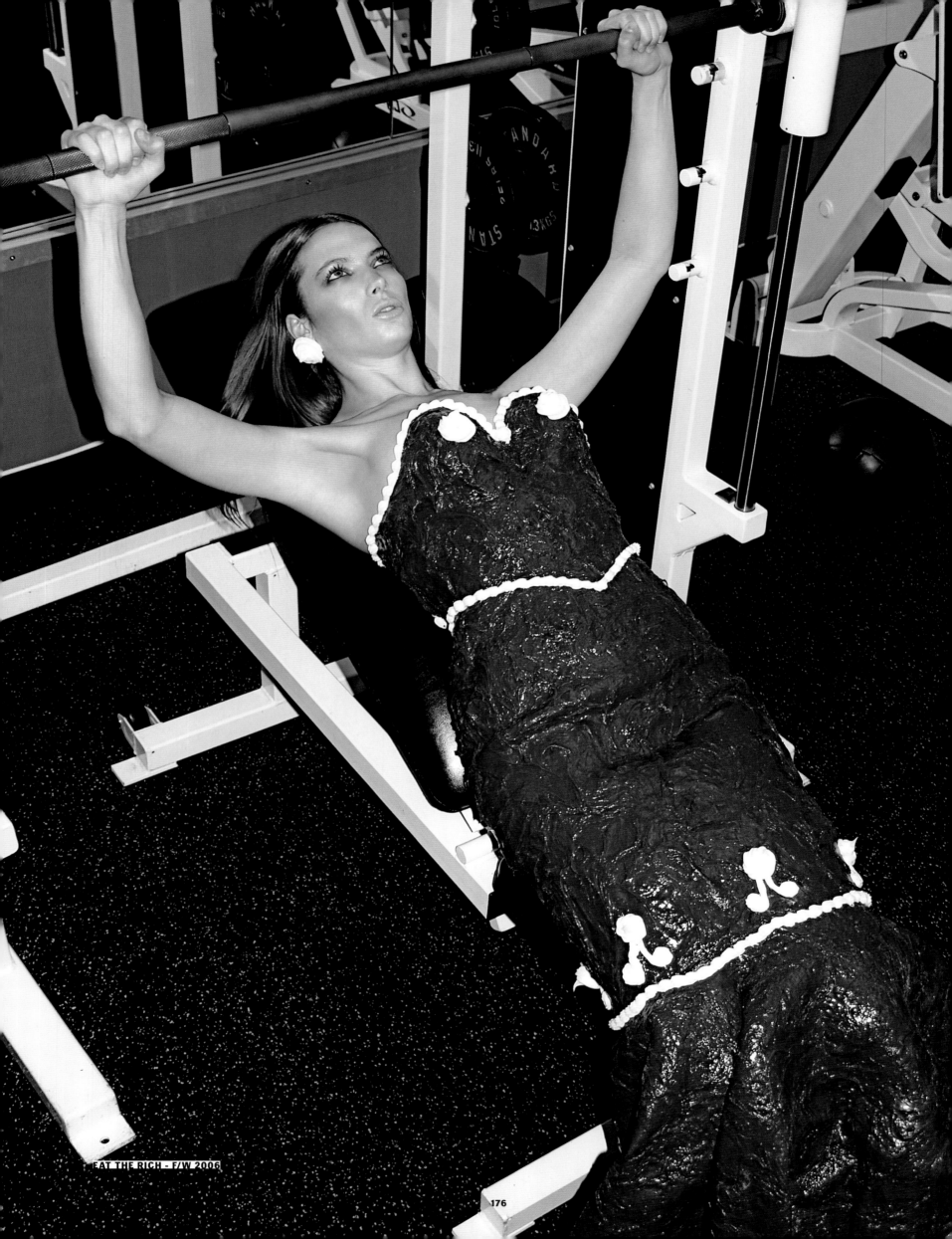

EAT THE RICH - F/W 2006

176

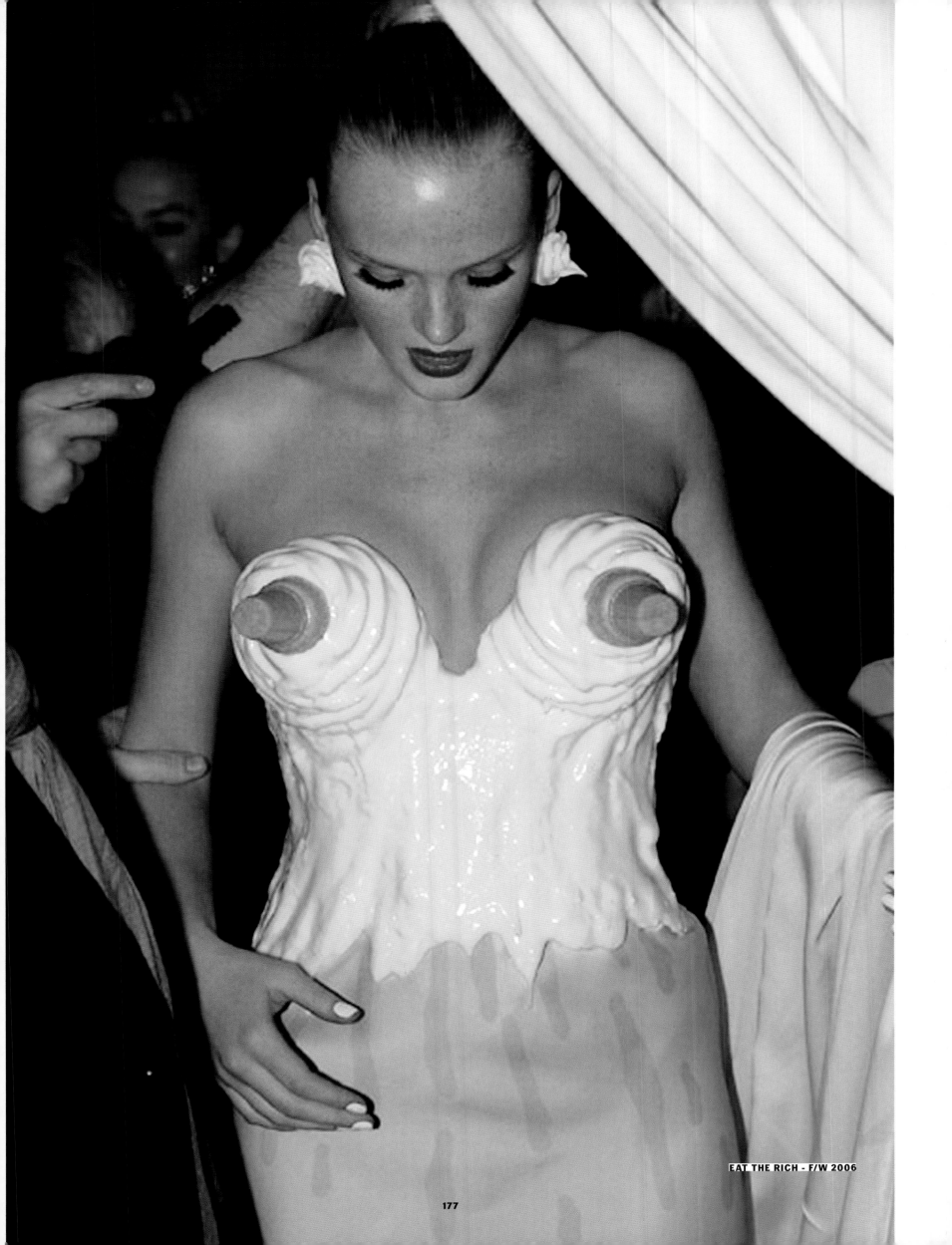

EAT THE RICH - F/W 2006

177

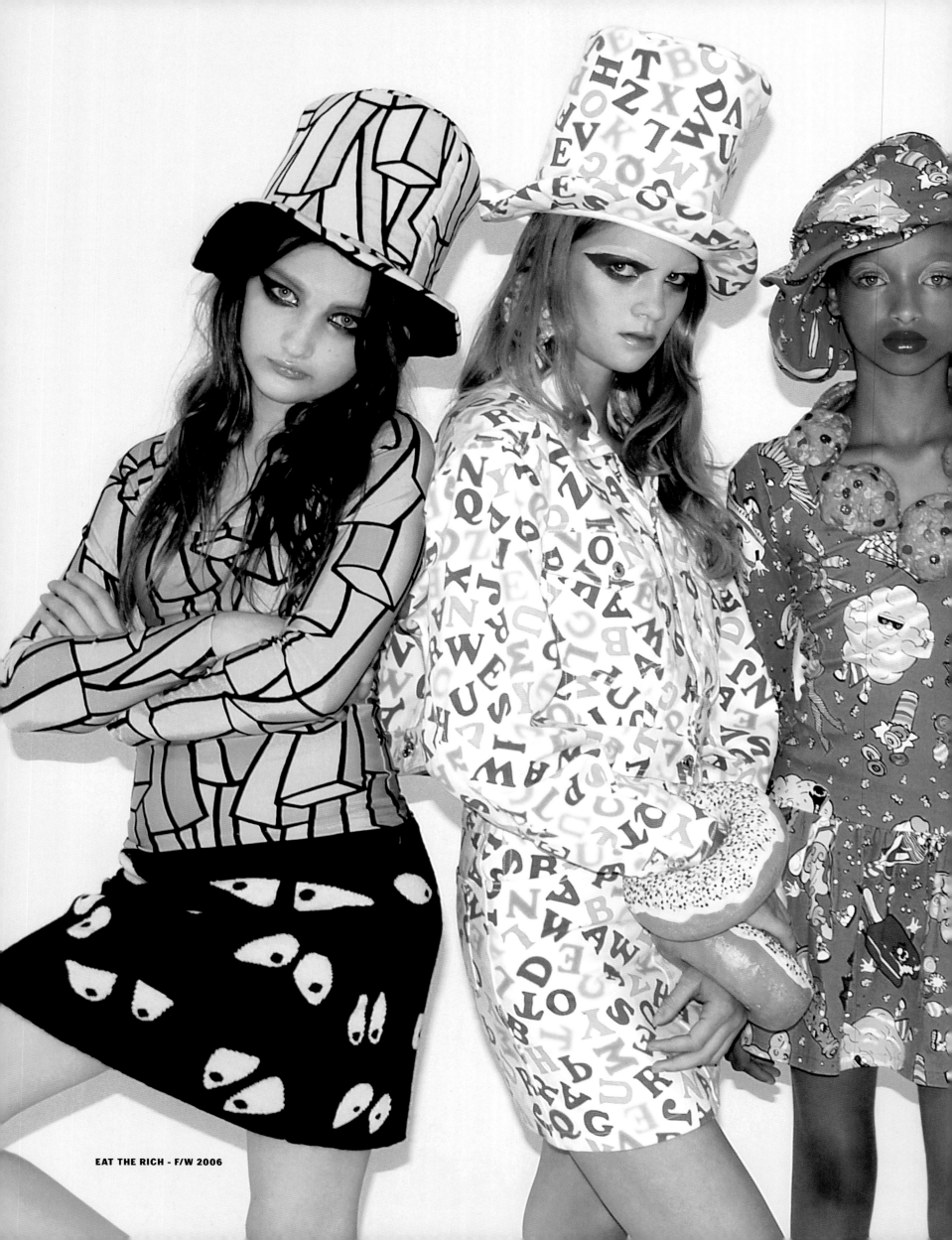

EAT THE RICH - F/W 2006

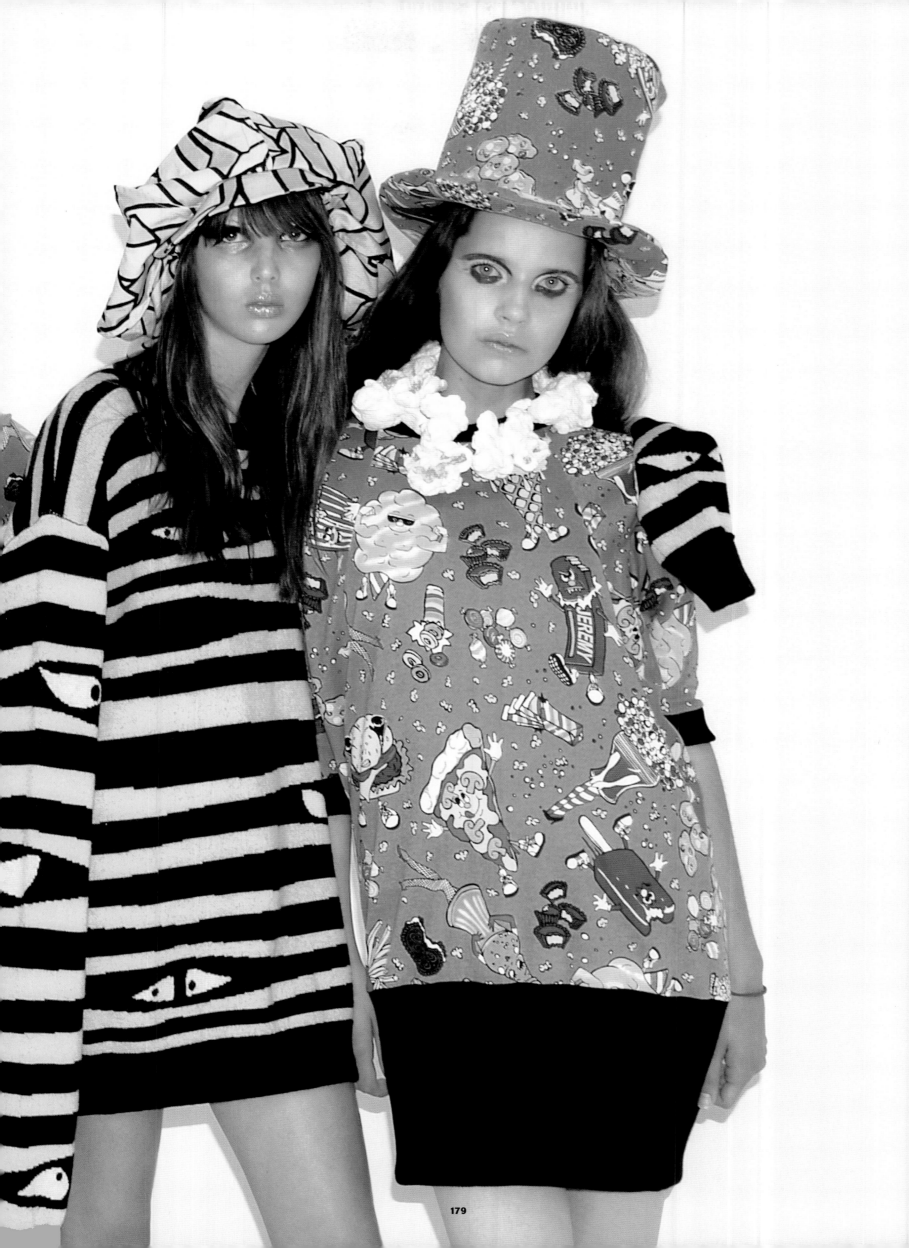

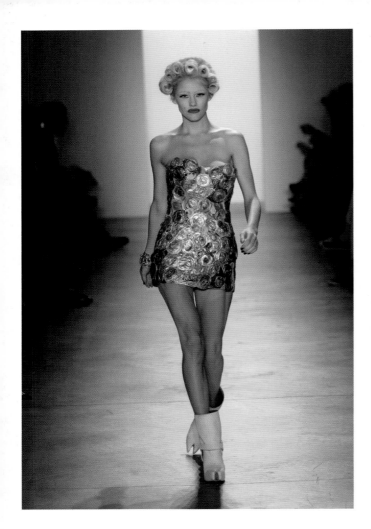

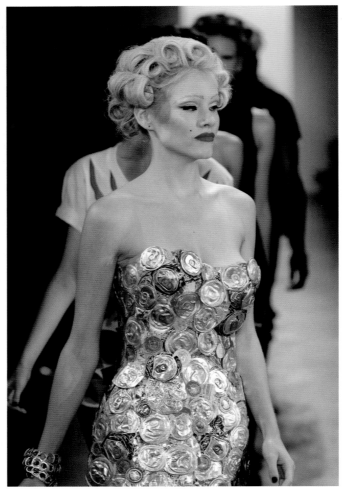

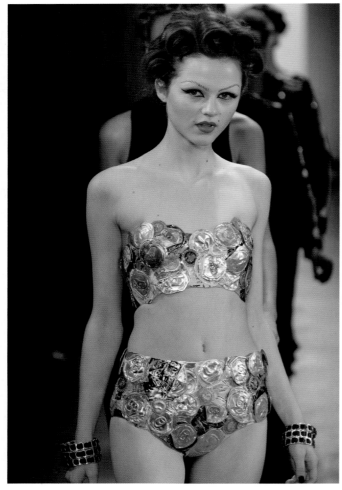

BOUDOIR BOMBSHELLS - S/S 2011

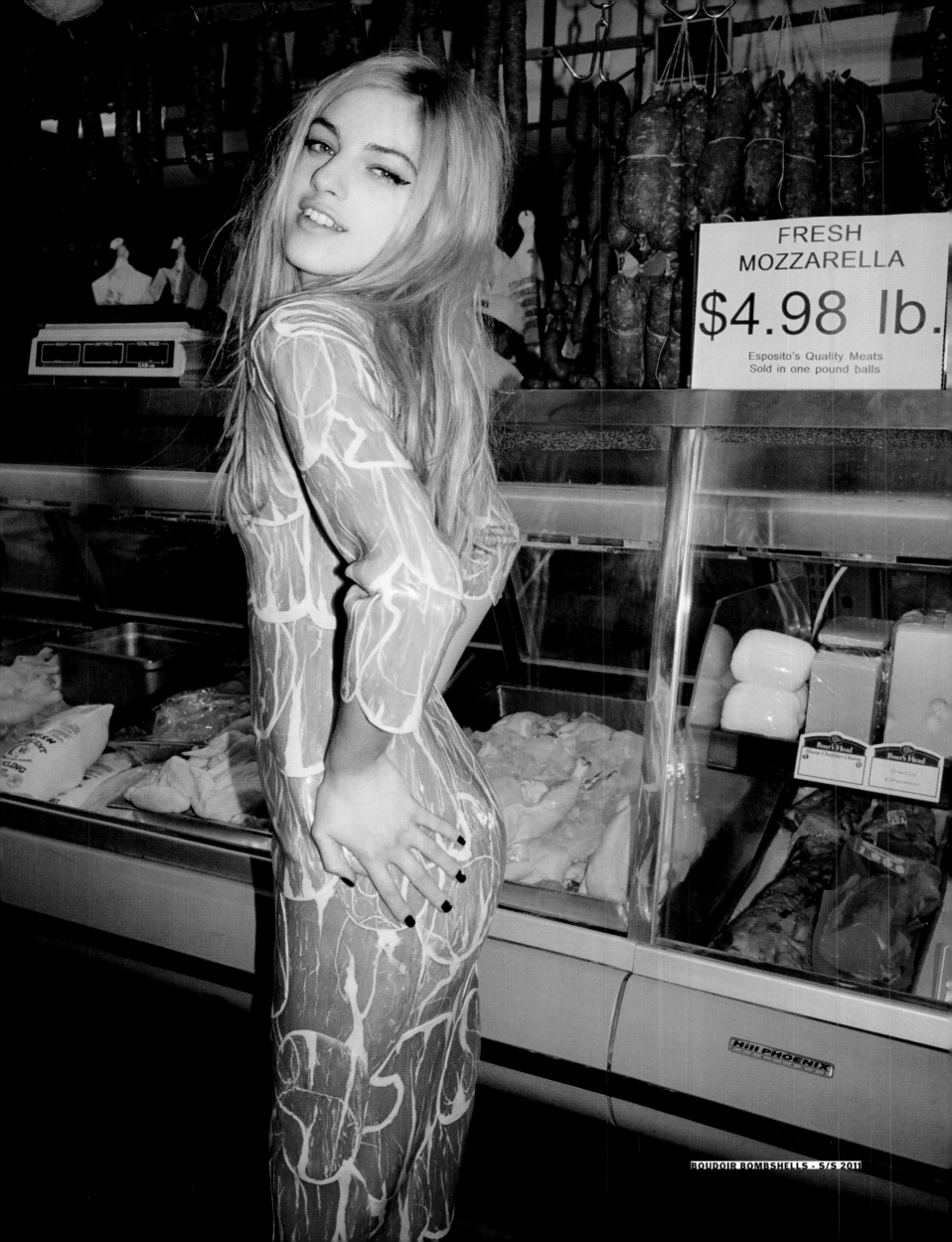

FRESH
MOZZARELLA
$4.98 lb.

Esposito's Quality Meats
Sold in one pound balls

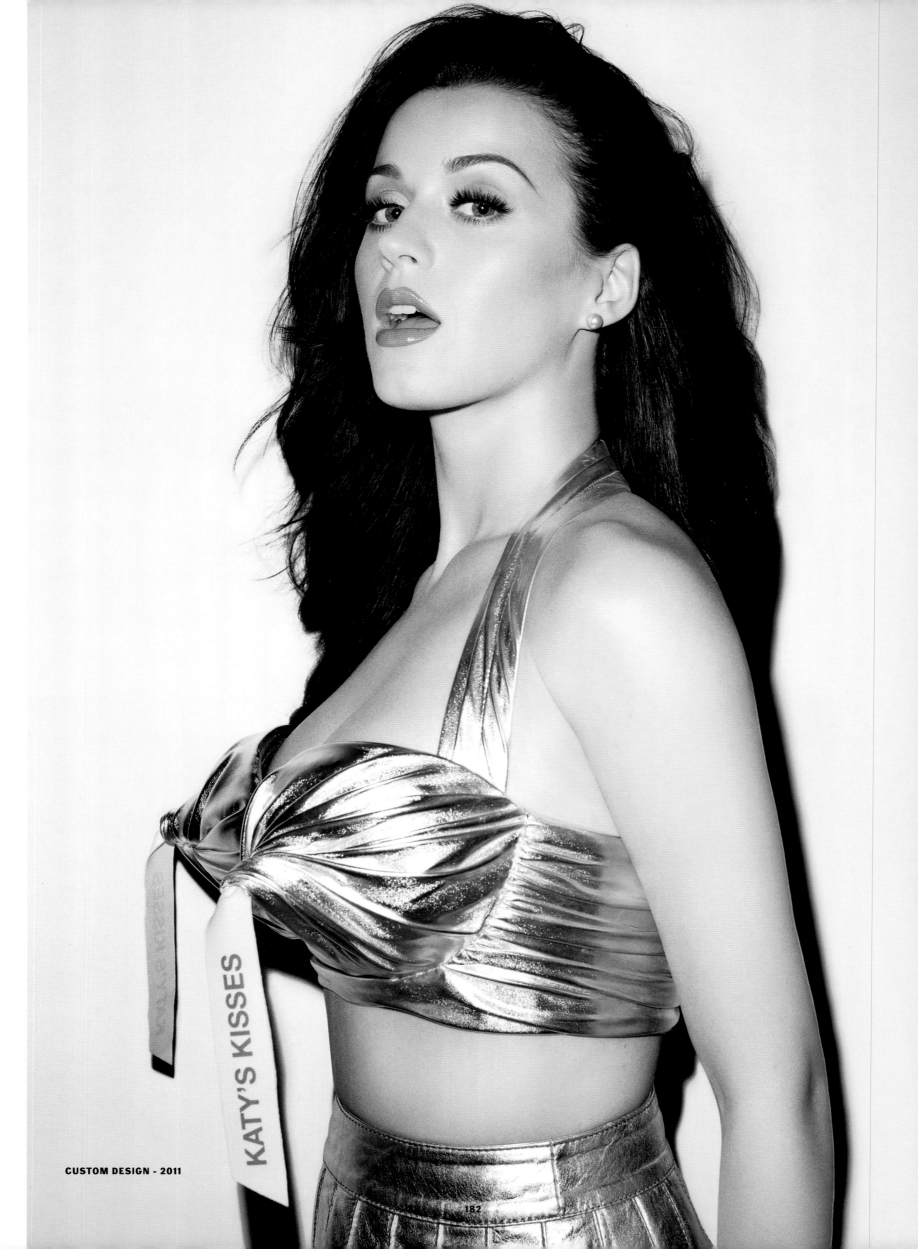

KATY'S KISSES

CUSTOM DESIGN - 2011

182

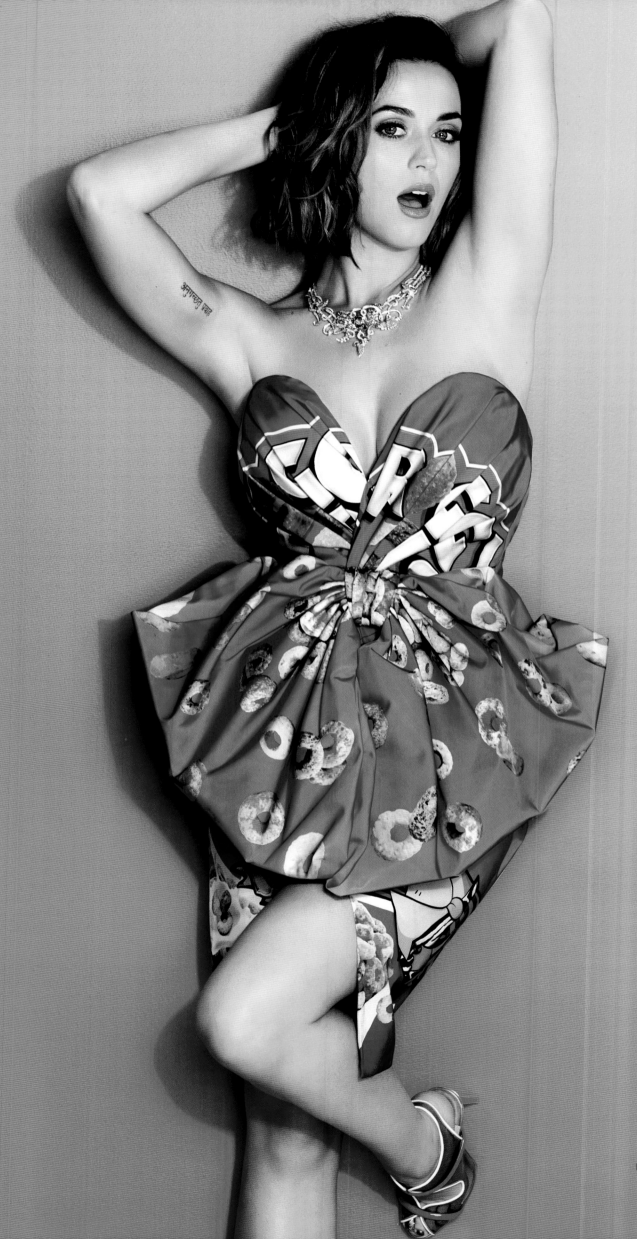

MOSCHINO - F/W 2014

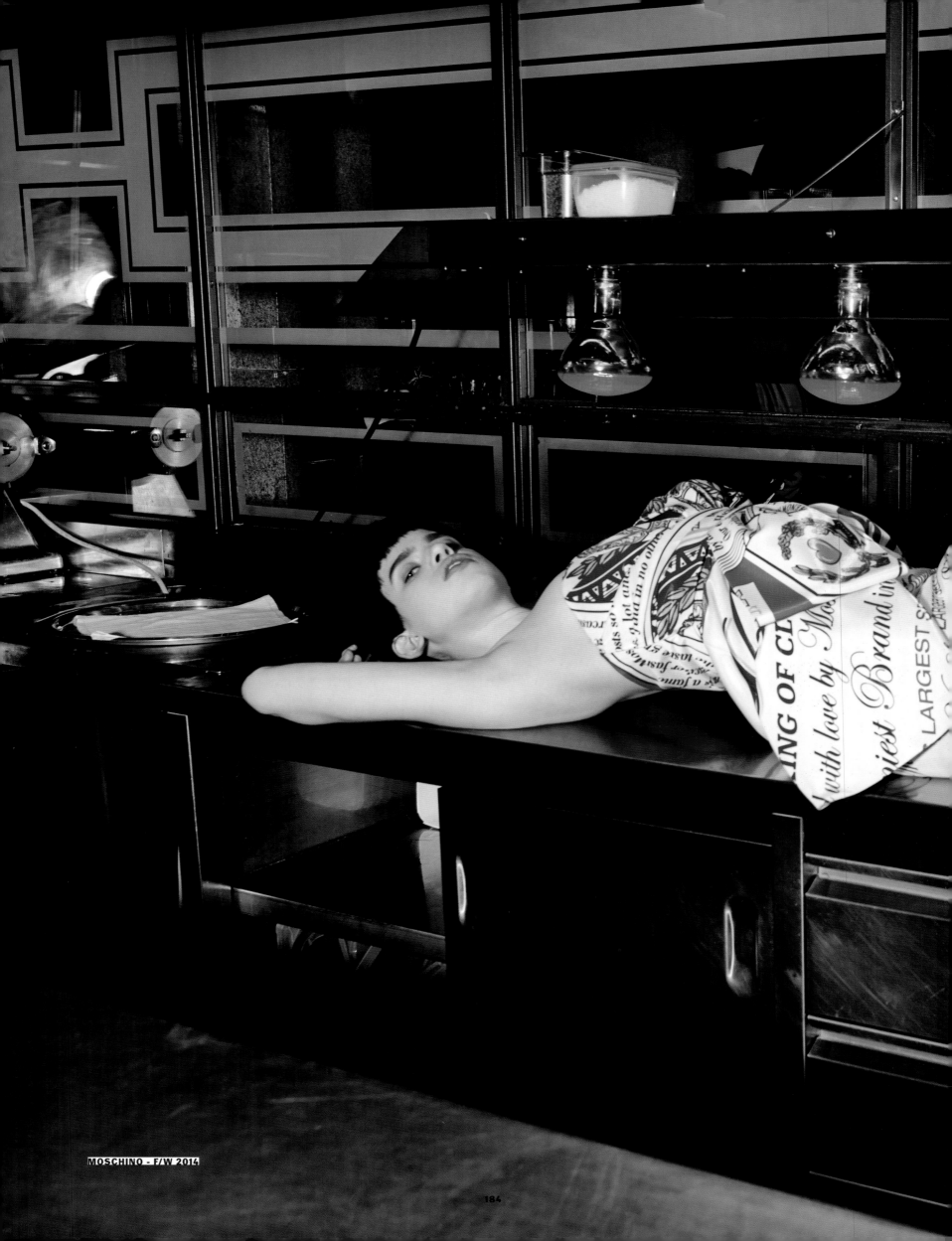

MOSCHINO - F/W 2014

184

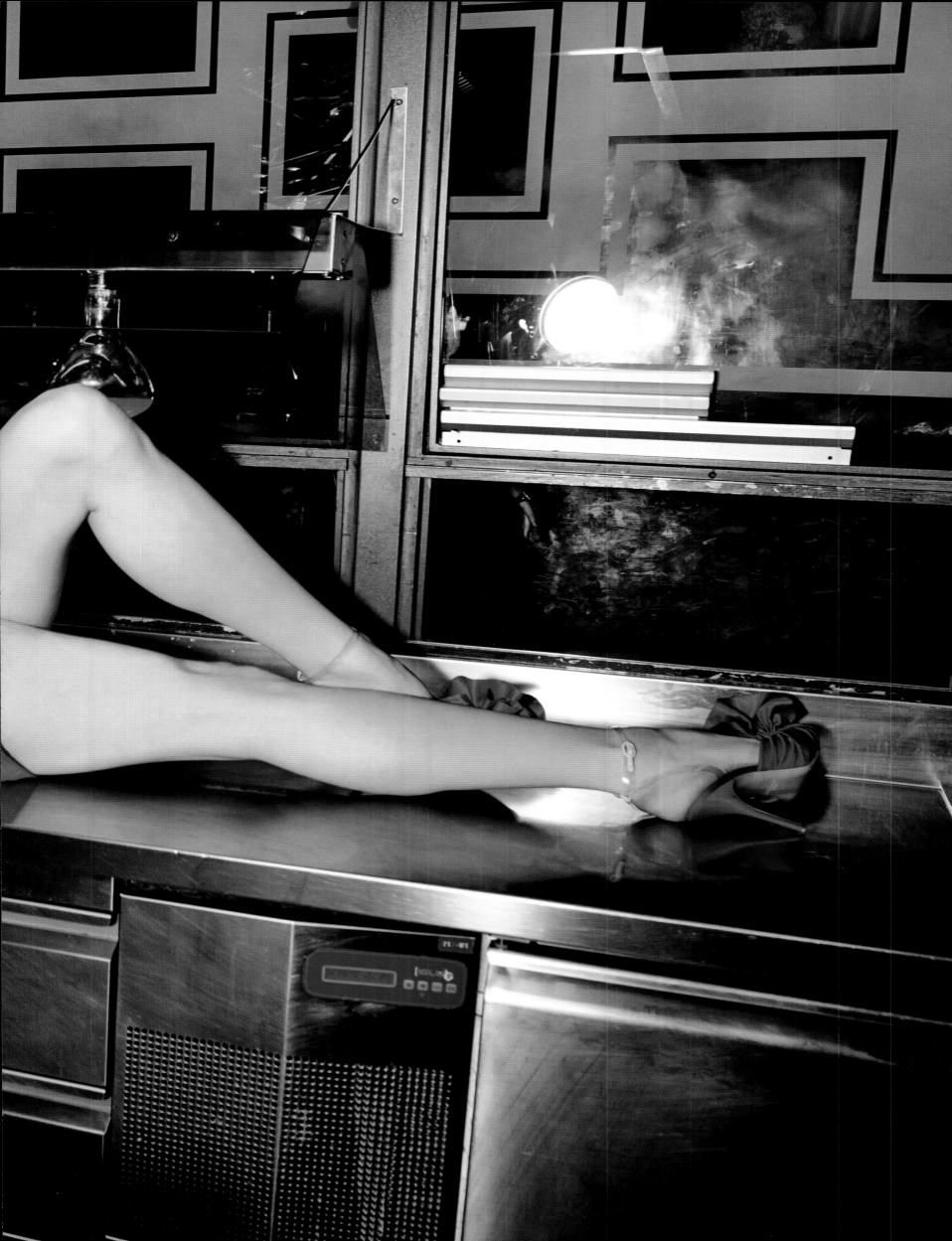

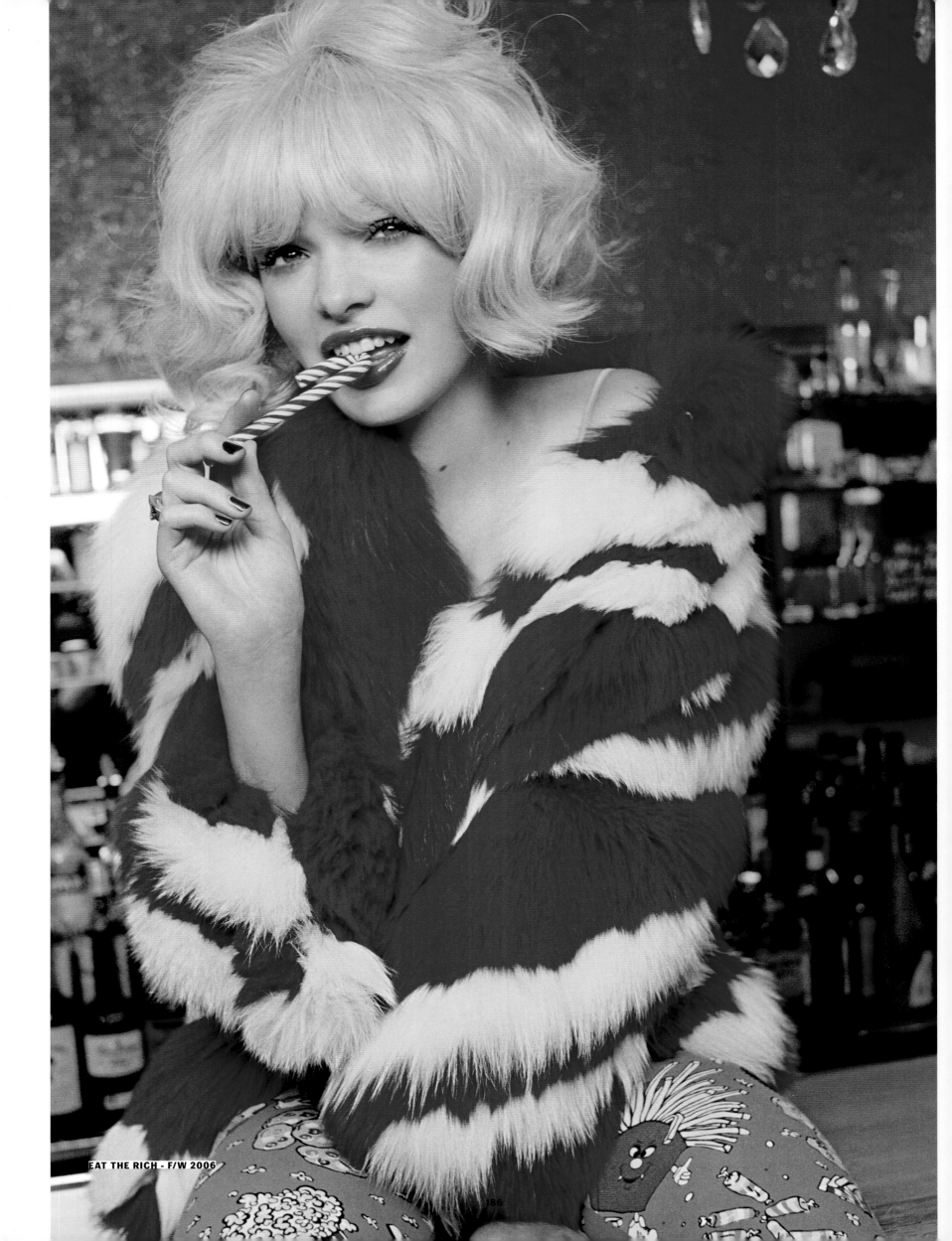

EAT THE RICH - F/W 2006

186

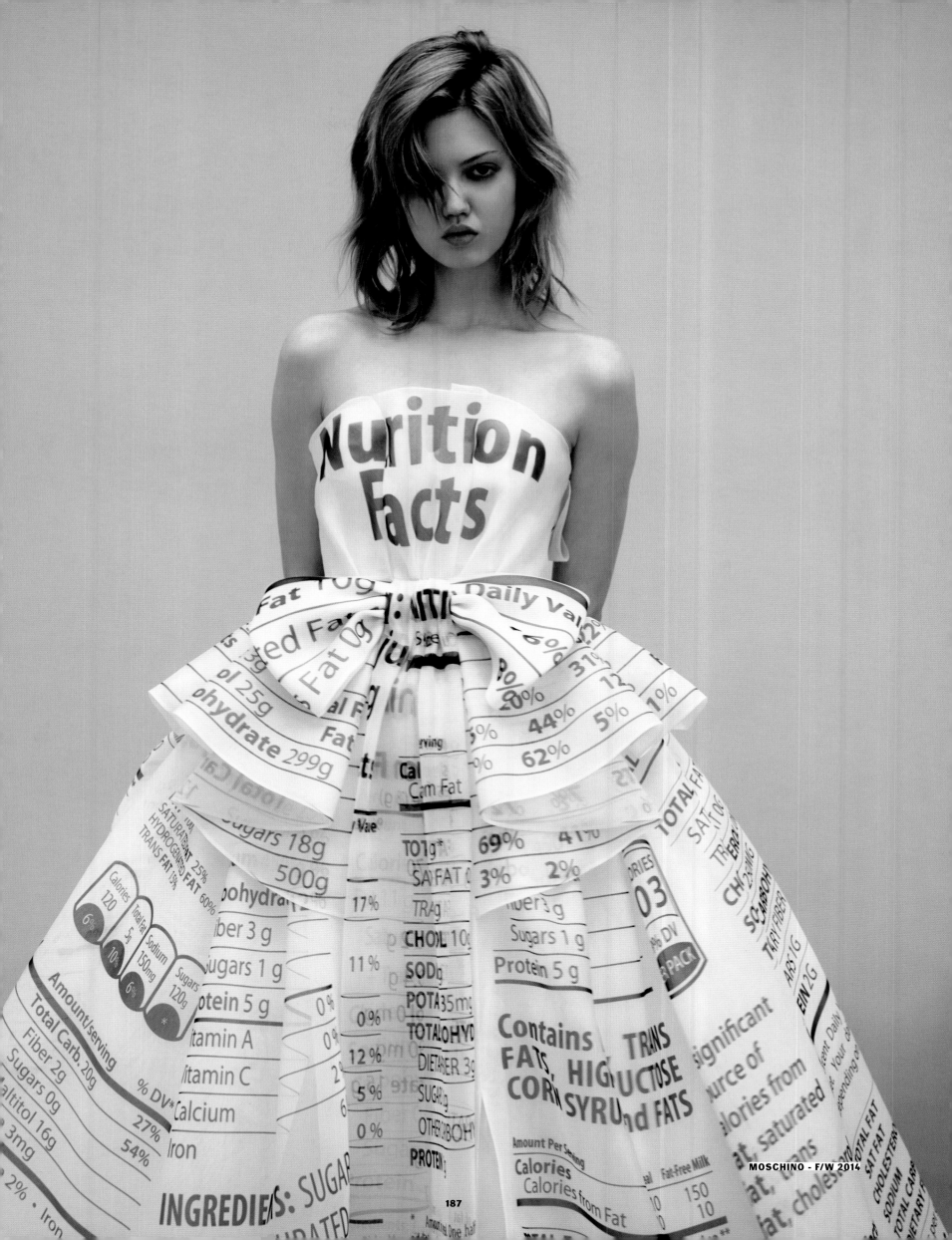

MOSCHINO - F/W 2014

187

SEXYBITION

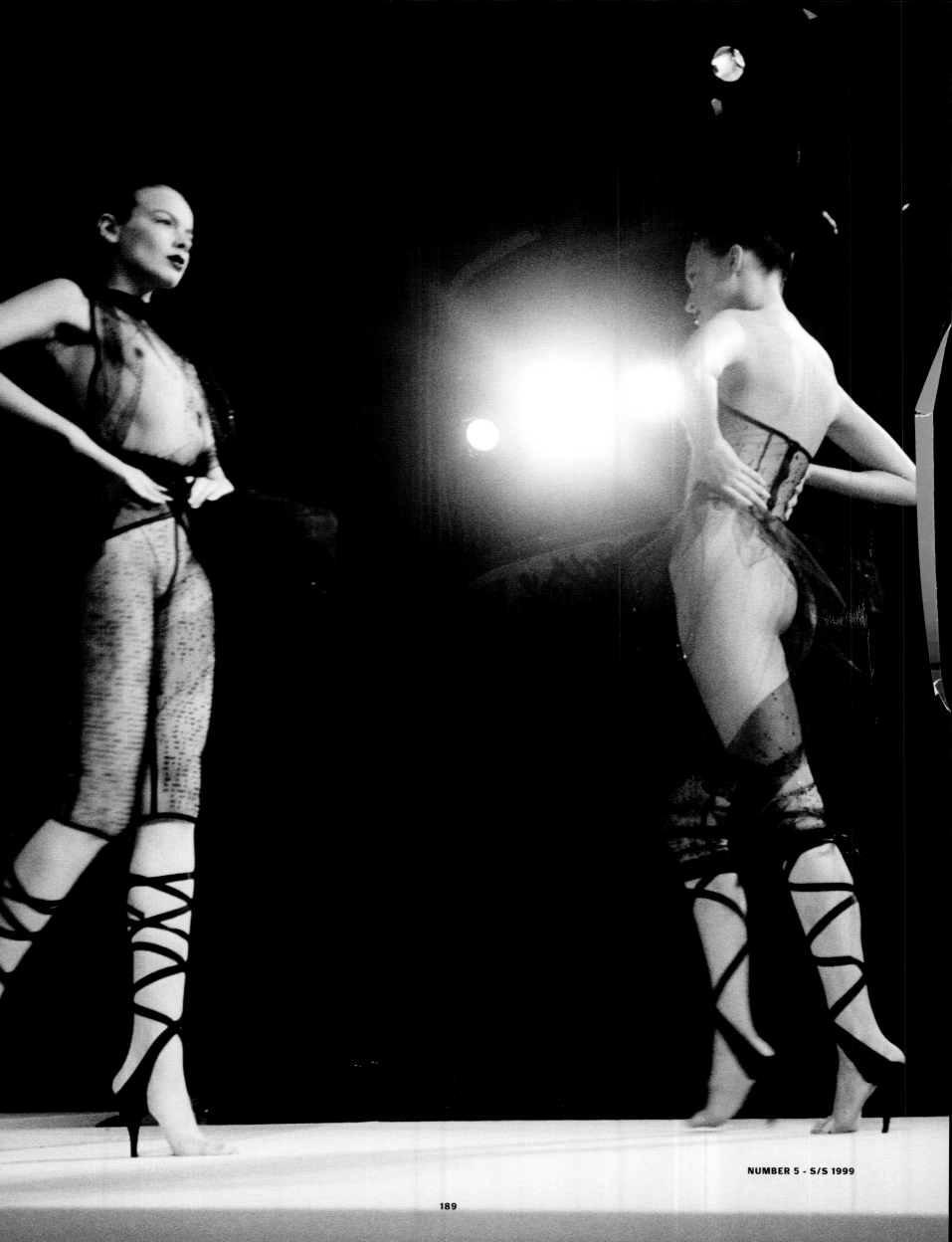

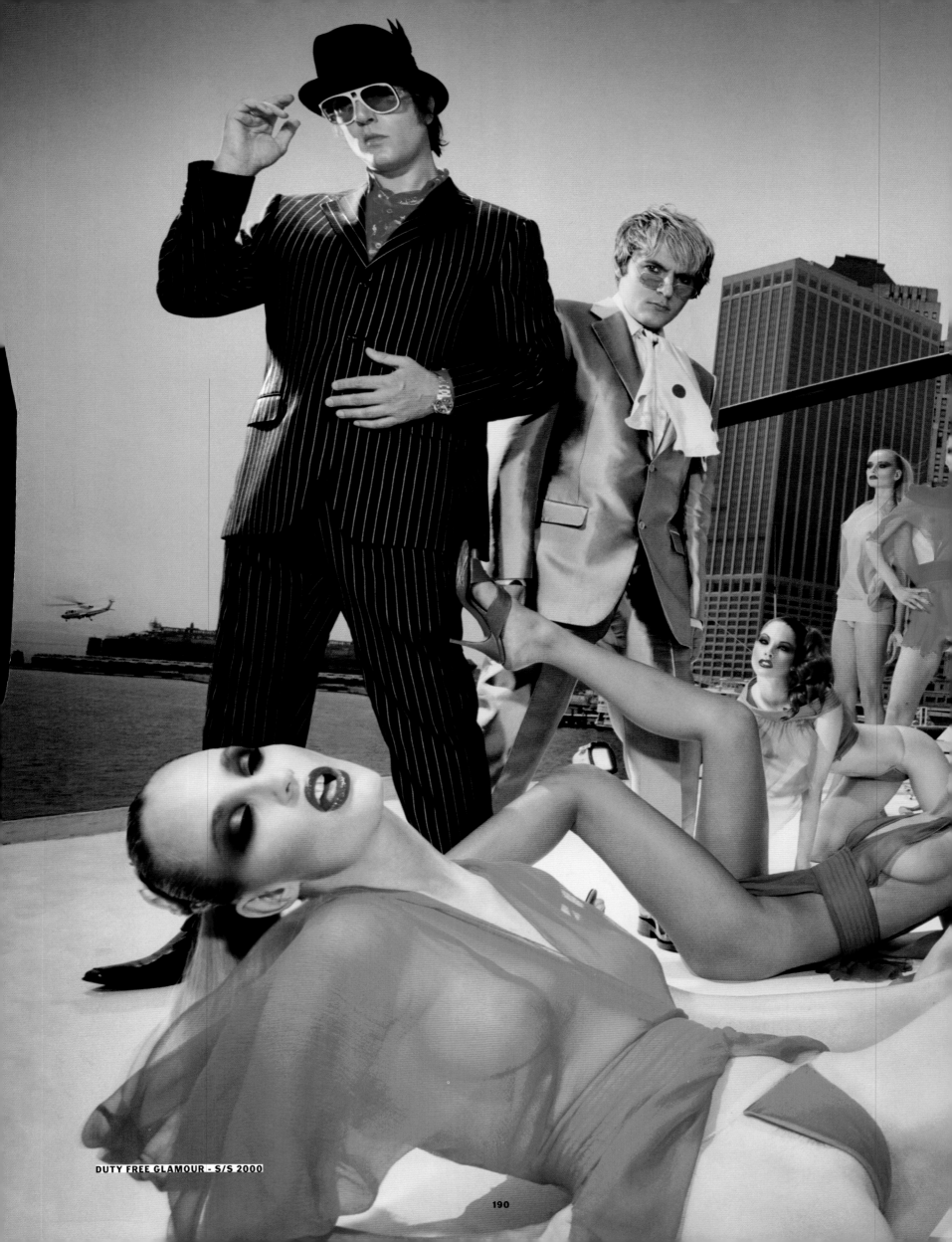

DUTY FREE GLAMOUR - S/S 2000

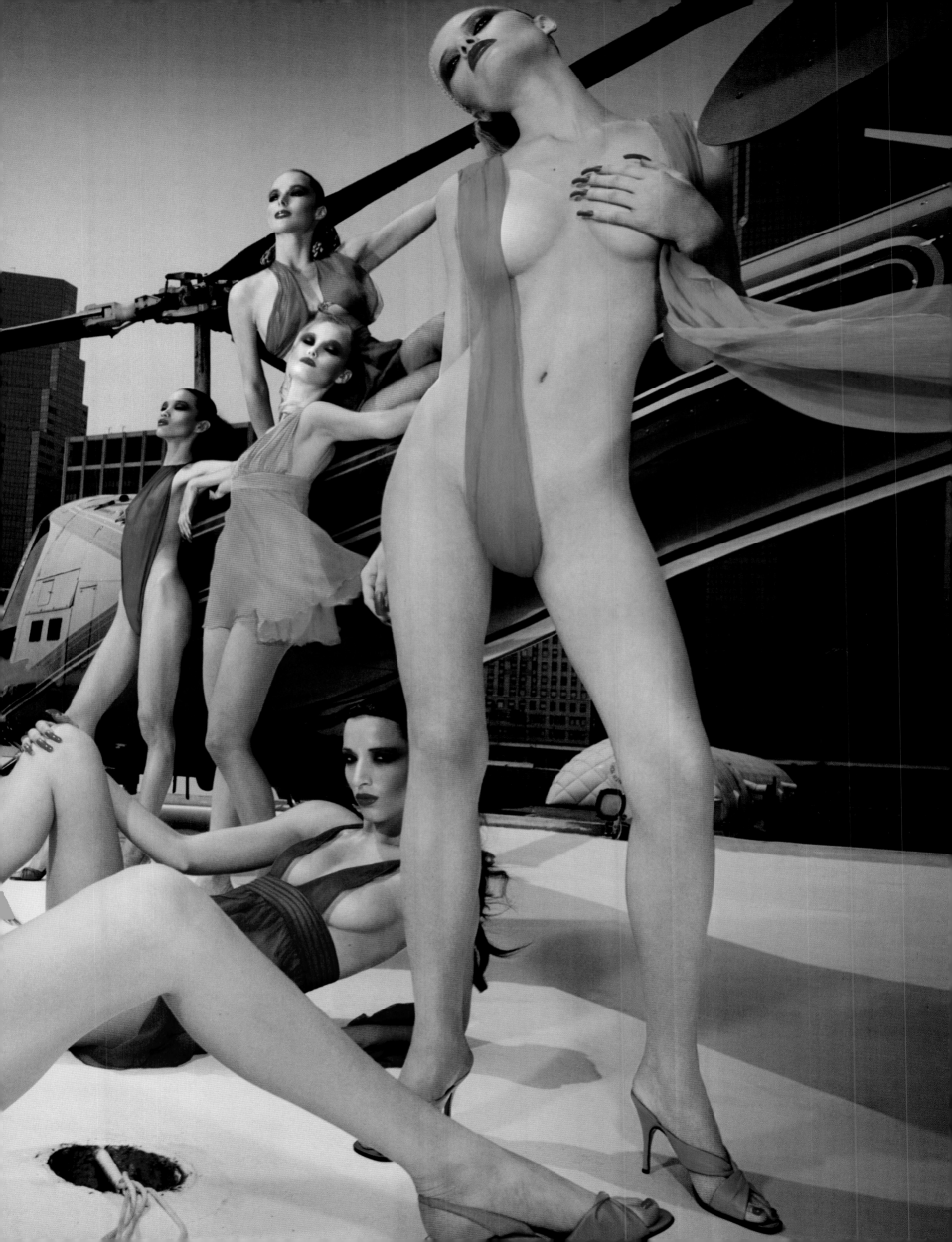

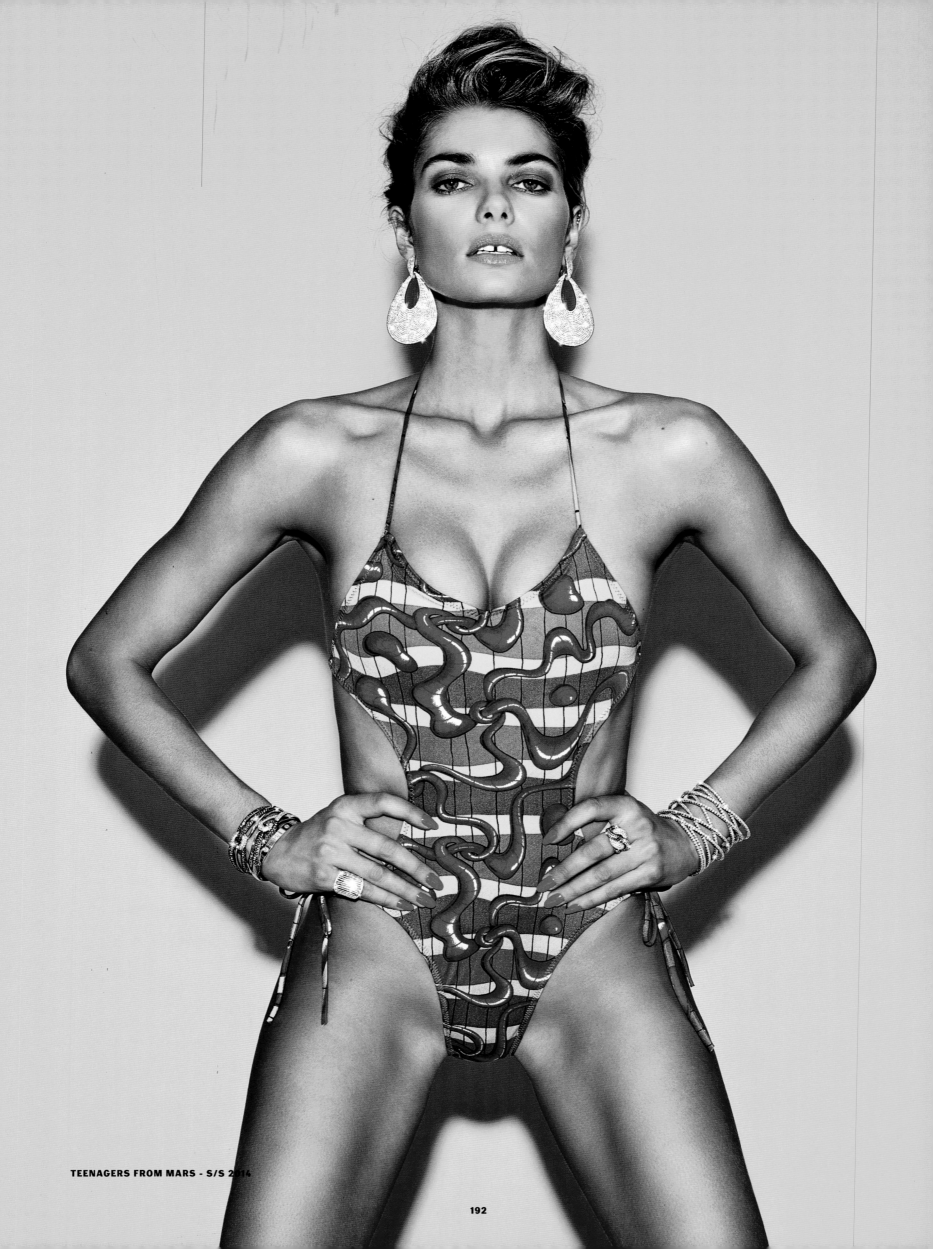

TEENAGERS FROM MARS - S/S 2014

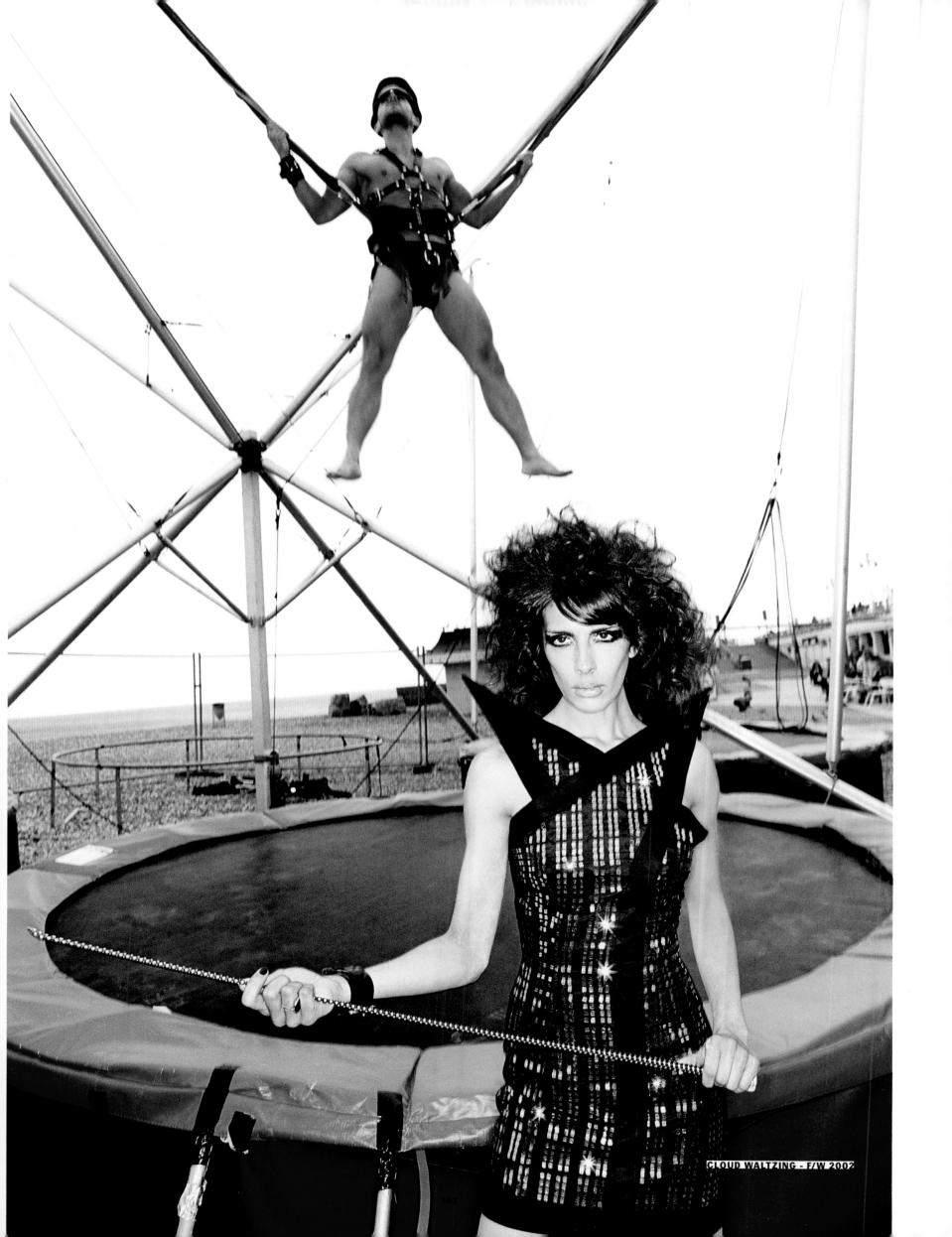

CLOUD WALTZING - F/W 2002

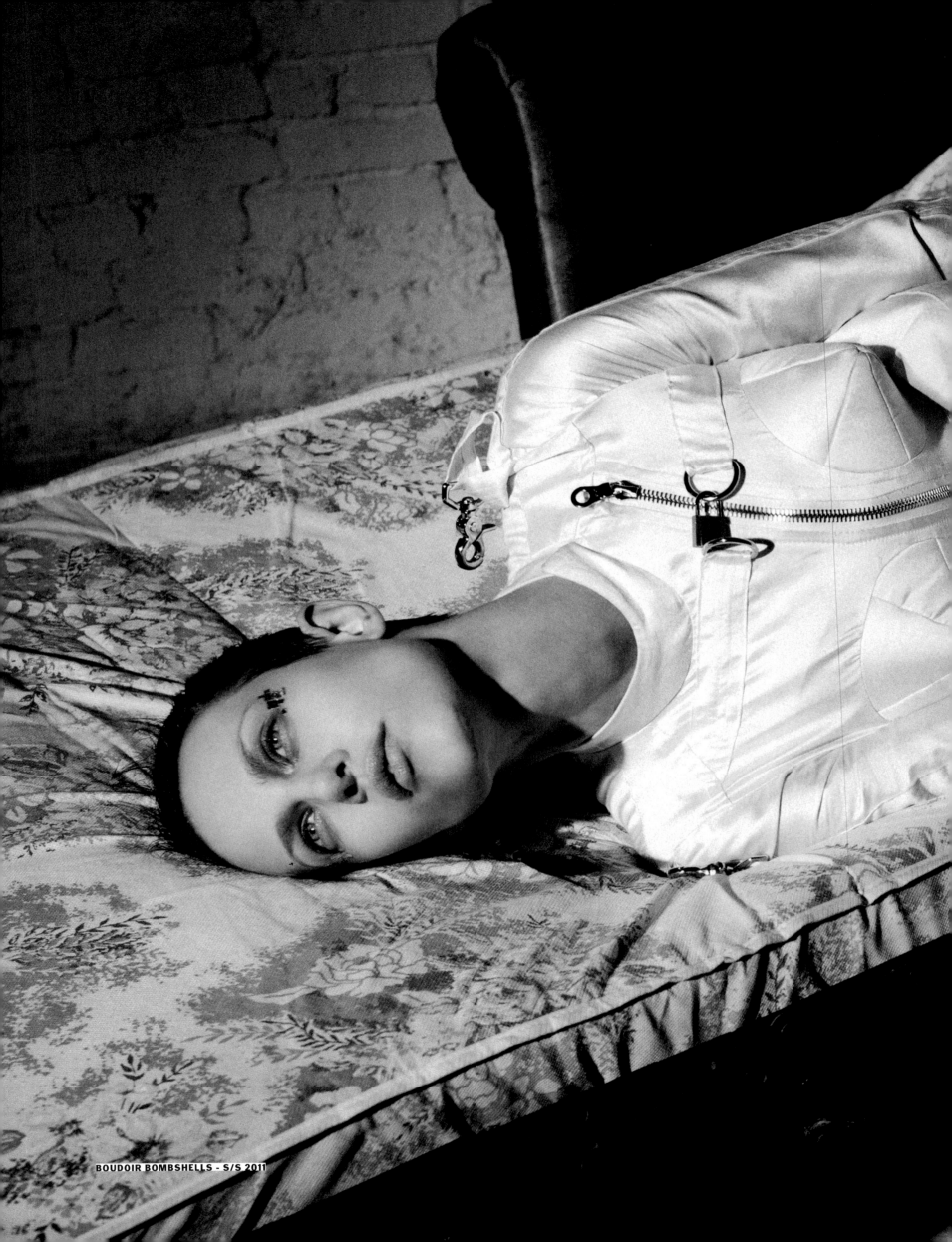

KAREN

Natasha 19

ANOUK 40

OLUCHI 28

RAQUEL Z 26

Inga 43

Nicola 23

RIE 22

OLUCHI 12

VENUS RISING - S/S 2003

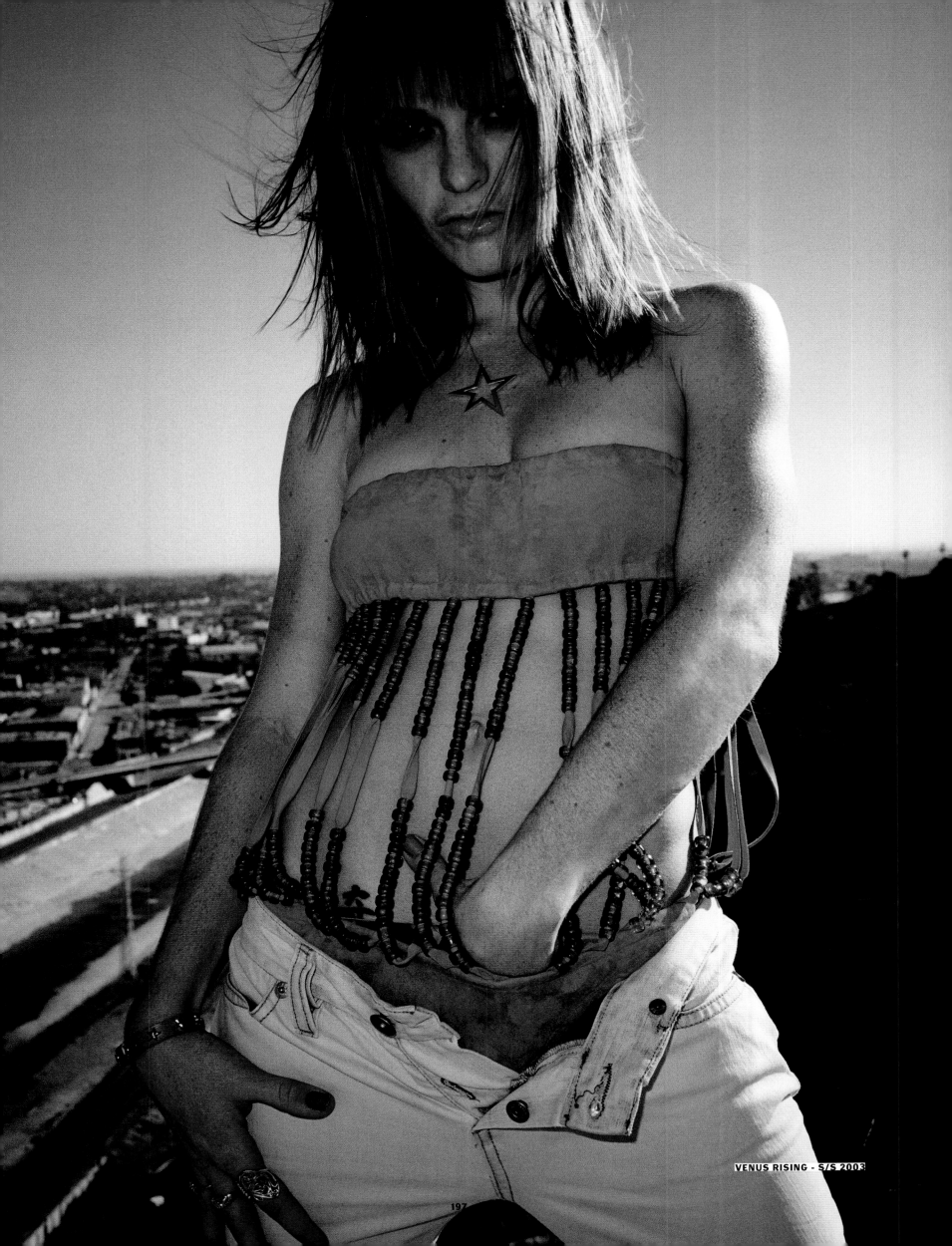

197

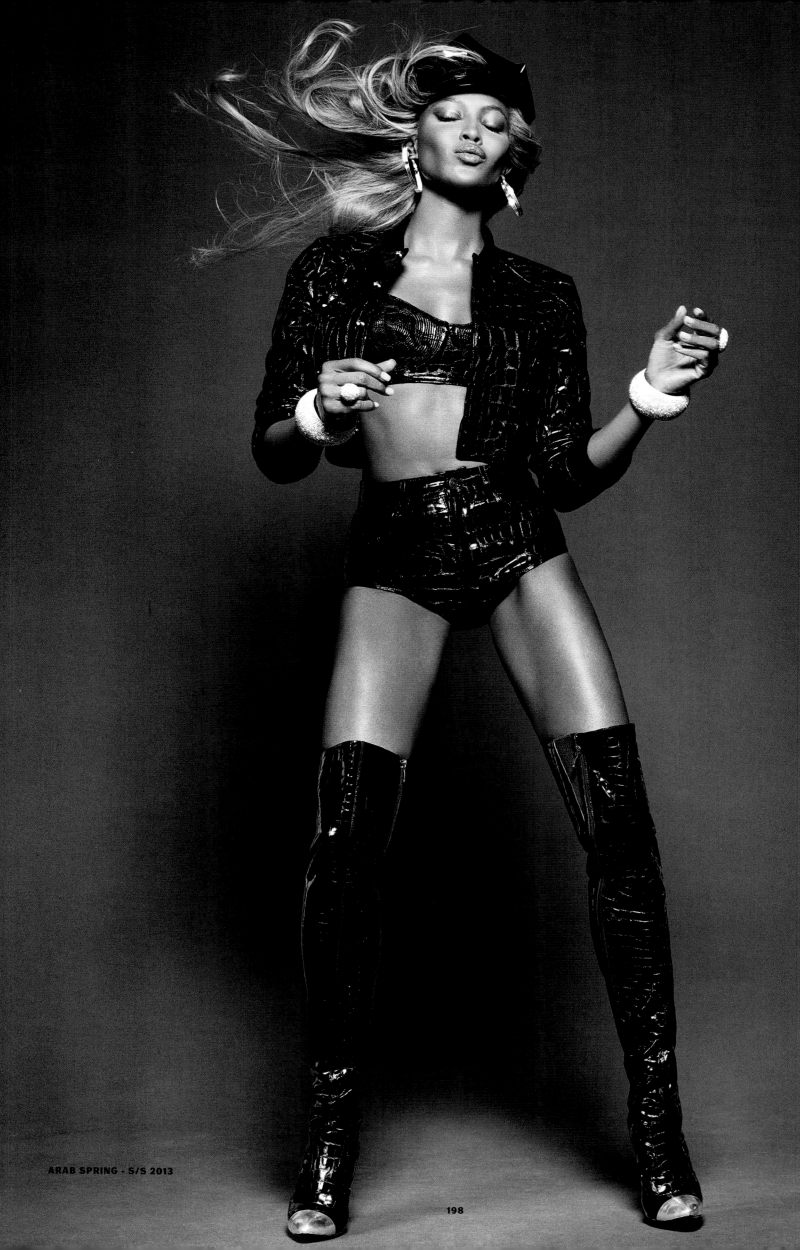

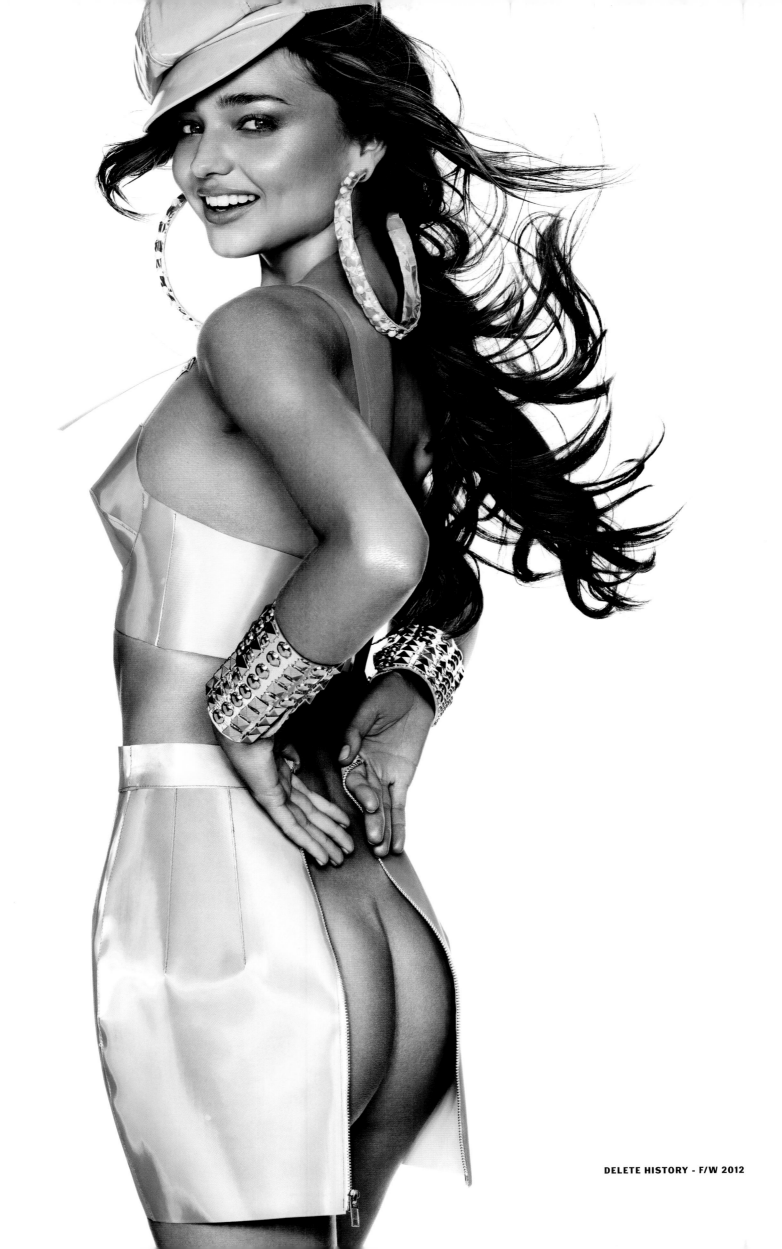

DELETE HISTORY - F/W 2012

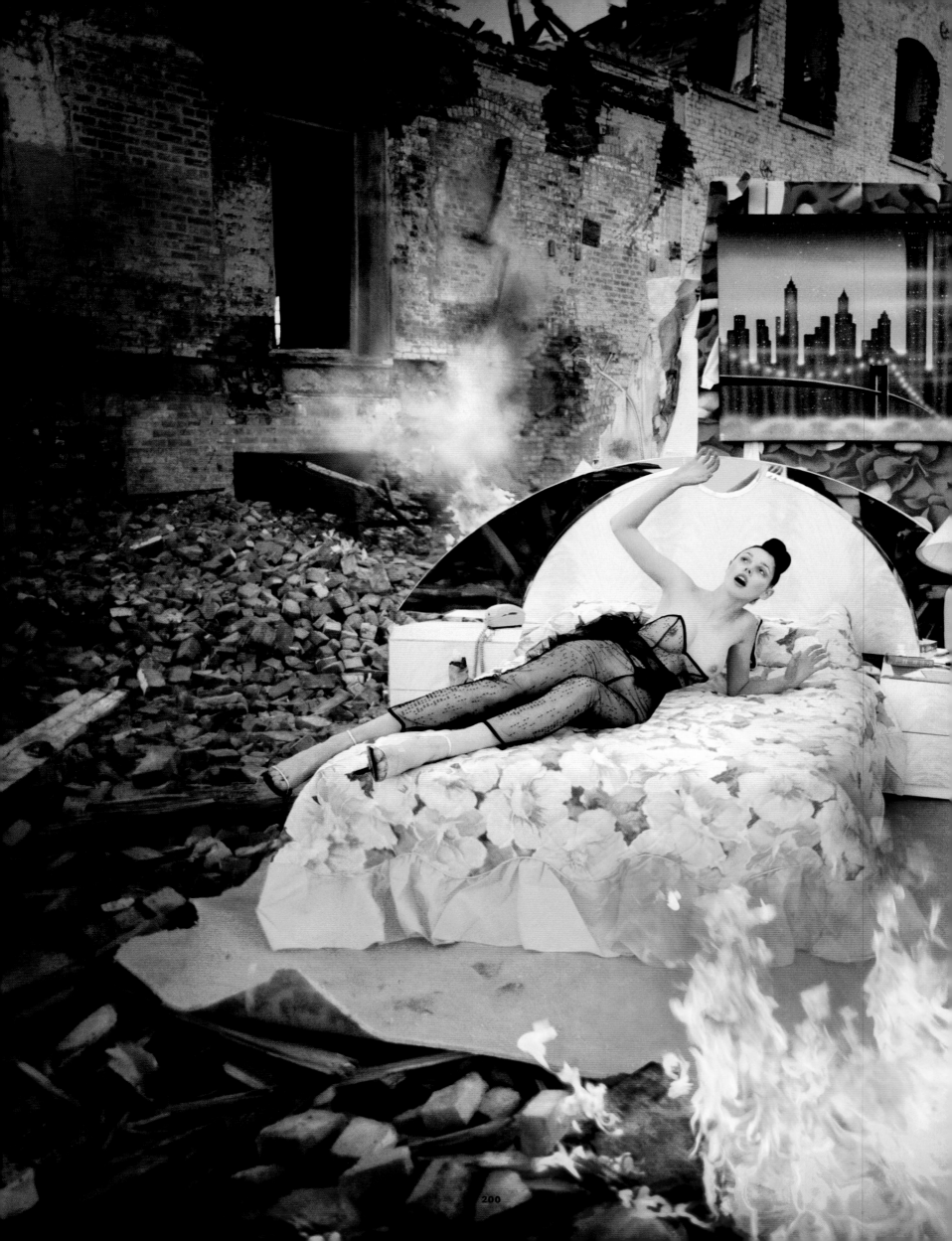

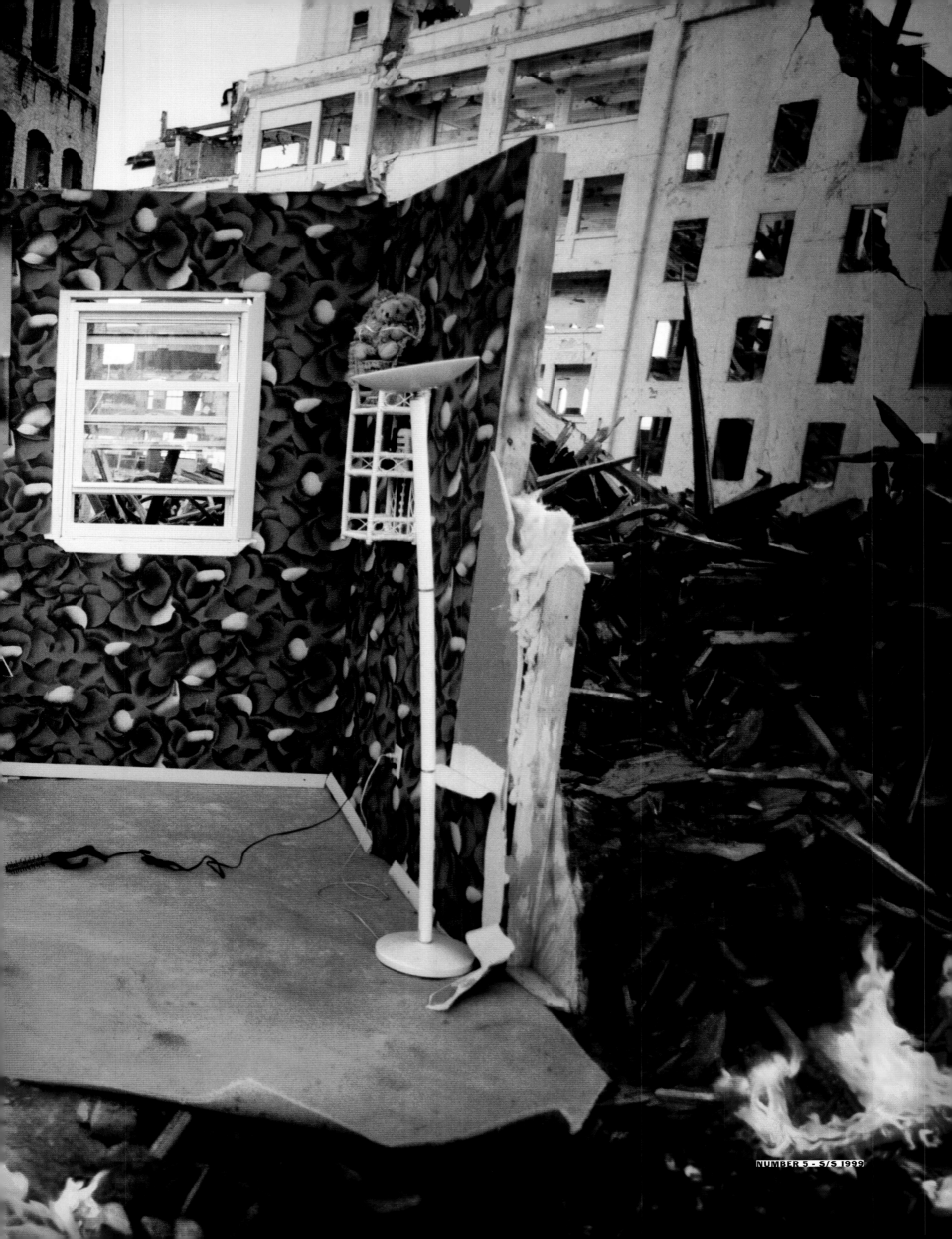

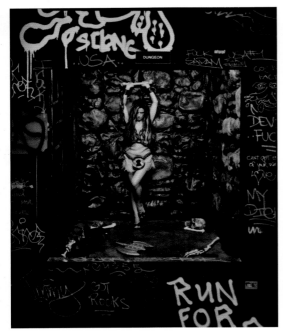
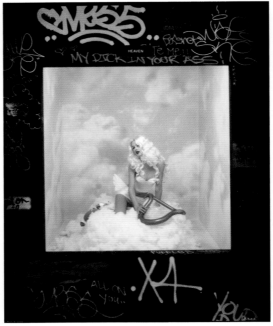
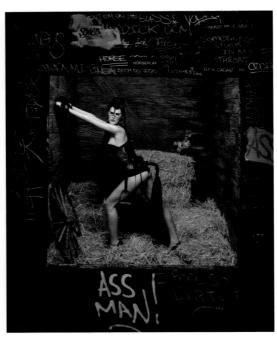
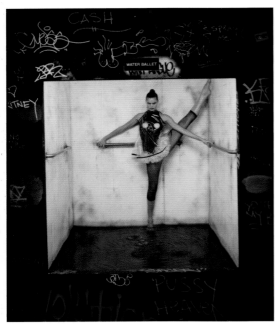
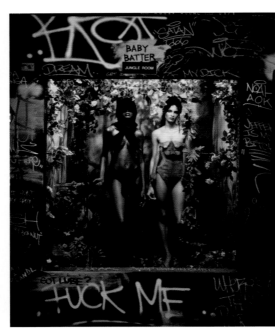
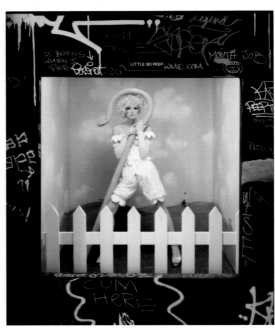
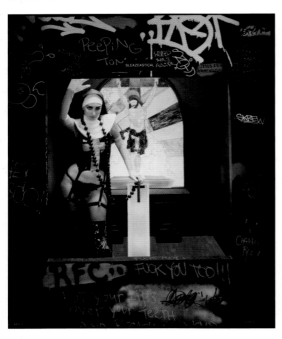
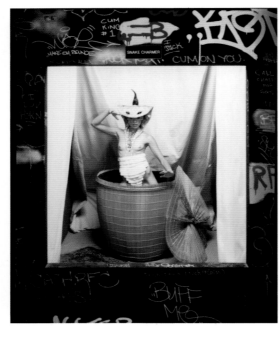
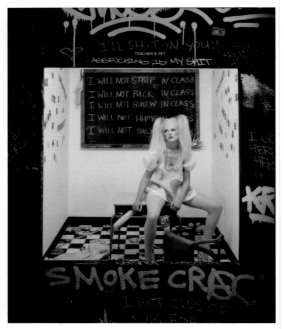

SEXYBITION - S/S 2004

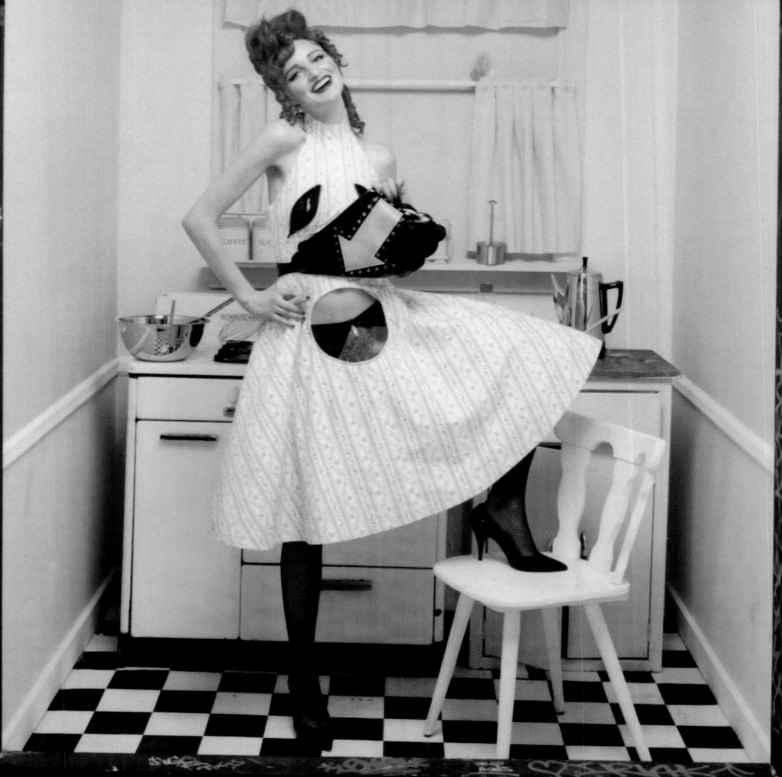

WHAT'S COOKING?

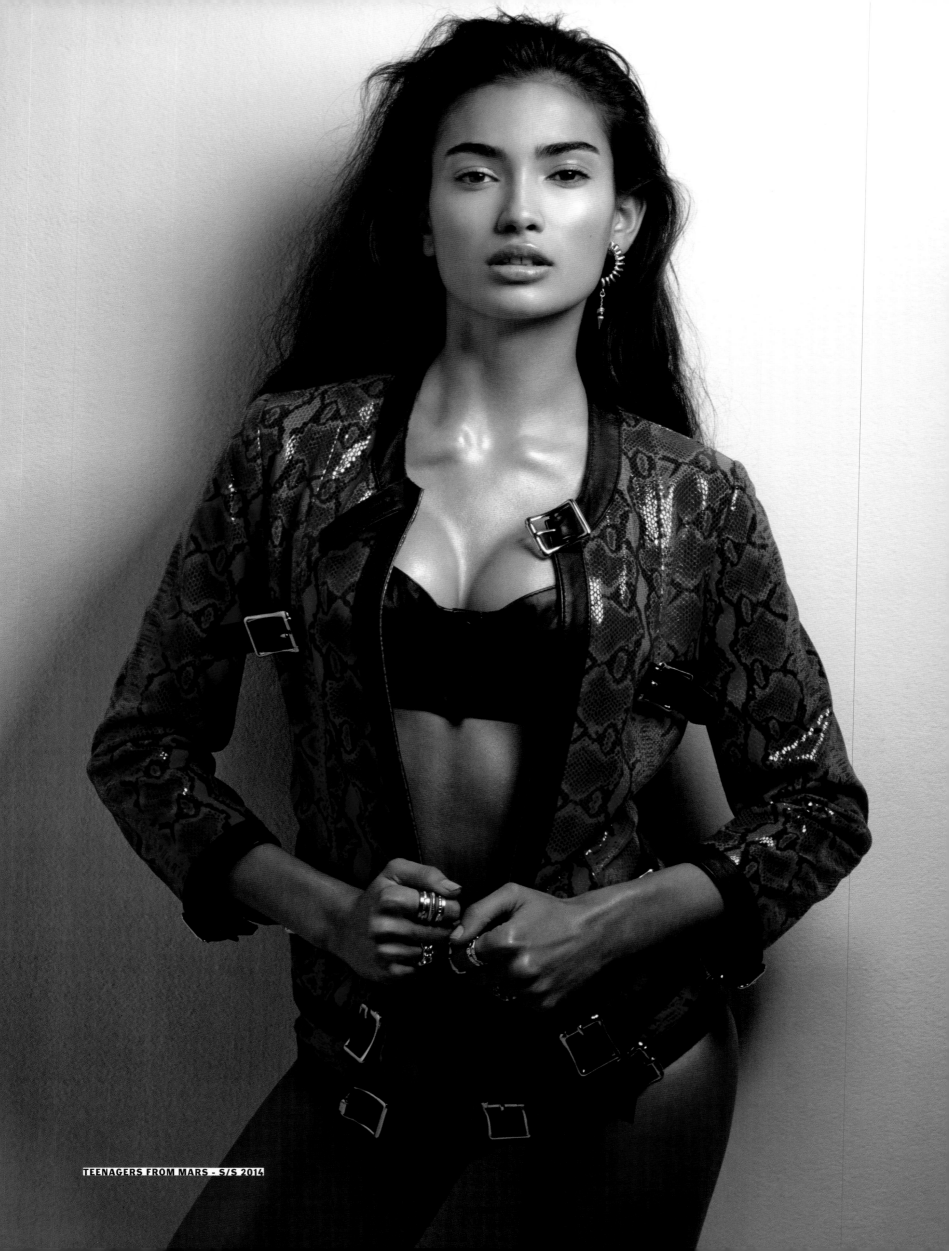

TEENAGERS FROM MARS - S/S 2014

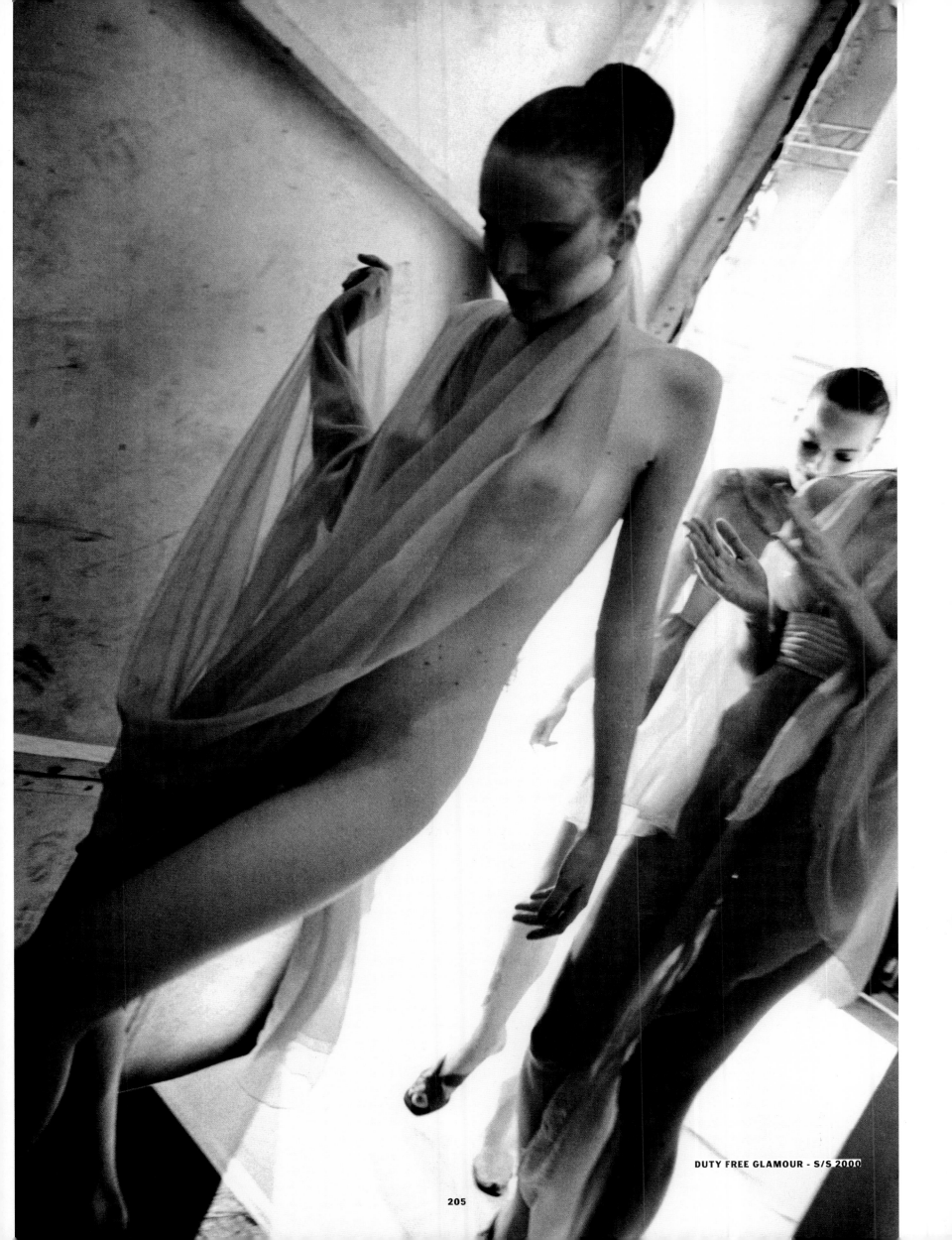

DUTY FREE GLAMOUR - S/S 2000

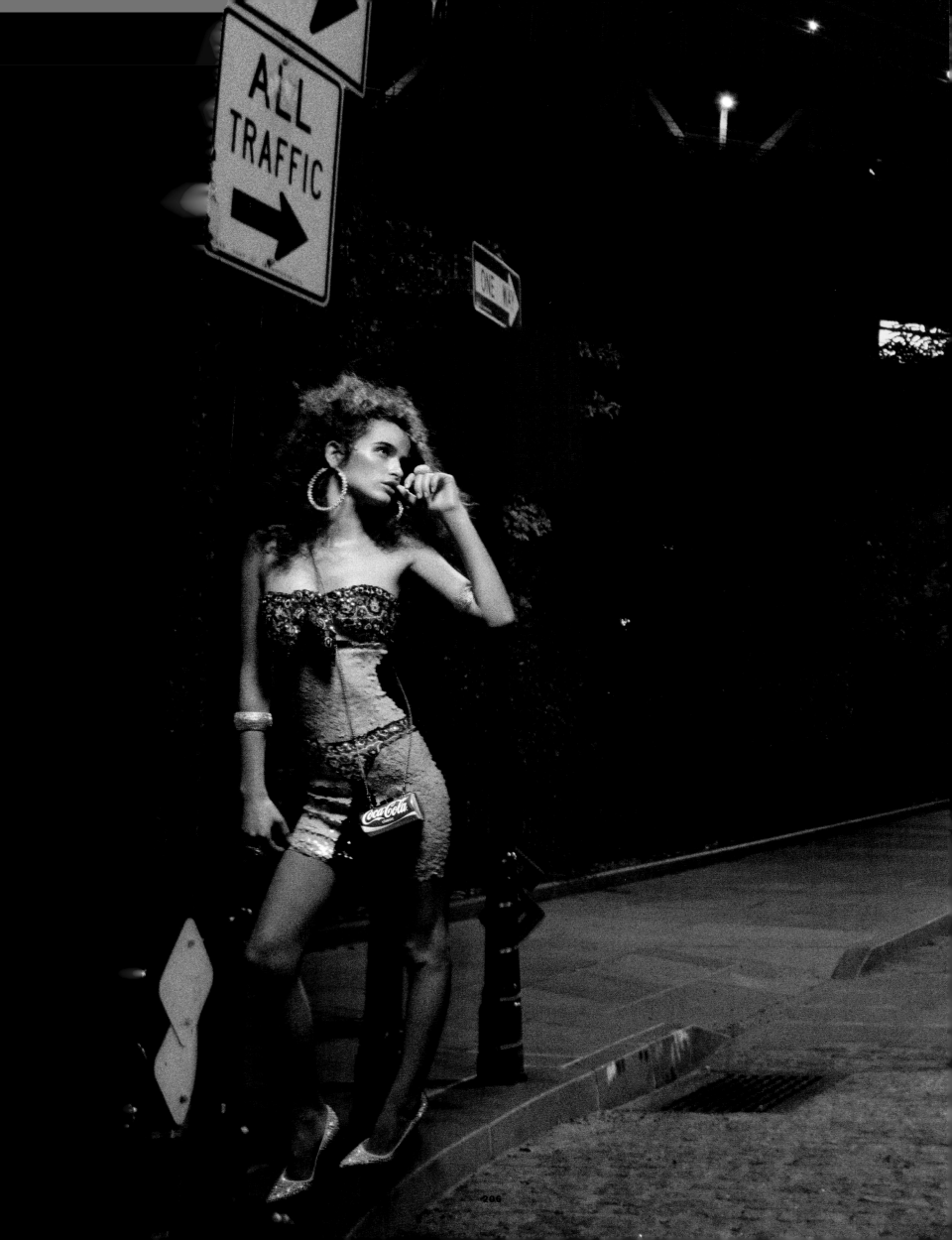

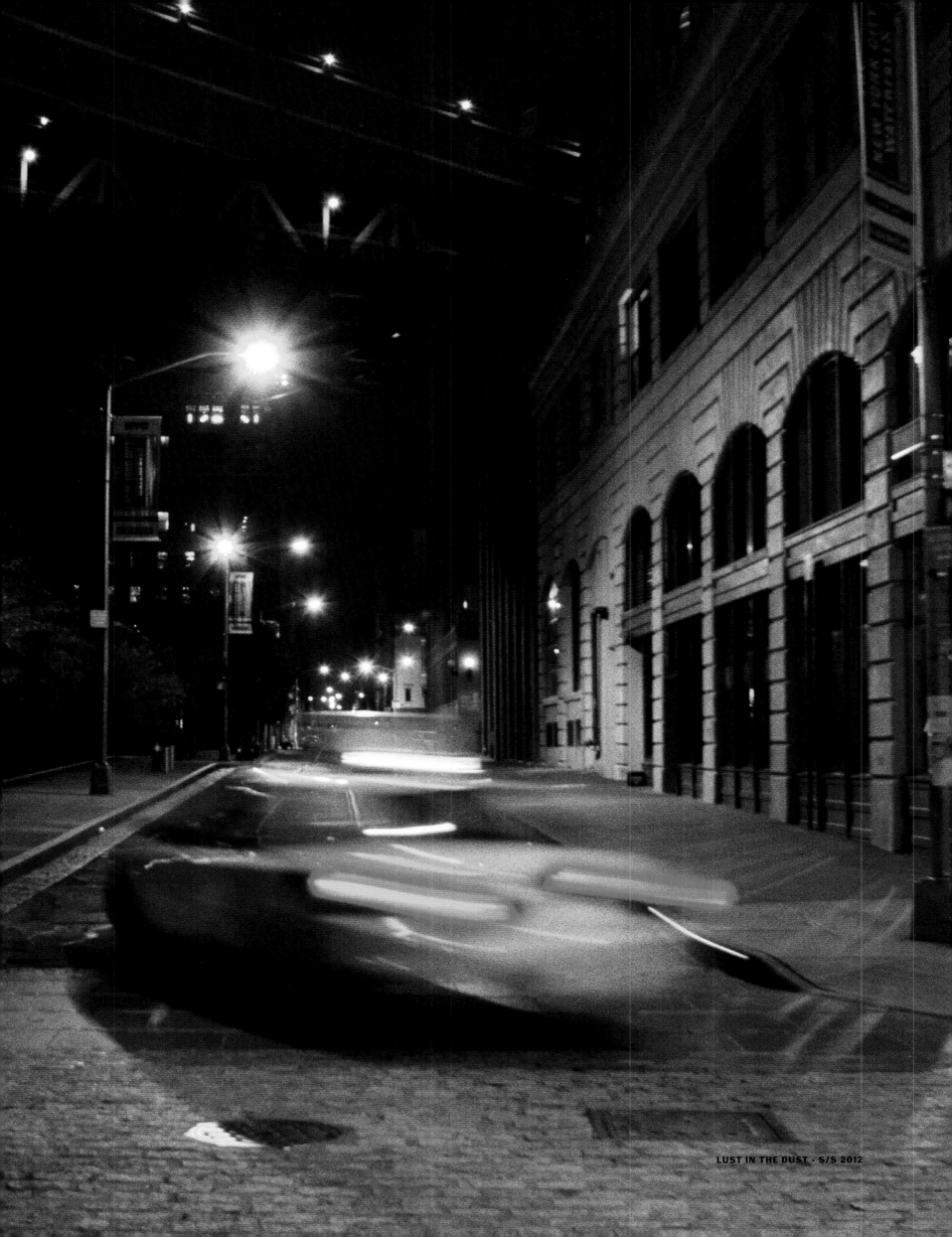

LUST IN THE DUST - S/S 2012

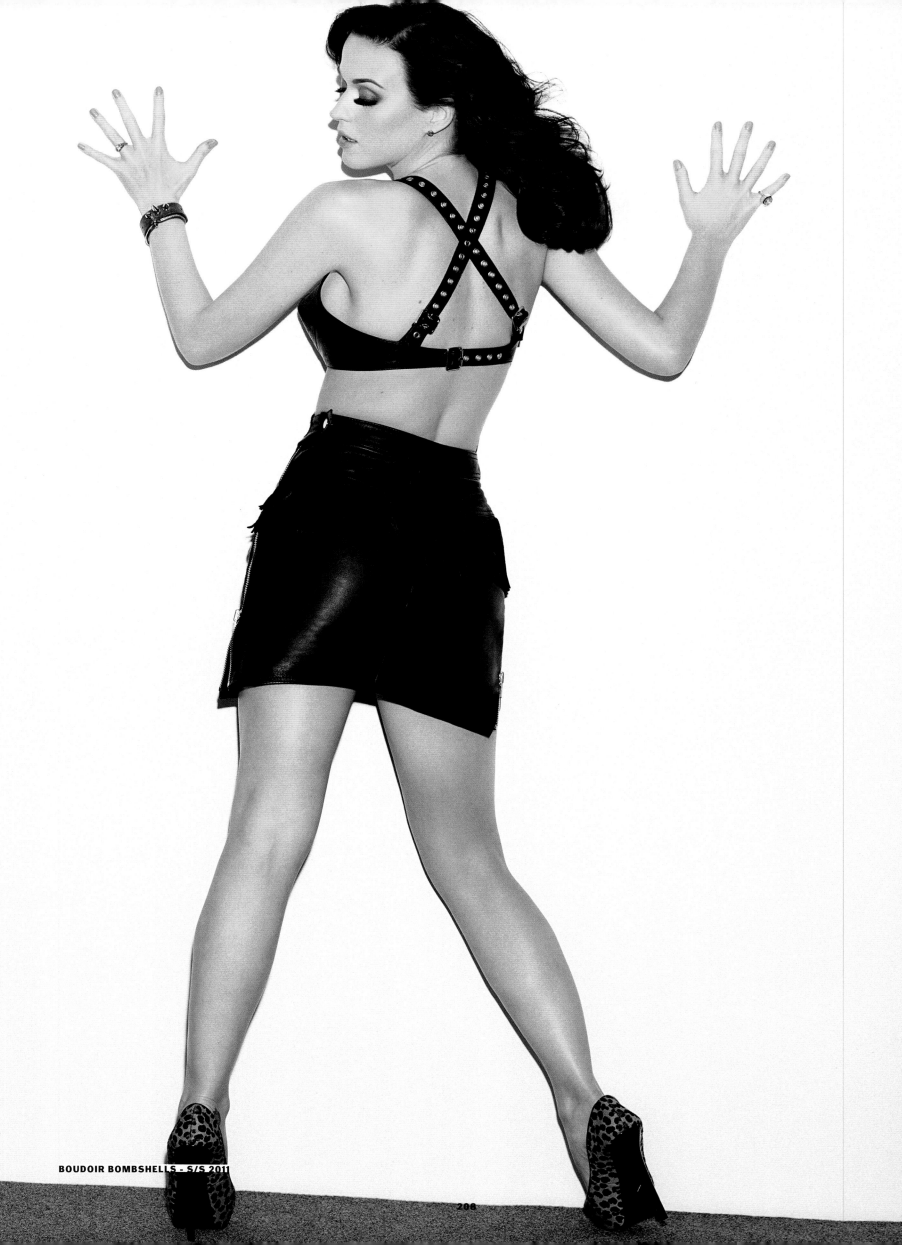

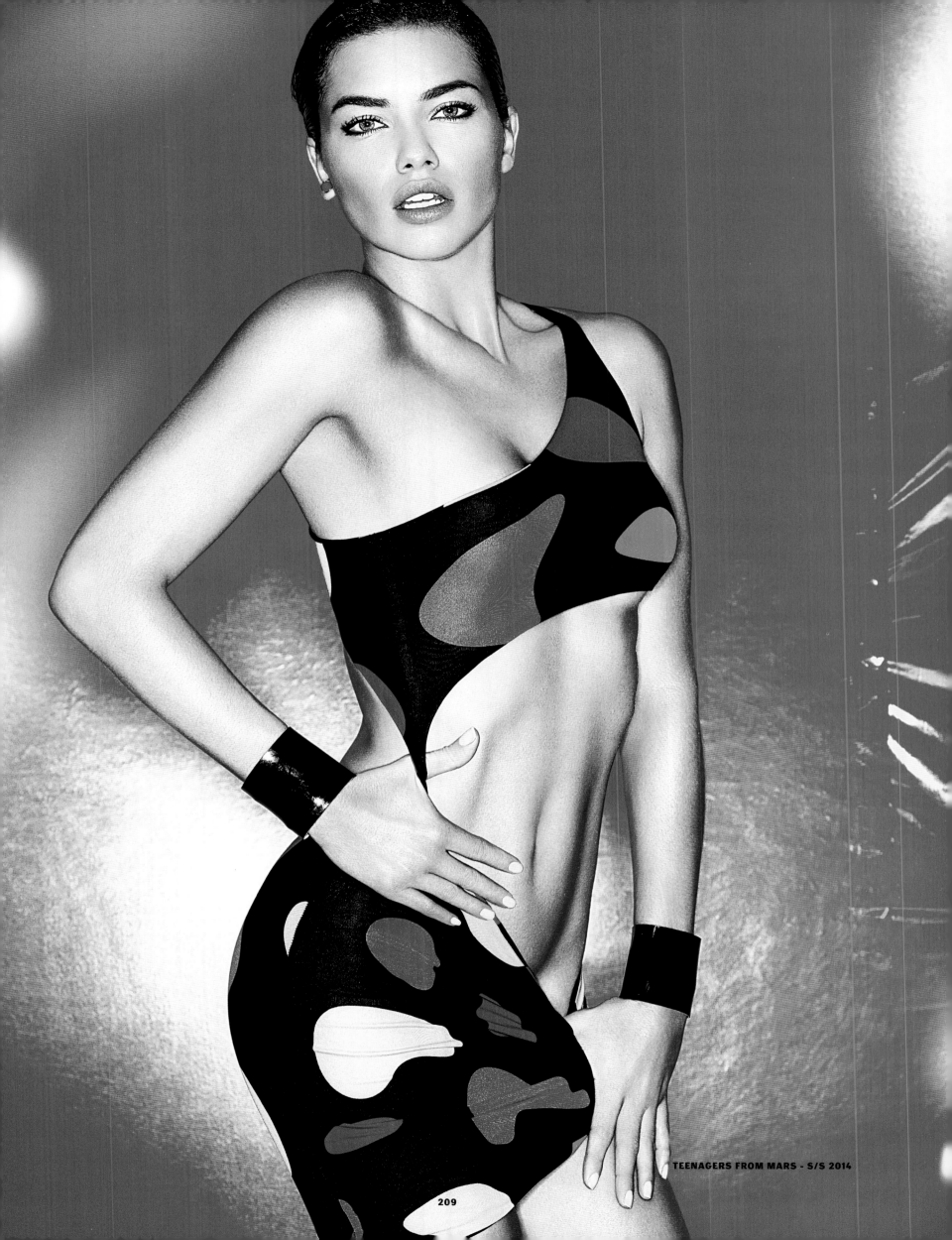

TEENAGERS FROM MARS - S/S 2014

209

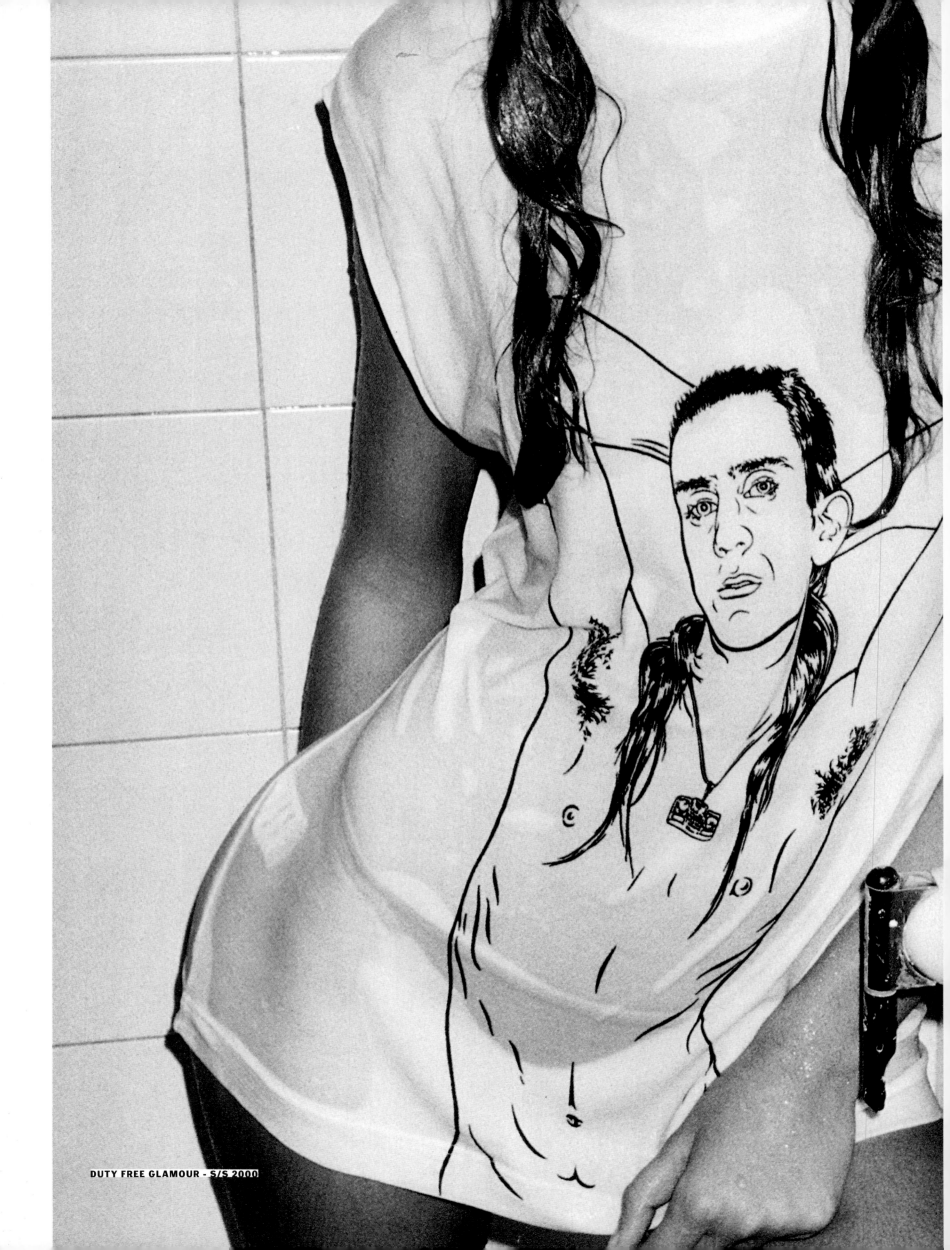

DUTY FREE GLAMOUR - S/S 2000

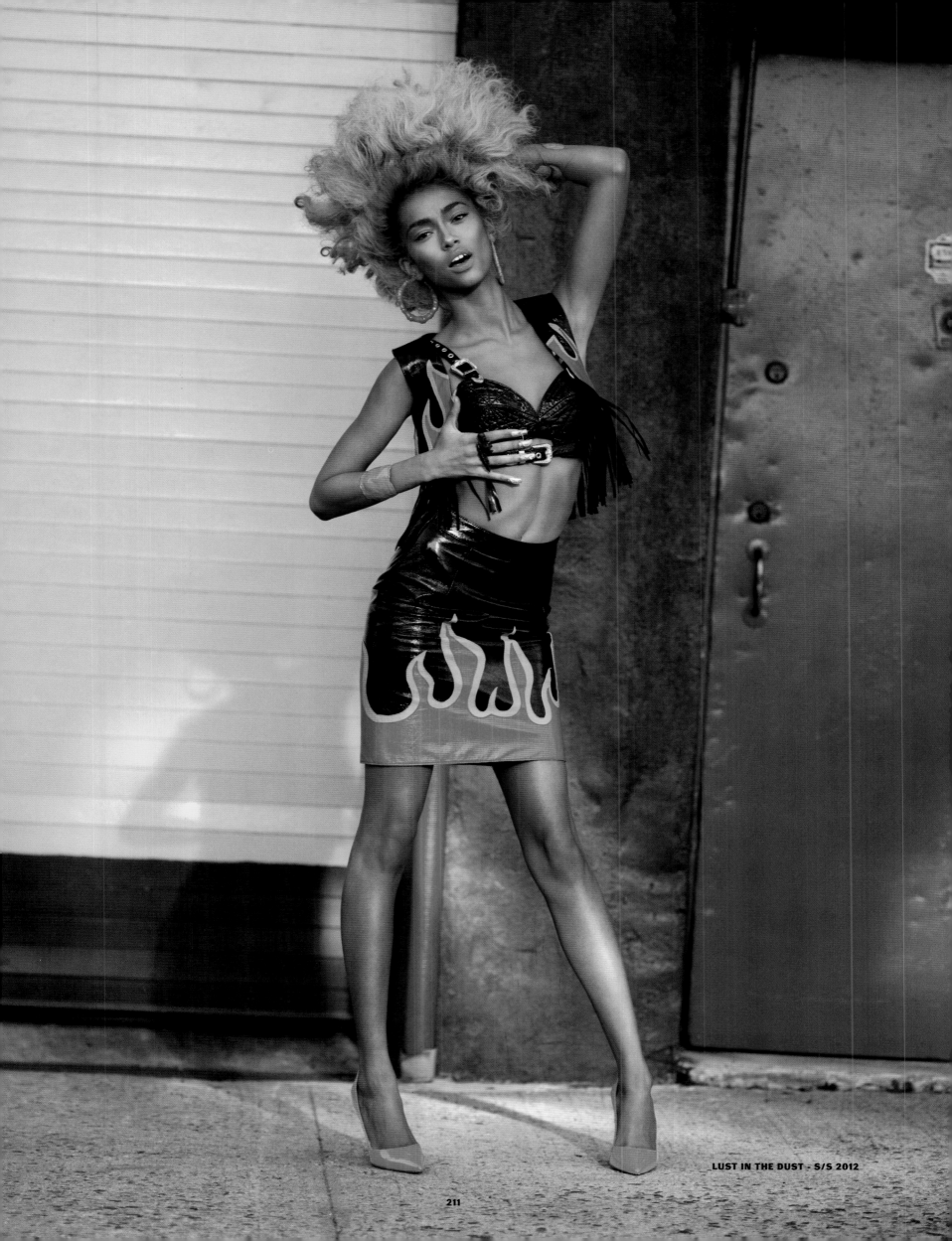

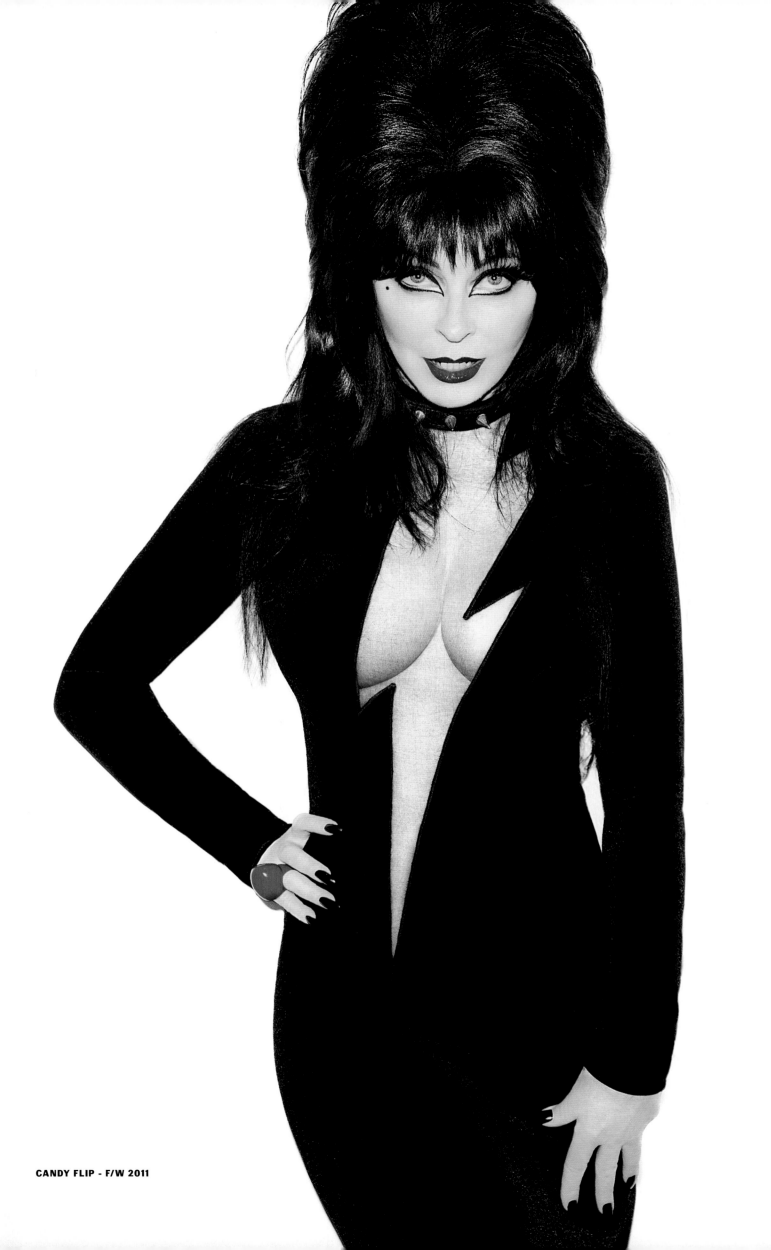

CANDY FLIP - F/W 2011

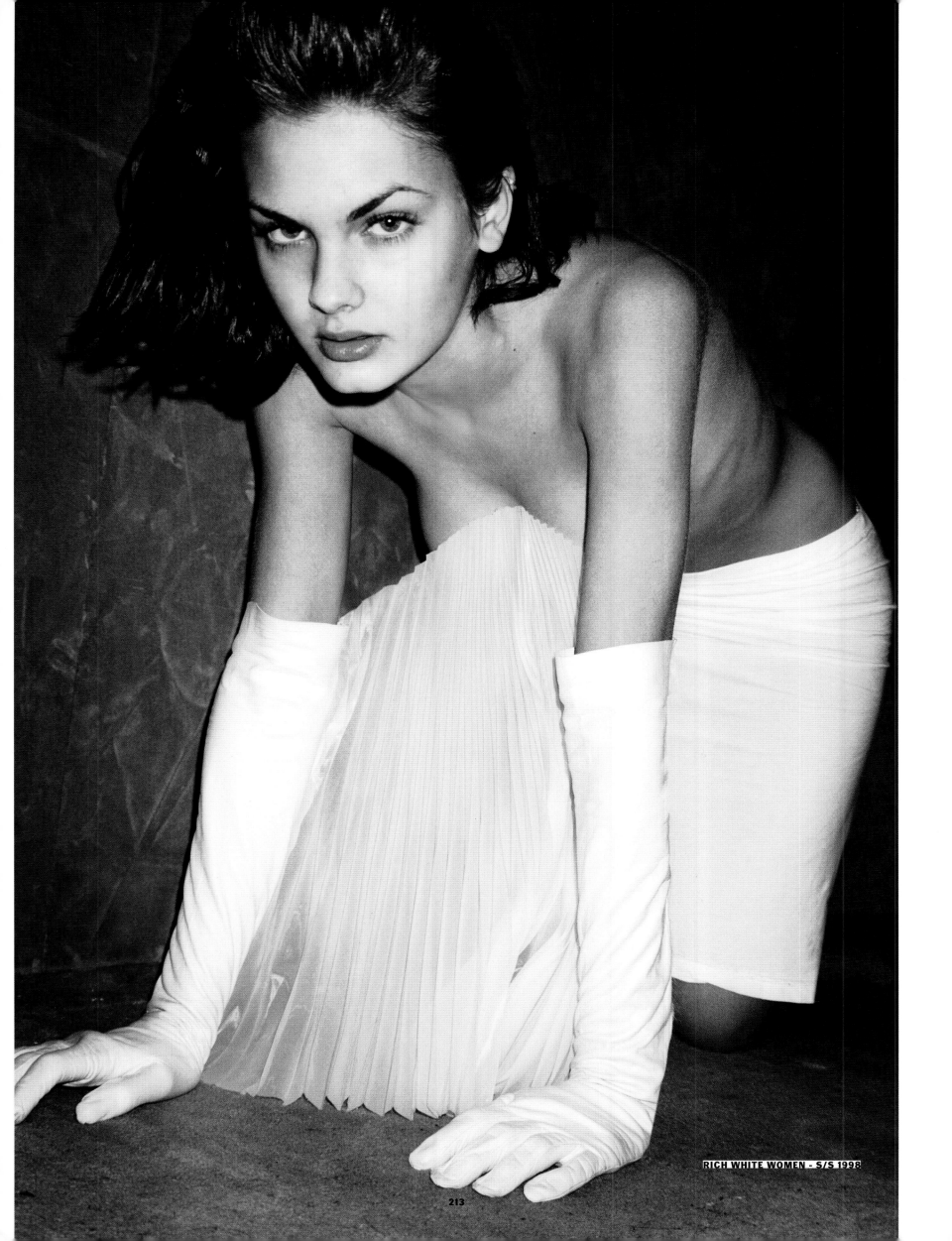

RICH WHITE WOMEN - S/S 1998

213

UNDER
CONSTRUCTION

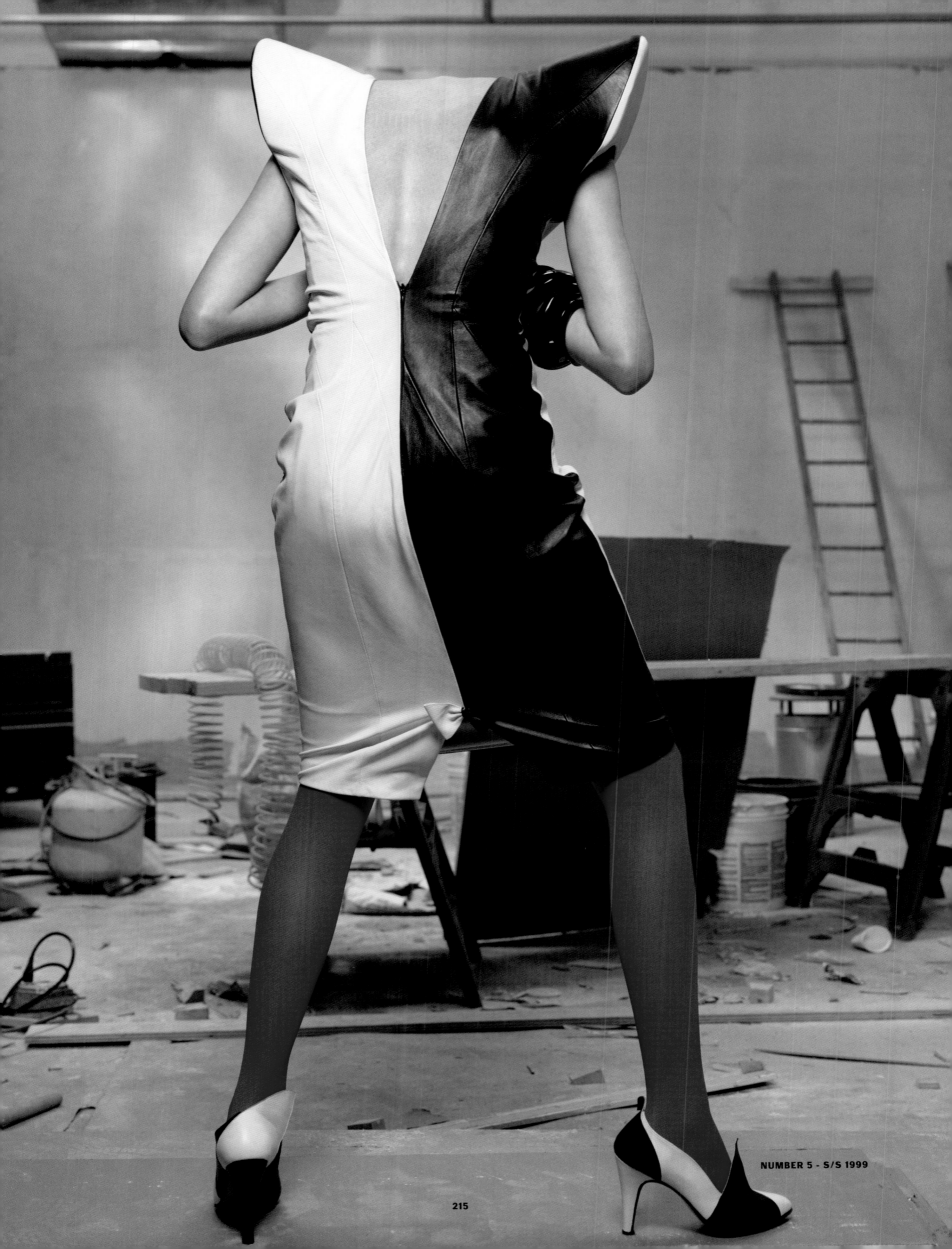

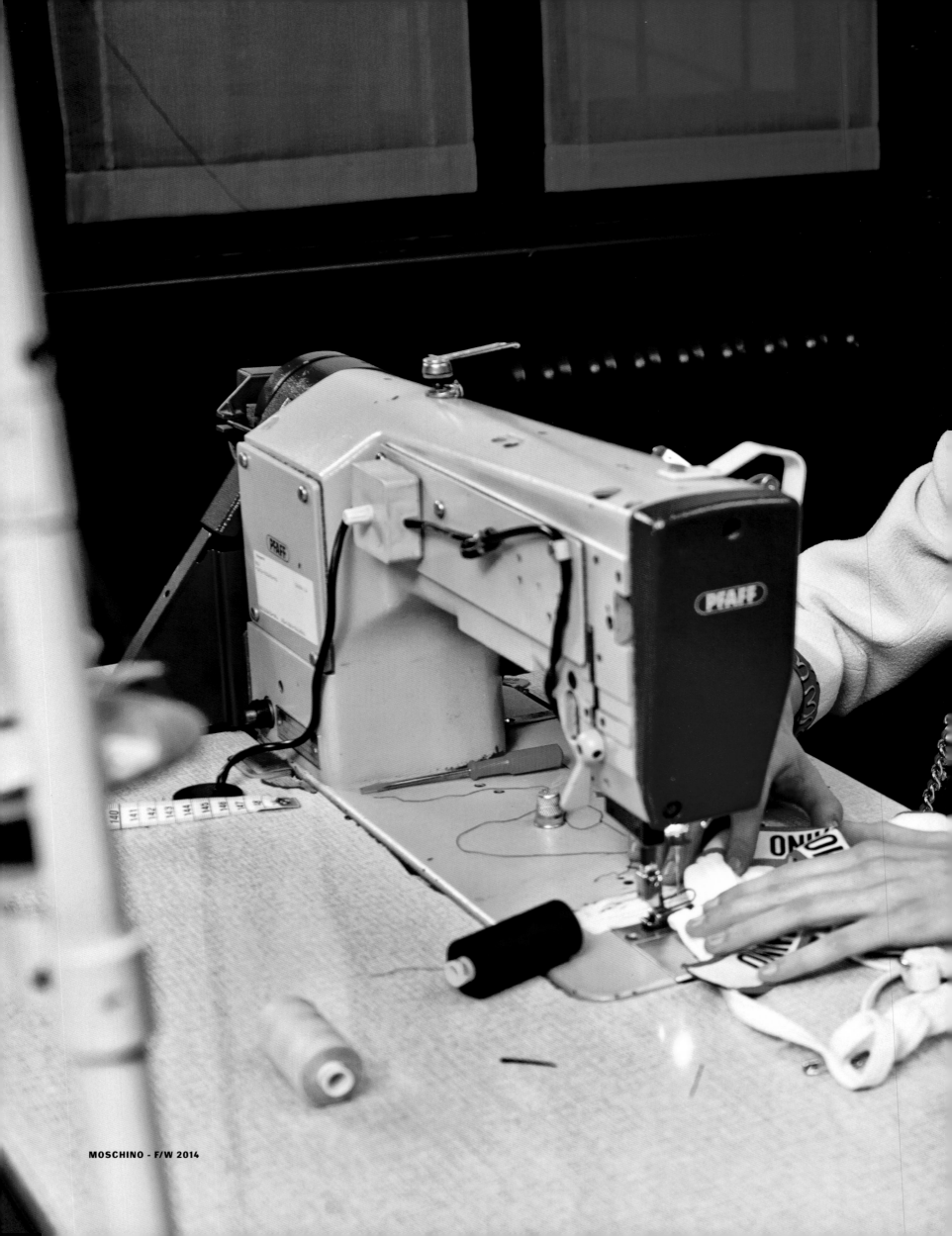

MOSCHINO - F/W 2014

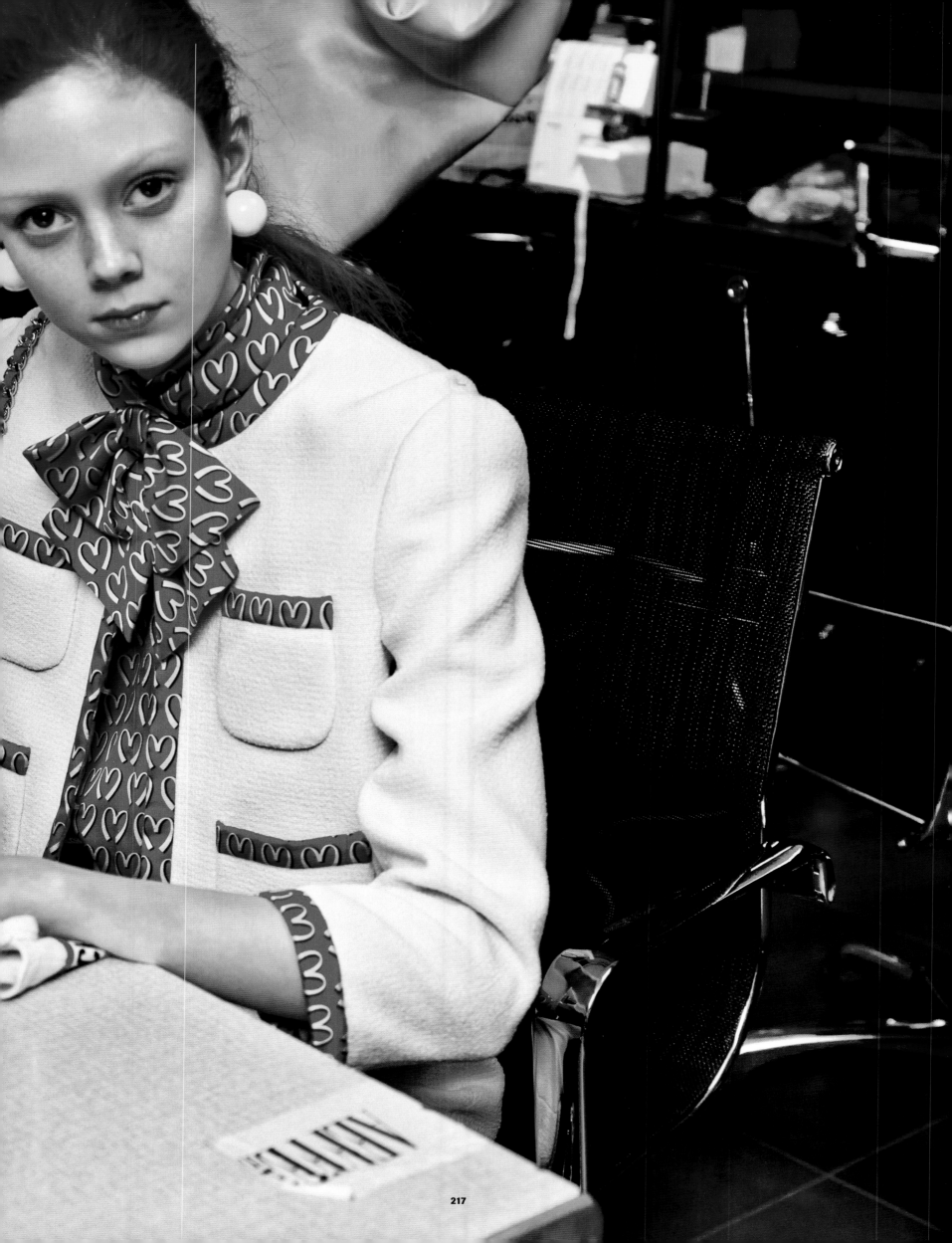

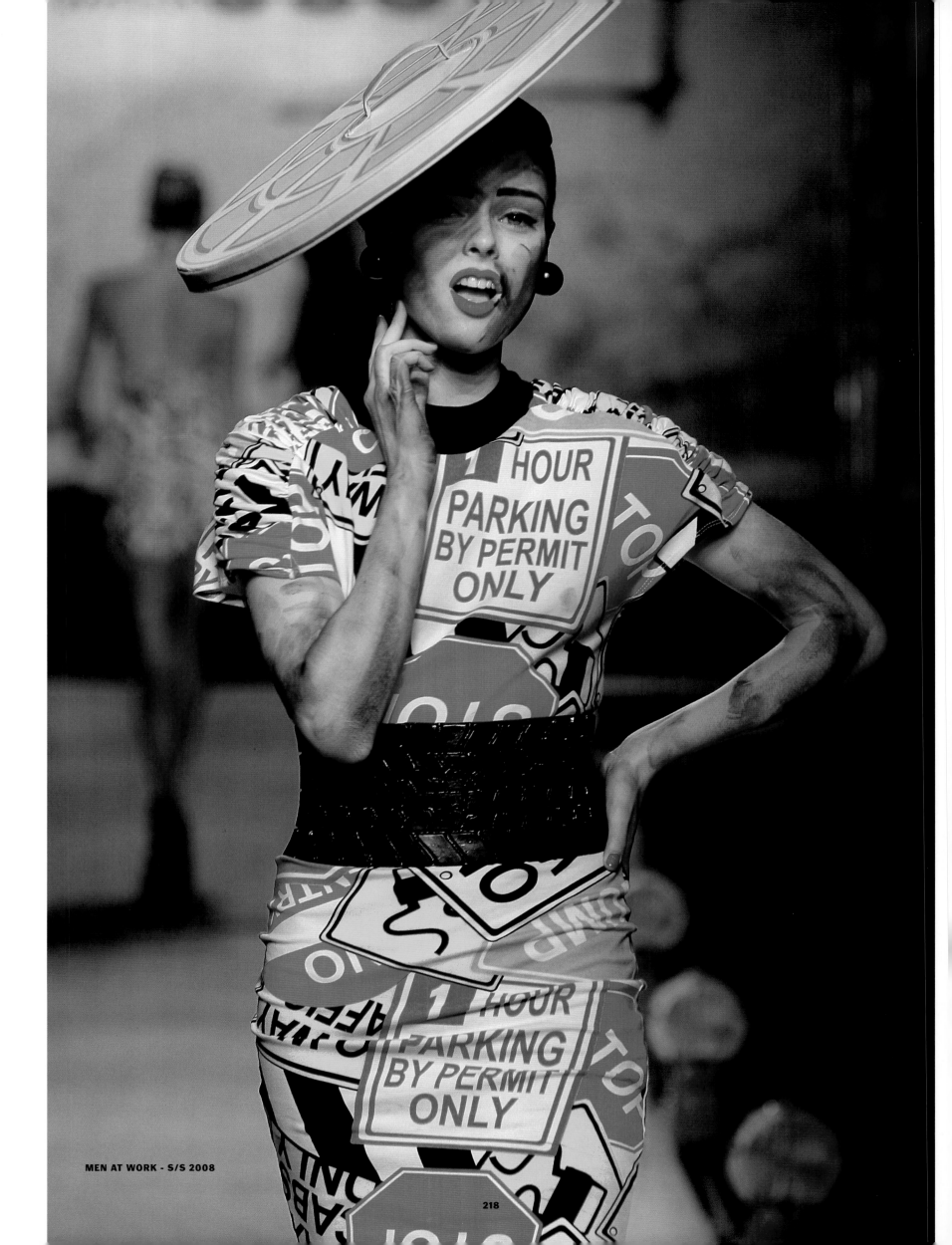

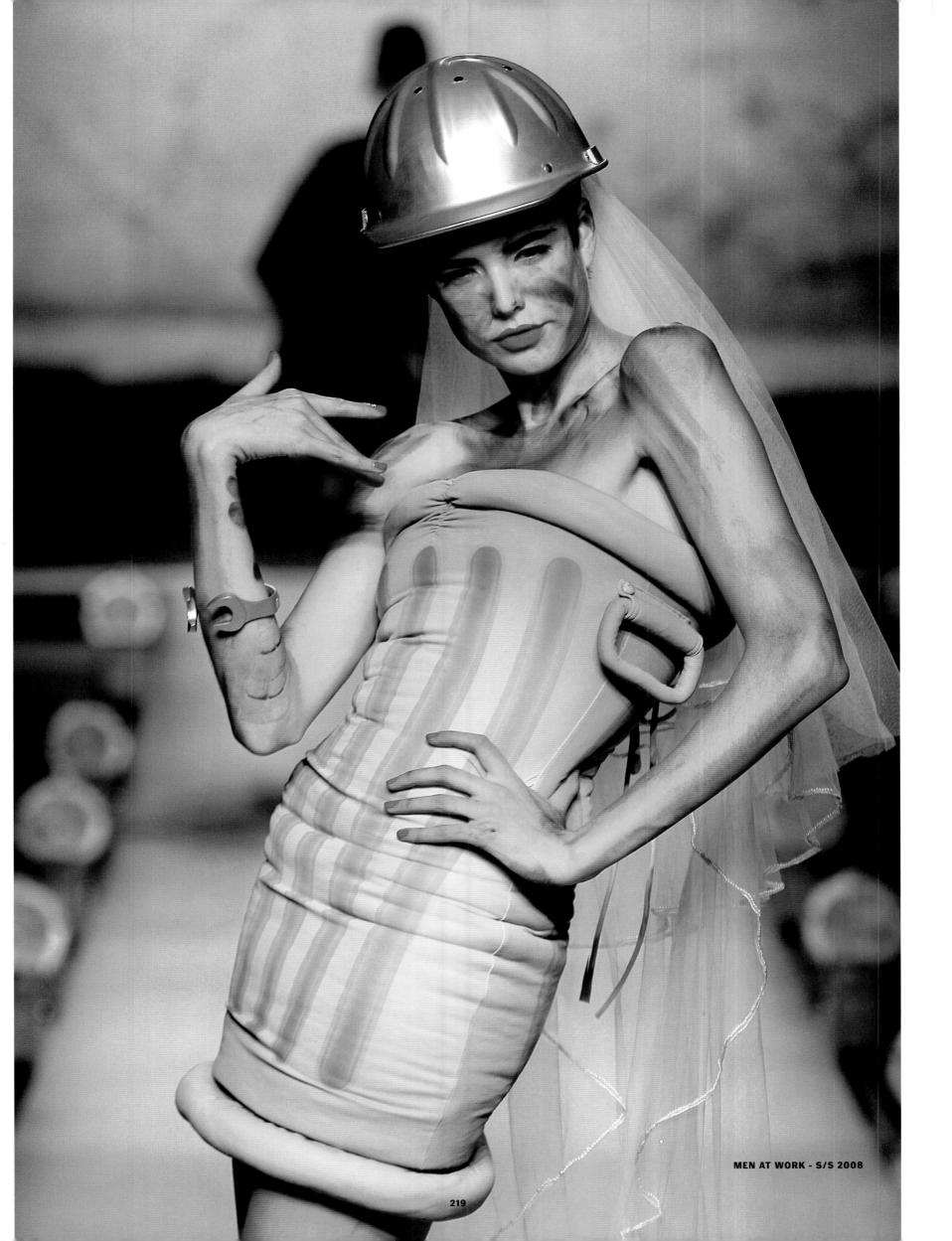

MEN AT WORK - S/S 2008

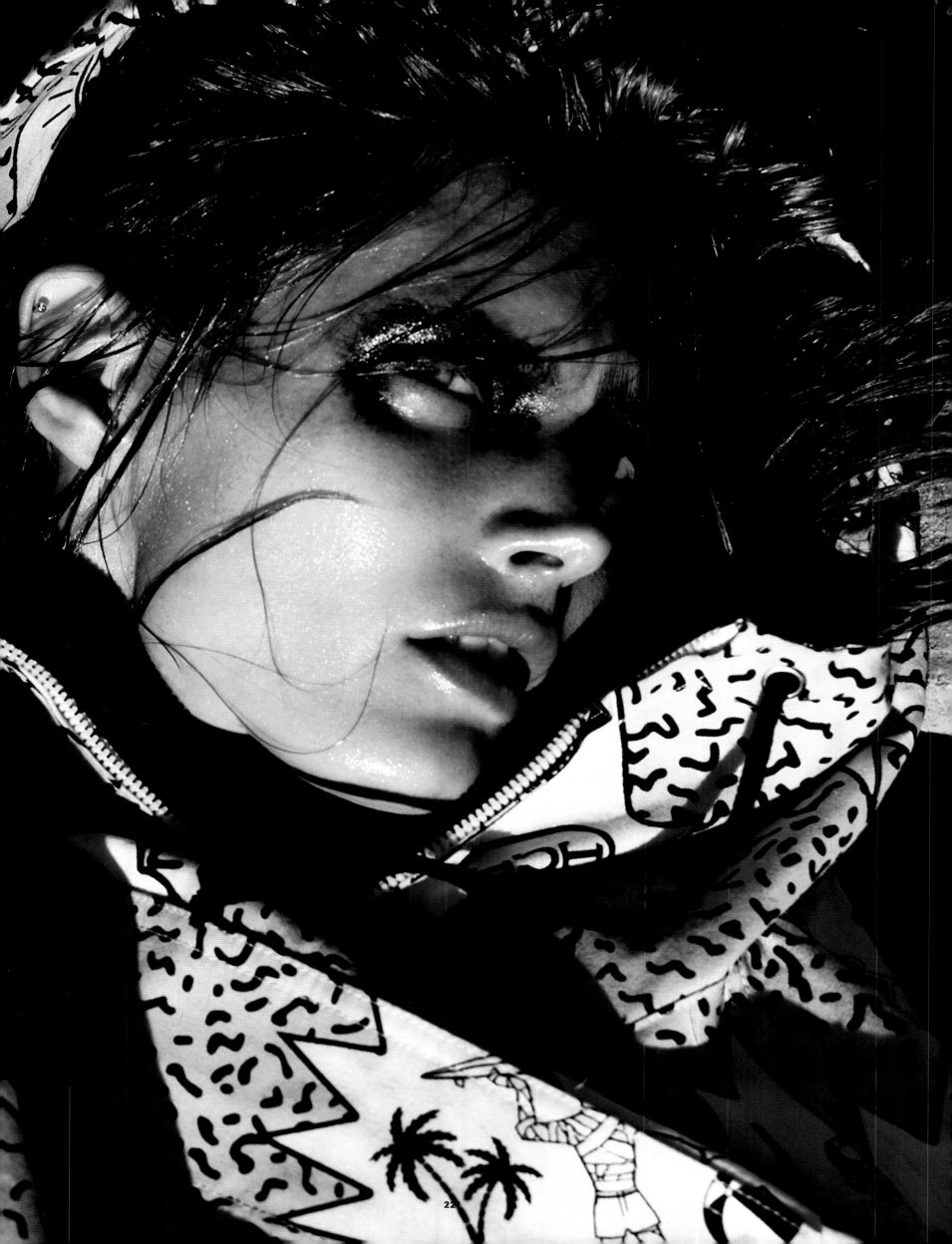

TUT TV - S/S 2006

223

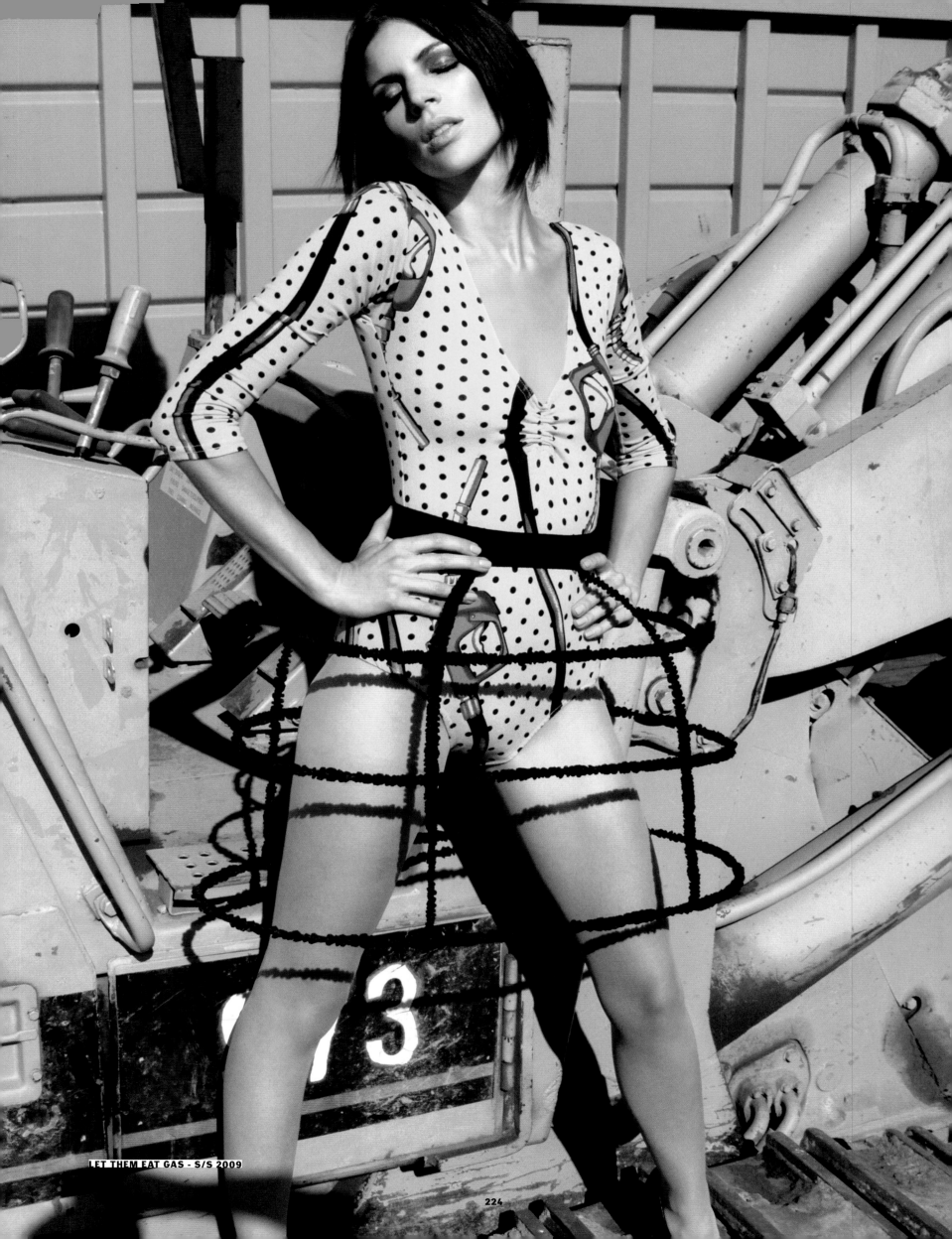

LET THEM EAT GAS - S/S 2009

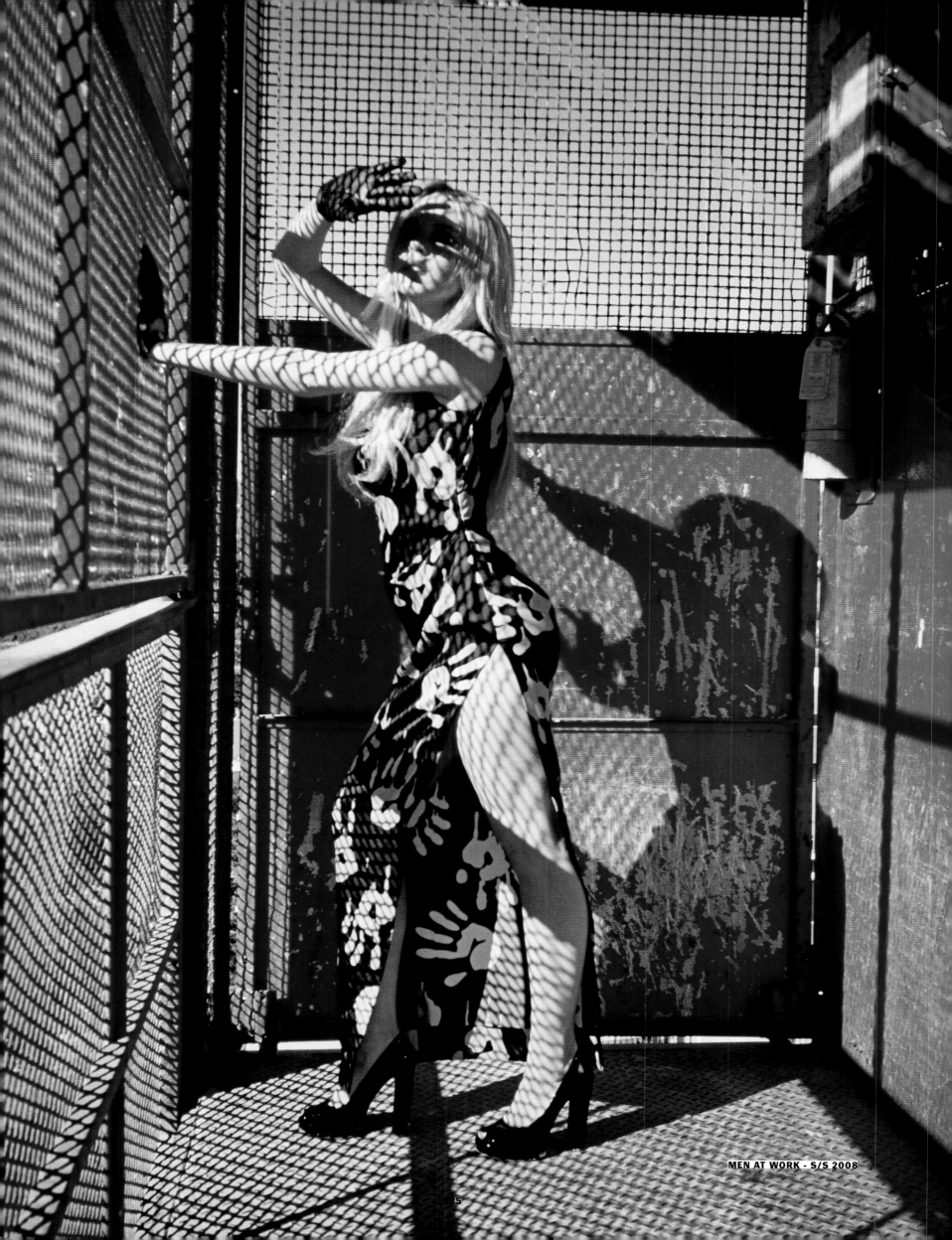

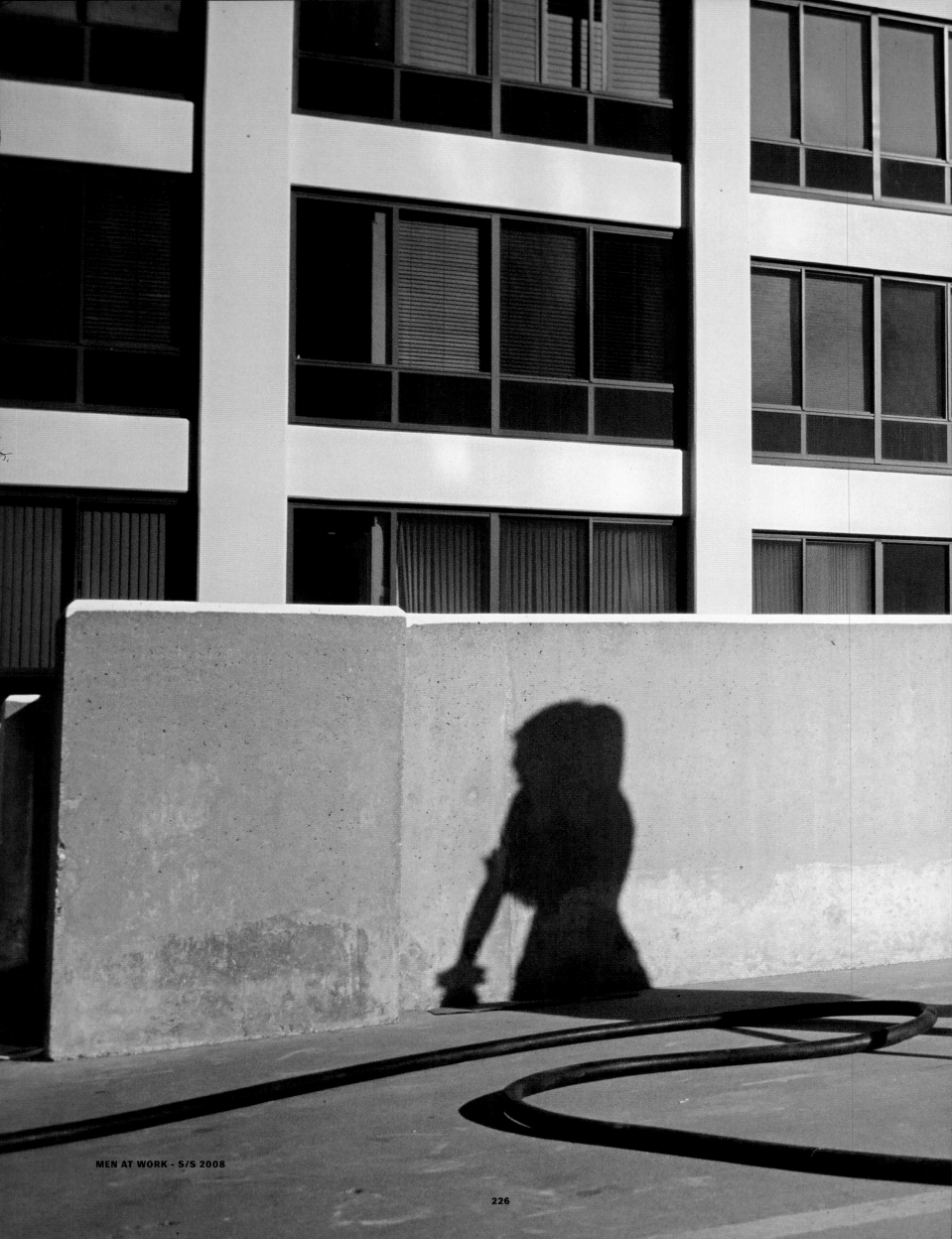

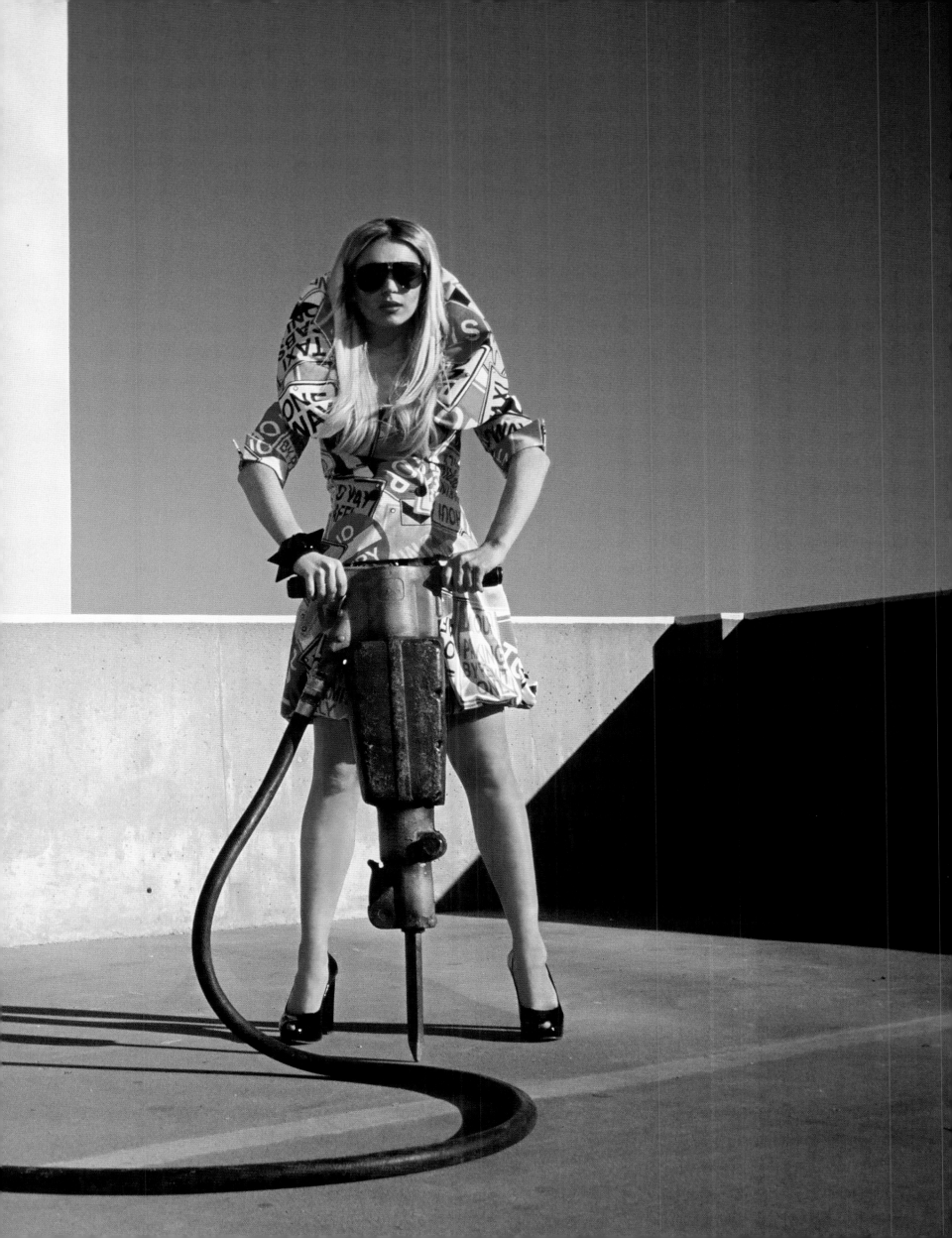

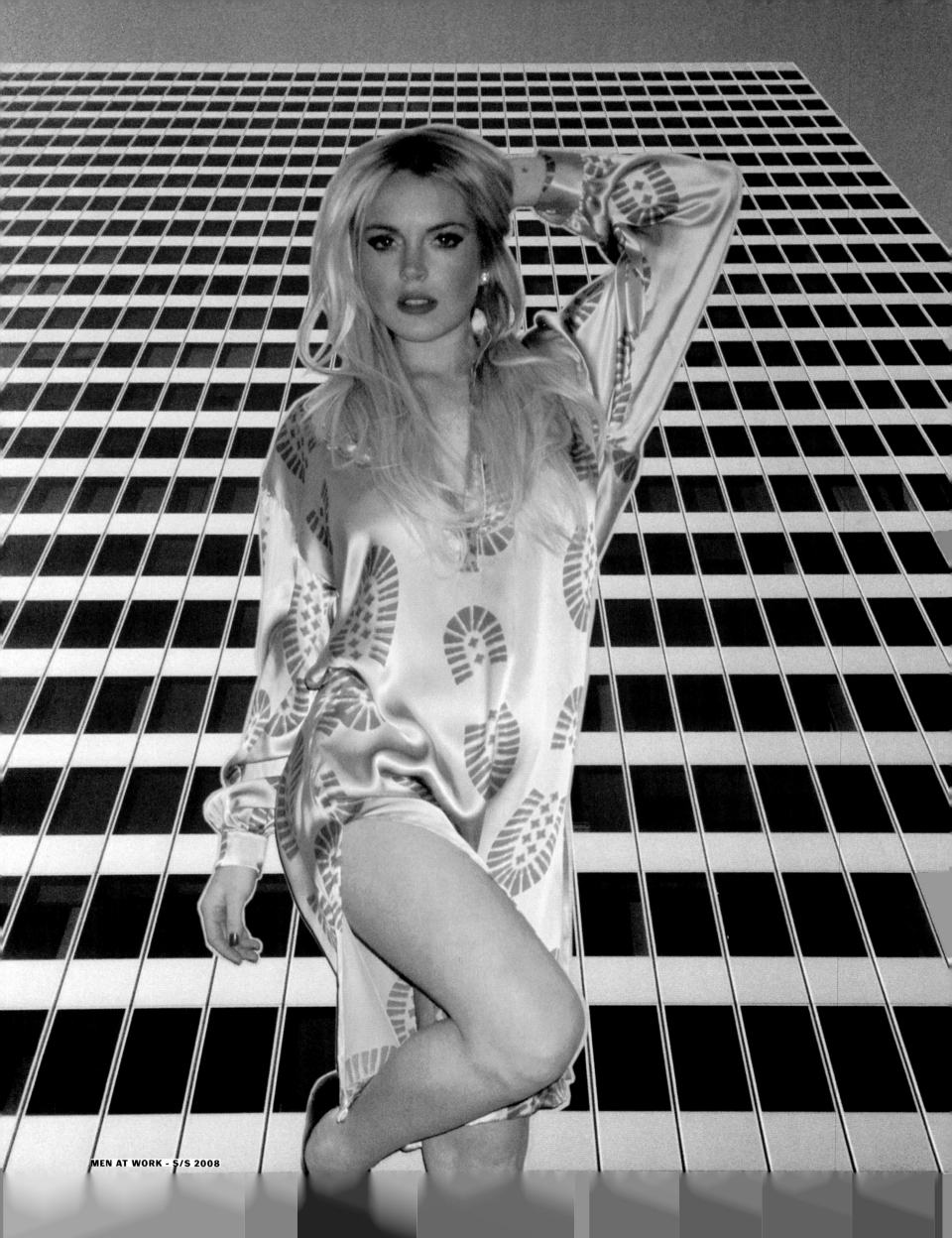

MEN AT WORK - S/S 2008

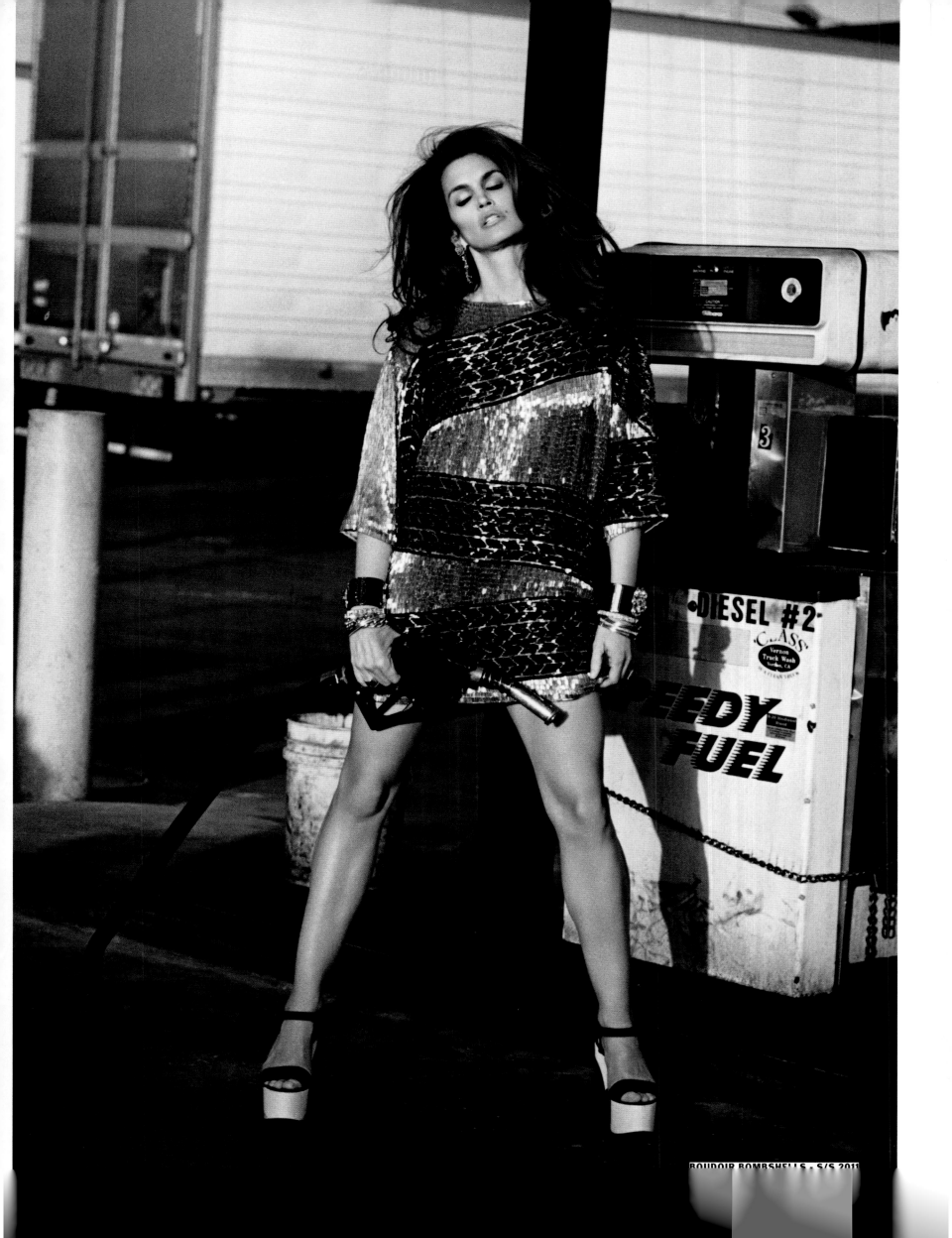

THE POLITICS OF FASHION

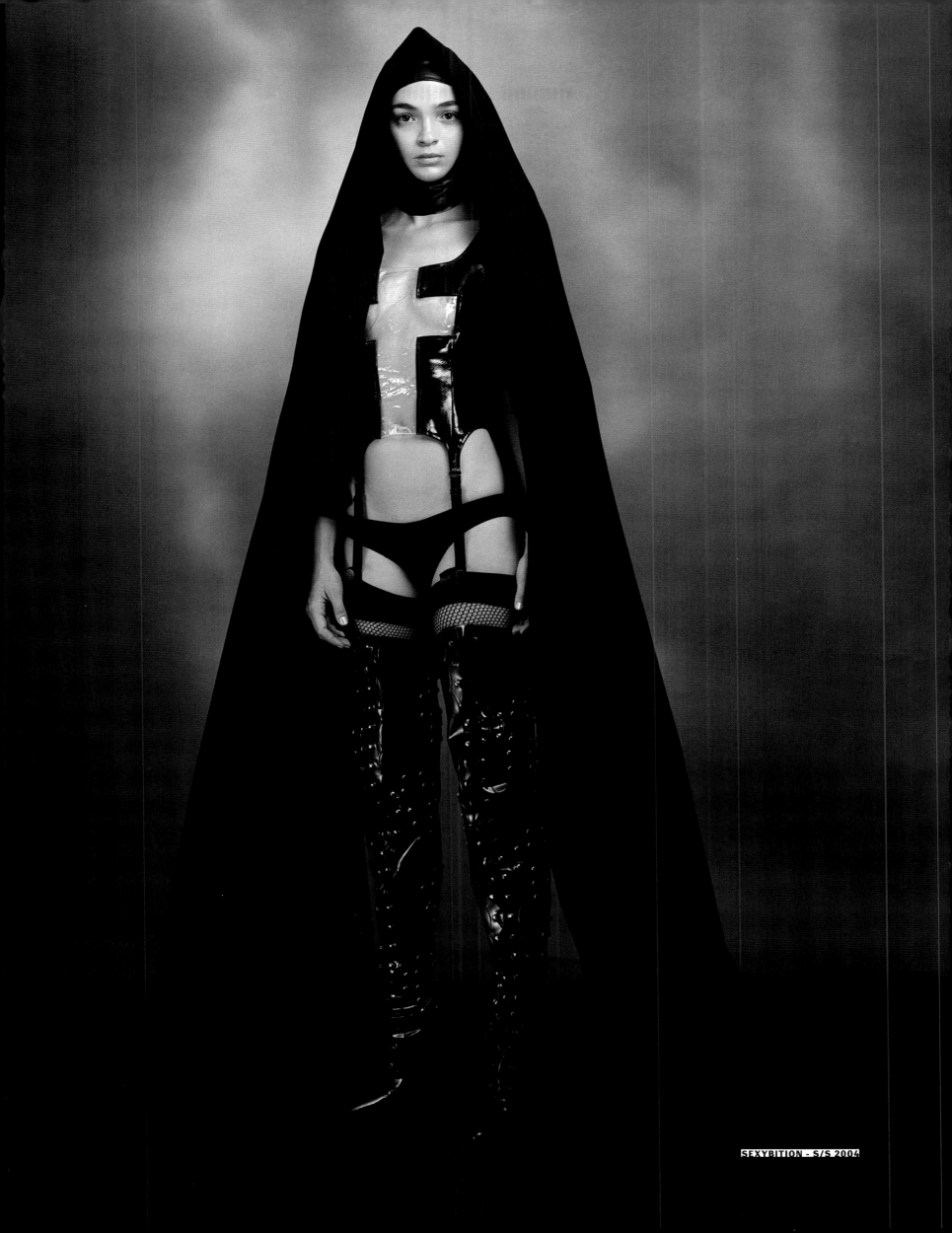

SEXYBITION - S/S 2004

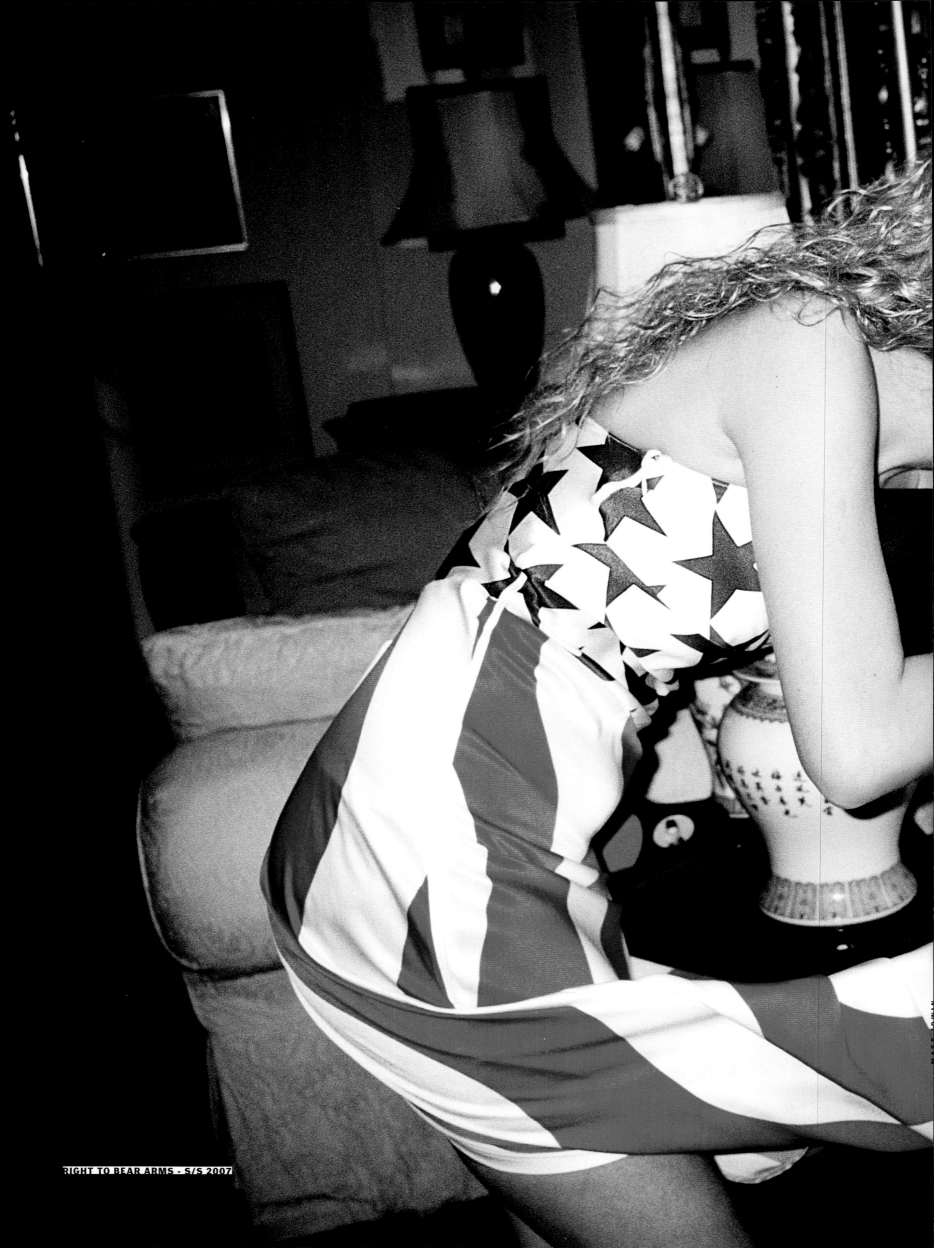

RIGHT TO BEAR ARMS - S/S 2007

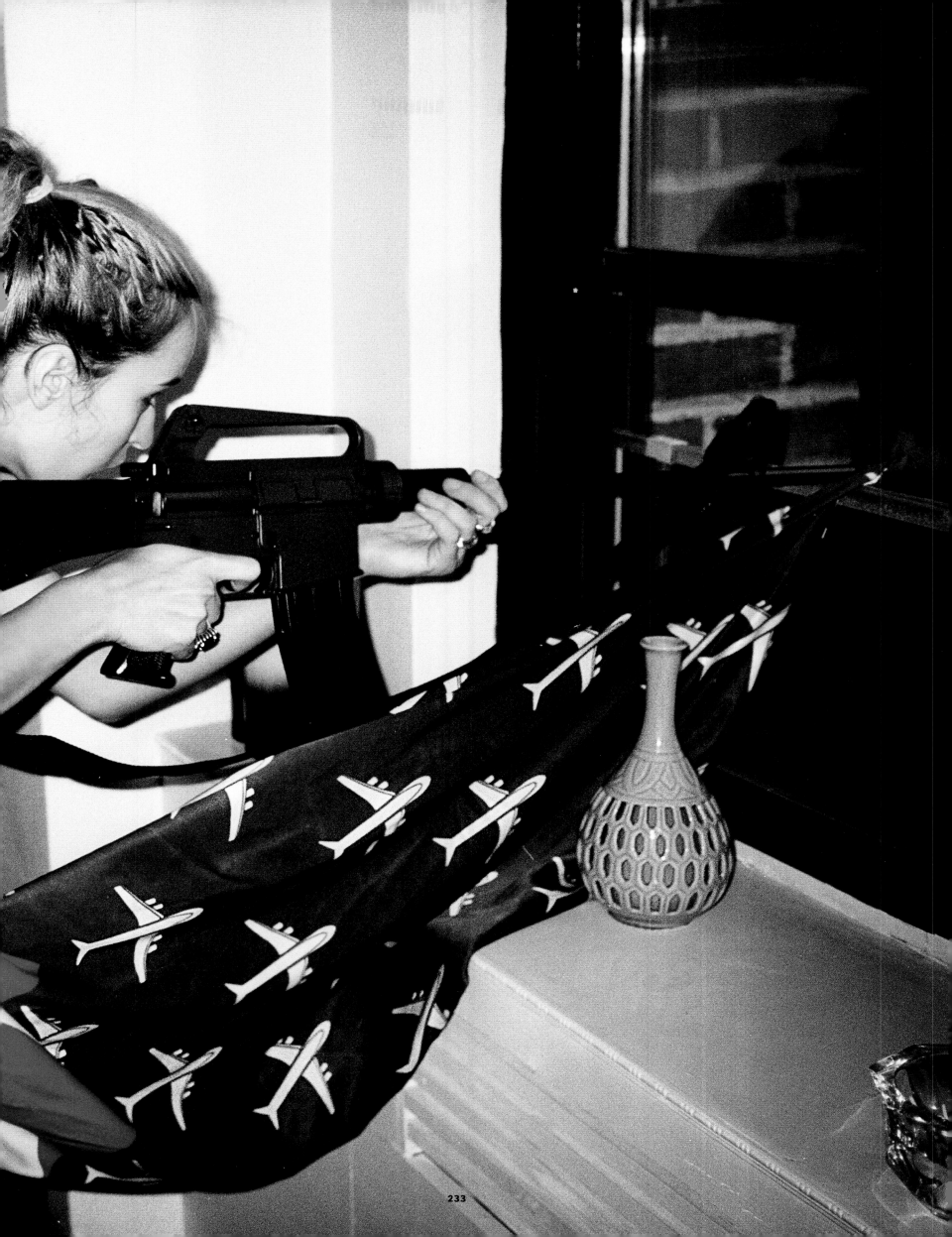

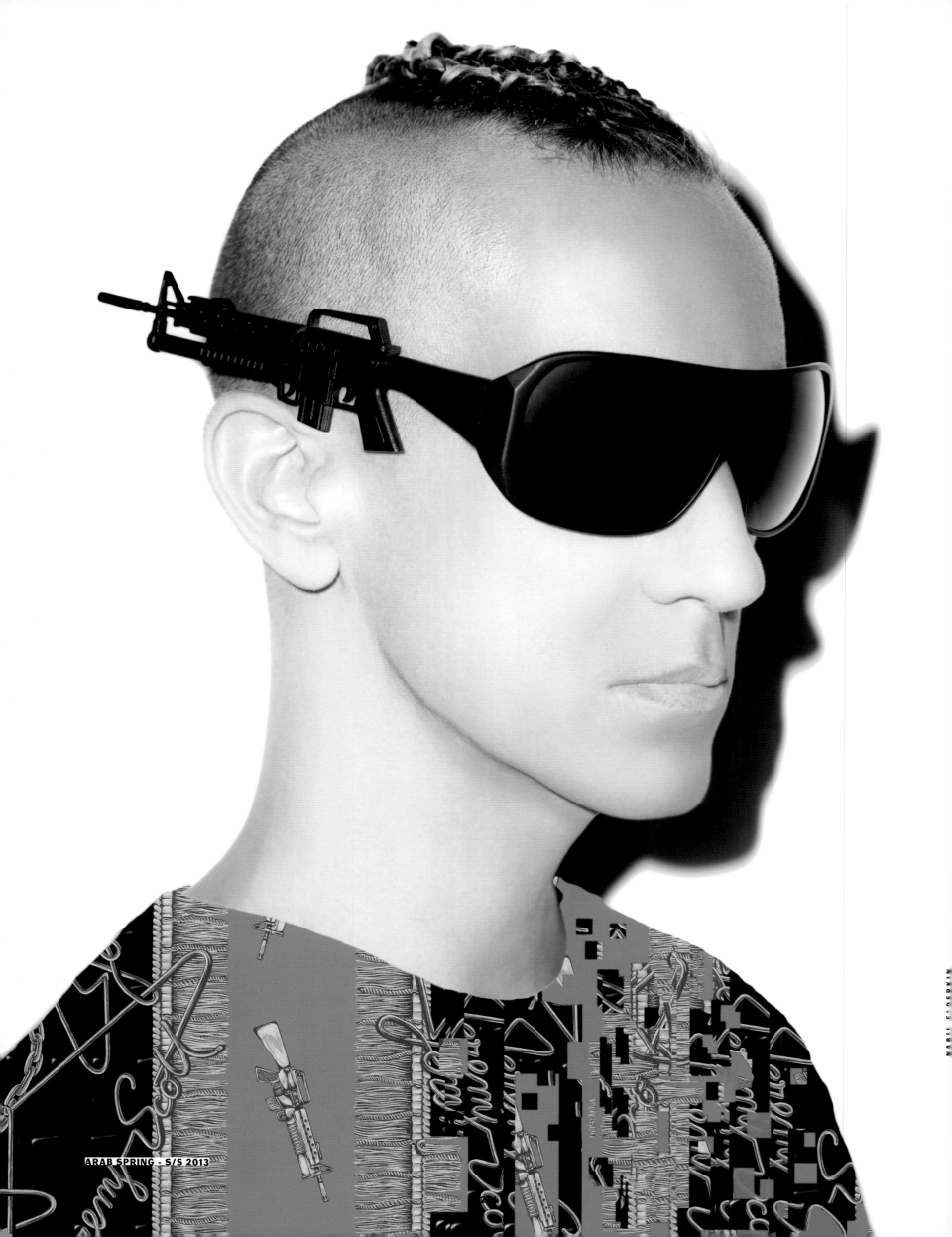

ARAB SPRING - S/S 2013

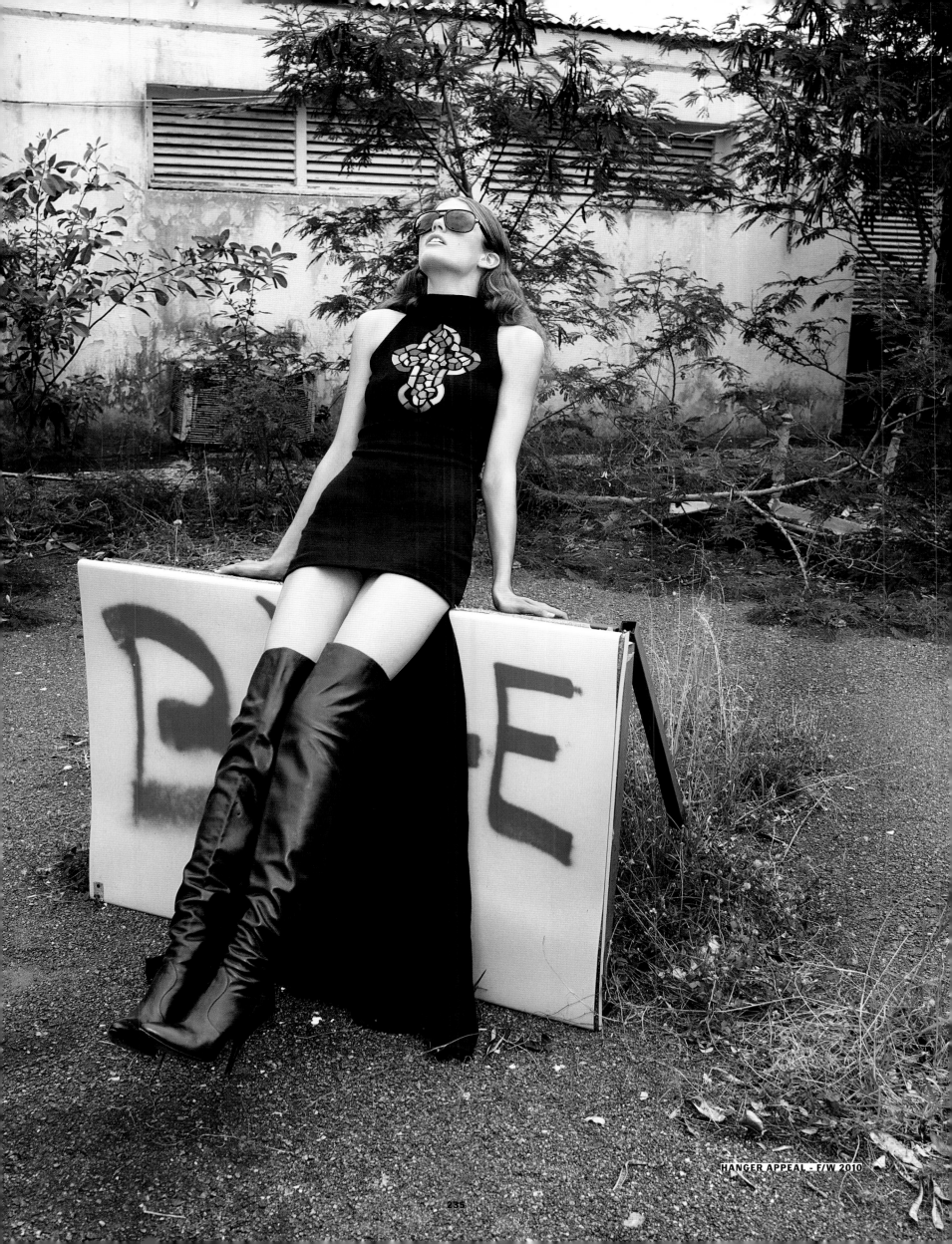

HANGER APPEAL - F/W 2010

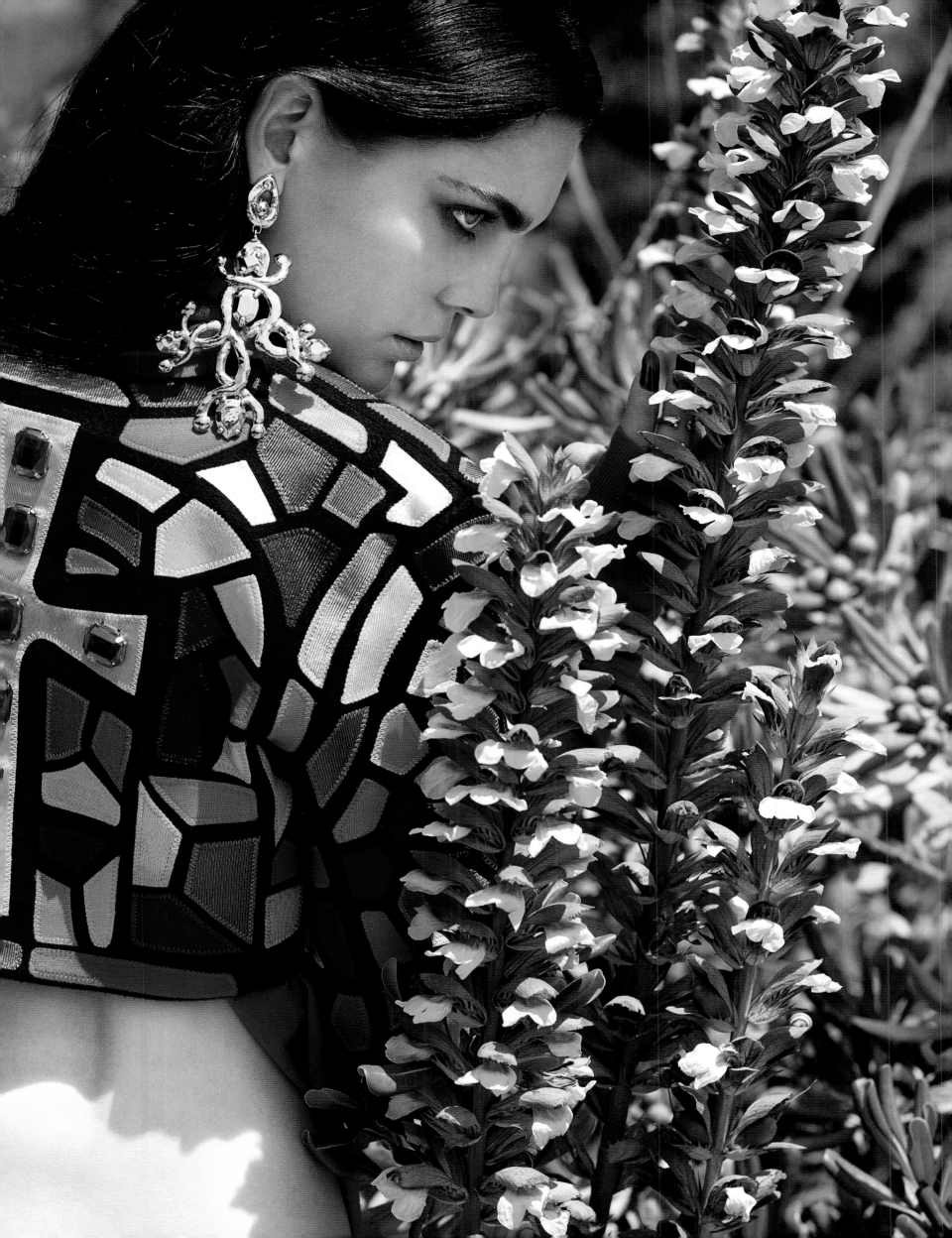

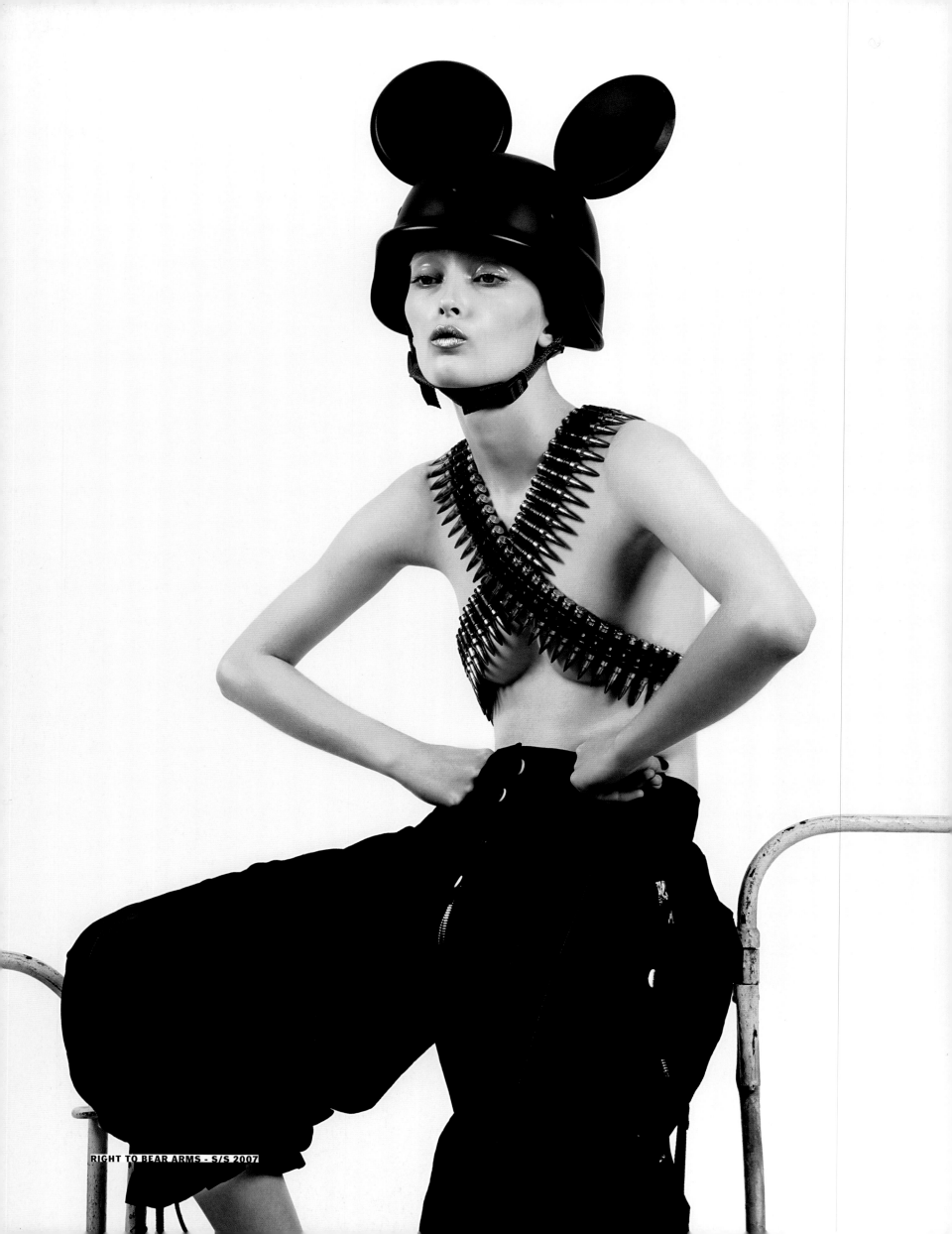

RIGHT TO BEAR ARMS - S/S 2007

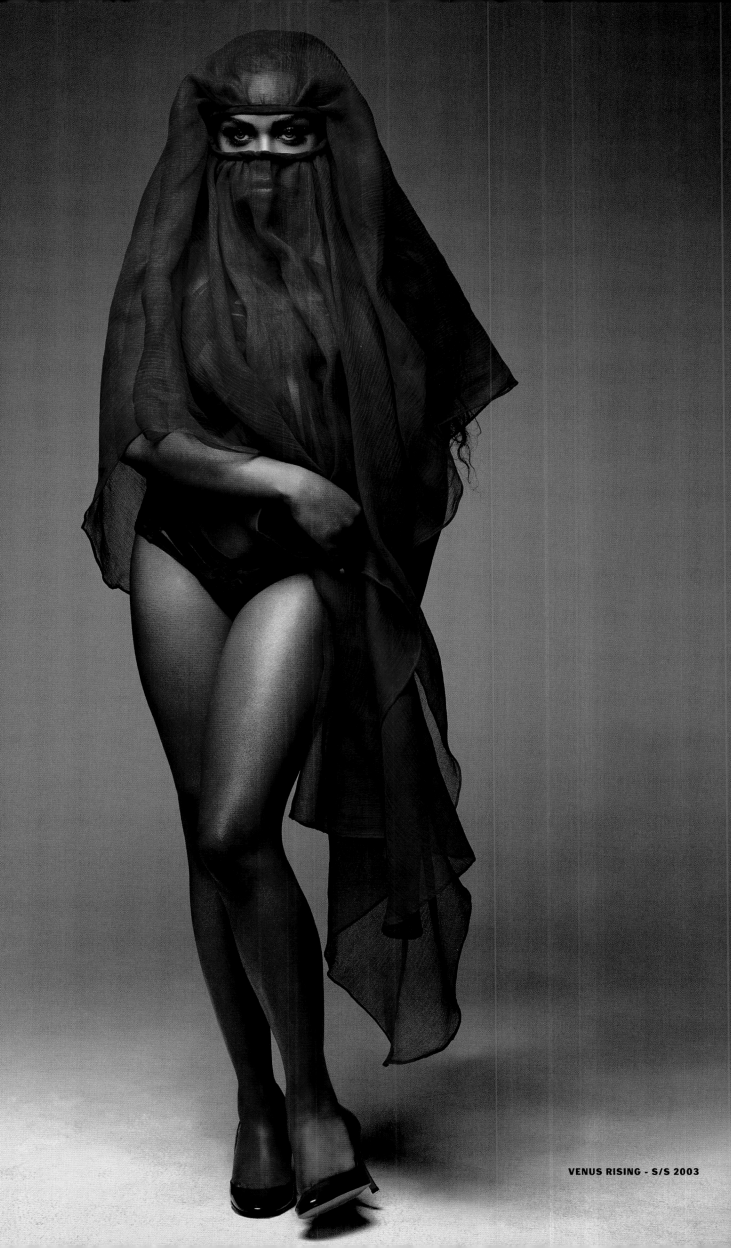

VENUS RISING - S/S 2003

GREED IS GOOD

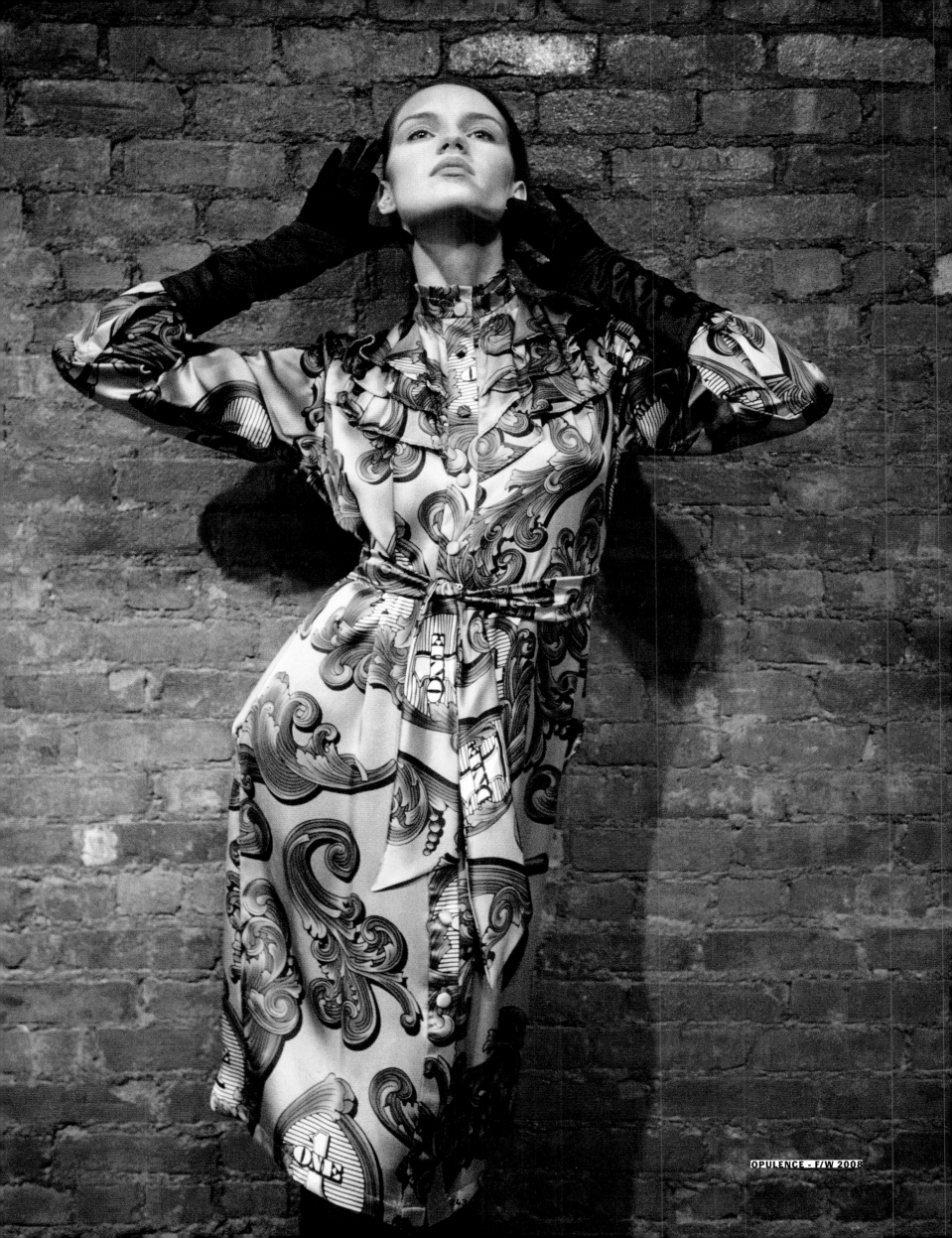

OPULENCE - F/W 2008

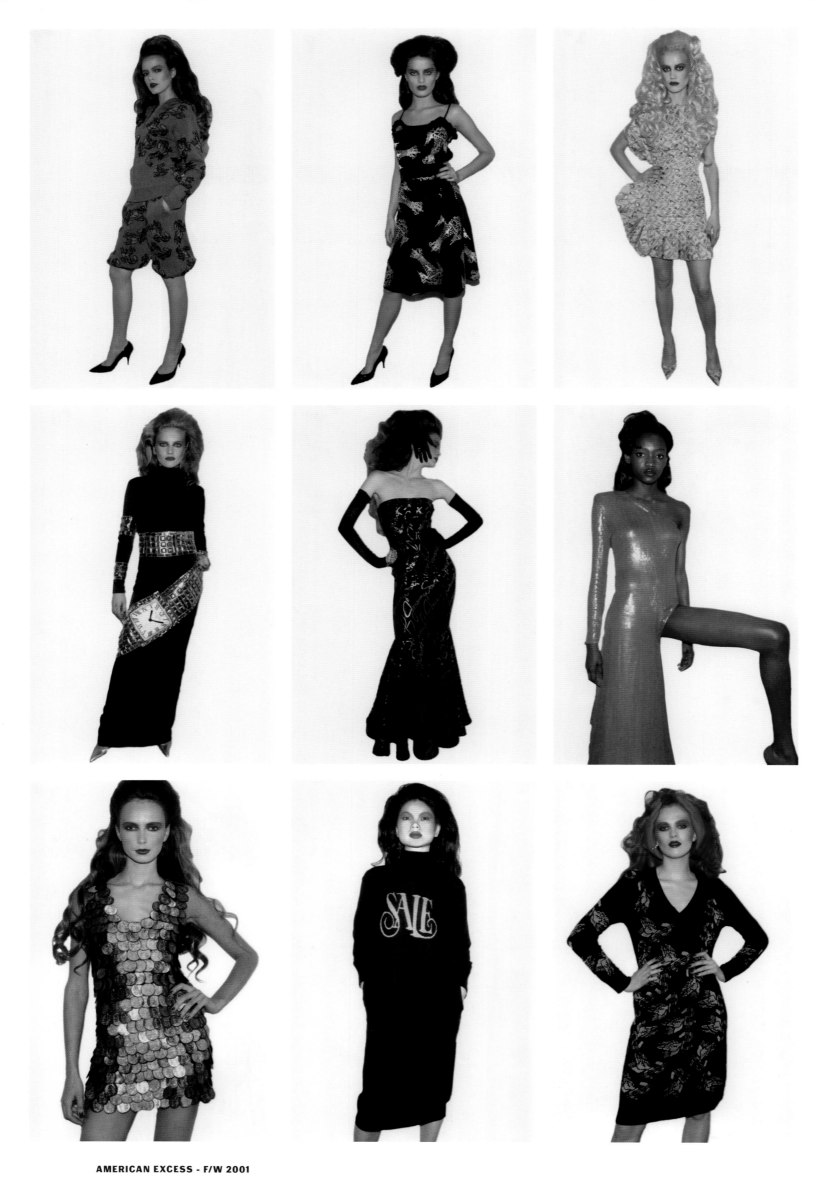

AMERICAN EXCESS - F/W 2001

244

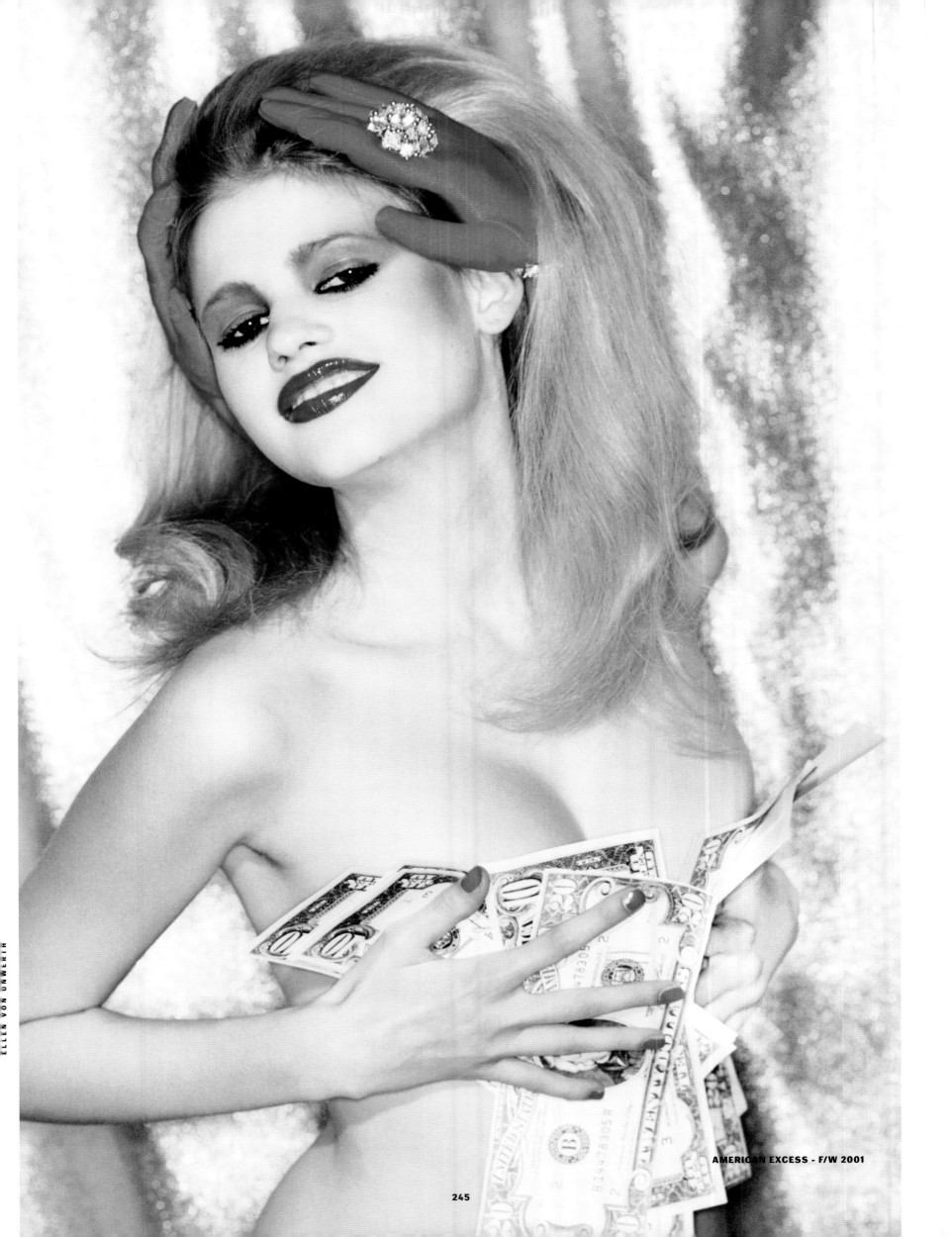

AMERICAN EXCESS - F/W 2001

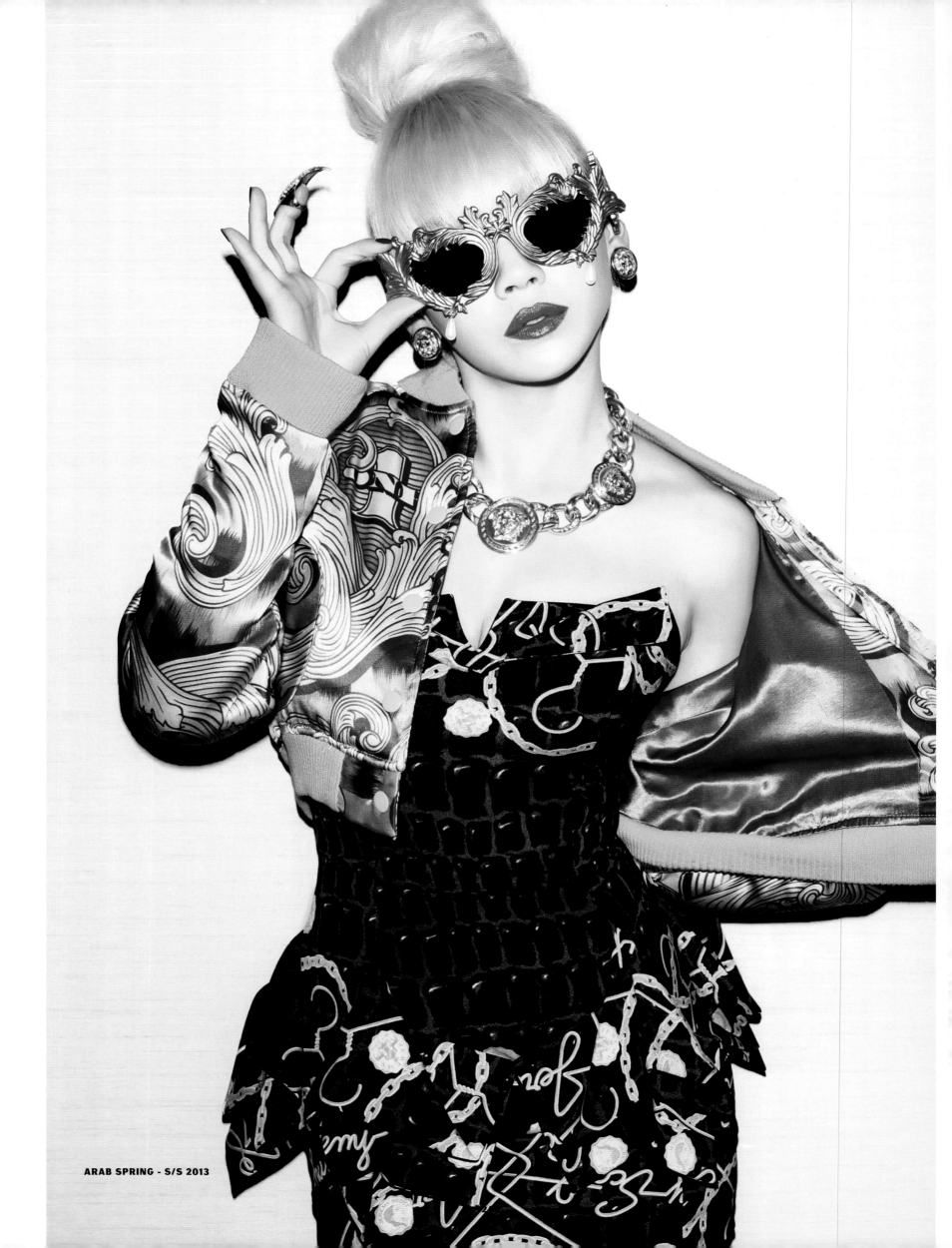

ARAB SPRING - S/S 2013

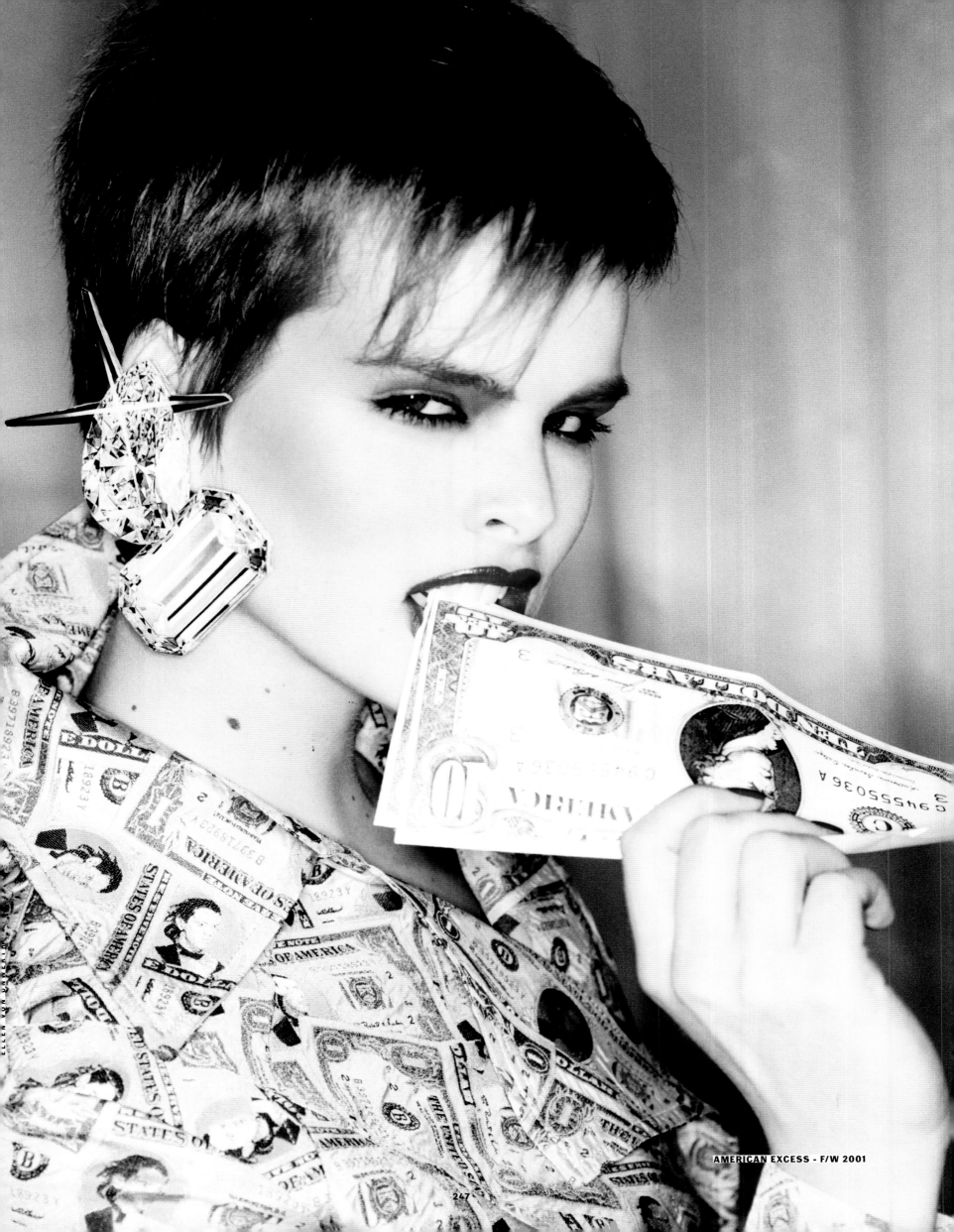

AMERICAN EXCESS - F/W 2001

FUR
REAL

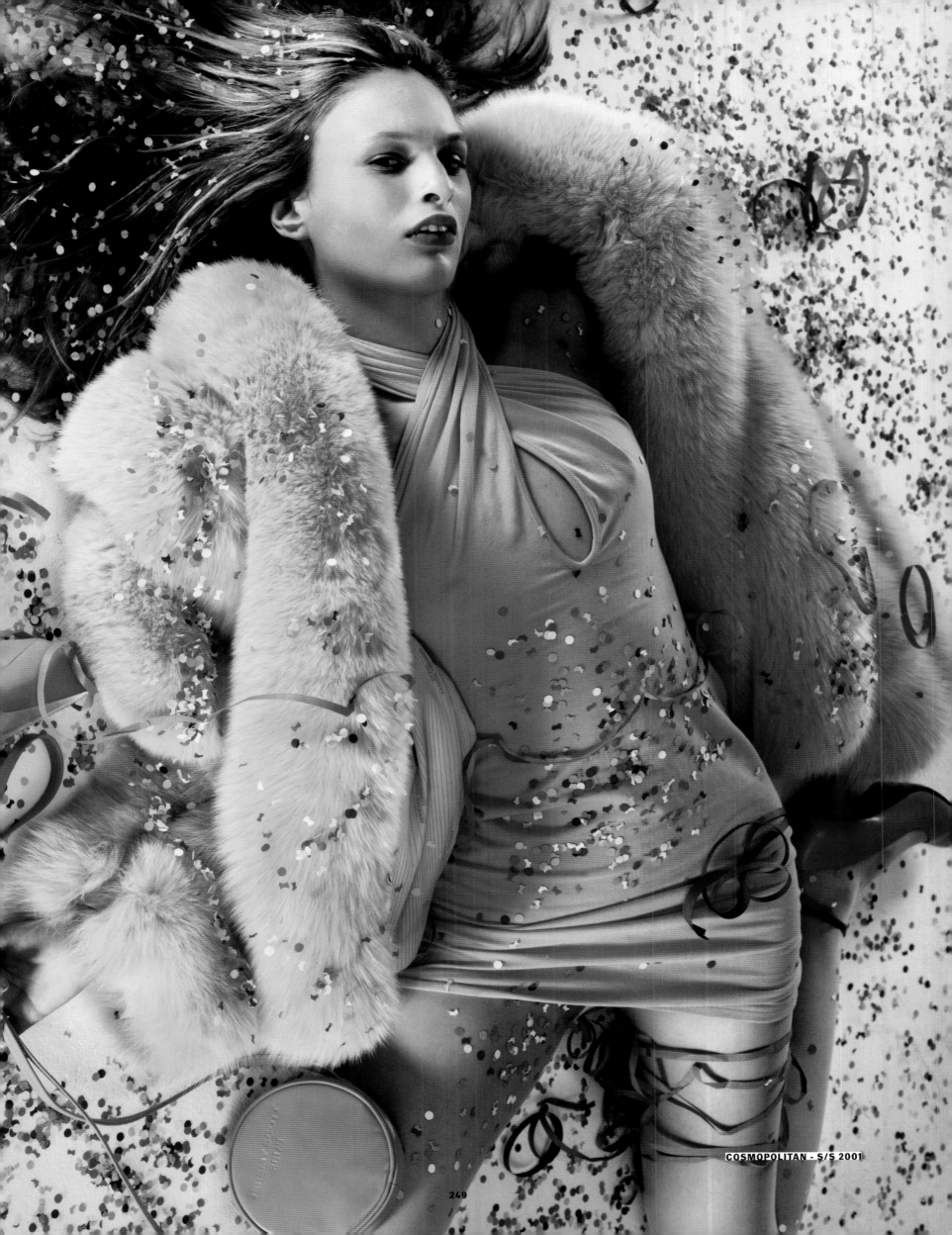

COSMOPOLITAN - S/S 2001

249

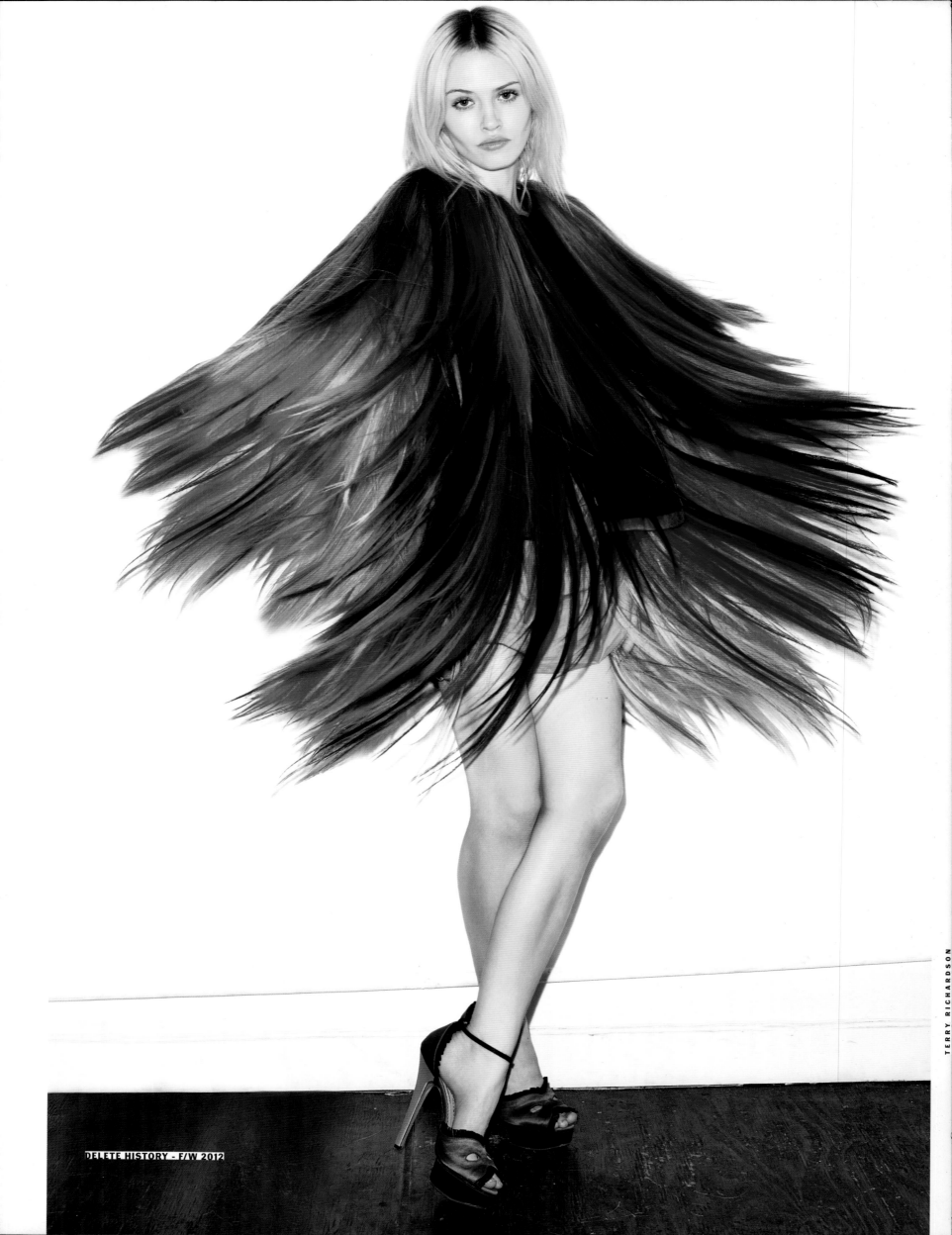

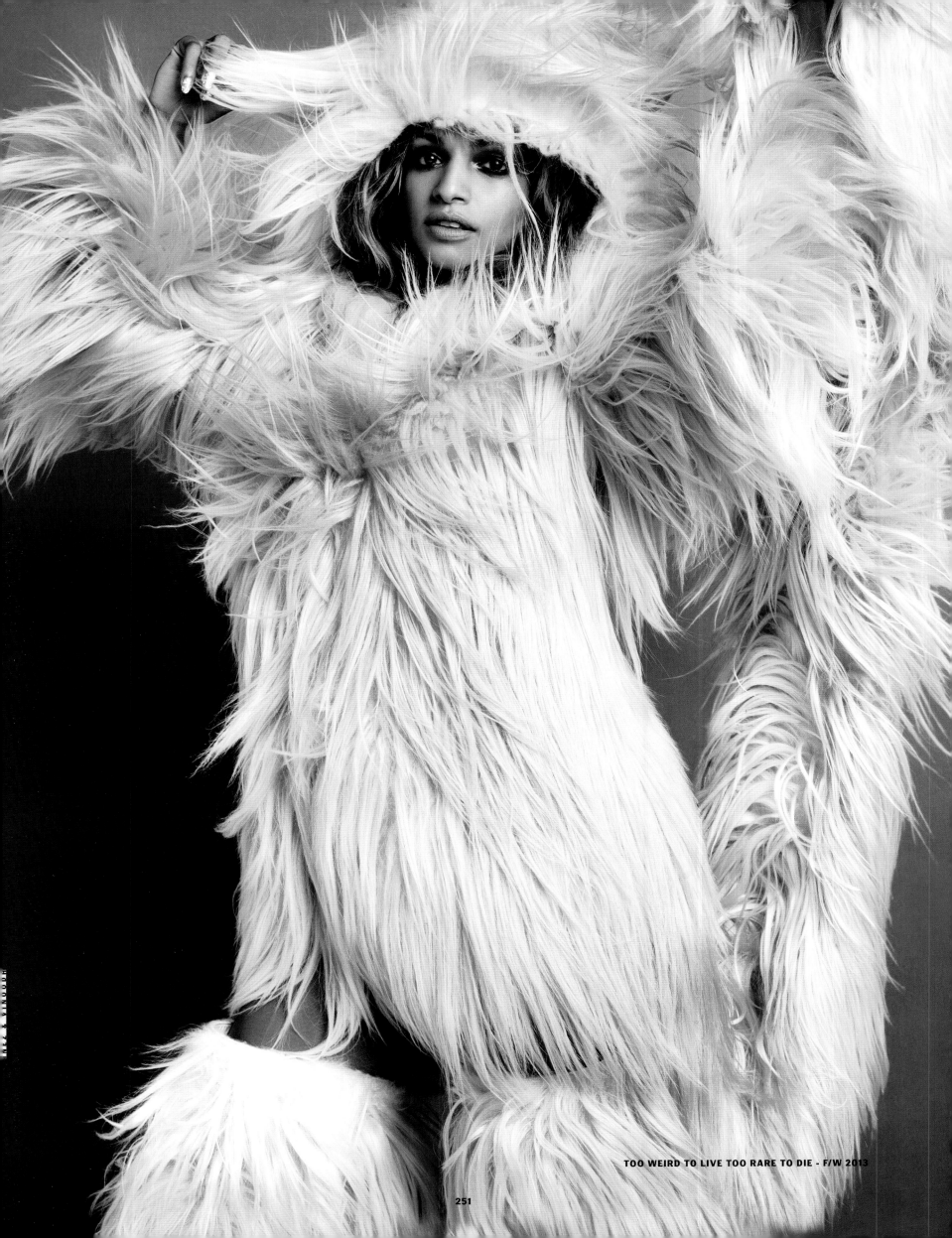

TOO WEIRD TO LIVE TOO RARE TO DIE - F/W 2013

251

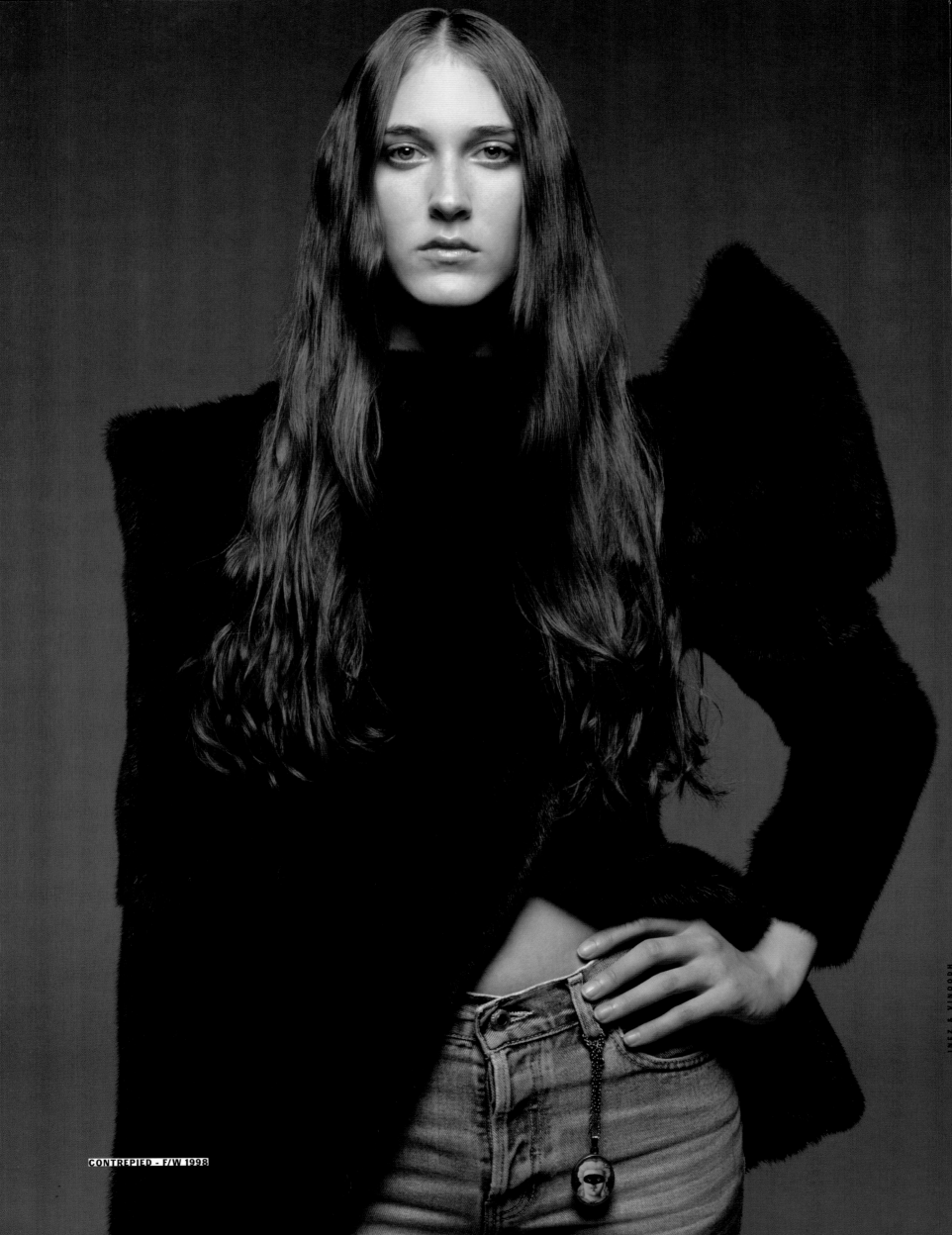

CONTREPIED - F/W 1998

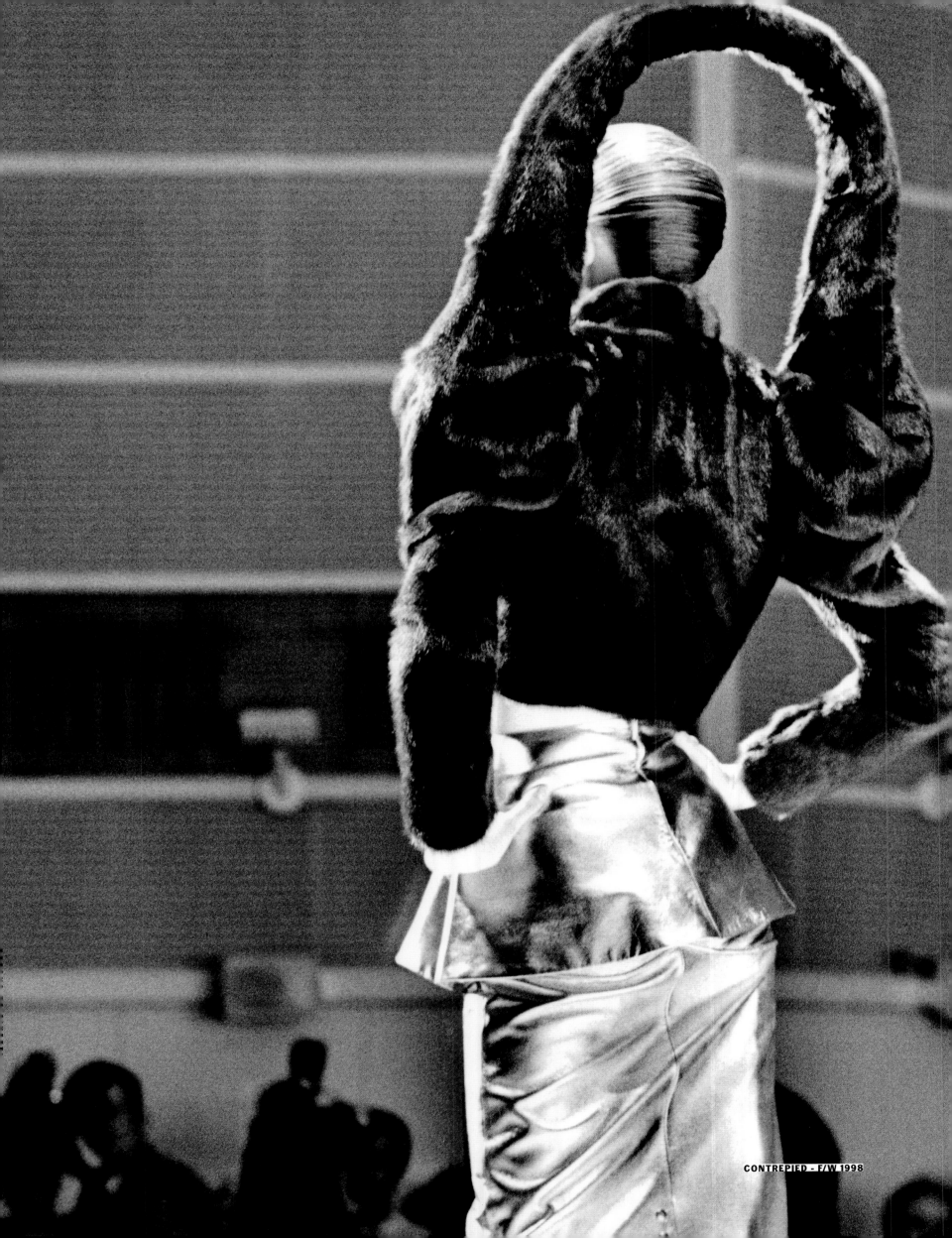

CONTREPIED - F/W 1998

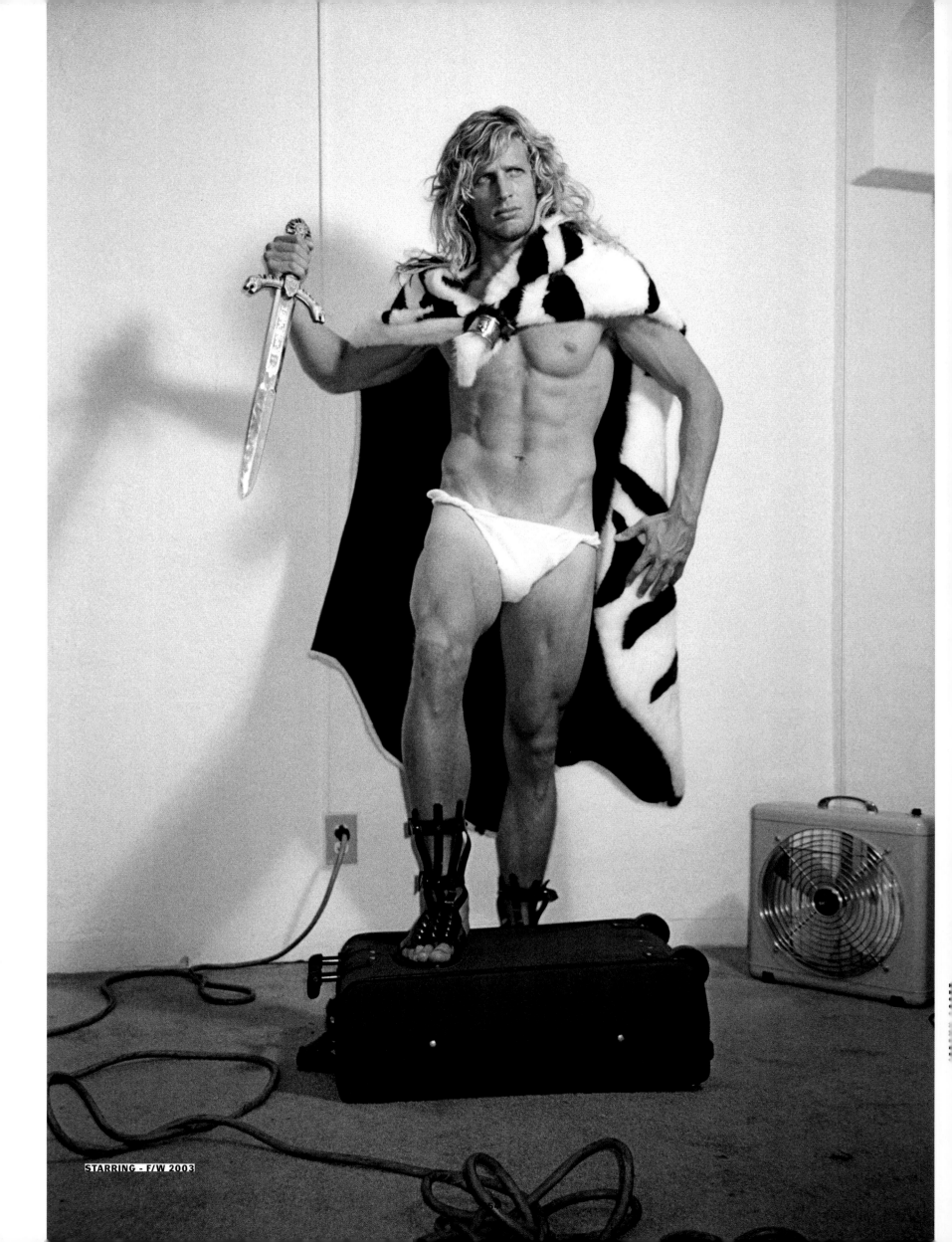

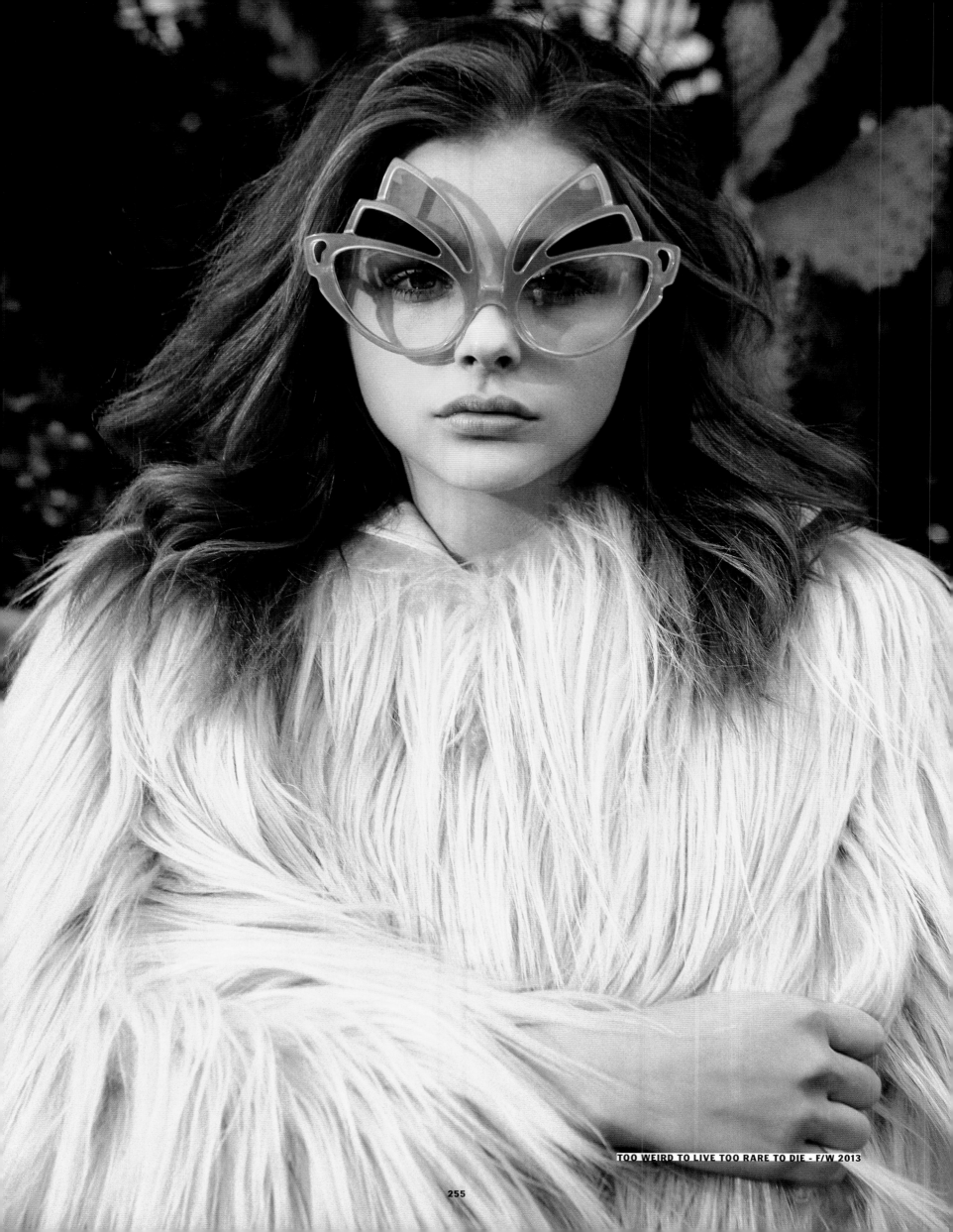

TOO WEIRD TO LIVE TOO RARE TO DIE - F/W 2013

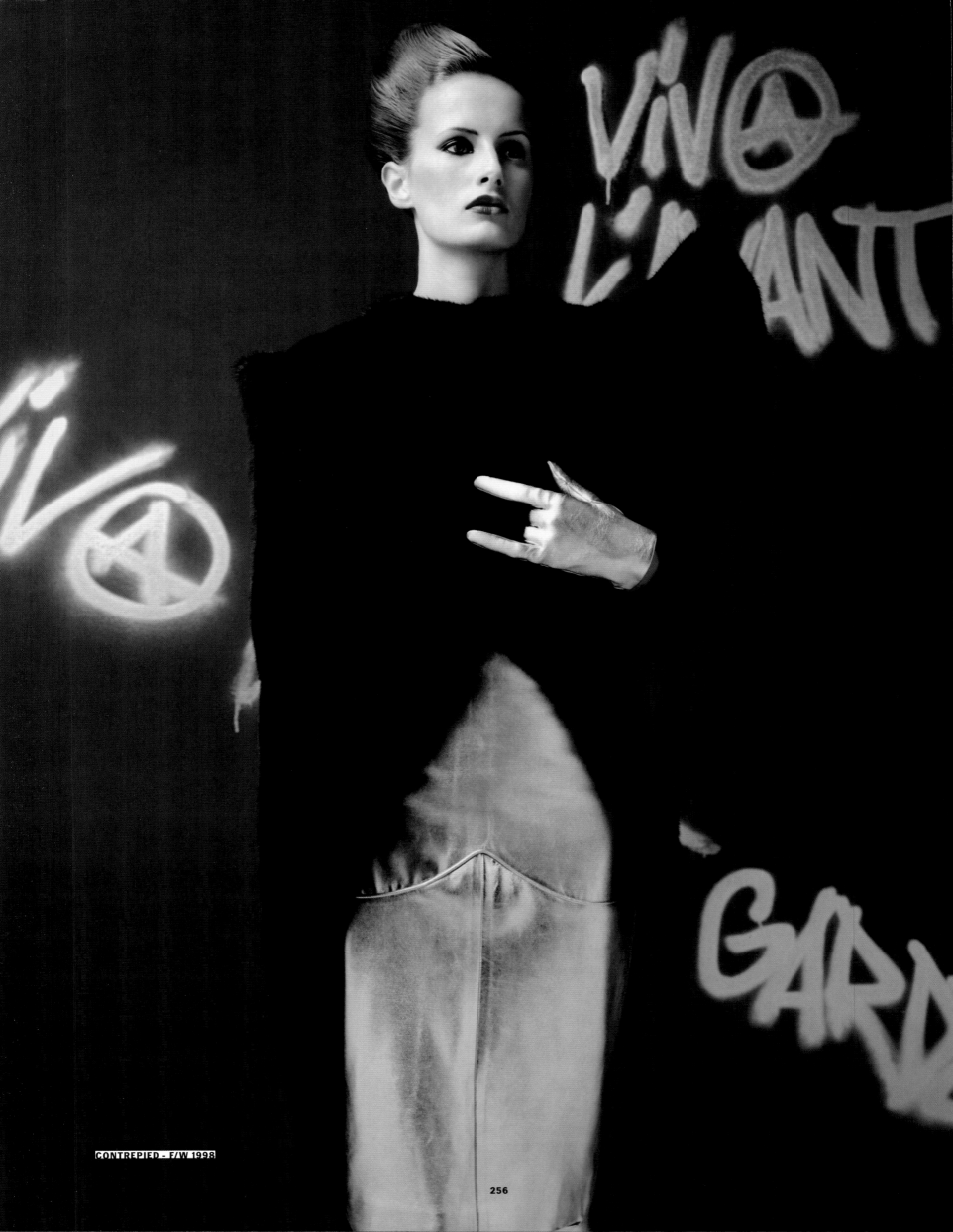

CONTREPIED - F/W 1998

256

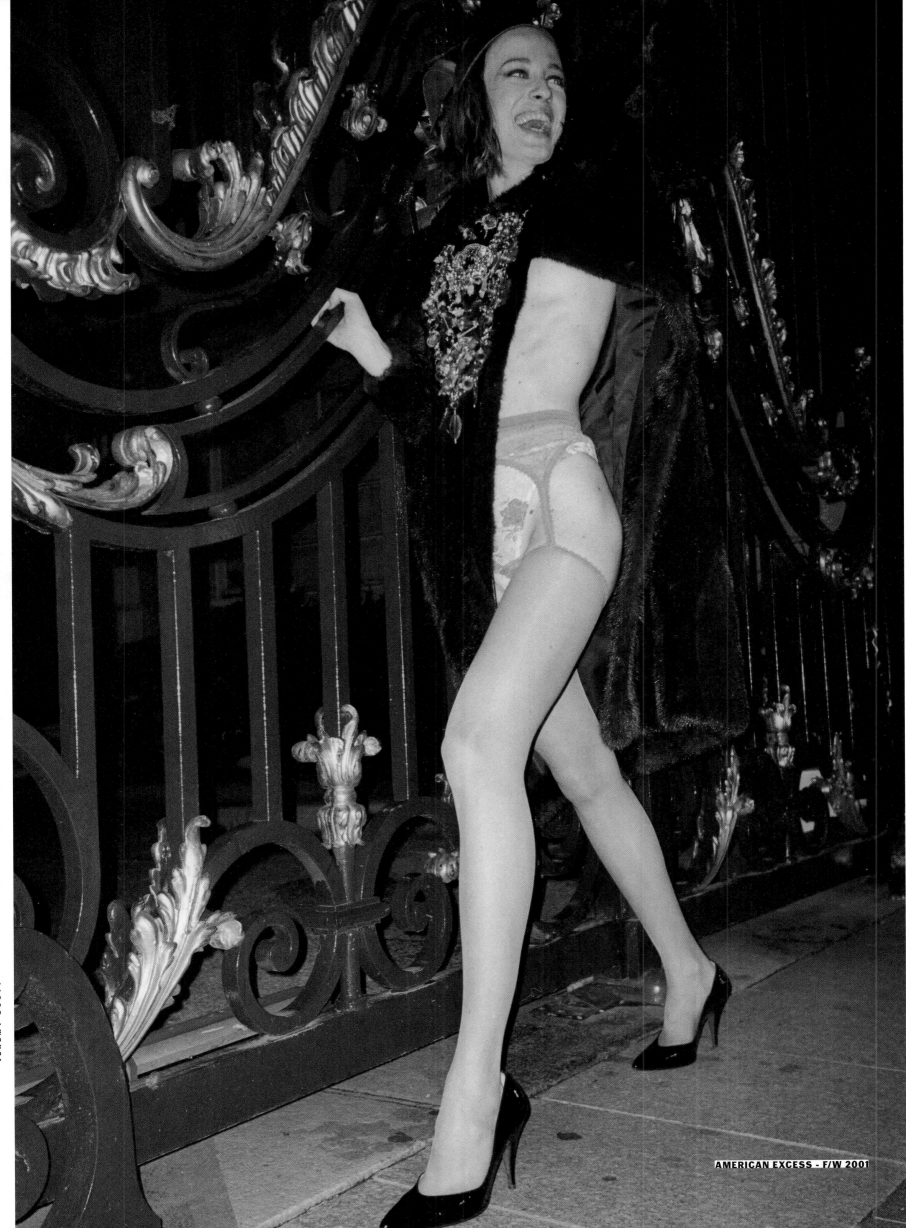

AMERICAN EXCESS - F/W 2001

JEREMY SCOTT

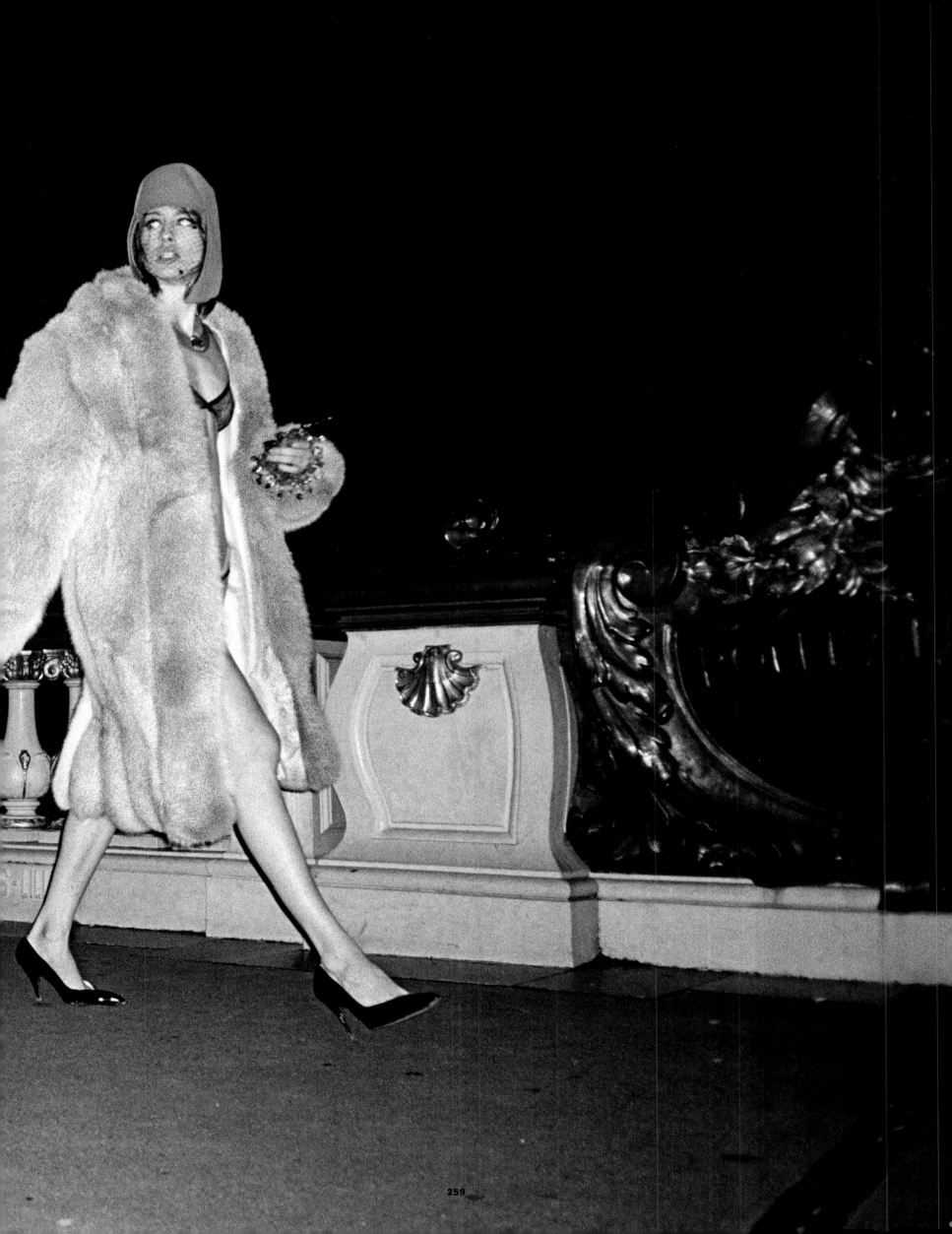

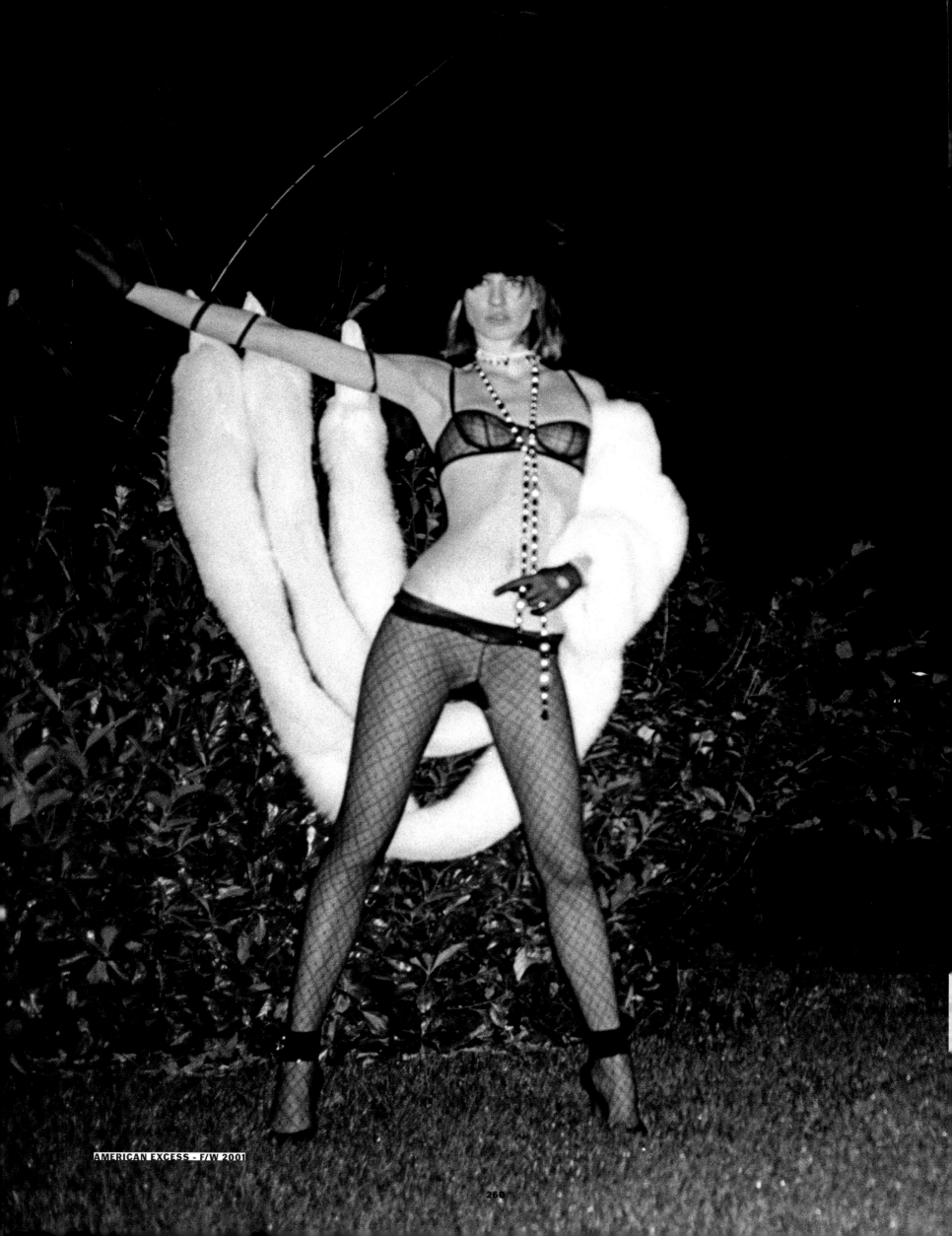

AMERICAN EXCESS - F/W 2001

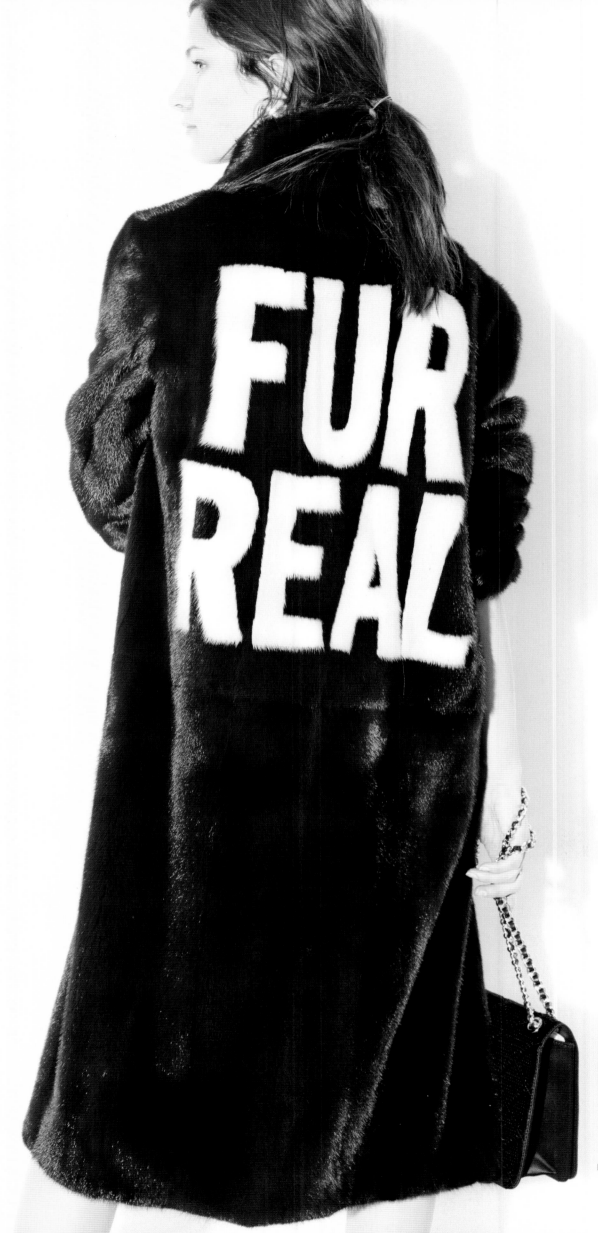

MOSCHINO - F/W 2014

JER
A
ME

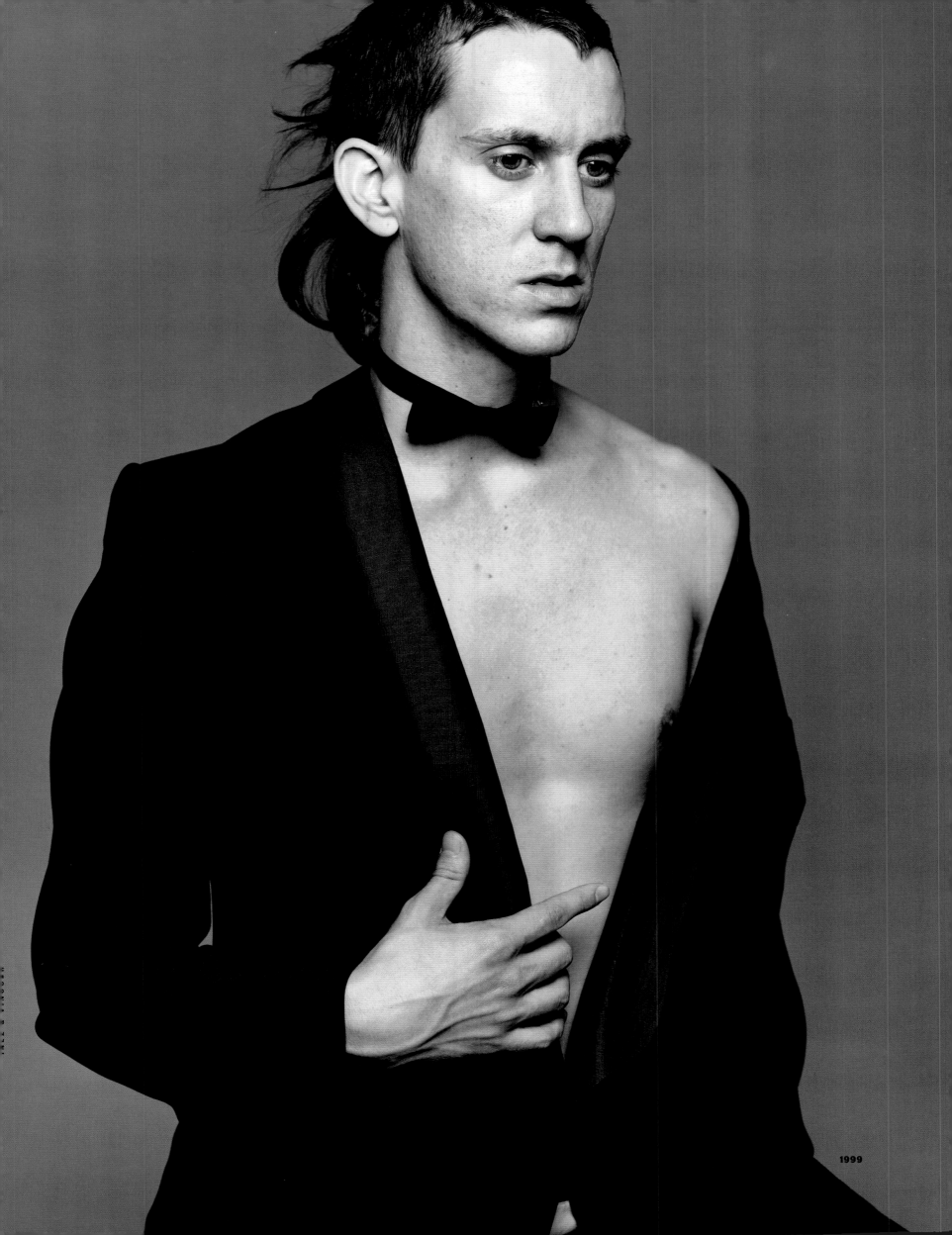

1999

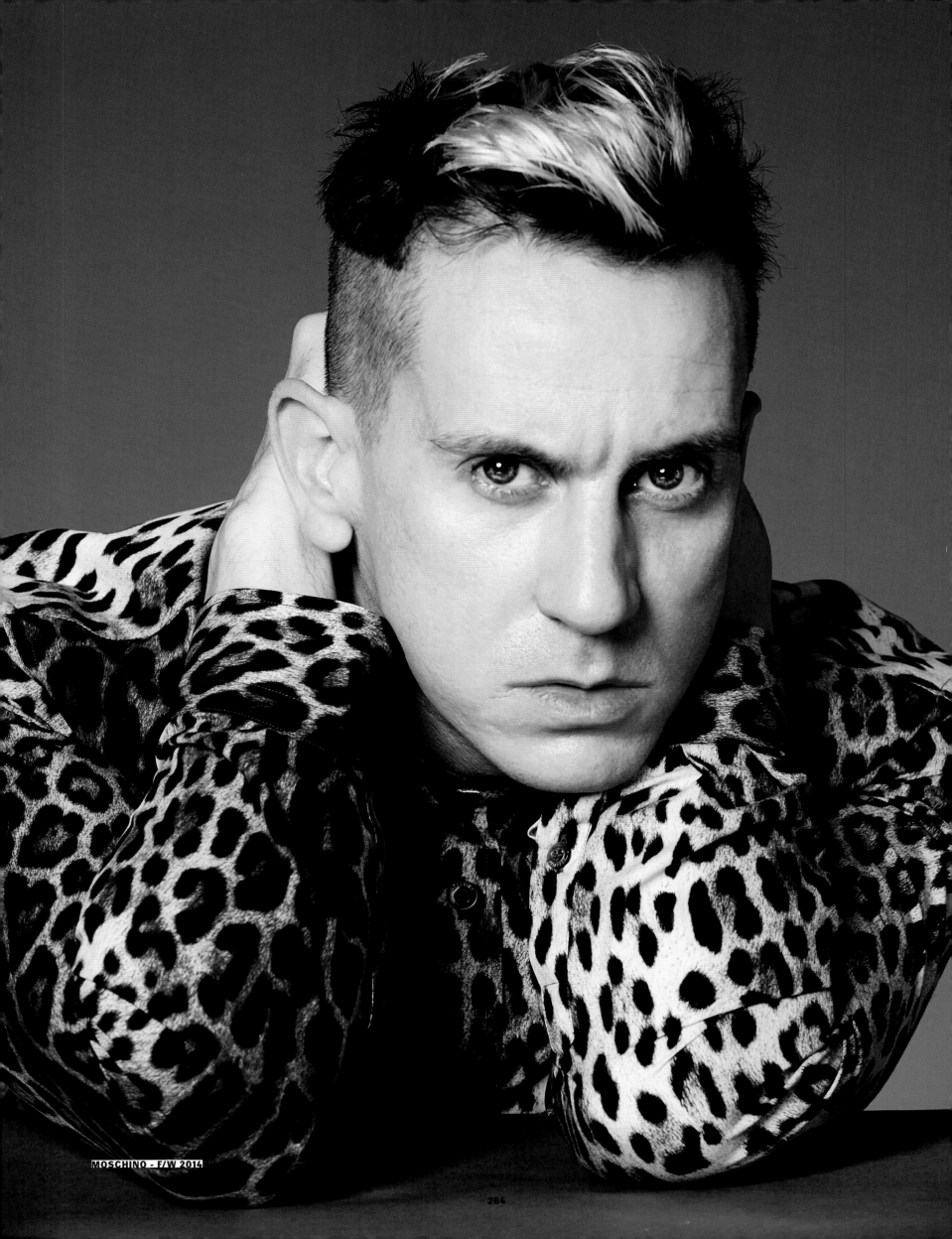

264

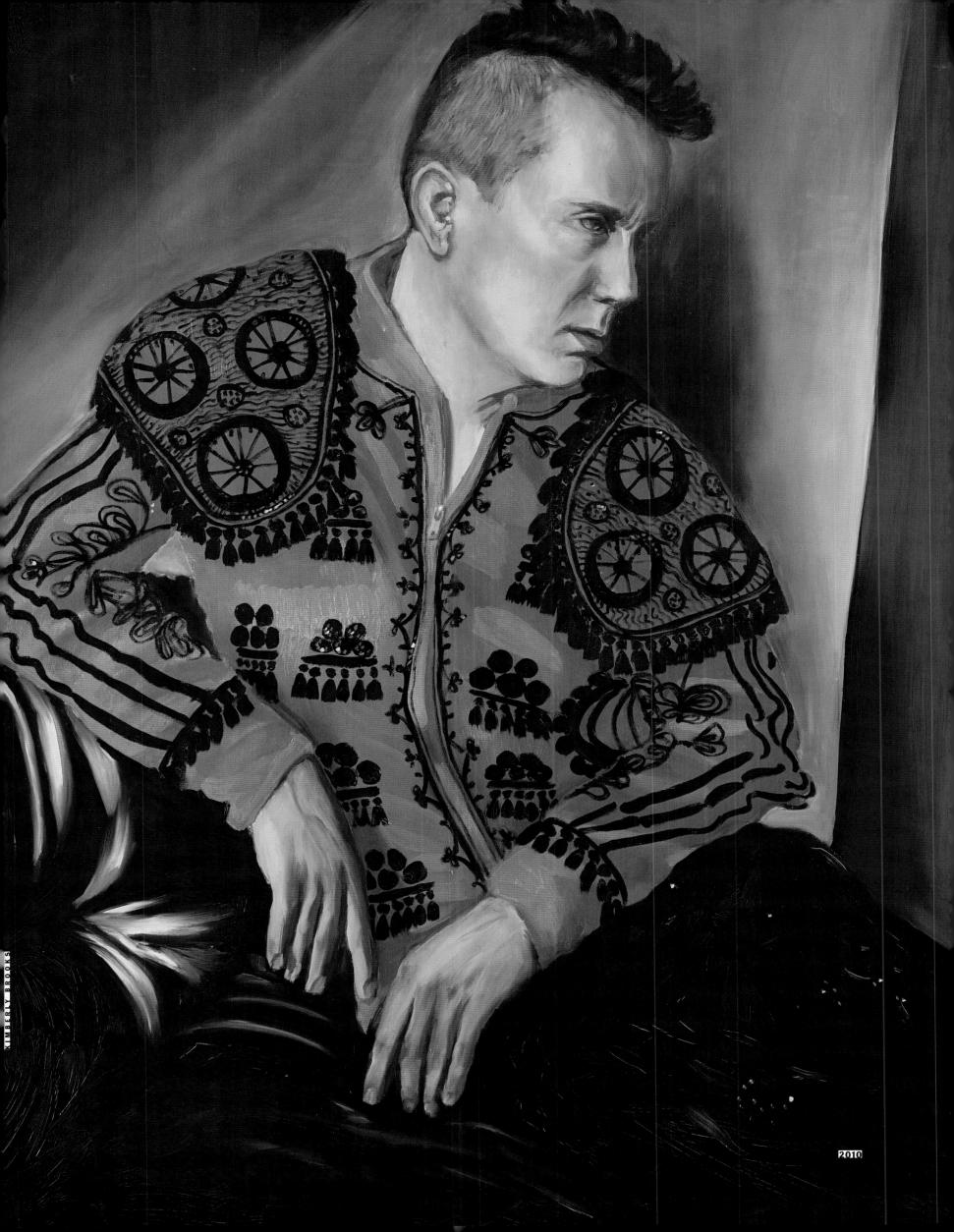

2010

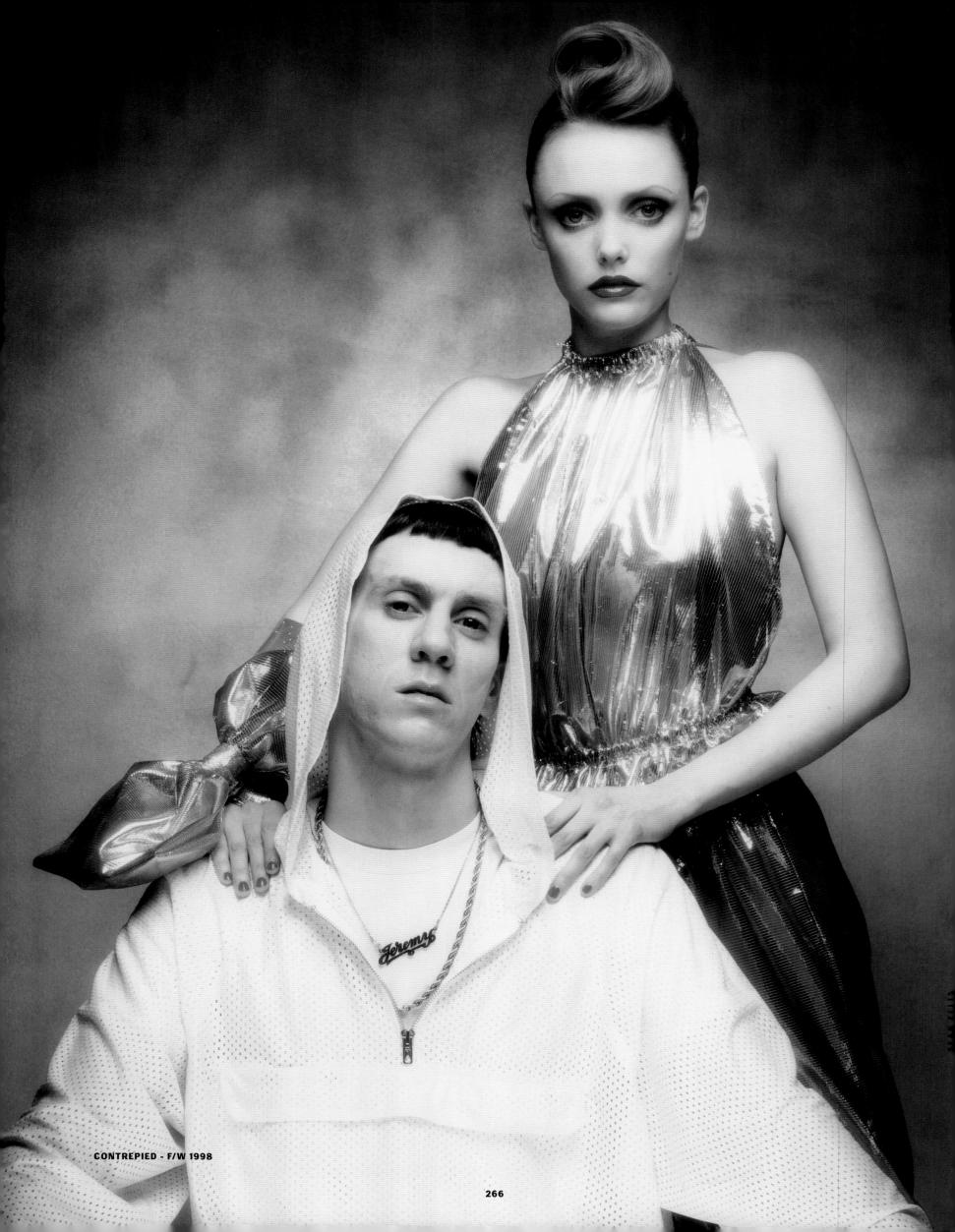

CONTREPIED - F/W 1998

266

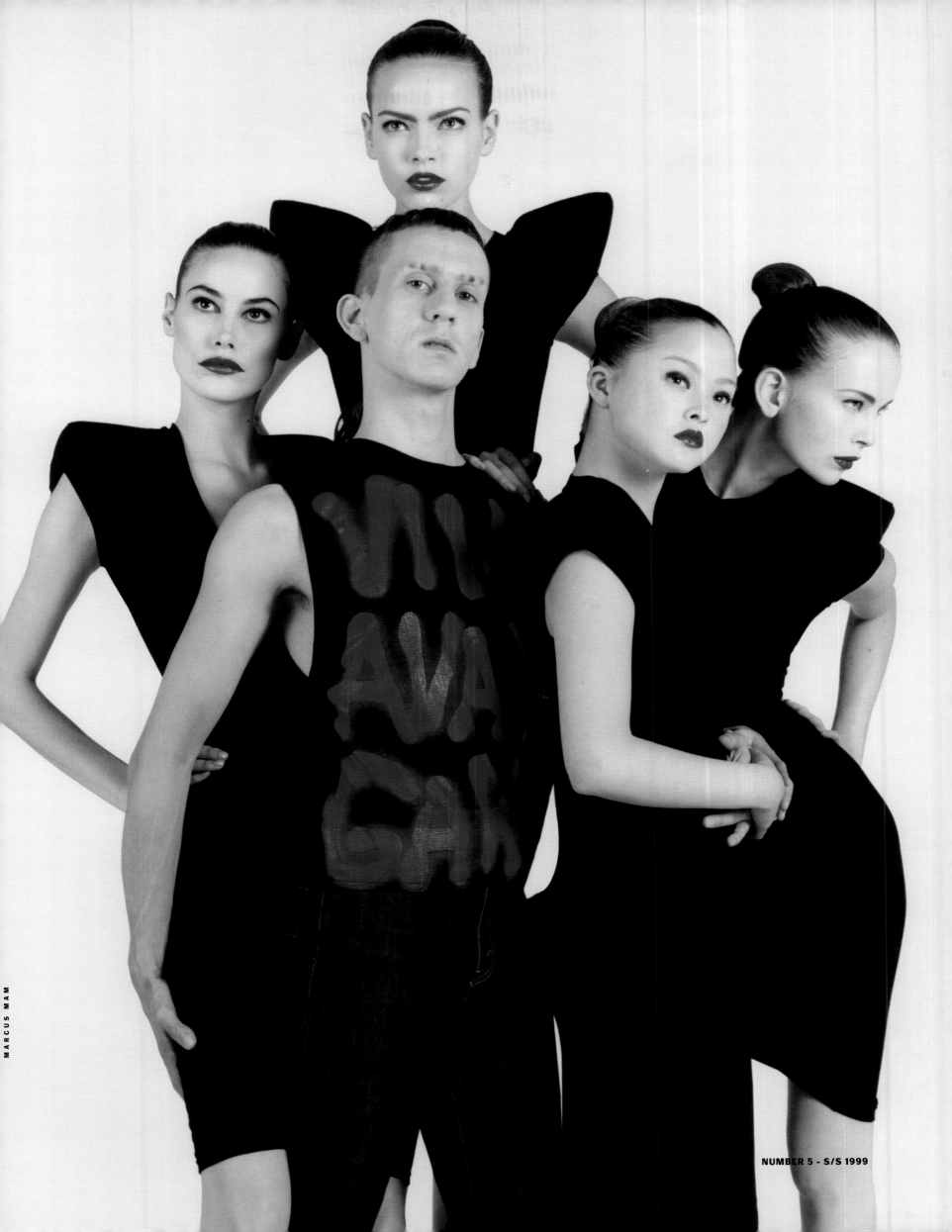

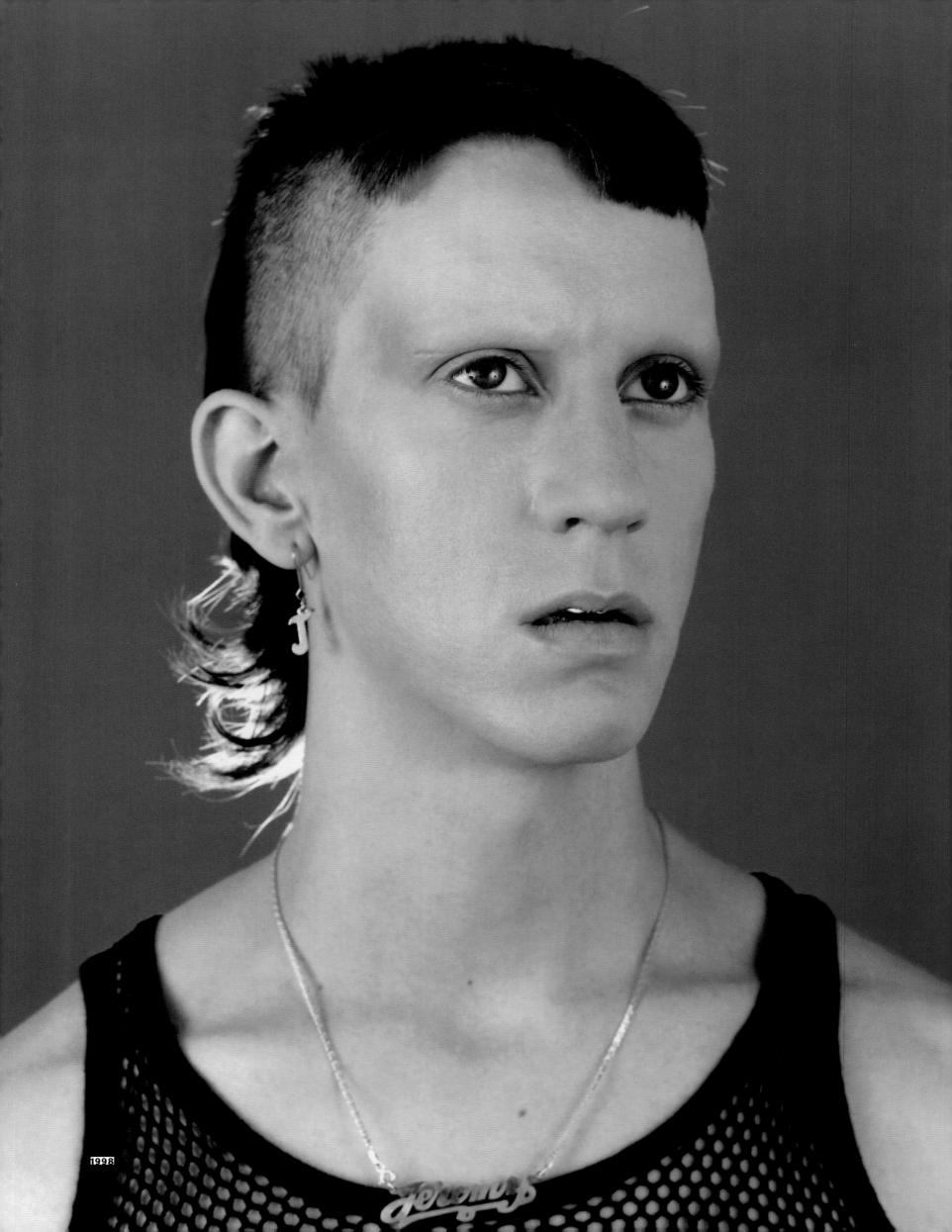

1998

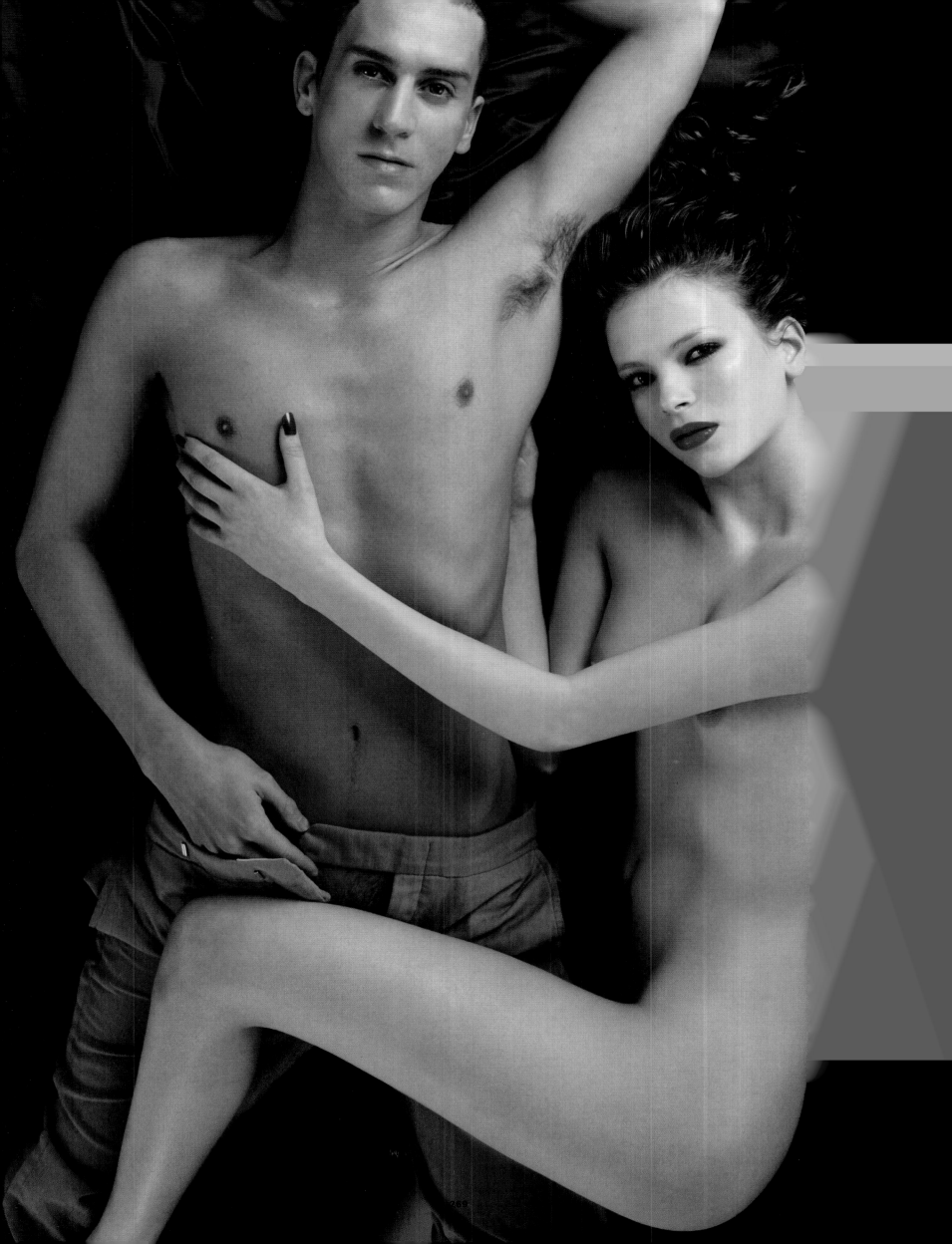

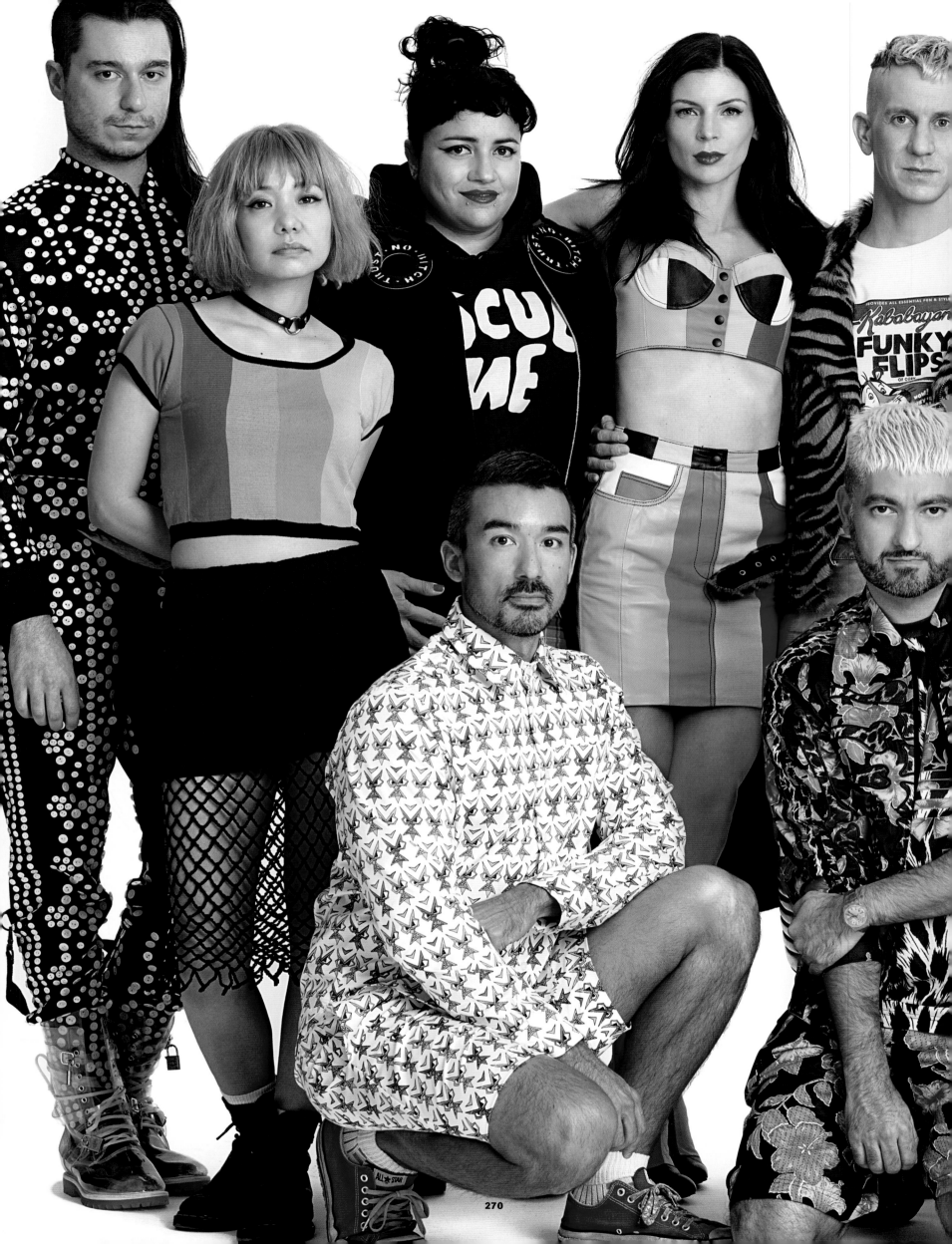

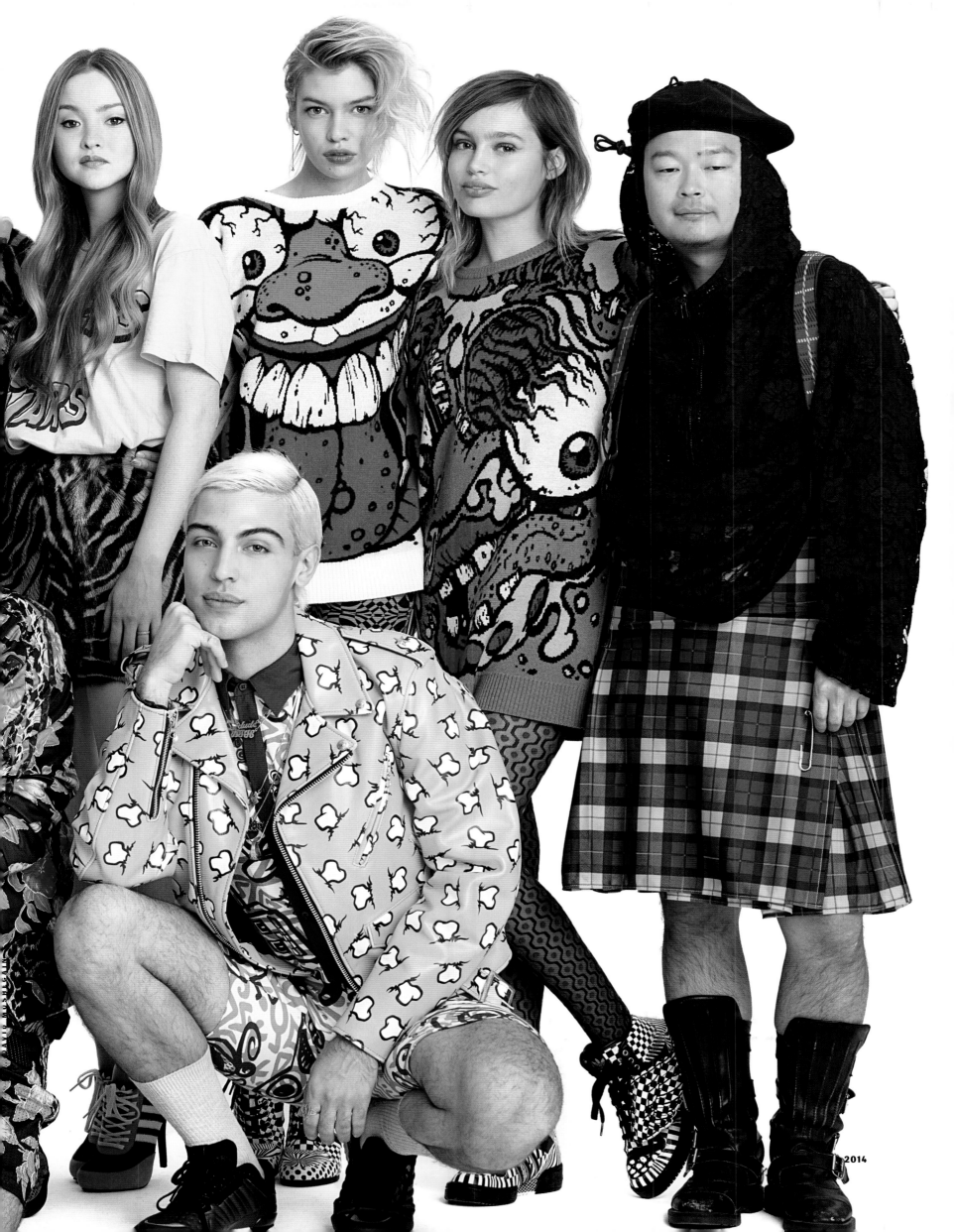

2014

When putting together this book that spans my career to date, it would be impossible for me to properly thank everyone who has contributed and show how grateful I truly am.

I'd like to start by thanking **ALEX WIEDERIN** for making sense of a diverse array of images, **JACOB LEHMAN** and **MARTYNKA WAWRZYNIAK** with **RIZZOLI** for coming to me with the enthusiasm to do this book and helping manage all the logistics, and **JEFFREY DEITCH** for the beautiful words. I'd like to give a heartfelt thank you to all the photographers who have lent their photos for the book, and for having created inspiring images with my work. Especially to **INEZ AND VINOODH** for honoring me with the cover portrait for this book, as I could not think of anyone else I would rather immortalize me than the two of you! Thank you to all the models, performers, and personalities who have agreed to be in my book, I'm so grateful for your support and inspiration! There are models and then there are muses: **LIBERTY ROSS**, **JESSICA MILLER**, **CHARLOTTE FREE**, and **DEVON AOKI**, thank you for taking the leap whenever I said jump! Extra special thanks go out to **KATY PERRY** for being not only a wonderful ambassador but a true friend, to **RIHANNA** for always being ride or die, **CL** my baby girl for embodying the spirit of my designs, **NICKI** for all your words of encouragement, **M.I.A.** for the power power, **RITA ORA** for your undying love, **MADONNA** for teaching me about being a Leo, and **BJORK** for giving me a chance before anyone else had.

I'd like to thank **ANASTASIA BARBIERI**, who styled the first shoot I did as a photographer and encouraged me to shoot my own work. **ARIANNE PHILLIPS** for always being my rock. **JOANNE BLADES** for coming to check on me that day before my first show in New York and then staying by my side for so many years after, you're like a sister to me. **ANNA DELLO RUSSO** for being my #1 cheerleader. My darling **CARLYNE**, words cannot express the depth of my love, admiration, and gratitude; your belief in me gives me a strength I never knew I had, a courage I only dreamed of, and the belief that anything is possible.

Very special thanks to all the talented people who have helped me create my vision on the runway: **EUGENE SOULEIMAN**, **VAL GARLAND**, **KABUKI**, **PETER PHILIPS**, **AARON DE MEY**, **PETER GRAY**, **WARD**, **ODILE GILBERT**, and **PAUL HANLON**. The maestro **MICHEL GAUBERT** for giving a soundtrack to my life's work, **FRANCESCA BURNS**, **MASHA ORLOV**, **CATHERINE BABA**, **AUTUMN WALTERS**, **MARCUS MAM** and **KELLY CUTRONE** for your many years of support.

Last but certainly not least, **PABLO OLEA**, for being there through thick and through thin. I could not have done it without you.

JEREMY SCOTT FOR ADIDAS - F/W 2012

Thanks to all the photographers and models who allowed their images to be included in this book. All images are courtesy the photographers themselves and reproduced with kind permission of the models unless otherwise noted below.

Images on pages 10, 33, 241
Courtesy the photographer and
JED ROOT.

Images on pages 13, 25, 26, 28,
78, 79, 81, 89, 97, 111, 121, 130,
152, 153, 160, 186, 197, 206-207,
212, 215, 231, 245, 247, 251, 252,
255, 263, 270-271
Courtesy the respective
photographers and TRUNK
ARCHIVES.

Images on pages 35, 69, 115, 137,
182, 250
Courtesy the respective
photographers and ART PARTNER.

Images on pages 46-47, 64-65,
88, 139, 140-141, 161, 211
Courtesy the respective
photographers and ART +
COMMERCE.

Images on pages 58, 204, 229
Courtesy the photographer and
RAY BROWN PRODUCTIONS.

Image on pages 85,129
Courtesy the respective
photographers and CORBIS.

Images on pages 109, 133, 208
Courtesy the respective
photographers and GETTY
IMAGES.

Image on page 135
Courtesy SIPA USA.

Image on page 205
Courtesy the photographer and
GAMMA RAPHO.

Pages 61, 106
Photography
© NOBUYOSHI ARAKI
Styling ERIKA KURIHARA
ID magazine (The Define Yourself
Issue, no. 309, Fall 2010)

Page 71
Photograph by
RICHARD AVEDON
BJÖRK, dress by JEREMY SCOTT,
New York, June 18, 2000
© THE RICHARD AVEDON
FOUNDATION

Page 55
Photograph by
NAPOLEON HABEICA
BABY BABY BABY magazine
Stylist: ROMINA HERRERA
MALATESTA
Makeup & Hair: GINA CROZIER
Model: TATIANA LYADOCHKINA
at NEW YORK MODEL
MANAGEMENT

Page 246
Photograph by
YEUNG WAI YEE KAT
KETCHUP Magazine
Model: CL

Page 124
Photograph by YEONG JUN KIM
Stylist: 2NE1 stylist team
(YG ENTERTAINMENT)
Hair: SEO YOUN, HYEJIN
Make-up: SUNG EUN SHIN,
MINSUN KIM,
JUKYUNG KIM

Pages 14-15, 73, 190-191, 193,
200-201

Photographs by
DAVID LACHAPELLE:
Pages 14-15
OBJECTS OF DESIRE, 2000
Styled by ISABELLA BLOW
CHROMOGENIC PRINT
© DAVID LACHAPELLE STUDIO
Page 73
MARILYN MANSON: OFFICE
VISIT, 1997
Styled by PATTI WILSON
CHROMOGENIC PRINT
© DAVID LACHAPELLE STUDIO
Pages 190-191
DURAN DURAN: GIRLS ON FILM,
2000
CHROMOGENIC PRINT
© DAVID LACHAPELLE STUDIO
Page 193
JUMPING JACK TRASH, 2002
Styled by PATTI WILSON
CHROMOGENIC PRINT
© DAVID LACHAPELLE STUDIO
Pages 200-201
MORNING AFTER, 1999
Styled by ISABELLA BLOW
CHROMOGENIC PRINT
© DAVID LACHAPELLE STUDIO

Pages 58, 204, 229
Photographs by
THIERRY LE GOUÈS for
FRENCH REVUE DE MODES
Magazine
Page 58
AJAK DENG (IMG),
FRENCH REVUE DE MODES #22
Page 204
KELLY GALE (DNA),
FRENCH REVUE DE MODES #24
Page 229
CINDY CRAWFORD,
FRENCH REVUE DE MODES #20

Pages 31, 43, 125, 181
Photographs by
CHRISTIAN LUCIDI:
Pages 31, 43, 181
JEREMY SCOTT IS POP!
HUNTER Fashion Magazine
Model: NAOMI PREIZLER
Stylist: MARCELL ROCHA
Page 125
JUNGLE FEVER (Personal)
Models: ATAUI DENG, REINA
MONTERO, HENRY WATKINS
Stylist: MARCELL ROCHA

Pages 118-119
Photographs by
OLIVIER STALMANS /
TOMORROW MANAGEMENT
DANSK Magazine #22 F/W 2009
Model: HANNE GABY ODIELE

Pages 134, 208
KATY PERRY by YU TSAI,
January 2011

Pages 192, 213
Photographs by
MATHIAS VRIENS MCGRATH:
Page 192
JESSICA HART for L'OFFICIEL
Page 213
MATHIAS VRIENS MCGRATH,
Paris 1997

ASHLEY SMITH appears
courtesy ASHLEY SMITH/
THE SOCIETY MANAGEMENT.

ONDRIA HARDIN, ANAIS MALI,
ANDREJ PEJIC, and AYMELINE
VALADE represented by DNA
MODEL MANAGEMENT
NEW YORK.

FIRST PUBLISHED IN THE UNITED STATES OF AMERICA IN 2014 BY
RIZZOLI INTERNATIONAL PUBLICATIONS, INC.
300 PARK AVENUE SOUTH
NEW YORK, NY 10010
WWW.RIZZOLIUSA.COM

© 2014 JEREMY SCOTT
FOREWORD © 2014 JEFFREY DEITCH

DESIGNED BY: BUERO NEW YORK
CREATIVE DIRECTOR: ALEX WIEDERIN
ART DIRECTOR AND GRAPHIC DESIGN: GABRIEL J. VILLASMIL
TYPOGRAPHY DESIGN: ANTJE ERASMUS
PRODUCER: RONIT AVNERI

RIZZOLI EDITORS: JACOB LEHMAN & MARTYNKA WAWRZYNIAK
PRODUCTION MANAGER: KAIJA MARKOE
EDITORIAL ASSISTANCE: SUPRIYA MALIK, KRISTEN ROEDER, JULIE SCHUMACHER

SEPARATION BY ALTAIMAGE

2014 2015 2016 2017 / 10 9 8 7 6 5 4 3 2 1
PRINTED IN CHINA
ISBN: 978-0-8478-4357-2
LIBRARY OF CONGRESS CONTROL NUMBER: 2014931973